Joshua Reynolds
The Creation of Celebrity

Joshua Reynolds
The Creation of Celebrity

Edited by
Martin Postle

With essays and catalogue entries by
Martin Postle and Mark Hallett
and essays by
Tim Clayton and Stella Tillyard

Tate Publishing

First published 2005 by order of the Tate Trustees
by Tate Publishing, a division of Tate Enterprises Ltd,
Millbank, London SW1P 4RG
www.tate.org.uk/publishing

on the occasion of the exhibition
Joshua Reynolds: The Creation of Celebrity

Palazzo dei Diamanti, Ferrara
13 February – 1 May 2005

and

Tate Britain, London
26 May – 18 September 2005

British Library Cataloguing in Publication Data
A catalogue record for this book is available from
the British Library

ISBN 1 85437 564 4

Distributed in the United States and Canada by
Harry N. Abrams, Inc., New York

Library of Congress Cataloging in Publication Data
Library of Congress Control Number 2004111329

Designed by Laura Quaggia
Printed in Ferrara, Italy by Sate srl

Cover: *Omai c*.1776 (detail of cat.67)

Contents

Foreword

Tate Britain and Ferrara Arte are delighted to be presenting, in collaboration, the first major exhibition for twenty years of the work of Sir Joshua Reynolds (1723–92), founding president of the Royal Academy and the most important single figure in the history of eighteenth-century British art. Whereas the 1985–6 exhibition at the Grand Palais, Paris, and the Royal Academy, London, presented a broad survey of Reynolds's artistic production, the present exhibition focuses especially on the relationship between his greatest works – the portraits – and the vibrant and complex high society of Georgian England from which they evolved and to which they contributed so richly.

Reynolds was both a 'celebrity' in his own right, the best-known living British artist at home and abroad, and a broker of the fame and reputations of countless well-known individuals of the day – from courtesans to politicians, intellectuals to generals, actors to aristocrats. A social networker *par excellence*, he performed the role of friend, agent and publicist, honing images and shaping personae for eager public scrutiny. Public thirst for celebrity was revealed and expressed in many ways: through the burgeoning popularity of exhibitions of contemporary art in London, to which of course Reynolds regularly contributed portraits of men and women of the moment; by a flourishing print trade supplying inexpensive multiple reproductions of the most popular exhibits; and by the voracious consumption of newspapers and broadsheets supplying details of the public and private lives of society's movers and shakers. As this exhibition shows, Reynolds's influence and impact in all these spheres derived in part from his populist antennae and in part from his careful elevation of his subjects away from the potential banality of their actual achievements and into the realms of classicism, history and high culture.

The origins of Reynolds's famous mission to raise British art and its reputation to the greatest heights of European achievement lie in his visit to Italy from 1749 to 1752, a journey which unveiled to him the work of many of the Old Masters whom he was later to extol in his Discourses to the Academy. En route from Bologna to Venice in the summer of 1752, he stopped briefly at Ferrara, where he admired, among others, the art of Guercino. Many years later, Angelo Talassi, a poet from Ferrara, met Reynolds in London, together with the artist's close friends, Edmund Burke, Samuel Johnson and the actor, David Garrick. On his return to Ferrara, he characterised them in flattering terms as 'il Cicerone, il Platone, L'Apelle, ed il Roscio dell'Inghilterra'. Against such a background, it is with great pleasure that we are able to open this exhibition, Reynolds's first major showing in Italy, at the Palazzo dei Diamanti.

The exhibition was conceived and curated by Martin Postle, Curator (Head of British Art), Tate Collection. He has worked closely with many museum colleagues in both London and Ferrara, and with a legion of extraordinarily generous lenders to the exhibition. He has also been assisted in the making of the catalogue by the distinguished scholars, Tim Clayton, Mark Hallett and Stella Tillyard. The project must be recognised as a huge personal achievement for Martin himself. He has devoted more than two decades to the study of Reynolds, and the range, ambition and originality of his interpretation here of the artist's incomparable importance as a portraitist and as a player at the heart of Georgian London will, we believe, give great pleasure and enlightenment to a new public in Italy and in Britain.

Stephen Deuchar
Director, Tate Britain

Andrea Buzzoni
Cultural Activities Director, Ferrara Municipal Council

Acknowledgements

Many people have contributed to the making of this exhibition. I would like to thank Tim Clayton and Stella Tillyard for their invaluable contributions to the exhibition catalogue, and also Mark Hallett, who, in addition to his essay, contributed catalogue entries and assisted in the selection of works.

As ever, the exhibition would not have been possible without the generous support of private lenders as well as colleagues in public museums and art galleries. I would therefore like to thank the following people for their generosity and support: the Duke of Abercorn, the Duke of Buccleugh, the Duke of Devonshire, Lord Egremont, Lord Harewood, Lord Lansdowne, the Earl of Leicester, the Duke of Marlborough, the Duke of Norfolk, Sir William Proby, Lady Rosebery, Sir Jacob Rothschild, Mr John Schaeffer, Earl Spencer, Lady Juliet Tadgell, Mrs Charlotte Townshend, and those lenders who wish to remain anonymous.

I would also like to express my gratitude for their help in facilitating loans to Sir Jack Baer, Janet Boston, Rachel Brodie-Venart, Roy Clare, Keith Cunliffe, Anne Dulau, Susan Foister, James Holloway, Alistair Laing, Adrian Le Harivel, Michele Leopold, Christopher Lloyd, Stephen Lloyd, Amber Ludwig, James Millar, Amy Myers, David Moore-Gwyn, Guy Morrison, Angela Nevill, Sheila O'Connell, Lucy Peltz, Janice Reading, Jennifer Scott, Desmond Shawe-Taylor, Janice Slater, Helen Smailes, Mary Ann Stevens, Terry Suthers, Joan Celeste Thomas and Melanie Unwin.

At Tate I am grateful to my colleague Ben Tufnell, who shouldered so much of the day-to-day responsibility for the organisation of the exhibition for Tate Britain, and to Judith Nesbitt and Cathy Putz who worked closely with our colleagues in Ferrara. I would also like to thank Rica Jones for her tremendous contribution through the conservation of works for the exhibition, both from Tate's collection and from lenders. I am grateful, too, to Julia Nagel, to Jacqueline Ridge, who was responsible for the conservation of *Lady Talbot*, and to Gerry Alabone, Alastair Johnson and Adrian Moore for their craftsmanship in conserving the picture frames, and for making from scratch a beautiful new frame for Tate's *Mrs Hartley as a Nymph with a Young Bacchus*. The conservation of John Henry Foley's magnificent marble statue of Reynolds was expertly undertaken by Emily Fryer, through funds generously donated by the Tate Members. For their help in different ways I would also like to thank Heather Birchall, Gillian Buttimer, David Clarke, Catherine Clement, Andrew Dunkley, Sionaigh Durrant, Claire Eva, Joanna Fernandes, Bronwyn Gardner, Ken Graham, Lisa Hayes, Karen Hearn, Mark Heathcote, Sarah Hyde, Zoe Kahr, Marcella Leith, Marcus Leith, Ben Luke and Andy Shiel.

I would like to express my gratitude to the editor of the exhibition catalogue at Tate, John Jervis, as well as Leigh Amor, Rebecca Fortey, Katherine Rose and Emma Woodiwiss, for their invaluable contributions. I would also like to thank my colleagues in Ferrara for their tremendous contribution to the success of the exhibition and the catalogue, and also for their warm hospitality and friendship: Silvia Garinei, Tiziana Giuberti, Federica Guerrini, Barbara Guidi, Maria Luisa Pacelli, Laura Quaggia and Federica Sani.

The exhibition at Tate Britain was designed by Liza Fior and Carolina Thorbert of muf architecture with their customary flair and professionalism. For their assistance in organising respectively insurance, indemnity and transport, I am grateful to Robert Graham of Blackwall Green (Jewellery and Fine Art) Ltd, Andrew Middleton at the Department for Culture, Media and Sport, and Victoria Sowerby of Momart.

The exhibition would not have been possible without the enthusiastic support of Stephen Deuchar, Director of Tate Britain, and Andrea Buzzoni, Director of Ferrara Arte. I would like to thank them both for allowing me the opportunity to organise this exhibition, and for their confidence in the project.

Finally, I would like to express my profound gratitude to my colleague, David Mannings, whose recent catalogue raisonné of the portraits of Joshua Reynolds has contributed so much to our knowledge and understanding of the artist.

Martin Postle
Curator, Head of British Art to 1900, Tate Collection

Essays

Martin Postle
Mark Hallett
Tim Clayton
Stella Tillyard

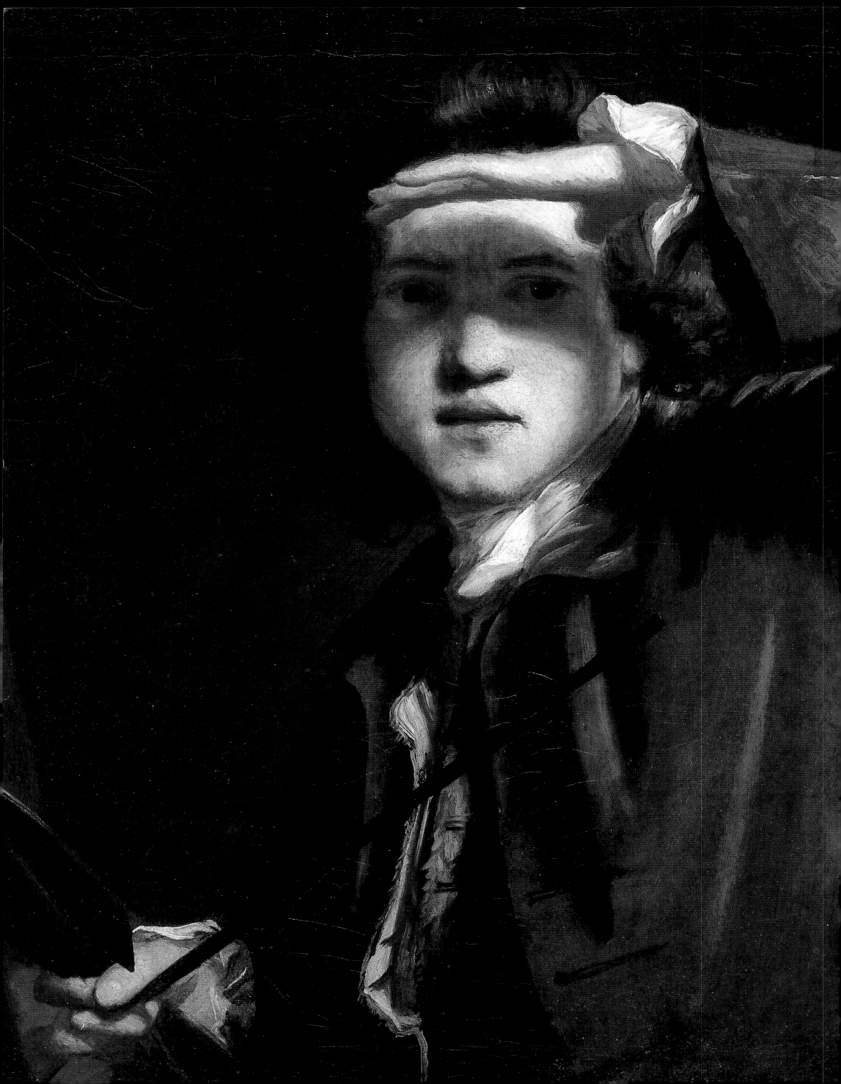

'The Modern Apelles': Joshua Reynolds and the Creation of Celebrity

Martin Postle

Unblemish'd let me live, or die unknown,
Oh, grant an honest Fame, or grant me none!

Alexander Pope, *The Temple of Fame*, lines 523–4

In his allegorical poem of 1715 the youthful Alexander Pope mused upon the ambivalence of fame, and the price paid by those who pursue it with an eye to posterity. Several decades later, Joshua Reynolds, then training as an artist in London, came face to face with Pope, one of his boyhood heroes, and now among the most famous Englishmen alive (fig.1). The year was 1742, the place, a crowded auction room in Covent Garden. As Pope entered the room people pressed forward. Reynolds, who was in the second row, thrust out his hand under the arm of the person in front and grasped the poet's hand. The memory of this moment stayed with Reynolds for the rest of his life.[1] Conscious as he was of Pope's fame as a poet, this personal contact confirmed his appeal to Reynolds as a recognisable public figure. The incident also allows us to understand more fully Reynolds's attitude towards fame, and how it was inextricably bound up with a concern for his public persona, or what we today would call his 'celebrity' status.

The concept of fame, and its relationship to honour and virtue, was a popular topic in the literature of the Enlightenment, not least because at this time poets, actors and writers were attracting the attention that in previous generations had been accorded to military heroes and courtiers. Fame was the just reward for artistic endeavour, the laurel wreath that crowned a lifetime of creative struggle. John Milton, another of Reynolds's literary heroes, stated:

Fame is the spur that the clear spirit doth raise
(That last infirmity of noble mind)
To scorn delights, and live laborious days;[2]

Fame, then, was a laudable aspiration, but as Reynolds was aware, it could not be guaranteed by labour alone, or even by royal favour. As the court declined in influence so artistic reputations were established through new channels, by essayists and journalists, through reproductive engravings and, from their inception in 1760, through public art exhibitions. Reynolds desired fame above all else; fame that would outlive him and transmit his name to future generations. This he achieved. However, he did so by using the mechanisms associated with what has become known as 'celebrity', a hybrid of fame driven by commerce and the cult of personality. Reynolds needed to establish a name in a culture where, as John Brewer has observed, the 'most high-minded and patrician forms – the epic, history painting, and tragedy – were jostled and sometimes nudged aside by a demotic throng of mock epics, ballad operas, urban pastorals, conversational pieces, comic history painting, and performances and products that could only be described as olios, potpourris, or pastiches.'[3] If he was to achieve fame in his own lifetime Reynolds realised that he needed to appeal to popular as well as polite culture, to transient tastes as well as eternal truths.

Joshua Reynolds was the son of a schoolteacher and cleric. He was originally baptised Joseph, the baptismal register being altered only after his death.[4] In retrospect Joshua (meaning 'saviour') seems more apposite, for just as his namesake had led the Israelites to the promised land, so Reynolds saw it as his mission to establish a new golden age for British art. Reynolds received a well-rounded education at his father's grammar school in Plympton, Devon. In addition to his formal schooling, Reynolds kept a 'commonplace book', in which he

copied passages from his favourite authors.[5]
As well as classical writers such as Theophrastus,
Plutarch, Seneca and Ovid, the book included quotations
from Shakespeare, Milton, Pope and John Dryden,
extracts from Joseph Addison and Richard Steele's
Spectator and *Tatler* essays, and from the playwright,
Aphra Behn.[6] The greatest influence upon Reynolds was,
however, Jonathan Richardson's *Essay on the Theory of
Painting* of 1715.[7] Richardson was the first English writer
on art to present a cohesive and rational argument for the
educative role of painting and sculpture, and its parity
with other Liberal Arts.[8] Endowed with a philosophical
justification and seriousness of purpose, the artist was,
according to Richardson, worthy of admiration and
emulation, as well as tolerance and understanding.
As a result he was able to make the following
exhortation: 'And now I cannot forbear wishing that some
Younger Painter than my self, and one who has had
Greater, and more Early Advantages would exert himself,
and practise the Magnanimity I have been recommending,
in this Single Instance of Attempting, and Hoping only to
equal the greatest Masters of whatsoever Age, or nation.'[9]
Reynolds, who surely identified with Richardson's
hypothetical 'Young Painter', rose to the challenge; for as
his father acknowledged at the time, Joshua would rather
have been an apothecary than an '*ordinary* painter'.[10]
Even so, as his pupil James Northcote later observed,
Reynolds believed that even had he trained as a surgeon,
'he should not have been obscure, for as fame was
allways [*sic*] his desire he would have study'd physick
and at least have attemted [*sic*] if not realy [*sic*] made the
greatest physician in the world'.[11]

 In London, in the early 1740s, Reynolds was
apprenticed to his fellow Devonian, Thomas Hudson.
Hudson taught Reynolds to paint portraits, but as
important for his career was the society into which
Hudson introduced him. Reynolds's father observed
in December 1744 that 'Joshua by his master's means
is introduced into a club composed of the most famous
men in their profession'.[12] During the 1720s and 1730s
a number of clubs devoted to Italian classicism and the
visual arts sprang up in the metropolis.[13] Foremost among
these was the Roman Club, founded in 1723. Its members,
as Louise Lippincott has noted, 'based their concept of
the artist as a gentleman of learning, and the gentleman as

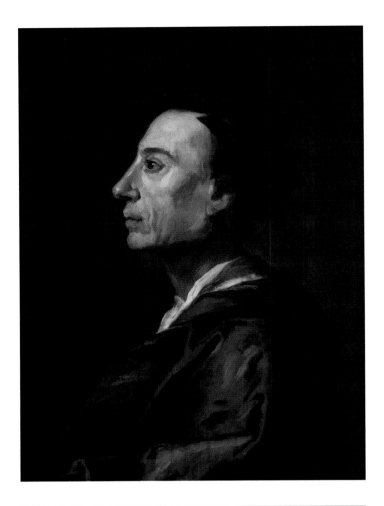

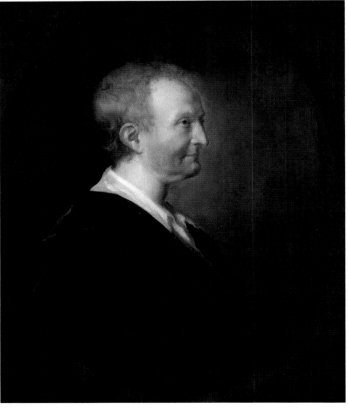

a connoisseur and patron of the arts and literature, on the theoretical writings and living example of their mentor Jonathan Richardson'.[14] Although the Roman Club was disbanded in 1742 its ethos continued to be embodied by similar organisations including the Society of Dilettanti (founded in Rome in the 1730s), the Pope's Head Club (founded in 1744 in honour of the eponymous poet), as well as a nameless collectors' club dedicated to Old Master prints and drawings. It was to this club that Hudson evidently introduced Reynolds. The collectors' club, organised by Hudson and his fellow artist, Arthur Pond, provided Reynolds with introductions to influential connoisseurs such as John Bouverie, Charles Rogers and Philip Yorke. Of these individuals the most significant was Yorke, son of the Lord Chancellor, later to become 2nd Earl of Hardwicke and Reynolds's close friend and patron.[15] Making contacts, learning about connoisseurship and collecting, and rubbing shoulders with the 'great and good', were the most valuable opportunities that Hudson gave to Reynolds.

It was at this time that Reynolds painted a portrait of his father (fig.2). It has been suggested that this was a posthumous portrait painted from memory sometime after his father's death in December 1745.[16] The profile portrait, derived ultimately from classical coins and medals, can be commemorative. However, its use was also reserved as a form of tribute to the living, especially literary figures, whose achievements had already guaranteed their fame. Examples familiar to Reynolds

fig.1
Jonathan Richardson (1667–1745)
Alexander Pope c.1737
Oil on canvas, 61.3 x 45.7
National Portrait Gallery, London

fig.2
Samuel Reynolds c.1746
Oil on canvas, 76.1 x 63.1
City Museum and Art Gallery, Plymouth; Cottonian Collection

would have included Sir Godfrey Kneller's 1721 profile portrait of Alexander Pope, Jonathan Richardson's 1732 drawing of his father and his portrait of Pope (fig.1),[17] as well as Arthur Pond's recent portrait of the eminent scholar and collector, Dr Richard Mead.[18] Significantly, Reynolds was to restrict the use of the profile portrait to his distinguished literary friends, notably Samuel Johnson and Oliver Goldsmith, who were portrayed in this manner several decades later in their respective roles as Professor of History and of Ancient Literature at the Royal Academy.[19] By depicting his own father in likewise fashion, Reynolds effectively elevated him to the artist's own temple of fame, affirming his support for the continued validity of this pictorial convention.

In 1749 Reynolds travelled to Italy. There he spent three years studying the art of the Old Masters and cultivating new friends and patrons. As a London journal had remarked a few years earlier, the successful portrait painter 'must have the Name of having travelled to *Rome*; and when he comes Home, he must be so happy as to please some great Personage, who is reputed a Connoisseur, or he remains in Continual Obscurity'.[20] Indeed, towards the end of his own Italian sojourn Reynolds was deeply concerned that it should have the maximum impact upon his future career and prospects. As he noted at the time, 'by being in too great a hurry perhaps I shall ruin all and arrive at London without reputation & nobody that has ever heard of me, when by staying here a month extra-ordinary my name will arrive before me, and … nobody will dare find fault with me since it has had the approbation of the greatest living Painters'. [21]

A key factor in Reynolds's ability to promote his name and extend his social network was his active social life, including his membership of London's elite clubs and societies. Over the years, Reynolds's circle embraced an astonishing range of influential individuals. Reynolds often entertained at home, although one aristocratic guest voiced the common complaint that 'he always spoils his dinners by having more people than his table can hold comfortably'.[22] He was also very much the man about town. 'During the London season', recalled one of his pupils, 'he rarely dined at home … and though the frequent dining-out probably shortened his life, it was of great advantage to him in his profession.'[23] While he seldom left his studio by day, in the evening he attended

balls, masquerades, and, in order to enhance his social skills, took dancing lessons.[24] He regularly socialised with his naval associates, or his 'Mediterranean friends' as Boswell described them, and he rarely missed a gathering of the Sons of the Clergy – although he never went to church. Reynolds loved to drink and gamble and belonged to several notorious gaming clubs, including the 'Thursday-night Club' at the Star-in-Garter Club in Pall Mall. He also sought membership of White's Club, where members played card games such as faro and hazard for high stakes. Unfortunately, on this occasion he was blackballed.[25]

From the 1760s Reynolds was admitted to several clubs with significant cultural and intellectual cachet, notably the Royal Society and the Society of Dilettanti, which, as it has been observed, 'encouraged gentlemen of relatively modest means and some of the richest men in Britain to mix on equal and familiar terms'.[26] Of greater personal significance, however, was the club that Reynolds himself founded in 1764. To outsiders it was known as the Literary Club, but to the elite corps of members it was simply 'the Club'. The original membership was restricted to nine individuals, including Samuel Johnson, Edmund Burke, Oliver Goldsmith and Reynolds. It was, as Johnson boasted, the hub of London's intellectual community: 'we have Reynolds for Painting, Goldsmith for Poetry … Nugent for Physick; Chamiere for Trade, Politics and all Money Concerns; M^r Burke for Oratory, M^r Beauclerk for Polite Literature … Langton for Ecclesiastical History & indeed all Branches of Learning Sir John Hawkins for Judicature & ancient Musick.'[27] Over the years other members of Reynolds's social circle were admitted, including David Garrick, Edward Gibbon, Charles James Fox, Adam Smith and Richard Brinsley Sheridan. To Reynolds this was his own contemporary 'temple of fame' and a coterie that eclipsed even the most exclusive aristocratic and courtly enclaves.

In 1771 the wealthy brewer, Henry Thrale, began to commission from Reynolds a series of portraits of their mutual friends to grace the library of his country house in Streatham, south London. Fanny Burney, whose father was included among the portraits, playfully labelled them the 'Streatham worthies', an allusion to the celebrated Temple of British Worthies (fig.3) erected at Stowe, Buckinghamshire by the architect William Kent, which

contained busts of famous historical figures, such as Shakespeare, Milton, Pope, Sir Isaac Newton, John Locke and Francis Bacon. Burney's epithet also pinpointed the ethos of Thrale's enterprise, which was to form his own pantheon of the great and good. The creation of 'genial companies', in the form of sculpted busts, paintings or print collections, by amateurs and aspiring literati had become particularly widespread by the mid-eighteenth century.[28] The difference at Streatham was that the various 'worthies' were still alive, and were regular visitors to Henry Thrale's house. Most of them were members of, or associated with, the Club. In this sense they recall two earlier series of British 'club' portraits; Sir Godfrey Kneller's Kit-Cat Club portraits and those painted for the Society of Dilettanti by George Knapton between 1736 and 1763.[29] Kit-Cat Club members had been united by a political as well as a cultural bond, thus their common adherence to the Whig creed was reflected in the uniformity of their collective image. Reynolds's Streatham Worthies, on the other hand, were presented as prodigies: Baretti buries his nose in a book (cat.44), Burney flourishes a musical manuscript (cat.48), Johnson speaks (cat.47), and Reynolds listens (cat.46).

As Nadia Tscherny has pointed out, parallels can be drawn between the Streatham portraits and the literary genre of 'intimate biography', pioneered by Johnson's *Lives of the Poets* and later adopted by Boswell in his *Journal of a Tour to the Hebrides with Samuel Johnson* of 1782, as well as works such as Philip Thicknesse's *Sketches and Characters of the most eminent and most singular persons now living*.[30] As Tscherny observes, there was at this time an increasing interplay between the language of painting and literary characterisation. Indeed Reynolds was described some years later by one newspaper as 'sitting to Boswell for his *picture*, to be done in the *size* and manner of *Johnson*', a reference to Reynolds's expectation that Boswell would write his biography.[31] Nor was Reynolds himself content merely to paint his friends' portraits. During the 1770s and 1780s he produced his own series of literary sketches, including a warm tribute to Johnson, a painstakingly honest appraisal of Goldsmith's strengths and weaknesses, and a surprisingly bitter denunciation of Garrick who, he concluded, 'died without a real friend, though no man had

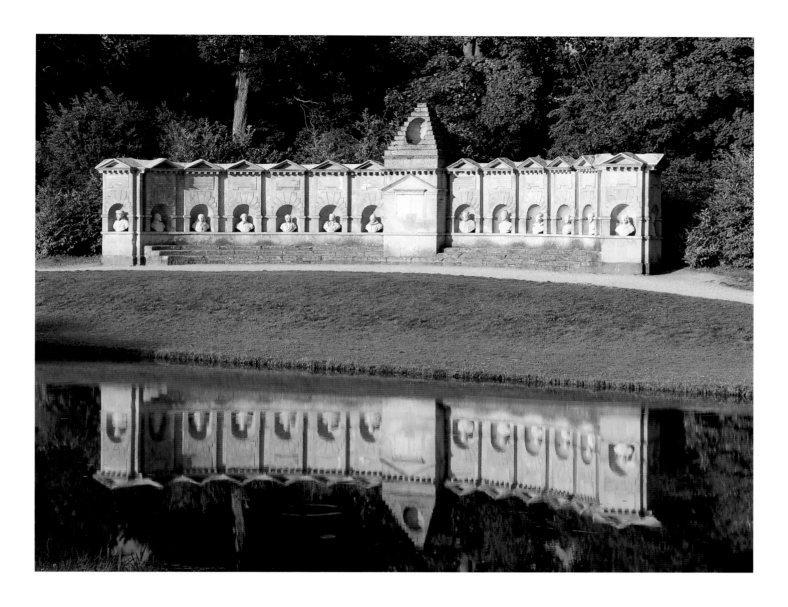

fig.3
William Kent (1685–1748)
The Temple of British Worthies, Stowe, Buckinghamshire 1731–5

a greater number of what the world calls friends'.[32] Yet, Reynolds's own capacity for friendship, like Garrick's, was inextricably tied to his aspiration that these individuals would, in turn, contribute to the elevation of his own reputation and status.

During Reynolds's formative years the royal court retained its place as the focal point of artistic patronage. The position of Painter to the King was regarded as the acme of artistic achievement, as well as a guaranteed source of wealth, fame and public honours. Naturally, when George III – the 'patriot king' – ascended to the throne, the post was coveted by Reynolds, who had recently painted his portrait (fig.4). He was, however, overlooked in favour of the Scottish portraitist, Allan Ramsay, who already had the ear of the King's Prime Minister, and fellow Scot, the Earl of Bute.

Characteristically, Reynolds was to turn the situation to his advantage. In 1768 the King confirmed Reynolds's position as first President of the Royal Academy. Even so, Reynolds ensured that the King had as little as possible to do with the policy of the Academy, which he kept firmly within his grasp. And, while there can be no doubt that Reynolds had the interests of the artistic community at heart, his ambitions for the Royal Academy were inalienably allied to the promotion of his personal status, through friends, patrons, his own writings on art, and his astute manipulation of the media.

When Samuel Johnson was asked whether Reynolds had minded being passed over for the post of Painter to the King in 1760, he replied that 'when he was younger he believed it would have been agreeable; but now he does not want their favour. It has ever been more profitable to be popular among the people than favoured by the King: it is no reflection on Mr. Reynolds not to be employed by them; but it will be a reflection on the Court not to have employed him.'[33] As Johnson knew, the Hanoverian Court was far from omnipotent in the cultural sphere, a comment echoed recently by the historian Linda Colley, who has observed that one 'did not need to please the Royal Family to be a cultural success in London, indeed entertaining the City was likely to prove far more profitable to an artist than flattering the court'.[34] For Reynolds, however, the greatest profit lay in cultivating not the common people or City burghers, but the King's political opponents, the aristocratic oligarchy who controlled the Whig party.

Since the early 1750s, following his return from Italy, Reynolds had constructed his patron base around the country's most powerful Whig dynasties, notably the Cavendish, Spencer, Russell and Wentworth families. By the 1770s his public identification with the Whig opposition was increasingly evident, through the aristocratic portraits he chose to exhibit at the Royal Academy, his hectic social calendar, and his close friendship with prominent Whig politicians such as Burke, Fox and, latterly, Sheridan. At the same time Reynolds made life difficult for the King, threatening to resign as President of the Royal Academy unless he was awarded a knighthood. Later, on the death of Allan Ramsay, Reynolds used political pressure to force George III to appoint him Painter to the King – despite the King's

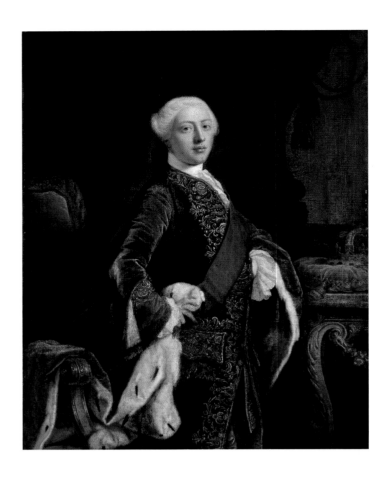

fig.4
George III as Prince of Wales 1759
Oil on canvas, 127.8 x 101.8
The Royal Collection

clear personal preference for Gainsborough. No wonder the King described Reynolds as 'poison in my sight'.[35] Socially, Reynolds was also increasingly identified with the rakish element within the Whig establishment, which by the early 1780s centred upon the King's dissolute eldest son, George, Prince of Wales, and his cronies and mistresses. In his portraits of the Prince (fig.5), Reynolds pandered to the Prince's thirst for 'celebrity' and fuelled his narcissistic fantasies. He also courted his company.

Shortly after the foundation of the Royal Academy, Reynolds instituted the Royal Academy Dinner, held annually on 23 April, the feast of Saint George, and the anniversary of Reynolds's own knighthood. As well as the Academicians themselves, a limited number of prestigious guests were also invited: 'persons high in rank or official situation, to those distinguished for talent, and to patrons of art'.[36] In 1785, the same year that the Prince of Wales's portrait (cat.30) was commissioned from Reynolds by the Duke of Orléans, Reynolds also painted Orléans's portrait for the Prince (see cat.84). When he exhibited it at the Royal Academy in 1786, reactions to the painted image mirrored the common revulsion felt towards this notoriously debauched French aristocrat.[37] Nonetheless, Reynolds displayed his personal allegiance to Orléans by making him guest of honour at the Academy's annual dinner, where he was seated directly beneath his portrait by Reynolds.[38] Through portraits such as these, Reynolds openly identified with fashionable Whig society; the Georgian 'glitterati' – liberal in their politics, liberated in their social attitudes, and libidinous in their sexual behaviour. It comes as no surprise, therefore, to learn that Reynolds's sister, a god-fearing Methodist, described his soul as a 'spectacle of poverty', and that even Samuel Johnson, his close friend (and a dyed-in-the-wool Tory), considered that Reynolds's laurels were somewhat tarnished through his association with 'infidels'.[39]

Reynolds grew up in an age that witnessed the birth of modern journalism. He was also the first British artist to pursue his career in the media spotlight. With the advent of the public exhibition in 1760 (see pp.35–47), newspapers played an increasingly important role in the evolution of the critical reception of contemporary British art. On the whole critics maintained their anonymity, adopting colourful pseudonyms such as 'Candid', 'Ensis', 'Fabius Pictor', 'Gaudenzio', 'Guido', and even

'Pudenda'. In general these critics concentrated their commentary on the annual art exhibitions of the Royal Academy and the Society of Artists, although increasingly they also followed the progress of paintings in artists' studios, as well as broadcasting titbits of juicy gossip. In terms of column inches alone, Reynolds commanded greater attention than any other artist.

While Reynolds was at times a target for hostile criticism, he could also rely on his influential friends to promote his reputation to a far greater extent than most of his contemporaries. To take just one example: in 1774 'A Friend to the Arts' wrote a piece in the *London Chronicle*, justifying the inclusion of Reynolds's portraits in a commentary otherwise confined to a discussion of history painting.[40] He concluded by stating that 'while some Artists paint only to this age and this nation, he paints to all ages and all nations; and we may justly say with the Artist of old, *in aeternitatem pingo*'. These words would have sounded familiar to anyone acquainted with Reynolds's third Discourse to the Royal Academy, published in 1771. There Reynolds had stated that the ideal artist 'addresses his works to the people of every country and every age; he calls upon posterity to be his spectators; and says with Zeuxis, *in aeternitatem pingo*'. The *soi-disant* 'Friend to the Arts' was also evidently a friend of Reynolds.

At the time newspapers were run on a daily basis by an editor, who in turn was responsible to small groups of shareholding booksellers, who met regularly to discuss the paper's accounts and editorial policy.[41] While the majority of newspapers were prepared to entertain a variety of viewpoints on contemporary art, the *Public Advertiser* was consistently sympathetic towards Reynolds, his works being the first to be addressed specifically in any exhibition review. The editor and printer of the *Public Advertiser* (which in the 1770s had an average daily circulation of about 3,000) was Henry Woodfall, a close mutual friend of Reynolds's associate, Caleb Whitefoord.[42] Woodfall was also the publisher of the Royal Academy's exhibition catalogue as well as the celebrated series of letters by Junius criticising the government of George III, which were printed in the *Public Advertiser* between 1769 and 1772.[43] On 29 April 1777 Woodfall uncharacteristically printed a defamatory epigram on Reynolds. Reynolds was deeply offended,

less perhaps at the verses themselves but because they appeared in the one newspaper that he could usually rely on to serve his cause. Woodfall, who had clearly not sanctioned the appearance of the epigram, immediately wrote to Caleb Whitefoord and tendered his sincere apology: 'you may be assured I shall take particular Care that the P.A. shall not be disgraced in future by Lines, Letters or Paragraphs in abuse of a Gentleman of his Worth and Abilities. If you have an Opportunity, your setting this Matter to Rights will greatly oblige'.[44] The next day, the 'Answer to the Epigram', written presumably by Whitefoord, was published. In mitigation, Woodfall admitted that he had already on a previous occasion suppressed a letter that he considered to be injurious to Reynolds.[45] Even so, Reynolds did not have things all his own way. In 1776, for example, 'A Young Painter' writing to the *Morning Chronicle* suggested that the best portrait on display in the exhibition was not by Reynolds, but by the Swiss artist, Angelica Kauffman, 'however fashionable it may be to flatter Sir Joshua'.[46] Similarly, in 1780 the *Morning Post* stated that it would quite openly criticise Reynolds's portraits of George III and Queen Charlotte 'were it not likely to be deemed high treason against the *Prince of Painters*'.[47]

As experience of the modern media tells us, a sure sign that an individual's fame has been transmuted into 'celebrity' is when press interest in his or her professional achievements extends to their private and social life. This was certainly the case with Reynolds. As early as 1770, an opponent of the Royal Academy, the Reverend James Wills, spread rumours in the *Middlesex Journal* about Reynolds's extra-curricular activities in his studio with the courtesan Kitty Fisher. 'Catherine', he alleged, 'has sate [*sic*] to you in the most graceful, and most natural attitudes; and indeed I must do you the justice to say you have come as near the original as possible'.[48] As an intimate oil sketch of Kitty Fisher reveals (fig.6), Reynolds was clearly on close terms with his favourite model. Indeed, given Reynolds's penchant for publicity and his unbuttoned attitude to sexual mores, he probably revelled in such accusations. Nearly a decade later, in 1779, when Reynolds was well into his fifties and still a bachelor, the *Town and Country Magazine*, in its notorious 'Tête-à-Tête' column, provided a résumé of Reynolds's old flames, including 'Lady L—r', who was

in the habit of viewing his picture collection after hours, and 'Lady G—r', who sat for her portrait in the evening as well as in the morning in order that 'the knight should give a resemblance of her in the most natural way'.[49] According to the column the current love interest of 'The Modern Apelles', as he was described, was the 'amiable' Miss Laura 'J—gs' (fig.7), the daughter of a naval officer, whose portrait he had painted, and to whom he had subsequently 'offered his purse and person'.

The prime purpose of the *Town and Country Magazine* was to provide its readers with the latest gossip. However, as it has been observed, the stories often had some basis of fact, albeit interlarded with speculation and innuendo.[50] It is quite possible that Reynolds had been paying court to 'the amiable Laura', especially as his name had already been publicly linked to the painter, Angelica Kauffman, as well as the Devonshire beauty, Mary Horneck, to whom he had allegedly proposed marriage. Also, at this time Reynolds's friends, Mrs Thrale and Mrs Montagu, were endeavouring to matchmake him with the young novelist, Fanny Burney.[51] On their first meeting, Burney noted that Reynolds had been particularly attentive towards her, 'though he did not *make Love!*'[52] Shortly afterwards, to her intense mortification, Fanny's name ('dear little Burney') was romantically linked to Reynolds in a vulgar satirical pamphlet.[53] Ultimately, however, Reynolds's severe attack of paralysis in November 1782 put an end to any marriage prospects.[54] 'How, my dearest Sissy', she told her younger sister, 'can you wish any wishes about Sir Joshua and me? A man who has had two shakes of the palsy!'[55]

Despite his clubbable disposition and his reputation as a man about town, Reynolds's studio remained the focal point of his professional and social world. Reynolds was a creature of habit, beginning his working day at nine or ten in the morning and working until four or five in the afternoon, often seven days a week. On average a portrait head required five or six separate one-hour sittings, although it is not unusual to find evidence of up to a dozen.[56] From the 1750s, as his 'sitter books', or engagement diaries, reveal, he invariably painted throughout the year, with only a few weeks' break in the summer, when he pursued his own projects, visited friends in the country, or occasionally went abroad. Reynolds's prolific rate of portrait production, an average

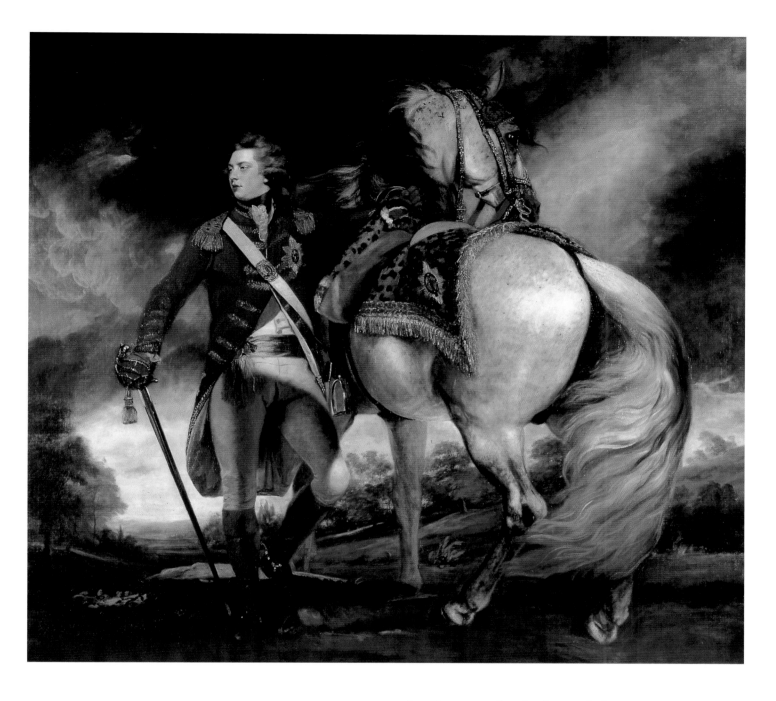

fig.5
*George IV as Prince of Wales c.*1783
Oil on canvas, 238.7 x 266.7
Private Collection

of well over one hundred commissions a year, was matched by the high prices he charged. Indeed, from the moment he returned to London from Italy in 1752, rather than undercutting his more established rivals, Reynolds had the confidence to set a similar scale of charges to his old master, Thomas Hudson, and Allan Ramsay, both well-established society portraitists.[57]

In July 1760 Reynolds purchased a forty-seven year lease on a large house on the west side of Leicester Square, one of the most fashionable addresses in London at the time.[58] Immediately, he set about refurbishing the

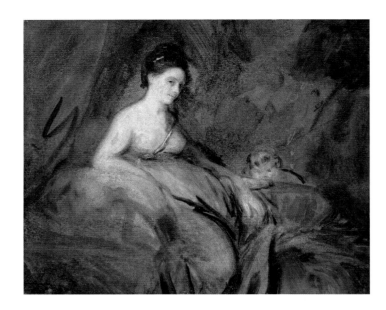

property, ripping out staircases, installing custom-built fireplaces and furnishings, and hiring additional servants. Reynolds also purchased land to the rear of the property, where he built a series of studios and a picture gallery to house his collection of Old Master paintings, as well as examples of his own work.[59] And, so that his arrival did not go unnoticed, 'Mr Reynolds gave a ball and refreshments to a numerous and elegant company on the opening of his gallery to the public'.[60] Last but not least, he purchased a coach that had formerly belonged to the Lord Mayor of London. Reynolds had no inclination to use the coach, but encouraged his sister, Fanny, to ride around the neighbourhood in it. Fanny, who was shy and retiring, hated it, especially when she went shopping and the gathering crowd enquired who it belonged to. As Reynolds's pupil, Northcote, recalled, 'this was just what Sir Joshua wanted!'[61]

Recently, Richard Wendorf, in his study of the social mores that guided Reynolds's career, has focused upon the important role played by 'complaisance' – or the art of pleasing.[62] As Wendorf rightly observes, Reynolds was adept at cultivating patrons through observing the rules of polite society. However, there was also much to be gained by flouting the rules. Reynolds, for example, deliberately refused to kowtow to those who regarded themselves as his social superior – as one aristocrat observed, following a studio visit: 'I really am not in the least surpriz'd at your dislike to him: I think, in my life, I never saw so vulgar & so familiar a forward fellow, really worse than you described him.'[63] Reynolds did not habitually address his aristocratic sitters by their titles, nor did he seek to disguise his own provincial background.[64] 'His pronunciation', as one female acquaintance recalled, 'was tinctured with the accent of Devonshire; his features coarse, his outward appearance slovenly'.[65] The art of being a true 'gentleman', as Reynolds had learnt from his more raffish friends, sometimes involved the cultivation of some quite ungentlemanly habits. (Reynolds's friend, Topham Beauclerk, who was regarded as among the 'finest gentlemen' in the Club, was also renowned for his lack of personal hygiene: there followed an infestation of lice after his departure from Blenheim Palace.)[66] Reynolds, as we have seen, spent lavishly upon his household in order to impress clients. However, as Northcote tellingly remarked, while his octagonal

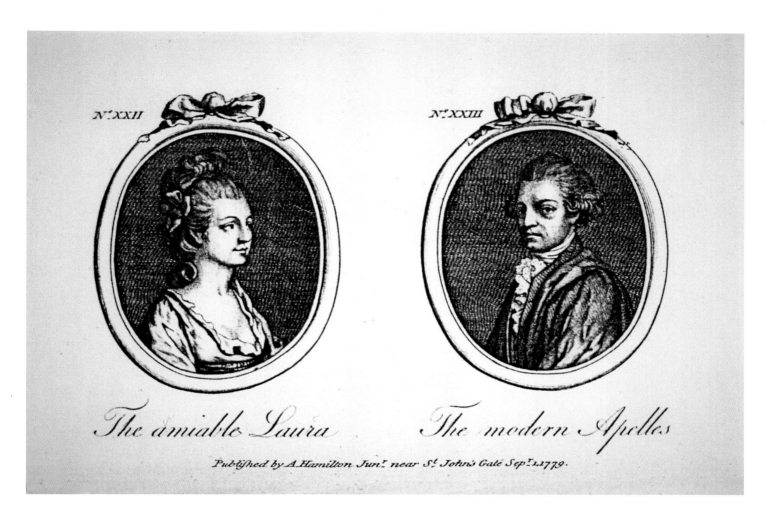

The amiable Laura The modern Apelles

Published by A. Hamilton Jun.ʳ near S.ᵗ John's Gate Sep.ᵗ 1.1779.

painting room was 'beautifully decorated ... this very room, when he became celebrated, he suffered to remain tarnished and blackened with London smoke, and cared nothing about it'.[67]

While ultimately the professional relationship between Reynolds and his patrons was a commercial one, he nevertheless began to paint uncommissioned portraits of his own volition early on in his career. These he evidently retained for display in his own gallery. It was standard practice for portraitists to paint works for this purpose: Reynolds's portrait of his assistant Giuseppe Marchi (cat.58) performed such a function, as did Gainsborough's celebrated portrait of Jonathan Buttall, the so-called 'Blue Boy' (c.1770; Huntington Library, San Marino, California).[68] Reynolds, however, went one stage further, by establishing under his own roof a collection of portraits of individuals who, for one reason or another, were in the news, and had therefore attained celebrity status. One early example, discussed by Mark Hallett (see cat.11),

is the portrait of the soldier, Robert Orme, which, rather than being an unwanted commission, was made as a direct result of Orme's 'fifteen minutes of fame' in the American wars of the 1750s. Nor was this in any way an exception. Looking through the posthumous sales of Reynolds's paintings by his heirs in 1796 and in 1821, one is struck by the number of important portraits that Reynolds retained in his possession throughout his life. They include that of the Polynesian native, Omai (cat.67), the exotic Mrs Baldwin (cat.68), the actress Mrs Robinson (1782; Waddesdon Manor, The National Trust), as well as notable aristocratic ladies such as the Duchesses of Marlborough (c.1776; untraced) and Gordon (c.1778; Norton Gallery, Florida).[69] Inevitably Reynolds, who over the course of his career painted over 2,000 portraits, was left with unclaimed works on his hands. However, in the case of the above works, where there is no evidence of a financial transaction, Reynolds clearly painted them for pleasure and to enhance his own

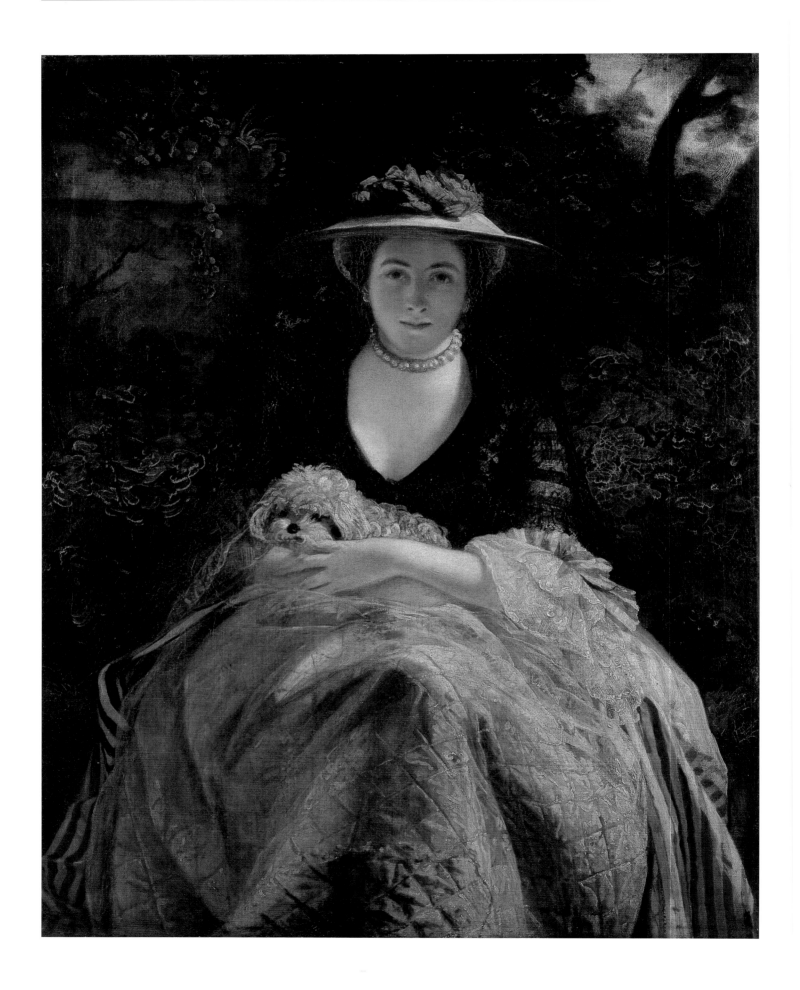

public profile as well as that of his subjects. The instances where Reynolds parted with works in his own lifetime demonstrate that his ownership of, and personal association with, the images he had created was of paramount importance to him. In 1784 Reynolds exhibited a portrait titled *Mrs Siddons as the Tragic Muse* (see cat.69) at the Royal Academy. It has often been supposed that it may have been commissioned by Richard Brinsley Sheridan, in whose theatre Siddons then performed.[70] However, as it has recently been noted, Sheridan's interest may have related merely to the print after it, rather than the painting itself.[71] Reynolds retained the picture for several years until he sold it to a French aristocrat in 1790. Despite rumours in the press that Reynolds was unable to dispose of the work, the hefty price tag of 1,000 guineas he apparently set on the work suggests he was in no hurry to sell.[72]

In terms of his desire to associate himself with the celebrity of others, the most compelling paintings by Reynolds are surely his portraits of courtesans, which he began to make from the late 1750s onwards. The majority of these works were painted of the artist's own volition and remained with him for as long as the individual in question remained in the public spotlight. In the early 1760s, for example, he painted the portrait of the courtesan, Nelly O'Brien, a picture now in London's Wallace Collection (fig.8). At the time Nelly was the mistress of Frederick, 2nd Lord Bolingbroke, an unpleasant character, known as 'Bully'. Bolingbroke did not acquire the picture (although when Reynolds was painting his wife he instructed Reynolds to 'give the eyes something of Nelly O'Brien, or it will not do').[73] O'Brien died in 1768, and Reynolds sold the picture four years later. By retaining pictures such as this, and presumably displaying them in his own gallery, Reynolds deliberately placed himself at the heart of contemporary

courtesan culture, a phenomenon that had its roots in antiquity. Indeed, as the historian James Davidson has noted in his study of the sex trade in classical Athens, there was a marked social distinction between *hetaerae*, or courtesans, and *pornai*, or common prostitutes.[74] The *hetaera*, like her eighteenth-century counterpart, could not be bought merely for money, but distributed her favours to a select coterie who maintained her establishment, and sexual favours were granted discreetly. Like Phryne, the greatest of all courtesans, 'carefully rationing out sighting' and 'carefully calculating withdrawal and disclosure' were vital.[75] The artist played a key role: when the ancient philosopher, Socrates, visited the artist's house with friends, the courtesan was to be found under the gaze of the painter. Thus, both Reynolds, and the courtesans who sat to him, were re-enacting a ritual sanctioned by classical civilisation. The 'complaisance' of the courtesan was a counterpart of Reynolds's own gift for pleasing his patrons, and boosting his own celebrity.

Whether any of the rumours concerning Reynolds's sexual relations with his courtesan friends were true cannot be ascertained. We do know, however, that he was fully appraised of the goings-on in London's various brothels and bagnios. In the summer of 1772 he came across Mrs Armistead, subsequently the mistress (and later wife) of Charles James Fox, when she was living in a bagnio in Golden Square. The following year he noted down the address of a bagnio recently opened by a Mrs Goadby.[76] In 1781 Reynolds exhibited at the Royal Academy a portrait of one of the most celebrated courtesans of the age, Emily Warren, in the guise of the *hetaera* Thaïs, mistress of Alexander the Great (fig.9). Emily, who features prominently in the lurid memoirs of one William Hickey, was, as he recalled, greatly admired by Reynolds. He states that Reynolds 'often declared every limb of hers perfect in symmetry, and altogether he had never seen so faultless and finely formed a human figure'.[77] At the time, the press accused Reynolds of taking his revenge on Emily for not taking delivery of a portrait that she had commissioned of herself some years earlier (depicting her as a *hetaera*) and simultaneously making a 'sarcastic allusion to her private life'. Despite the protestations of Reynolds's biographer James Northcote, the rumour clearly had substance, not least because

fig.8
*Nelly O'Brien c.*1762–4
Oil on canvas, 126.3 x 110
Wallace Collection, London

'Thaïs' was then a well-known soubriquet for prostitute.[78] Thus, the portrait, which Reynolds chose to exhibit as a subject picture, was inextricably linked to Emily Warren's profession, upon which Reynolds now traded.

In April 1769 Reynolds had been elevated to the knighthood. Three years later, in September 1772, he was elected an Alderman of the Borough of Plympton, and the following year was sworn in as mayor. In the summer of 1773 he was awarded a Doctorate of Civil Law at the University of Oxford. Two years later he was invited to present his self-portrait to the Grand Duke of Tuscany (cat.4). Finally, in 1784, following intensive lobbying, he was appointed Painter to the King of England. By now Reynolds could justifiably regard himself as among the most famous artists in Europe. His reputation had spread abroad as a result of the dissemination of prints after his paintings, his position as President of the Royal Academy, and his public lectures that were published as the *Discourses on Art*, which by the end of the decade were available in Italian, German and French editions.[79] During the late 1770s, Mrs Hester Thrale, wife of the brewer, Henry Thrale, noted the impact which the publication of the *Discourses* was having on their author. 'Sir Joshua', she stated, 'is indeed sufficiently puffed up with the Credit he has acquired for his written Discourses, a Praise he is more pleased with than that he obtains by his Profession; besides that he seems to set up as a Sort of Patron to Literature; so that no Book goes rapidly thro' a first Edition now, but the Author is at Reynolds's Table in a Trice'.[80] She also believed that Reynolds was deliberately manipulating the situation: '*his* Thoughts are tending how to propagate Letters written in his Praise, how to make himself respected as a Doctor at Oxford, and how to disseminate his Praise for himself, now Goldsmith is gone who used to do it for him.'[81] Oliver Goldsmith, who died in 1774, had four years earlier dedicated his poem, *The Deserted Village*, to Reynolds. The same year George Colman prefaced his farce, *Man and Wife; or the Shakespeare Jubilee*, with a flattering dedicatory epistle to Reynolds.[82] (Reynolds, in turn, returned the favour by showing Colman's and Goldsmith's portraits at the Royal Academy's 1770 exhibition.) As the years went by, countless odes, panegyrics and dedications were directed towards Reynolds, ranging from minor literary works such as *The Tears of Genius* by the self-styled 'Courtney Melmoth' and George Huddesford's vulgar satire, *Warley*, to an edition of Goldsmith's plays and poems, Sheridan's *The School for Scandal*, and Boswell's *Life of Johnson*.[83] Collectively, these dedications formed a tribute not previously accorded to a British artist.

In his third Discourse of 1770, Reynolds had advocated to the students of the Royal Academy the pursuit of 'fame' as a laudable aspiration.[84] In this respect he was not untypical of a whole range of writers, actors and artists who regarded fame as the standard for judging the worthiness of their own performance against the achievements of the past. The merits of fame were discussed by Reynolds's friends, including Adam Smith (whose *Theory of Moral Sentiments* had already made him famous as a philosopher), as well as authors such as Bernard Mandeville, Francis Hutcheson and Montesquieu. Reynolds also discussed the issue of fame informally with friends. Boswell noted in 1776, during a discussion of anonymously written reviews, that 'Sir Joshua said, what I have often thought, that he wondered to find so much good writing employed in them, when the authors were to remain unknown, and so could not have the motive of fame'.[85] In his later years Reynolds was without doubt famous – as famous as Pope had been when Reynolds had encountered him many years earlier. Indeed, one of his servants recalled that when Reynolds entered a social gathering, 'the people … all turned round and stared so, upon hearing Sir Joshua's name announced, and they even made a lane for him to pass through, whereas when a duke or an earl was announced, few of the people took any notice'.[86]

Reynolds died on 23 February 1792. A week later, on 2 March, his body was laid out in the Royal Academy: the room was draped in black, and lit by candles mounted in silver sconces. The following day, at half past twelve, Reynolds's coffin was conveyed from Somerset House to St Paul's Cathedral. It was accompanied by a cortège of

fig.9
Thaïs 1781
Oil on canvas, 229.3 x 144.8
Waddesdon Manor, The Rothschild Collection, The National Trust

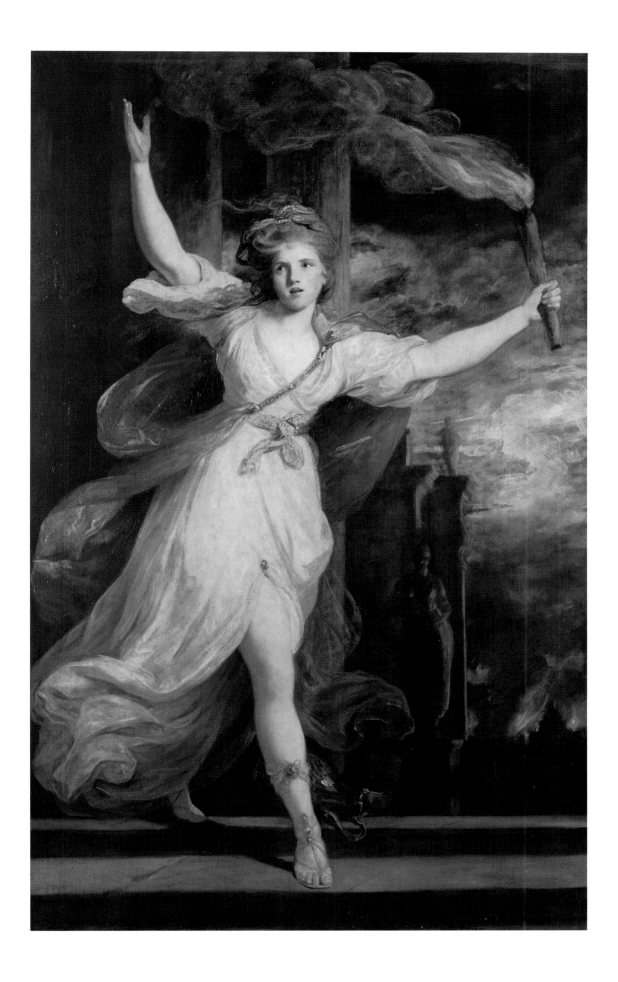

ninety-one carriages. The pallbearers were exclusively composed of the country's most senior peers, including the Duke of Portland, the Duke of Leeds and the Earl of Carlisle. 'Everything', Edmund Burke told his son, 'was just as our deceased friend would, if living, have wished it to be; for he was, you know not altogether indifferent to this kind of observances [*sic*].'[87] Just over twenty years later, a statue of Reynolds was erected under the dome of St Paul's (see cat.89). This was made possible because in

the 1780s Reynolds had himself spearheaded a campaign to install a statue of Samuel Johnson in St Paul's – the first figurative monument of its kind to be admitted.[88] At the time Reynolds had argued for the importance of conferring and achieving honours. 'Distinction', he affirmed, 'is what we all seek after, and the world does set a value on them [*sic*], and I go with the great stream of life.'[89] It may serve as his epitaph.

Notes

[1] Northcote 1813, pp.13–14; Leslie and Taylor 1865, vol.1, pp.24–5; Hilles 1952, pp.22–3.

[2] John Milton, *Lycidas*, 1638, lines 70–2.

[3] Brewer 1995, p.16.

[4] The following was subsequently noted in the baptismal register: 'In the entry of Baptisms for the year 1723 the Person, by mistake named Joseph son of Samuel Reynolds Clerk Baptized July 30th was *Joshua* Reynolds the celebrated Painter, who died February 23, 1792.' See Hudson 1958, p.6.

[5] Reynolds's commonplace books are in the Yale Center for British Art; Reynolds MSS nos.33–4.

[6] See Hilles 1936, p.6.

[7] For Reynolds's appreciation of Richardson see Malone 1819, vol.1, p.viii; Northcote 1818, vol.1, pp.14–15; Cotton 1856, pp.34–41; Leslie and Taylor 1865, vol.1, pp.9–12; Hilles 1952, p.21.

[8] For a critical assessment of Richardson's writings see Gibson-Wood 2000, pp.141–229; also Lipking 1970, pp.109–26; Wendorf 1990, pp.136–50.

[9] Richardson 1715, p.212.

[10] Leslie and Taylor 1865, vol.1, p.16.

[11] Northcote, writing to his brother, Samuel, on 21 September 1771. Royal Academy manuscript, MS Nor/5. See also Whitley 1928, vol.2, p.283; Gwynn 1898, p.65.

[12] Leslie and Taylor 1865, vol.1, p.28.

[13] See Lippincott 1983, especially pp.18–30.

[14] Ibid., p.19.

[15] Ibid., p.46.

[16] See White, Alexander, D'Oench 1983, p.33; David Mannings, in Penny 1986, p.166.

[17] For a discussion of the origins and role of the profile portrait in eighteenth-century English art, including the portraits of Pope and

Richardson, see Shawe-Taylor 1987, pp.53–64.

[18] See Wolstenholme and Piper 1964, pp.282–7. For the suggestion that Reynolds may have been influenced by Pond's portrait of Mead see Balkan 1972, p.38.

[19] See Shawe-Taylor 1987, p.57.

[20] Robert Campbell, *The London Tradesman, Being a Compendium of all the Trades, Professions, Arts, both Liberal and Mechanic, now practised in the Cities of London and Westminster*, London 1747, p.97.

[21] British Museum sketchbook, LB12, f.9 verso.

[22] Connell 1957, p.254. See also Leslie and Taylor 1865, vol.1, pp.383–4.

[23] Fletcher 1901, p.186.

[24] See Leslie and Taylor 1865, vol.1, p.327.

[25] *Morning Post*, 11 April 1789: 'To blackball SIR JOSHUA REYNOLDS [*sic*], who is so superior to the world of artists, does no honour to the club at White's! Nevertheless, we are not displeased at the KNIGHT'S disappointment, who after many mortifying results he has received from a certain quarter, is still the humble idolator of a Court.'

[26] Penny 1986, p.281.

[27] Ingrams 1984, p.45.

[28] See Shawe-Taylor 1987, especially pp.6–10.

[29] See Harcourt-Smith 1932, pp.44–69.

[30] Tscherny 1986, p.7. See also Philip Thicknesse, *Sketches and Characters of the most eminent and most singular persons now living. By several hands*, Bristol 1770.

[31] Tscherny 1986, p.8.

[32] See Hilles 1952, p.87.

[33] Ozias Humphry to his brother, the Revd William Humphry, 19 September 1764, in Hill 1897, vol.2, pp.401–2.

[34] Colley 1992, p.200.

35 Lloyd 1994, p.16.

36 See Leslie and Taylor 1865, vol.1, pp.310, 398, 441; vol.2, pp.72, 124, 154, 216, 290, 325, 361, 397, 433–5, 484, 505. Reynolds's central role in inaugurating the practice was underlined by the fact that (initially at least) he retained the sole right of issuing such invitations (see Leslie and Taylor 1865, vol.1, p.310).

37 See Penny 1986, pp.309–10; Leslie and Taylor 1865, vol.2, pp.479–80 and 485–6; Millar 1969, pp.104–5.

38 Whitley 1928, vol.2, pp.66–7.

39 Balderston 1942, vol.1, p.80.

40 The London Chronicle, 7–10 May 1774. The portraits were the Duchess of Gloucester, Princess Sophia of Gloucester, Three Ladies Adorning a Term of Hymen, and Mrs Tollemache as Miranda.

41 See for example Richard P. Bond and Margorie N. Bond, 'The minute books of the St James's Chronicle', Studies in Bibliography, vol.28, 1975.

42 See Ivon Asquith, 'Advertising and the Press', Historical Journal, vol.18, 1975, p.723, which analyses the accounts of the Public Advertiser. See also Hilles 1929, p.45 note.

43 Hilles 1929, p.45; Ingamells and Edgcumbe 2000, p.56.

44 Hewins 1898, p.151.

45 Ibid.

46 Morning Chronicle, 1 May 1777.

47 Morning Post, 2 May 1780. The anonymous critic describes the portrait of George III, which did not have a catalogue number, as a 'whole length piece of a gentleman in the Old English dress'.

48 'Fresnoy', Middlesex Journal, 14–17 October 1769. For the identification of 'Fresnoy' as James Wills see Whitley 1928, vol.2, pp.272–8.

49 'Histories of the Tête-à-Tête annexed: or, Memoirs of the Modern Apelles and the Amiable Laura', Town and Country Magazine, September 1779, pp.401–4.

50 Bleackley 1905, pp.241–2. See also Penny 1986, p.387.

51 See Leslie and Taylor 1865, vol.2, pp.224 and 239.

52 Burney 1994, p.143.

53 George Huddesford, Warley, a Satire, London 1778. For Fanny Burney's reaction see Burney 1994, pp.194 and 220. It has been suggested that Reynolds had described Fanny to Huddesford as 'dear little Burney', a pet name given to her by Johnson, see Burney 1994, p.224, n.39.

54 See Postle 2003a, pp.33–4.

55 Leslie and Taylor 1865, vol.2, p.385.

56 For Reynolds's practice in the 1750s see Waterhouse 1966–8, pp.112–64.

57 For Hudson see Farington 1819, p.42, note. For Ramsay see Smart 1992, p.92, and Appendix B. See also Shawe-Taylor 1990, pp.22–3, and Mannings and Postle 2000, vol.1, pp.21–2 for a table of Reynolds's portrait prices.

58 Joseph Farington noted on 9 August 1807: 'Lady Thomond I met at two o'Clock at Sir Joshua Reynolds's late House in Leicester Square, a Sale of the goods remaining there being to be sold by auction on Tuesday next. The lease of the House will expire in September next.' Farington 1978–84, vol.8, p.3103.

59 It was probably as a direct result of Reynolds's rebuilding work that the rateable value of his house was raised to £100 per annum. For the history of Reynolds's house, its rateable value and Reynolds's redecoration of the property see Hudson 1958, pp.72–4. See also Breward 1995, pp.9–14.

60 Northcote 1818, vol.1, p.102.

61 Fletcher 1901, p.204; also Gwynn 1898, p.245; Northcote 1818, vol.2, pp.102–3; and Cormack 1968–70, p.107 (for Reynolds's references to his coach).

62 Wendorf 1996, especially pp.12–59.

63 The Honorable John West to Simon, 1st Earl Harcourt, then Viscount Nuneham, 26 June 1759. Hist. MSS Comm. Harcourt Papers, vol.8, p.30.

64 Hazlitt 1830, pp.289–90.

65 Kaye 1861, vol.1, p.9.

66 Noted in a letter from the 3rd Duke of Portland to Dorothy, Duchess of Portland, 27 January 1772. See MSS papers of William Henry Cavendish Bentinck, 3rd Duke of Portland, University of Nottingham Library, PwF 10597.

67 Fletcher 1901, p.204.

68 Sloman 2002, pp.74 and 78–80.

69 See 'A catalogue of Portraits, Fancy Pictures, Studies and Sketches, by the later Sir Joshua Reynolds', Greenwood's, 14–16 April 1796, and 'A Catalogue of the very valuable and highly important collection of Ancient and modern Pictures, of the Marchioness of Thomond, deceased', Christie's, 18–19 May 1821.

70 Whitley 1928, vol.2, p.7.

71 See Asleson 1999, p.109 and n.53.

72 See Mannings in Penny 1986, pp.324–5.

73 Postle 2003, p.27.

74 Davidson 1998, pp.109–36; cited in Postle 2003, p.29.

75 Davidson 1998, pp.133–4.

76 See Postle 2003, pp.40–1.

77 See Spencer 1913–25, vol.2, p.250; cited in Postle 2003, p.44.

78 See Northcote 1818, vol.2, p.120; see also Postle 2003, pp.44–5.

79 The first Italian edition, comprising the first seven Discourses, was published in Florence in 1778. A German edition appeared in 1781, and a French edition in 1787. See Hilles 1936, pp.287–95.

80 Balderston 1942, vol.1, p.80.

81 Ibid., p.80.

82 See Hilles 1936, pp.xv and 30.

83 See ibid., pp.94–7. 'A Pindaric Ode on Painting. Addressed to JOSHUA REYNOLDS Esq.' was advertised in the Public Advertiser, 16 May 1768. See also 'A Poetic Epistle to Sir Joshua Reynolds, Knt. and President of the Royal Academy', advertised in the Morning Chronicle, and London Advertiser, 7 May 1777.

84 See Reynolds 1975, p.42, lines 26–7 and p.18, lines 151–6.

85 Boswell 1934–50, vol.3, p.44.

86 Fletcher 1901, p.80.

87 Leslie and Taylor 1865, vol.2, pp.634–5.

88 Keene, Burns, Saint 2004, p.275.

89 Leslie and Taylor 1865, vol.2, p.611.

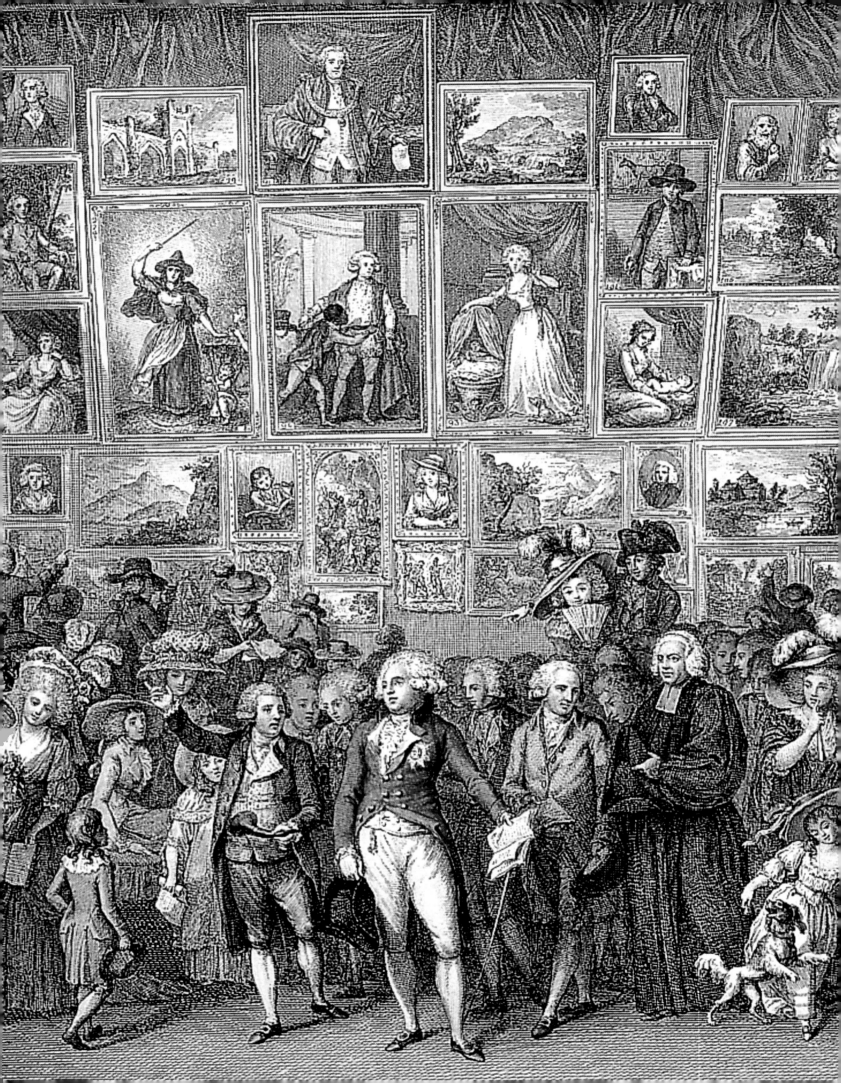

Reynolds, Celebrity and the Exhibition Space

Mark Hallett

The first public exhibition of contemporary British art opened in London on 21 April 1760, an event playfully commemorated in a poem published in the London *Public Advertiser* later that month. In the poem, the figures of 'Apollo' and 'Albion' celebrate the fact that, at last, British works could now compete with those on display in countries such as Italy:

> Says *Apollo* to *Albion*: My best thanks, at least,
> Are due (Generous Friend!) for this elegant feast
> These pieces shown singly, must please as we gaze –
> But this Constellation! – how sweet our Amaze!
> Adieu – see, my Phaeton waits at the door –
> To *Monte Testaccio* – haste! – fly! – 'tis past Four.
> Albion smiled at the God; and thus, jokingly, spake –
> That's in Rome: – You're in London: – O charming
> mistake![1]

Held under the auspices of the Society for the Encouragement of Arts, Manufactures and Commerce, and taking place in the Society's 'Great Room' on the Strand, the display comprised 130 exhibits submitted by sixty-eight artists, and represented the culmination of years of activity amongst the capital's leading painters, engravers, sculptors and draughtsmen.[2] These artists had long sought to secure for themselves a public showcase analogous to those exhibitions taking place on the continent, most obviously the biennial Salons held in Paris since 1737. The exhibition at the Society's Great Room – described in the *Lady's Magazine* as 'ingross[ing] the whole attention of the public, who crowd thither daily' – not only saw the realisation of this ambition, but also the inauguration of a new era in the nation's visual culture.[3] Such exhibitions, in which pictures were typically hung in a dense mosaic across the walls (cat.87), quickly came to dominate the whole process of producing, displaying and viewing ambitious art in late eighteenth-century Britain. They provided artists with an event through which they could advertise their talents and compete with their fellow practitioners, gave patrons the opportunity to peruse potential purchases and weigh up the merits of exhibitors, and offered an increasingly interested public – normally on the payment of a shilling admission charge – the chance to exercise their aesthetic appreciation and participate in an increasingly fashionable form of urban entertainment.[4]

Such events also functioned as crucibles of celebrity. More specifically, these exhibitions helped generate, shape and sustain the reputations of a wide range of public figures, from politicians to authors, aristocrats to courtesans and actors to artists. And they did so partly because portraitists like Reynolds quickly realised the potential for stimulating public interest in their art through submitting works depicting celebrated figures. These well-known individuals, we can go on to add, were familiar to the great majority of exhibition visitors through the means of print culture. In particular, the visitor's encounter with the painted image of celebrities was crucially informed by those other burgeoning cultural sites of the period, the newspaper and the periodical. These publications not only offered increasingly regular commentaries on the art exhibitions themselves, but provided ever-more detailed accounts, both fawning and acidic, of the lives and activities of the men and women they considered to be of public interest.[5] And if the press functioned as one vital counterpart to the exhibition space

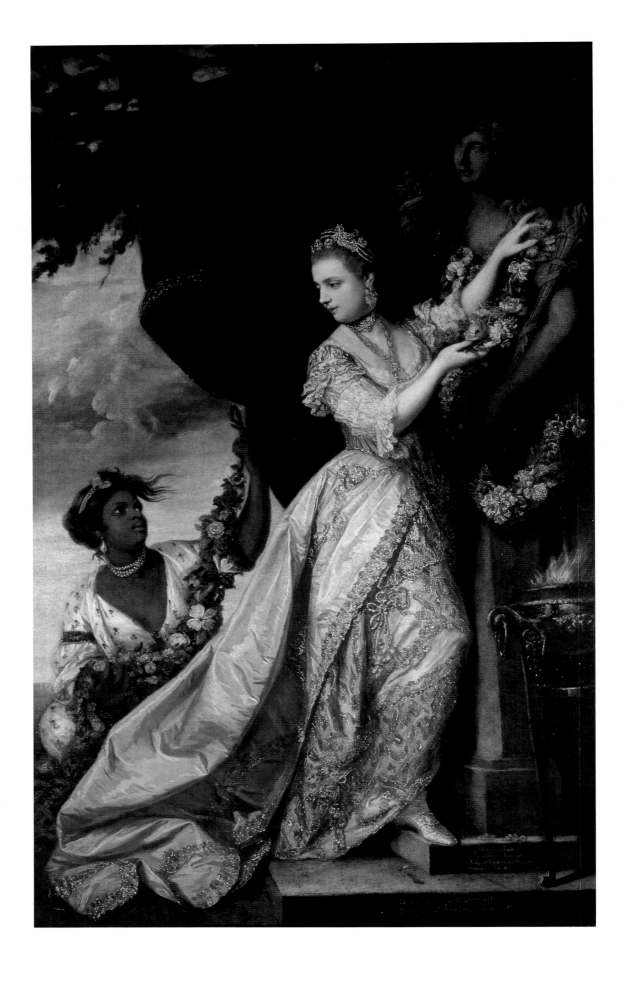

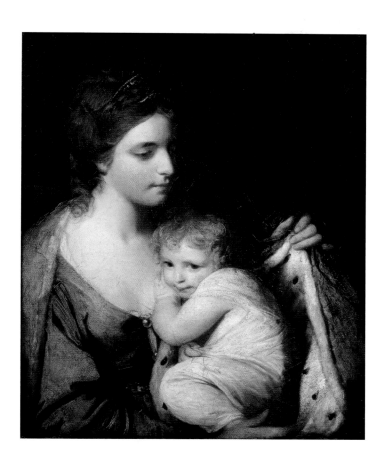

fig.10
Lady Elizabeth Keppel 1761
Oil on canvas, 236 x 146
The Marquess of Tavistock and the
Trustees of the Bedford Estates at Woburn Abbey

fig.11
Maria, Countess Waldegrave,
and her Daughter, Lady Elizabeth Laura 1761
Oil on canvas, 76 x 64
Musée Condé, Chantilly

in terms of what was emerging as a recognisably modern economy of celebrity, another was provided by graphic culture. As Tim Clayton points out elsewhere in this catalogue (pp.49–59), celebrated individuals were not only defined as such because they were painted or written about in the London press, but because their portraits were also to be found being circulated in engraved or etched form.

Celebrity, among other things, is about the commodification of fame, about the dissemination of images representing the individual celebrity, and about the collective conversations and fantasies generated by these processes. In these terms, the eighteenth-century exhibition, a commercial event that more often than not incorporated numerous, idealised portraits of men and women, and that stimulated animated discussion as well as visual pleasure, was well placed to succeed in fusing the discourses of art and celebrity. But this could only happen, of course, with the willing participation in such a project of the artists who supplied these events with objects to exhibit. Reynolds was one such artist, and this essay, through looking at the groups of paintings he sent to a variety of public displays over a thirty-year period, will suggest the ways in which he exploited the narratives and attractions of celebrity throughout his exhibition career.

Before focusing on the works of Reynolds himself, however, it will be useful to return to the early history of the London exhibitions, a history that was marked by fragmentation and expansion. Only a few months after the 1760 exhibition had closed, a group of artists who had participated in this show, chafing against what they saw as the restrictive conditions laid down by the Society of Arts, decided to set up an alternative exhibiting organisation, which they rather confusingly named the Society of Artists of Great Britain.[6] From 1761 onwards, this new Society – of which Reynolds was a leading member – held rival annual displays at the 'Great Room' in Spring Gardens, near Charing Cross in London. Through the rest of the decade the Society of Artists exhibitions grew steadily in scale. Thus, in the first year of its existence, the Society's exhibition was made up of 229 works; by 1768, however, the number of exhibited works had increased to 320.[7] If the number of exhibited works proliferated over this decade, so did the quantity of visitors to the Society of Artists' shows –

from some 11,200 in 1763 to nearly 18,400 in 1768.[8] Significantly, portraiture dominated this artistic arena. Ranging in character from full-length canvases painted in oil to groups of miniatures executed in watercolour on ivory, portraits consistently made up the largest component within the ensemble of works displayed in the Great Room.

Reynolds immediately recognised the significance and impact of these exhibitions, and the possibilities they offered for his own artistic advancement. Between 1760, when he sent four paintings to the Society of Arts show, and 1768, the year in which the Royal Academy was formed, he submitted twenty-seven portraits for public consumption.[9] When we look at these paintings as a group, we quickly find that the artist tended to choose very particular types of works to advertise his talents. Most strikingly of all, the majority of the portraits he exhibited in the 1760s pictured individuals with a distinct public identity, men and women whose lives and careers would have been well-known to many exhibition visitors, partly thanks to the regular and sometimes intensive coverage they attracted in the capital's print culture. Thus, in 1761 Reynolds exhibited a bold portrait of the author Laurence Sterne (cat.33), whose *Tristram Shandy* was the literary sensation of the time. The following year the artist submitted a spectacular portrait of the famous actor David Garrick (cat.60), whilst surreptitiously exhibiting a portrait of another, more scandalous kind of celebrity – the courtesan Nelly O'Brien (cat.52). The *St James Chronicle* of 25–7 May 1762, having

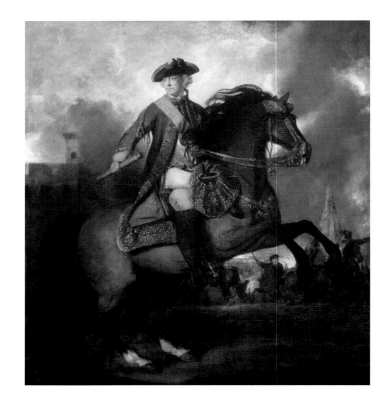

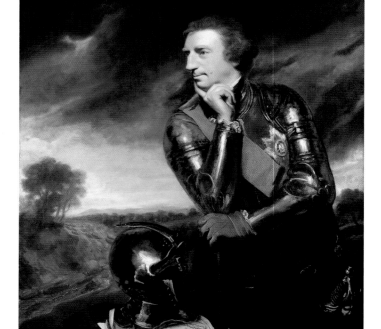

fig.12
John, 1st Earl Ligonier 1760
Oil on canvas, 171 x 157
Fort Ligonier, Pennsylvania

fig.13
Sir Jeffrey Amherst 1765
Oil on canvas, 125.7 x 100.3
Mead Art Museum, Amherst College

reviewed the three catalogued pictures by Reynolds in the display, goes on to note that 'There is another portrait, by the same hand, unmarked and unregistered in the catalogue, which hangs at the other end of the room, and represents a young lady well known *on the Town* [*sic*] by the name of *Miss Nelly O'Brien*'.[10] The phrase 'well known on the Town' is telling: clearly, Reynolds was trading on the fact that, for a substantial number of urban visitors to the Society of Artists' show, his painting of O'Brien could be appreciated not just for its aesthetic values, but also for the ways in which these values fused with the titillating storylines of illicit sexuality and aristocratic libertinage conjured up by her face and name.

Over the same period, Reynolds regularly displayed portraits of a far more respectable but equally celebrated type of woman – female aristocrats whose looks, dress and activities were continually being discussed in the newspaper and periodical columns of the day, and who were often the focus of widespread gossip in the capital. Thus, for the 1760 exhibition, the artist sent to the Society of Arts a full-length semi-allegorised portrait of the celebrated Irish 'beauty' Elizabeth Gunning, Duchess of Hamilton and Argyll (fig.28), who since her arrival in England a decade earlier had attracted considerable notice not only within elite culture, but within the London press. Meanwhile, in 1762 and 1765 Reynolds exhibited more elaborately allegorised full-length portraits of two other aristocratic women, Lady Elizabeth Keppel (fig.10) and Lady Sarah Bunbury (Art Institute of Chicago). The two women had come to public prominence when acting together as royal bridesmaids to Queen Charlotte at her wedding to George III in 1761, and were, until their own later marriages, widely praised as exemplars of aristocratic eligibility and youthful beauty. In arranging that his pictures of such women were placed on public show – the first showing Keppel wearing one of the spectacular bridesmaid's dresses that had 'attracted the eyes of everyone' at the royal wedding – Reynolds, we can now suggest, was contributing to, and trading upon, a burgeoning cult of aristocratic celebrity within the sites and spaces of urban culture.[11]

Even more intriguingly, the artist seems to have introduced a form of temporal sequencing into his display of such portraits. Thus, the full-length of Elizabeth Keppel he exhibited in 1762 offered a sequel to another,

more modest painting of the same sitter that he had sent to the 1760 exhibition. Meanwhile, the powerful formal and allegorical correlations between his grand portraits of Keppel and Bunbury would have invited viewers of the latter painting to link it to the memory of the former. Most strikingly of all, the artist sent no fewer than three different portraits of Maria, Countess Waldegrave to the Society of Artists' exhibitions of the 1760s. In these pictures, the Countess, described by her uncle Horace Walpole as the 'first match in England – for beauty' at the time of her marriage in 1759, is assigned a variety of pictorial identities.[12] She was depicted in profile wearing an exotic turban in the 1761 exhibition; shown in mythological guise as Dido in 1762 (fig.11); and represented, soon after her husband had died, as a mourning, saint-like figure in 1765. In being invited to track the shifting imagery of such women as Keppel, Bunbury and Waldegrave, attentive visitors to the London exhibition rooms thus became witness to an extended process of pictorial and narrative transformation, choreographed by Reynolds himself, in which his sitters became part of a gendered, role-playing theatre of aristocratic celebrity that was acted out on an annual basis in the public spaces of the exhibition room.

The final strand of Reynolds's exhibition portraiture during the 1760s – one that offers a kind of masculine counterpoint to the artist's exhibited portraits of aristocratic women – was made up of works depicting soldiers and commanders, a number of whom had become famous for their heroic behaviour during the military conflicts of the previous two decades. Reynolds's exploitation of martial celebrity began in 1760, when he exhibited portraits of Colonel Charles Vernon and General Charles Kingsley, the latter of whom had recently been publicly commended by the Allied Commander in Europe, Prince Ferdinand of Brunswick, for his 'courage and good order' at the crucial Battle of Minden fought against the French in 1759.[13] If such pictures suggest that Reynolds was already, in 1760, exploiting the public's jingoistic interest in military heroes at a time when the nation was emerging victoriously from the Seven Years War, the artist's submission of two further military portraits for the following year's exhibition – both painted on a heroic scale – confirms his strategies in this respect.

One depicted the young army officer Captain Robert Orme (cat.11), while the other showed Lord Ligonier (fig.12; see cat.14), who as Commander-in-Chief of the British Army since 1757 had played a central, highly publicised role in ensuring the nation's military success in the war against France. Over the next few years, Reynolds continued his policy of exhibiting portraits of distinguished soldiers. In 1763, for instance, he displayed a portrait of the Earl of Rothes (Private Collection), a veteran of earlier wars against the French, in which the uniformed aristocrat is pictured standing on a smoking battlefield with a sword resolutely in hand. Finally, in 1766, the artist's submission of four pictures included his brooding half-length portrayal of Sir Jeffrey Amherst (fig.13), lately the Commander of British forces in North America, and his grandiloquent full-length portrait of the Marquess of Granby (cat.15) who is shown bestriding the battlefield of Vellinghausen, where allied forces had won a great victory in the summer of 1761.

Part of the appeal of such paintings was that they aligned the most advanced forms of modern portraiture with the numerous celebratory narratives of these men's military achievements circulating in contemporary urban culture. Thus, to focus on the example of Granby, the Marquess's leadership and courage had, in the years preceding the exhibition of Reynolds's portrait, been relentlessly glorified in the capital's press and the flurry of contemporary histories of the Seven Years War.[14] Typical is the description of the Battle of Vellinghausen found in John Entick's *The General History of the Late War*, widely advertised in the 1765 newspapers: 'The French attacked the posts defended by the Marquis of Granby, with a most furious fire of artillery and small arms. But the British troops maintained their ground with an intrepidity and firmness natural to their country: and their gallant commander contributed so effectually, by his example, to inspire them with the love of glory and the desire of victory that they stood the whole torrent of that impetuosity.'[15] If such military qualities made Granby stand out, so did his bluff, plain-speaking demeanour, his evident love for his troops – expressed not only on the field but in his subsequent involvement in a charitable organisation for soldiers' widows – and his appearance: he was famously bald, to the point that the *London Chronicle* could publish a poem on precisely this topic in the autumn of 1760:

Caesar was prematurely bare
Just as is honour'd Rutland's heir [Granby],
(Nor will the likeness end there)
But Julius at his baldness griev'd,
If History may be believ'd,
And to conceal his want of hair,
Contrived the laurel wreath to wear:
While Granby (greater here than Caesar)
Whether in town, or on the Weser,
Without disguise his forehead shows,
Without concern, to friends and foes.[16]

Here, the writer manages not only to align Granby with a famous military predecessor, but to turn his baldness, and the ease he displayed concerning his natural appearance, into a powerful indicator of the Marquess's integrity and lack of pretension. Such qualities, in combination with his bravery and benevolence, translated into a fame confirmed and extended by his appearance in numerous engravings, book illustrations and publicly exhibited works of art in this period.[17]

In deciding to send a spectacular full-length depiction of Granby to the 1766 exhibition, Reynolds was thus undoubtedly fully aware that the wide currency enjoyed by the Marquess in print and visual culture would mean that his painting was sure to attract a high degree of public interest. Moreover, rather than standing alone in this respect, the artist's portrait of Granby can now be understood as just one element within an unfolding iconography of military celebrity that was being articulated by the artist in the exhibition space during the 1760s. Reynolds's decision to submit such paintings as that of Granby thus formed part of a coherent strategy of pictorial and artistic display, in which the regularly replenished depiction of the heroic officer took its place alongside the similarly familiar and renewable imagery of the allegorised aristocratic female, the desirable courtesan, the famous actor and the lionised author. In a process that seems to prefigure the ephemeral dynamics of heroism and redundancy found in today's celebrity culture, the exploitation of celebrity typified by Reynolds's representation of Granby depended not only on the glorification, in portrait form, of individuals who had already gained a certain kind of renown within the wider realms of urban culture, but also on the continual replenishment – from one year to the next – of this

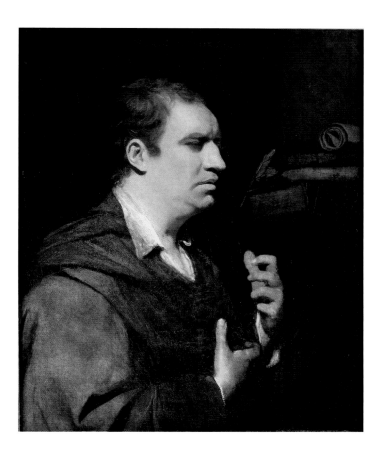

hyperbolic imagery of bravery, beauty and fame.

The exhibition culture that fostered such developments was disrupted in 1768, when a group of regular exhibitors at the Spring Gardens shows, desirous of forming a more formalised, prestigious institution for the promotion of British painting and sculpture, won the King's support for the creation of a Royal Academy of Art.[18] The following year, the Academy, with the newly knighted Reynolds at its head, held the first of its own annual exhibitions, which were housed until 1780 in a former print emporium on Pall Mall. After a relatively modest start, these exhibitions soon turned into even more expansive affairs than those that had taken place at Spring Gardens. In 1769 the display consisted of 136 exhibits, but by the middle of the 1770s the Pall Mall shows typically consisted of more than 400 works.[19] Attendance figures continued to grow, as did the amount of press criticism devoted to both the exhibitions and their audiences.[20] In these circumstances, the opening of an Academy exhibition increasingly became described as one of the key moments of the fashionable London season, the excitement of which is succinctly conveyed by *The Exhibition of Painting*, a poem published in 1775:

> Now feels Pall-Mall, a gen'ral bustle,
> And coaches – chairs, each other jostle;
> Fashion lends wings to expedition;
> For now a glorious *Exhibition*
> Opens indeed![21]

As had been the case in Spring Gardens, portraiture continued to dominate these exhibitions, despite the fact that the Academy's formation seems to have encouraged a concerted attempt to promote the more prestigious genre of historical painting.[22] Reynolds combined the display of history paintings with those whose subjects were of wide public interest. Thus, in 1770 the President exhibited a trio of portraits depicting the literary celebrities Samuel Johnson (fig.14), Oliver Goldsmith (see cat.43) and George Colman (Private Collection), while in 1771 and 1772 he submitted role-playing portraits of the actresses Mrs Abington (cat.54) and Mrs Quarrington (Private Collection). Over the next few years the focus on the most celebrated figures of urban society grew in intensity, partly thanks to a marked increase in the number of portraits Reynolds started sending to the annual exhibitions.

fig.14
Samuel Johnson by 1769
Oil on canvas, 76 x 64.8
Knole, Sevenoaks

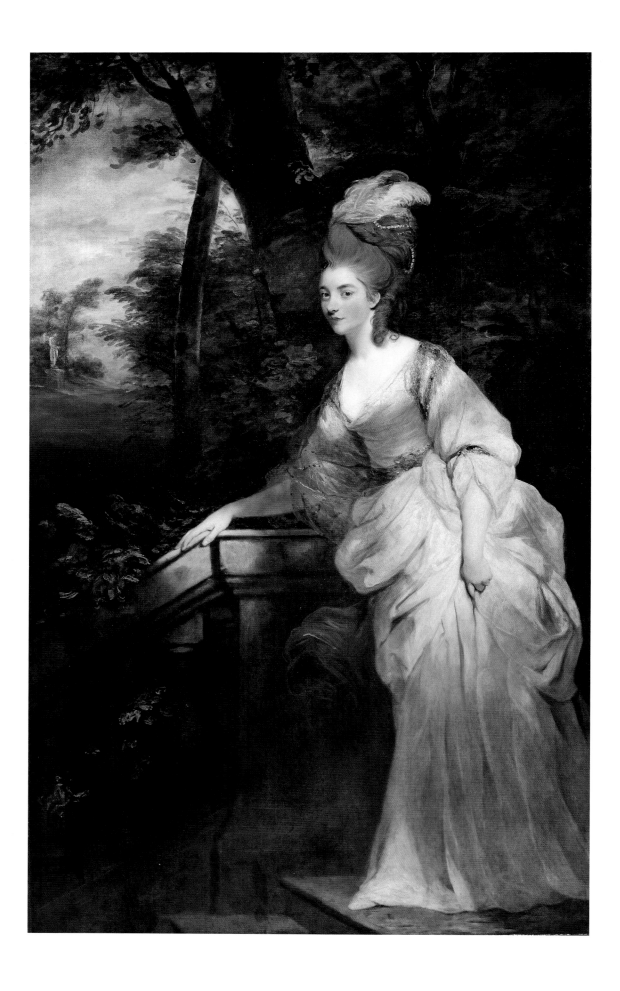

Whereas, in the years between 1769 and 1772, he had exhibited on average six paintings a year, for the rest of the decade he averaged more than eleven paintings for each display.[23] Closer inspection reveals that this expanded portfolio of exhibited works demonstrated a highly consistent character, not only in terms of the numbers of canvases Reynolds sent to the Academy shows, but also in terms of the categories of work he typically submitted. By far the most ubiquitous and dominant type of portrait Reynolds exhibited in these years was the full-length, single-figure portrait of a celebrated aristocratic 'beauty', now divested of the complex allegorical adornments found in such pictures during the 1760s. Instead, these women are depicted wearing quasi-classical dress and displaying a highly fashionable hairstyle, and placed in a generalised outdoor setting that fuses the features of a traditional pastoral landscape with the details of a modern aristocratic estate. Between 1773 and 1779 Reynolds showed no fewer than sixteen paintings conforming to this broad description, as against only six full-length portraits of men. To get a better sense of why Reynolds should have so regularly exhibited this kind of female portraiture, and of the ways in which he continued to draw upon the narratives and iconography of celebrity, we can turn briefly to the most famous example – Georgiana Cavendish, Duchess of Devonshire.

In 1776, the thirteen paintings by Reynolds listed in the Academy's exhibition catalogue are headed by his portrait of the Duchess of Devonshire (fig.15; see also cats.29 and 79). In the words of her most recent biographer, the Duchess 'had become a celebrity' by the mid-1770s, a status confirmed by the fact that her physical beauty, rarified social standing, hedonistic lifestyle and spectacular dress were relentlessly chronicled in the contemporary London newspapers.[24] Featuring prominently in this reportage were the new and extravagant modes of hair decoration associated in particular with the Duchess, which saw fashionable

women building up their hair into ever-higher towers, thickened with powder, perfumed with pomade, and adorned with ostrich feathers. Graphic satirists were quick to exploit the possibility such fashions offered for ridicule, and during the time the Duchess's portrait was on public display at Pall Mall, Matthew Darly engraved and published a scathing print showing two women crouched in a carriage, buckling under the weight of their towers of hair (fig.16). Significantly, the vehicle in which they stoop is decorated with two ducal coronets, and it is probable that, as Dorothy George notes, one of the figures would have been identified with the Duchess of Devonshire herself.[25]

Reynolds's portrait of the Duchess, just as much as Darly's satire, fully participated in the urban economy of celebrity that encompassed newsprint, painting and printmaking. In this instance, the resonant iconography of the Duchess's trademark hairstyle is fused with a sustained promotion of her individual beauty. A remarkably subtle management of dappled light and shadow ensures that visual attention is called to precisely those parts of her face and figure highlighted by contemporary theorists of feminine beauty as of especial fascination. In particular, Reynolds's painting of the Duchess's neck and upper body calls to mind the observations made by Edmund Burke in his seminal treatise on beauty: 'Observe that part of a beautiful woman where she is perhaps most beautiful, about the neck and breasts; the smoothness; the softness; the easy and insensible swell; the variety of the surface, which is never for the smallest space the same; the deceitful maze, through which the unsteady eye slides giddily, without knowing where to fix, or whither it is carried.'[26] In Reynolds's canvas, the pictorial articulation of such attractions alongside the exquisite, but self-consciously excessive, iconography of the headdress caters brilliantly to the metropolitan fascination – itself giddy, unfixed and fluid in nature – with the Duchess, accentuating exactly those characteristics of feminine desirability and fashionable extravagance that defined her vibrant public identity. We can even suggest that such details as the Duchess's 'antique' dress and rural surroundings would, however paradoxically, have reinforced these forms of interest and fascination. They transform her into a figure of pastoral fantasy, a delicately classicised icon of aristocratic otherness – someone who is both part of the world of the contemporary city but also, tantalisingly,

fig.15
*Georgiana Cavendish, Duchess of Devonshire c.*1775–6
Oil on canvas, 237 x 145
Huntington Art Gallery, San Marino

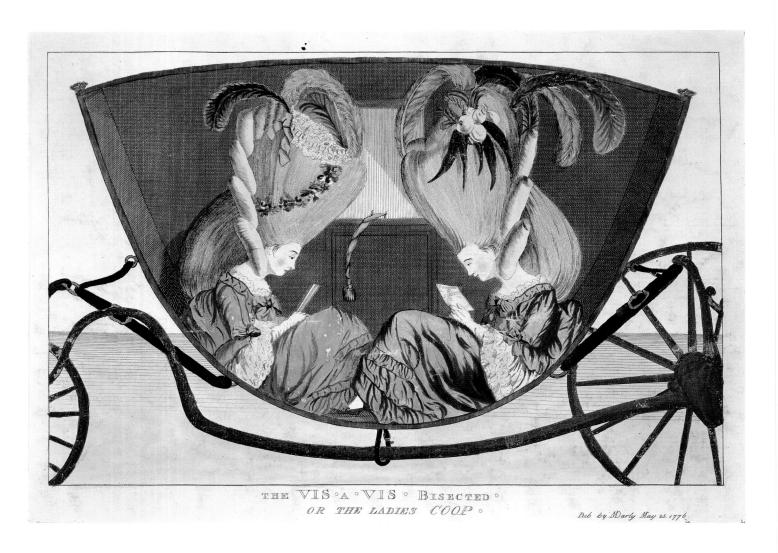

THE VIS·A·VIS·BISECTED·
OR THE LADIES COOP·

Pub by MDarly May 25. 1776.

temporarily withdrawn from its spaces and storylines. Thanks to all of these factors, the Duchess's outward look and intimate smile, even as they seem to anticipate the approbation of the aristocratic spectators who subsequently appreciated the painting as it hung in her father's country seat, seem just as much geared towards that London audience who vicariously followed her activities on an almost daily basis and who would have reciprocated her gaze in the exhibition room.

In 1780, four years after the display of the Duchess of Devonshire's portrait in Pall Mall, the Royal Academy and its annual displays moved to a purpose-built wing of Somerset House, overlooking the Strand.[27] Dominating the new headquarters was the Academy's Great Exhibition Room, located on the building's upper floor, and designed to show off contemporary paintings to the greatest effect. As well as featuring an innovative mode of top-lighting and a wooden armature, positioned some eight feet off the ground, that allowed banks of paintings to be tilted forward, the Great Room at Somerset House was also distinguished by being much greater in size than that at Pall Mall, and by having an ante-room that was also intended for the display of pictures. Other rooms in the building were also easily adapted for the exhibition of works of art. Unsurprisingly, given these conditions, the annual exhibitions continued to grow in size. In 1780 the catalogue records 489 works being put on display; by 1785 that figure had reached 581; and in 1790, the last year Reynolds submitted a group of his paintings for exhibition, no fewer than 703 paintings, sculptures and drawings were on show.

In the increasingly crowded exhibitions at Somerset House, Reynolds maintained his long-standing strategy of submitting portraits of public figures for display. In one striking case, moreover, the artist again showed portraits of the same individual in different exhibitions; in this

instance, significantly, the subject was no less a figure than George, Prince of Wales – the most controversial and flamboyant 'celebrity' of the age.[28] To an even greater degree than had been the case with such figures as the Duchess of Devonshire, the Prince's activities were discussed in obsessive and often salacious detail in the newspapers, periodicals, pamphlets and memoirs of the period. He was almost as ubiquitous in London's visual culture during the 1780s, pictured in numerous illustrations, prints, portraits, illuminations, decorations and portrait busts. The three portraits of the Prince that Reynolds exhibited during this same decade – in 1784, 1785 and 1787 respectively – responded to and helped perpetuate this contemporary cultural fascination with the Prince's public and private lives, as well as serving to cement the relationship between the Academy and an important royal patron.[29] Significantly, these portraits of the Prince also seem to have been perceived by both Reynolds and the exhibition audiences as pictures that interacted with the other works hanging in the Great Room. To better explain this notion of pictorial interaction, and to demonstrate how it functioned to disseminate and complicate the narratives of celebrity, we can usefully focus on the exhibition of 1785.

In that year, Reynolds submitted a head-and-shoulders portrait of the twenty-two-year-old Prince (cat.30) to the Academy show, and in doing so returned the public's attention to a figure who, during the previous winter and spring, had maintained his reputation as a rakish spendthrift, sportsman, drinker and womaniser. His attendance at parties, balls and masquerades, his extravagant dress and love of the turf, and his supposed affairs with both aristocratic women and common prostitutes were continually being reported, castigated and occasionally celebrated in the pages of the press. One strand of this commentary focused on the Prince's friendship with Lord John Lade, who was regularly lampooned in the London newspapers as someone with a similarly irresponsible love of fast vehicles and horseracing. Lade was also notorious for his unashamed and highly public attachment to the celebrated courtesan Letitia Derby, more commonly known as 'Mrs Smith', and herself the subject of numerous journalistic commentaries. A piece of fanciful gossip published in the *Morning Post* just before the opening of the Academy display brought all three of these *beau-monde* celebrities

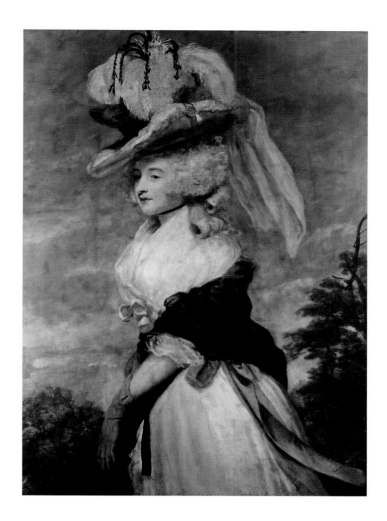

fig.16
Matthew Darly (fl.1749–75)
The Vis a Vis Bisected, or the Ladies Coop 1776
Line engraving, 21.8 x 32.9
The British Museum, London

fig.17
*Letitia Derby, later Lady Lade c.*1785
Oil on canvas, 131 x 96
Private Collection

together. In this scurrilous, innuendo-laden report, the Prince himself is implied as having had sex with Mrs Smith in Lade's carriage:

> Sir Jacky [Lade] received fresh cause of uneasiness from the P[rinc]e on Monday at Newmarket. His H[ighnes]s finding the course rather too hot, alighted from his horse, and went into Sir Jacky's carriage to cool himself, where he spent a considerable time tête-à-tête with Mrs S[mi]th, which has made the Lad [Lade] determine never to take her again to the race ground in an open carriage.[30]

Significantly, when the Somerset House exhibition opened only five days later, visitors would have seen not only Reynolds's portrait of the Prince, but also the same artist's glamorous, full-length portrait of Mrs Smith, now unfortunately cut down (fig.17), which hung directly opposite. If Reynolds had hoped to generate extra discussion of his works through his submission of both portraits, he was not to be disappointed. In particular, newspaper reviewers were quick to exploit the ways in which the controversial figures of the Prince and Mrs Smith were suddenly enjoying a new pictorial tête-à-tête across the space of the exhibition room itself. The *Morning Herald*, for instance, which took full account of the fact that Reynolds's image of Mrs Smith also looked out over Benjamin West's painting of *St Peter's First Sermon* (1785), gleefully noted that 'the portrait of Mrs Smith, from its situation at the Academy, stares West's *Sermon* full in the face. That she should be opposite to St Peter is well; and that she should be in full view of the Prince of Wales is better'.[31] If such comments suggest how Reynolds's celebrity portraits could play off each other within the Great Room, and in doing so invoke the most scandalous of narratives, another contemporary reviewer's observations extended this form of interplay and invocation to encompass a more anonymous group of pastel portraits of women, which hung in close proximity to the Prince's portrait. The writer jokes that these 'poor, clay cold heads', in themselves of little worth, nevertheless 'seem to receive some degree of animation, from the company of the Prince of Wales, who is between them, and who is indeed on all sides surrounded by petty coats; one in particular is paying great court and attention to him, and is raising her hand in admiration; but he seems

to be inflexible, and to have his eye attentively fixed to Mrs Smith, who is opposite to him in the Room'.[32]

These responses offer yet another indication of the ways in which Reynolds's exhibition portraiture, as well as inviting the most scrupulous forms of interpretative attention, also exploited and attracted the sensationalist, hyperbolic journalistic narratives that were increasingly structuring many of his subjects' public identities. The constant danger of such a strategy, of course, was that his art would thereby open itself up to the charge of vulgarisation. Indeed, precisely such a critique seems to have gained momentum in the last decade of the artist's exhibition career. Tellingly, this period saw Reynolds's portraits – and in particular their colouring – frequently attacked for both their gaudiness and their tendency to fade. With pictures such as that of Mrs Smith, these seemingly formal and technical concerns were quickly tied to the nature of the artist's sitter. Thus, in the words of one review of the painting, 'If the colouring appears rather tawdry, we should consider that it is particularly suited to the subject'.[33] Another writer on the same painting, focusing instead on the danger that it would soon lose its colour, noted wryly that 'Sir Joshua Reynolds's portrait of Mrs Smith does not by any means correspond with her situation in real life. The lady is in *good keeping*, and the picture is not'.[34] Such jokes, however local and specific in nature, suggest a wider form of unease about the relationship between portraiture and celebrity in Reynolds's work. They hint that the vividness of colour in the artist's late portraits – something that was often referred to as their 'glare' – was becoming closely aligned with the artificiality and vulgarity that was by the 1780s beginning to be seen as characteristic of those men and women who too assiduously courted the urban public's gaze. Secondly, and even more intriguingly, such responses opened up the possibility of interpreting Reynolds's rapidly fading portraits in terms of the fleeting nature of celebrity itself. From this perspective, the painted portrait, rather than standing as a bulwark against the passage of time for such temporarily renowned figures as Mrs Smith, ended up cruelly mimicking time's inexorable ravaging of the celebrity's body and reputation. This sentiment is captured nicely in a pre-exhibition commentary on Mrs Smith's portrait penned by another newspaper critic in 1785, written while the picture was still being painted in Reynolds's

studio. The correspondent, noting that the artist had laid on his paint very heavily in this portrait – itself a practice echoing the excessive use of make-up characteristic of the 'painted lady' – goes on to decry this doomed attempt to stave off the inevitable deterioration that both Reynolds's painting, and his subject, were soon to suffer: 'he has painted her "*Inch thick*" – and the *decayed* pictures around the gallery, may exclaim, "to our complexion you will come at last!"'[35]

The fact that an exhibition including paintings such as these is now taking place, more than two hundred years after Reynolds's death, helps put paid to such aspersions. They nevertheless suggest that, for some contemporaries at least, there was a nagging feeling that the artist and his portraits had themselves become too closely implicated in, and infected by, the machinations of celebrity culture. From our point of view, of course, such aspersions only serve to enrich and complicate our understanding of an artist who, we can now conclude, continuously used the exhibition space as an environment in which to exploit and disseminate the recognisably modern version of fame that celebrity represented.

Notes

1 *Public Advertiser*, 29 April 1760.

2 See *A Catalogue of the Pictures, Sculptures, Models, Drawings, Prints, &c. of the Present Artists. Exhibited in the Great Room of the Society for the Encouragement of Arts, Manufactures, and Commerce, on the 21st April, 1760*, London 1760. It is worth noting that a number of the exhibits, although listed as single objects, are actually made up of groups of works. For the best modern accounts of artists' efforts to collectively display their work in the years before 1760, and of the early history of the exhibitions themselves, see Solkin 1993, pp.157–213, and Hargraves 2003, passim.

3 *Lady's Magazine*, April 1760, p.282.

4 The 1760 Society of Arts show did not charge an admission fee; subsequently, however, the London exhibitions normally made an entrance charge of a shilling.

5 For a stimulating discussion of the expansion of print culture in this period see Brewer 1997, pp.452–63.

6 For this development see Hargraves 2003, chapter 2; Solkin 1993, pp.176–9; and Pye 1845, pp.97–106.

7 For these numbers see the exhibition catalogues of the Society of Artists for 1761 and 1768. Reproductions of these catalogues are to be found at the Paul Mellon Centre for Studies in British Art, London.

8 These figures are taken from Brewer 1997, p.237.

9 An incomplete but very useful list of Reynolds's exhibition submissions throughout his career is found in Waterhouse 1973, pp.177–83.

10 *St. James's Chronicle*, 25–7 May 1762.

11 The quote regarding the bridesmaid's dress comes from the *Public Advertiser*, 14 September 1761.

12 Horace Walpole to Mann, 11 April 1759, quoted in Mannings and Postle 2000, vol.1, p.475.

13 Ferdinand's praise for the English generals at Minden, including this commendation of Kingsley, was widely reported in the London newspapers and is reproduced in Entick 1766, vol.4, p.17.

14 For a biographical narrative of Granby's life and career see William Evelyn Manners, *Some Account of the Military, Political and Social Life of the Right Hon. John Manners, Marquis of Granby*, London and New York 1899.

15 Entick 1766, vol.5, p.144.

16 *London Chronicle*, 2–4 October 1760.

17 These included Edward Penny's *The Marquess of Granby Relieving a Sick Soldier*, displayed at the Society of Artists exhibition of 1765. For an extended account of this painting see Solkin 1993, pp.199–206.

18 For a detailed study of the Academy's early history see Hoock 2003, passim.

19 These figures are taken from the relevant Academy exhibition catalogues.

20 For the journalistic exhibition criticism attracted by the Academy displays, particularly after the institution's move to Somerset House in 1780, see Mark Hallett in Solkin 2001, pp.65–75.

21 *The Exhibition of Painting: A Poem*, London 1775, p.21.

22 For a related discussion, see Solkin 1993, pp.266–72.

23 See Waterhouse 1973, pp.178–80.

24 Foreman 1988, p.37.

25 In Stephens and George 1870–1954, vol.6, pp.238–9 (satire no.5373).

26 Edmund Burke, *A Philosophical Enquiry into the Origin of our Ideas of the Sublime and Beautiful* (first published 1757, 2nd edition 1759) in McLoughlin and Boulton 1997, vol.1, pp.274–5.

27 For the Royal Academy exhibitions at Somerset House, see Solkin 2001, passim.

28 For a useful account of the Prince of Wales, see E.A. Smith, *George IV*, New Haven and London 1999.

29 See Hallett 2004, pp.581–604.

30 *Morning Post, and Daily Advertiser*, 21 April 1785.

31 *Morning Herald, and Daily Advertiser*, 3 May 1785.

32 *Universal Daily Register*, 7 May 1785.

33 *Morning Post, and Daily Advertiser*, 30 April 1785.

34 *Morning Herald, and Daily Advertiser*, 4 May 1785.

35 Ibid., 1 April 1785.

'Figures of Fame': Reynolds and the Printed Image

Tim Clayton

In the eighteenth century it was essential for an ambitious artist such as Reynolds, who wished to win international fame, to get his paintings published in print form. Publication involved a printmaker engraving an imitation of a painting on a copper plate and printing hundreds or sometimes thousands of impressions from it onto paper. In the words of one influential French commentator writing in 1729, engraving was 'capable of giving their [a painter's] masterpieces the same immortality that the art of printing guarantees to Tasso's *Jerusalem Delivered* and the tragedies of Corneille … The art of engraving … can distribute to all the countries on earth, and transmit to the centuries to come, whatever is most precious and most inspired in the work of outstanding painters.'[1]

The process of engraving was a discovery made during the Renaissance, and painters quickly grasped its potential. As the French seventeeth-century artist and writer Roger de Piles observed:

Skilful painters who worked for glory, took the opportunity to make use of it to let the world know of their works. Raphael among others employed the burin of the famous Marcantonio to engrave several of his pictures and designs; and these admirable prints worked like so many figures of fame with his trumpet, which carried the name of Raphael to the whole world.[2]

By the eighteenth century, engravers had become highly sophisticated in translating the particular style and idiosyncrasies of individual painters into their own medium. Otherwise, little had changed since the days of Raphael. Engraving remained the principal route to a wider public, through which 'everyone can enjoy what, without engraving, would be the sole property of one man alone'.[3] Dictionaries of artists had begun to appear in which the engravings of a painter's work were listed, thus effectively defining their oeuvre by their published output. In the crudest possible terms, long lists of engravings made a painter look important, and an alliance with the best engravers brought prestige.

As is explained elsewhere in this catalogue, Reynolds explored several routes to fame, not passing up any opportunities to augment his public standing in the process. In striving to achieve the widest circulation possible for his work through the medium of engraving, Reynolds followed in the footsteps of Raphael and Rubens, and, more recently, Godfrey Kneller and his own master Thomas Hudson. By 1775 so many of his paintings had been published that the famous engraver Robert Strange could claim that:

No body knew better, or has more experienced, than Sir Joshua Reynolds the importance of engraving … Since the memorable aera [*sic*] of the revival of the arts, in the fifteenth century, I know no painter, the remembrance of whose work will depend more on the art of engraving than that of Sir Joshua Reynolds.[4]

In part this was a sarcastic reference to the notoriously fugitive pigments that Reynolds used, but Strange was also making a serious point. No contemporary painter's work was as well represented by prints, nor arguably by such good quality examples, as Reynolds's. He organised and thought through the publication of his own work with a systematic thoroughness that no painter of the time

Edward Fisher (1722–82) after Joshua Reynolds
Garrick between Tragedy and Comedy 1762 (detail of cat.72)
The British Museum, London

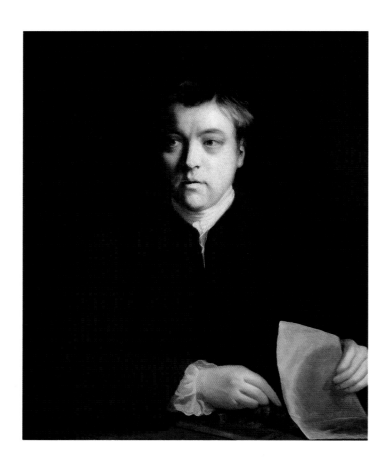

fig.18
*James McArdell c.*1756
Oil on canvas, 75 x 62
National Portrait Gallery, London

fig.19
James McArdell (1729–65) after Joshua Reynolds
Lady Charlotte Fitzwilliam 1754
Mezzotint, 27 x 22.5
The British Museum, London

fig.20
Unknown after Joshua Reynolds
*L'Homme entre le Vice et la Vertu c.*1764
Mezzotint
The British Museum, London

could match. In 1784 the *Gentleman's Magazine* published its first catalogue of engravings, listing 319 prints, all after Reynolds. In total over 400 prints authorised by Reynolds were published during his lifetime. Unauthorised piracies and copies take the total much higher.[5]

The process began soon after Reynolds's return from Italy in 1752. Thomas Hudson's paintings were engraved by the leading mezzotint engraver of the day, James McArdell (fig.18), and in 1754 it was McArdell who engraved the first print after Reynolds, *Lady Charlotte Fitzwilliam* (fig.19), the only print that we can be sure Reynolds published himself. 'By this man I shall be immortalised!', Reynolds said of McArdell, who scraped thirty-six mezzotints after Reynolds between 1754 and his early death in 1765.[6] Despite this prolific output, McArdell could not bear the burden of investing Reynolds with immortality alone and other engravers had to be employed on the task simultaneously. At first the leading engraver was Edward Fisher, who lived conveniently close to Reynolds in Leicester Square. But over a period of time all the best mezzotinters in Britain produced prints after Reynolds. Among the most notable were Valentine Green, John Dixon, William Dickinson, James Watson and John Raphael Smith. Reynolds also gave pictures to pupils and protégés to engrave, including Giuseppe Marchi and William Doughty. Fine prints were very much to the advantage of the painter since they represented his work in the optimum light, producing a crisp, legible image; even, at times, correcting deficiencies in the original work.

Few of Reynolds's paintings were engraved in line, which was then regarded as the most prestigious of printmaking techniques. A large line engraving was very slow and very expensive to produce. It was capable of printing thousands of impressions but it needed extensive sales to justify the cost. Mezzotints, on the other hand, could be scraped relatively quickly and cheaply. This made them ideal as a vehicle for capitalising swiftly but stylishly on a topical subject, such as a painting that was well-received in an exhibition, or portraying a celebrated individual. At the same time that Reynolds emerged as a prominent painter, a crop of highly talented Irish and English mezzotinters demonstrated unprecedented mastery of this branch of printmaking that was already

becoming known as '*la manière anglaise*'.

From 1760, when art exhibitions began to form a regular feature of the London calendar, the subjects of engravings were closely related to exhibited paintings. Indeed, most of the paintings that were exhibited were also engraved, but even engravings of unexhibited portraits tended to focus upon well-known, or newsworthy, individuals. The exceptions were mostly private commissions that need not concern us here since their exclusivity was not usually intended to court celebrity. Engravers also exhibited at the exhibitions of the Society of Artists of Great Britain, and to a limited degree at the Royal Academy, so that paintings and engravings of the same subject often appeared in the same exhibition. Also, the publication of engravings frequently coincided with these exhibitions, when London was crowded with art lovers and connoisseurs. In other cases, publication followed soon afterwards. In 1761, for instance, Edward Fisher exhibited alongside Reynolds his interpretations in mezzotint of the painter's *Laurence Sterne* (cat.33) and *John, 1st Earl Ligonier* (fig.12). Similarly, in 1762 Fisher's mezzotint of *Garrick between Tragedy and Comedy* (cat.72) was completed in time for exhibition in May 1762, some months before it was published officially in November. Prints were usually made for speculative sale and therefore it was crucial that there was widespread demand for an image of the sitter.

Publicity and celebrity were in many cases as useful to the sitter as they were to the painter. Reynolds's portrait of David Garrick caught between the muses of tragedy and comedy (cat.60) was one of a large number of portraits, subsequently engraved, that served to raise the actor's profile and confirm his stature as a figure of international importance. Garrick himself used these images as instruments of self-publicity. When he visited Paris in 1764 he sent for copies of Fisher's print as suitable gifts for his continental admirers:

> I am so plagu'd here for my Prints or rather Prints of Me – that I must desire You to send me by y^e first opportunity <u>six</u> prints from Reynolds's picture, You may apply to y^e Engraver he lives in Leicester fields, & his name is Fisher, he will give you good ones, if he knows they are for Me – You must likewise send me a <u>King Lear</u> by <u>Wilson</u>, <u>Hamlet</u> d^o <u>Jaffier</u> & Belv by <u>Zoffani</u>, speak to him for two

Lady Charlotte Fitz-William.

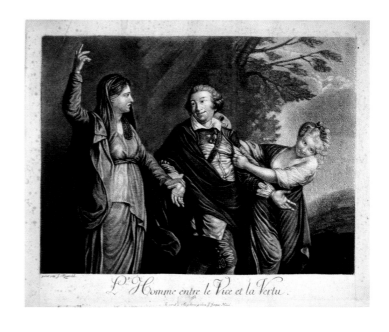

L^e Homme entre le Vice et la Vertu.

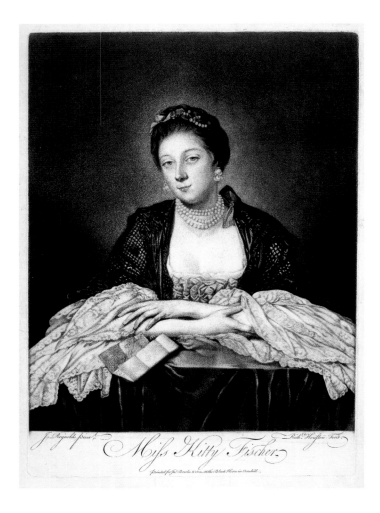

or 3, & what else he may have done of Me – There is likewise a print of Me, as I am, from Liotard's picture Scrap'd by MacArdel, send me 2 or 3 of them, speak to MacArdel, & any other prints of Me, if tolerable, that I can't remember.[7]

Although it is likely that few distributed their own image so carelessly and profusely as Garrick, the giving of a print as a souvenir to a friend or admirer was common practice. The British Museum has an impression of McArdell's print of Horace Walpole after Reynolds (see cat.32), inscribed (probably by the recipient) to show that it was a gift from the sitter. By the time this impression was printed the plate was very worn, suggesting that Walpole had given many away, although he refused to give McArdell a single print on the grounds that it was a private print and McArdell had made its existence public.[8]

Once an image was in print it often took on a life of its own. Within a short time Fisher's print of Garrick's portrait had been copied at least thirteen times.[9] Costing ten shillings and six pence, the seventeen-by-twenty-inch original was unusually large and expensive for its day. The printseller Robert Sayer of Fleet Street published a smaller fourteen-by-sixteen-inch version at five shillings, and a much reduced ten-by-fourteen-inch plate at one shilling. The Bowles family of printsellers, who were rivals of Robert Sayer, and who had shops in the City, published yet another two versions. Their fourteen-by-ten-inch print, a size known as the 'posture size', distinguished itself by making the image portrait format, with the figures shown full-length. A further copy with an inscription in French (the international language of the time) was published by Johann Jakob Haid in Augsburg, Germany (fig.20). This print was seen by the dramatist George Colman in Paris in 1765, causing him to report mischievously to Garrick that 'there hang out here in every street, pirated prints of Reynolds's Picture of you which are underwritten, "L'Homme entre le Vice et la Vertu"'.[10] The first Copyright Act of 1735, piloted by William Hogarth, was designed to curtail print piracy, although it contained many loopholes. Yet, even when a second act of 1767 extended copyright to prints that were not designed, engraved and published by the same person, there was no way of preventing international piracy.

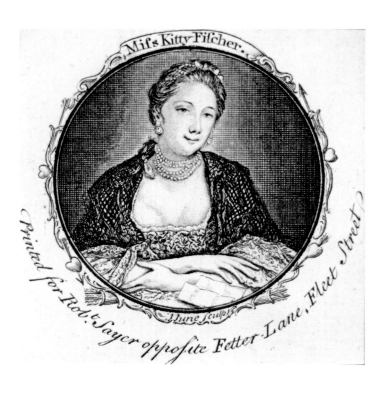

However, piracy only really mattered to people who had a financial stake in a copper plate. Unless they owned the copper plate, both the painter and the sitter were quite likely to welcome the multiplication of their image. Thus copies reached down the social scale and out into the provinces and colonies.

The presence of a print in the catalogues of Robert Sayer, John Bowles and Son and Carington Bowles, the most commercial of the printsellers, was a very good index of the celebrity status of the subject of a portrait. Before the 1767 Copyright Act these printsellers could commission copies of more or less any image they thought would sell well. Yet, to be fair, they sometimes published plates that were not piracies, and they also bought up old copper plates from which successful editions had already been printed and sold by another person. After McArdell's death, Robert Sayer bought what he presented as 'the Works of the late eminent and ingenious Mr. James Macardell [*sic*]', thus further extending the currency and longevity of many images by Reynolds.

The aforementioned posture size, as well as six-by-four-inch mezzotints, are especially well populated by images of 'celebrities'. The headings of the posture size sections in Sayer and Bennett's 1775 catalogue are revealing in themselves.[11] The male portraits are 'Statesmen, eminent Land and Sea Officers, Patriots, Chancellors, Judges &c. who have distinguished themselves, to the present time'. Among them are a number of portraits by Reynolds, including those of the Marquess of Granby (cat.15), George Keppel, Augustus Keppel (cat.9), Edward Boscawen (1753–6; Private Collection) and Laurence Sterne (cat.33). The females included are, needless to say, 'the most celebrated Beauties of the present time'. Here, as in the exhibitions, Duchesses jostle with prostitutes.[12]

Although she had died some years previously, the courtesan Kitty Fisher appears twice in this section of the 1775 catalogue, with her arms folded (see figs.21–2) and as Cleopatra (see cat.50). During her lifetime she had been attainable only by a privileged minority; the rest of the male populace having to content themselves with the image replicated in print form. The first print in the 1775 catalogue was by Richard Purcell, and a copy of the print by Richard Houston (fig.21) that John Bowles owned. The second, by Houston, is a copy of the print by Edward Fisher owned by the Bowleses. James Watson also

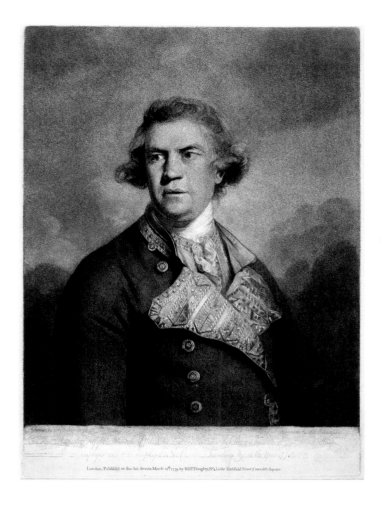

fig.21
Richard Houston (*c*.1721–75) after Joshua Reynolds
Miss Kitty Fisher 1759
Mezzotint, 33 x 22.8
The British Museum, London

fig.22
John June (fl. *c*.1747–70)
Miss Kitty Fisher c.1759
Etching, 5.8 diameter
The British Museum, London

fig.23
William Doughty (1757–82) after Joshua Reynolds
The Hon. Augustus Keppel, Admiral of the Blue 1779
Mezzotint, 45.4 x 32.5
The British Museum, London

engraved her as Cleopatra for John Bowles in the six-by-four-inch-print. The same two designs by Reynolds were etched for Sayer's series of 'Designs in Miniature for Watch-Cases', prints made to be inserted into pocket-watch-cases as an ornamental protection against dust (fig.22). These designs consisted of 'celebrated Ladies, Generals, Players, Venus, Maps, Views, Cupids, History Pieces, &c. ... Price 3d. each, neatly coloured, 6d.'[13] Reynolds's *Nelly O'Brien* (cat.52) and *Miss Day* (1760; Pittsburgh, Carnegie Museum of Art) were also etched for watch-cases. Kitty Fisher achieved the widest possible circulation, however, when her name provided the title to one of the eight-page songbooks sold by the popular print wholesalers Cluer Dicey and Richard Marshall at the wholesale price of eight shillings for 960 books.[14] These cheap products, once so common, are now so rare that it is impossible to know whether they were adorned with one of Reynolds's portraits of her, although it is likely that they were.

The same can be said for portraits of Admiral Edward Boscawen and the Marquess of Granby that were available as woodcut royals (one shilling and two pence for a quire of twenty-six), and of Boscawen, Edward Hawke and others which could be bought as crudely engraved royal sheets (at two pence a quire) and 'pott size' sheets (one shilling for a quire).[15] These prints were almost always copied from the best-known source and so it is likely that they resulted in versions of Reynolds's images being familiar in many a country cottage and alehouse. Similar reuse of images also meant that these figures appeared in several magazines, which would have been kept in coffee houses and private libraries.

From the publisher's point of view, then as now, images of famous people sold well and the better known they became the more widely they sold. In 1752 Reynolds painted a very fine portrait of Augustus Keppel (cat.9), who had given the young artist a passage to Italy in his ship, the *Centurion*, in 1749. While acting as Commodore, in the *Torbay*, Keppel took the French West African stronghold of Goree in December 1758, during the Seven Years War against the French. When news of this got back to London, Reynolds made a note in his pocket book, 'Commodore Keppel speak about print'. The engraving may not have been completed, however, before Keppel further distinguished himself under Edward Hawke in

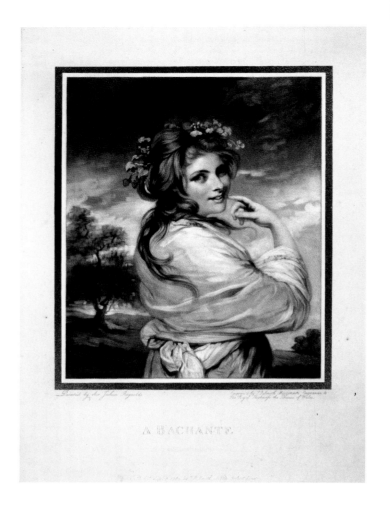

fig.24
John Raphael Smith (1752–1812) after Joshua Reynolds
A Bacchante 1784
Mezzotint, 37.3 x 28.6
The British Museum, London

NATURE

Flushed by the spirit of the genial year
Her lips blush deeper sweets, they breathe of Youth:
The shining moisture swells into her eyes.
Tis brighter glow, her wishing bosom heaves
With palpitations wild.

London Published May 1st 1774, by I. R. Smith No. Oxford Street.

fig.25
John Raphael Smith (1752–1812) after George Romney (1734–1802)
Nature 1784
Mezzotint, 37.3 x 28.6
The British Museum, London

the great victory over the French in Quiberon Bay on 20 November 1759. This triumph completed the subjugation of the French channel fleet, already partially achieved by Edward Boscawen's victory off Cape Lagos in Portugal earlier that year, which became known as the 'Year of Victories'. The date of the Quiberon Bay victory appears on most impressions of the print and on a second smaller and cheaper version scraped by Fisher early in 1760.

Luckily for Reynolds, his friend Augustus Keppel continued to make news. In 1761 he led the attack on the French island of Belleisle, off the south coast of Brittany, and successfully captured it – an operation in which Augustus Hervey (cat.13) also took part. The following year Keppel was second-in-command of the naval forces in the expedition led by his elder brother George, Earl of Albemarle, against the Spanish forces in Havana, Cuba. The surprise attack that took place in summer 1762 was an outstanding success that brought the Keppel family a large share of the £736,185 prize money (Augustus himself receiving £25,000). Reynolds and Fisher again combined to produce a mezzotint of George Keppel, published in October 1762. As well as these portraits of the leading protagonists, engravings of battle scenes themselves were also published.

After the war Augustus Keppel became naval spokesman in Parliament for the Rockingham Whigs. In 1779 he hit the news again when he was court-martialled after the indecisive Battle of Ushant in 1778.[16] The trial was the result of an acrimonious dispute between the Whig Keppel and his subordinate, Sir Hugh Palliser, a member of the Court faction, who had the backing of Lord North's government. When Keppel was acquitted a number of prints of him were published in celebration, among them one by William Doughty after Reynolds (fig.23). 'I have taken the liberty, without waiting for leave, to lend your picture to an engraver, to make a large print from it', Reynolds wrote to Keppel.[17]

Generally, sitters became celebrities and then prints were made of them. Very occasionally the print made the celebrity. This was the case with the prostitute Emma Hart, later Emma Hamilton, who made her 'celebrity' début through prints. Having begun her career as a servant of the sister of the printseller John Boydell, she moved to London. Not much is known of the next stage of her life except that by the age of sixteen she was the mistress of

Sir Harry Featherstonhaugh, who ejected her in 1781 when she became pregnant. Charles Greville, younger son of the Earl of Warwick, whose family had been painted several times by Reynolds, took her in. He installed her in a cottage on Paddington Green and introduced her to George Romney for whom she began to model in 1782 (see fig.25). A year later Greville's uncle Sir William Hamilton visited London from his post as Ambassador to Naples and paid for Reynolds to paint her portrait as a bacchante (see fig.24). John Raphael Smith acquired the rights to publish both Romney's and Reynolds's paintings of Hart. Smith cleverly issued the portraits in similar formats and sizes, so as to invite direct comparison between them.

By the mid-1780s Reynolds's quest for fame was effectively over, for by now he had firmly established himself as one of the dominant figures in the European art world. Discussion of his paintings and his writings had even been supported by the engraving of works from his personal collection of Old Master paintings. John Boydell published prints of pictures belonging to Reynolds, including a Guercino, a Poussin, two Rembrandts, an Ostade, a Teniers and a Sacchi. Others engraved and published a further four Rembrandts, a Dusart, a Hals, a Claude and two seascapes by Willem van de Velde the Younger.[18] Some of these attributions have withstood the test of time, others have not. But in the eighteenth century the process of publication itself helped to legitimise and give authority to the attribution. Once reputably published, Reynolds's Rembrandts took their place in the lists of engraved paintings that appeared under Rembrandt's name in the dictionaries of artists that were published at the time. In the process, the name of Sir Joshua Reynolds gained added lustre as that of a great connoisseur and picture collector.

Some of the Old Masters that Reynolds loaned to Boydell were published in Boydell's *Collection of Prints Engraved After the Most Capital Paintings in England*, a collection that Boydell initiated in 1763 and gradually expanded over a period of many years. In 1773 he introduced contemporary British paintings into his collection for the first time, one of them being an engraving of Lord Camden after Reynolds. Boydell was a great exporter of prints, and by 1773 it had become clear to him that there was a strong market for contemporary British art abroad.

In mainland Europe interested individuals had avidly followed the introduction of public exhibitions in London and the great expansion in production of fine contemporary prints they helped to stimulate. One notable response was the series of over two thousand reviews of British prints that appeared between 1758 and 1790 in a journal called the *Neue Bibliothek der schönen Wissenschaften und der freyen Künste* (The New Library of the Fine Sciences and the Liberal Arts). This important magazine was a spearhead of the Enlightenment in Germany.[19] Over one hundred and fifty of these reviews were devoted to prints after Reynolds and the magazine's editor, Christian Felix Weisse, personally translated Reynolds's *Discourses* (his Royal Academy lectures) for the benefit of his German-speaking readers.

Although the magazine was published in Leipzig in Saxony, the reviews of English prints were contributed by Georg Friedrich Brandes, the Hanoverian civil servant responsible for the University of Göttingen. This was an institution much favoured by George III who was ruler of Hanover as well as England. In the catalogue of Brandes's own print collection, which also featured a eulogy of Sir Joshua's qualities as a painter, 306 prints after him were described.[20] Once again Reynolds enjoyed the largest representation for a British artist in a publication, and his section of the catalogue even dwarfed the 220 prints representing Angelica Kauffman, a favourite since she was considered to be a German – despite the fact that she was actually Swiss.

Brandes, however, was a great deal more interested in history painting than he was in portraiture and it was one of Reynolds's attempts at 'history' that became his most celebrated composition in Europe. *Ugolino and his Children in the Dungeon* (1773; Knole, The National Trust) was exhibited at the Royal Academy in 1773 and the print by John Dixon (fig.26) received high praise from Brandes when he reviewed it soon after its publication in early 1774.[21] The subject was taken from Dante's *Divine Comedy* and showed the imprisoned Count Ugolino with his children starving to death around him. Its heroic subject-matter was well calculated to please a European audience, and in sympathetic circles it gave Reynolds the credibility as a master of imagination and expression that cemented his status as a great painter.[22]

fig.26
John Dixon (fl.1787–1801) after Joshua Reynolds
Ugolino 1774
Mezzotint, 50.4 x 62
The British Museum, London

Ugolino was an essential component in the considerable number of large collections of British prints that were compiled in Europe during Reynolds's lifetime. In these, he invariably claimed his place as the leading British artist, usually with a separate volume devoted to his *œuvre*. Many of these were princely collections and some had links with academies devoted to the local improvement of the arts. Most collections have since been dispersed, among them that of Count Georg von Einsiedel, Saxon Minister of State, whose collection of 106 prints after Reynolds was the largest section of his collection of English prints.[23] But a number of large German collections of English prints survive, notably those now held at the museums in Karlsruhe, Coburg and Aschaffenburg.

The sudden growth in demand for contemporary British prints on the Continent was a startling development of the period after 1770. Surviving catalogues of German, Italian and French printsellers, together with advertisements in Continental newspapers, provide firm evidence of a phenomenon that was much remarked upon in Britain. The market was strongest in decorative prints and history prints. There was not a huge demand, except among collectors, for Reynolds's portraits of the British aristocracy, although prominent military figures and cultural celebrities retained their desirability abroad. Thus, in the stock of the German printseller Carsten Friedrich Bremer of Braunschweig (Brunswick) in 1780 we find prints after Reynolds's *Omai* by the Austrian Johann (John) Jacobé (cat.80) and his portrait of the Italian author Giuseppe Baretti (cat.44). He also owned prints of Valentine Green's series of aristocratic portraits, cunningly (if sometimes misleadingly) presented for commercial consumption as 'Beauties of the Present Age', and the self-portrait of Reynolds in doctoral robes (see cat.5).[24] The Admirals Barrington, Rodney (see cat.12) and Keppel (see cat.9) were also represented.

Many copies of English prints began to be engraved and published in France, Germany and Italy. Sometimes these emulated famous prints; more often they provided cheaper alternatives to expensive British imports. Most reproduced decorative prints were intended as domestic furnishings and so there were relatively few copies of works by Reynolds. One exception was a copy of the portrait of Lavinia, Countess Spencer (1785–6; Althorp), engraved by Pietro Bonato and published in Bassano before 1791 by the Remondini family of art publishers.[25]

Reynolds took special pains to circulate his own portrait. Between 1777 and 1778 Charles Townley published seven of the self-portraits of artists in the Medici gallery in Florence, including that which Reynolds had presented to the Grand Duke of Tuscany in 1775 (see cat.4). This series put Reynolds in the company of Annibale and Lodovico Carracci, Domenichino, Leonardo, Rembrandt and Rubens: exactly the context in which he would have liked to have seen his portrait. As a result of this project Townley was made a member of the Florentine Academy, as Reynolds had been some years earlier. In 1786 Townley was persuaded to move to Berlin to take up the appointment of Engraver to the King of Prussia as well as membership of the Berlin Academy. He took the plate of Reynolds's portrait with him and it was advertised for sale in Prussia at Johann Mark Pascal's Berlin Royal Chalkographic Institute.[26]

By 1792, the year of his death, Reynolds's fame was spreading across Russia. The English engraver James Walker had gone to Russia to engrave prints of paintings in the Imperial collection: among them was Reynolds's *Infant Hercules Strangling the Serpents* (1788; The State Hermitage Museum, St Petersburg), which he engraved in St Petersburg and published simultaneously there and in London in that year. It was a remarkable testament to Reynolds's fame throughout the Western world, a fame communicated and confirmed by prints.

Notes

1. *Recueuil d'estampes d'après les plus beaux tableaux et d'après les plus beaux desseins qui sont en France*, 1729, p.1.

2. Roger de Piles, *Abregé de la vie des peintres*, Paris 1699, p.77.

3. Louis Gougenot, *Lettre sur la peinture, la sculpture, et l'architecture*, 2nd ed., Amsterdam 1749, p.137.

4. Robert Strange, *An enquiry into the rise and establishment of the Royal Academy*, London 1775, pp.2–3. Some years later the German journalist J.W. von Archenholz expressed a similar opinion: 'Sir Joshua has been more indebted to engraving, than any other Artist past or present. The preservation of such designs as his, is an act of service to fame. And so his fame has been preserved in near five hundred instances.' *British Mercury*, vol.3, Hamburg 1787, p.321.

5. See Clifford, Griffiths, Royalton-Kisch 1978, p.32.

6. Waterhouse 1973, p.20.

7. Little and Kahrl 1963, no.343, vol.2, pp.433–4.

8. Clifford, Griffiths, Royalton-Kisch 1978, p.43. See also Clayton 1997, p.58.

9. O'Connell 2003, p.138.

10. Boaden 1831, vol.1, p.232.

11. In 1775 Robert Sayer was working in partnership with John Bennett, hence the name Sayer and Bennett.

12. *Sayer and Bennett's enlarged catalogue of new and valuable prints …*, London 1775, pp.17–20.

13. Ibid., p.79.

14. *A Catalogue of Maps, Prints, Copy-Books, Drawing-Books, Histories, Old Ballads, Patters, Collections, &c.*, 1764, p.96.

15. Ibid., pp.72, 79, 31, 46.

16. The strategically placed island of Ushant (Ouessant) off the French coast was the usual station of British fleets blockading Brest in order to prevent French fleets from entering the Channel.

17. Ingamells and Edgcumbe 2000, pp.80–1.

18. For a discussion of the publication of fine paintings in British collections see Clayton 1997, pp.177–80.

19. See Anneliese Klingenberg, Katharina Middell, Matthias Middell and Ludwig Stockinger (co-ordinators), *Sächsische Aufklärung*, Leipzig 2001 for this publication and its context. Also Clayton 1993, pp.123–37.

20. Michael Huber, *Catalogue raisonné du cabinet d'estampes de feu Monsieur Brandes*, 2 vols., Leipzig 1793–4.

21. *Neue Bibliothek der schönen Wissenschaften und der freyen Künste*, XVIII, Leipzig 1775, p.176.

22. See Postle 1995, pp.140–55.

23. J.G.A. Frenzel, *Catalogue des Estampes de Mme la Comtesse d'Einsiedel*, Dresden 1833, nos.3563–669.

24. Johann Breitkopf (ed.), *Magazin des Buch- und Kunsthandels*, 3 vols., Leipzig 1780.

25. Giorgio Marini, 'Le "stampe fini moderne": Immagini decorative nella produzione remondiniana', in Mario Infelise and Paola Marini, *Remondini: Un Editore del Settecento*, Bassano 1993, pp.272 and 274.

26. Johann Georg Meusel (ed.), *Museum für Künstler und Kunstliebhaber*, Mannheim 1787, vol.1, pp.44–5.

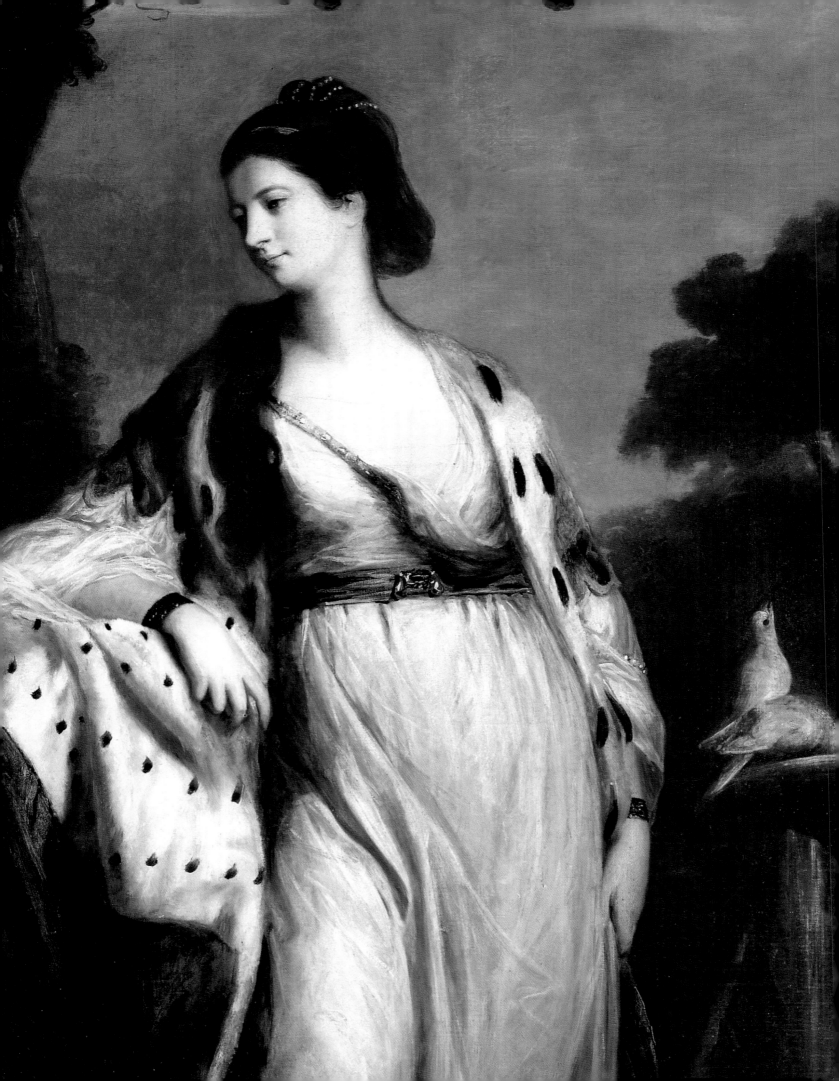

'Paths of Glory': Fame and the Public in Eighteenth-Century London

Stella Tillyard

In the last decade many historians and commentators have become fascinated by the apparent similarities between the eighteenth century and our own times. The free-wheeling commercial development of the eighteenth century, its unabashed enjoyment of consumption of all kinds, the importance of print culture in everyday life; all these seem to be precursors of our own day. So too does its obsessive interest in all kinds of fame and the diffusion of what we now call a culture of celebrity. Like so much else that defines us in Europe and America now, celebrity appears to have been made in the eighteenth century and in particular in eighteenth-century London, with its dozens of newspapers and print shops, its crowds and coffee houses, theatres, exhibitions, spectacles, pleasure gardens and teeming pavements.

In the delight at recognising ourselves in the mirror that the past seems to hold up, we have perhaps forgotten to ask a few ordinary questions. Are we gazing at ourselves, or at something altogether different? As we joyfully throw about the notions of celebrity and fame, often using them as interchangeable synonyms, are we forgetting to look past our own image in the glass to that other picture that lies there, half obscured, refracted through our present, but perhaps still traceable?

In our own day, celebrity has, I think, a particular narrative and story that describes and defines it. The story may be different in different places – in Italy, for instance, the way celebrities are written about and present themselves is not quite the same as it is in Britain or America – but the elements are common enough for the story to run successfully through all Western culture. The narrative, put simply, is one of rise (often from obscurity, poverty and ugliness), stardom, fall (usually through moral failure) and rise again. When first they come to prominence, celebrities tell the story – and we happily read it – of difficulty overcome, of their struggle to find an outlet for their talent, of their impoverished circumstances, of their desire to pursue a particular path in the face of opposition, and of their triumph and the flowering of achievement. To sustain their celebrity, though, stars in all walks of life need to be tested. A rock star is compromised by drugs, a ballerina crippled by injury, a president tempted by an intern, a soccer superstar surrounded by sirens. These trials haunt them, refine them, strengthen them and, if all goes according to the script we write and they inhabit, they emerge stronger, more brilliantly shining, more durable and admirable. The story is partly classical, making of every celebrity a wandering Ulysses, but it is mostly Christian: the carpenter's son born in obscurity who achieved notoriety, was tested by temptation, was humiliated and crucified and who rose again to immortality. When Bill Clinton humbly atones in a thousand interviews and profiles for the sin of his affair with Monica Lewinsky we know that his resurrection has begun. His days in the wilderness and his 'crucifixion' in the press (for so the English-speaking world describes the darkest days in the celebrity story) are over. But when we read the scorn heaped on Francesco Totti or David Beckham for showing their arrogance and vanity, we understand that their trials are just beginning. Few in our culture of many stars make it into celebrity elysium; some never emerge from the wilderness, many we forget about, a few step out of their own story.

This narrative, though, is new, a creation of the twentieth century. Even the persona of 'a celebrity', the translation of a bundle of attributes and behaviours into a

proper noun, is only a century-and-a-half old. The *Oxford English Dictionary* finds the first printed use of the word celebrity as applied to a person in 1849, and the persistent identification of individuals as 'celebrities' only entered everyday culture, in Britain at any rate, with the explosive growth in the popular press and mass literacy at the end of the nineteenth century. I have never read it in any eighteenth-century letter, journal, novel or newspaper. 'The celebrated Dr Johnson'; 'the season's most celebrated beauty'; even, remarkably, the philosopher David Hume writing that people saw in Jean-Jacques Rousseau's odd behaviour 'an act to gain celebrity': these formulations are there, but never the notion that a person is, or wants to be, 'a celebrity'. Although one might argue that the reason for this is that the phenomenon was so new that no word, no proper noun, had yet emerged to describe it, I would like to suggest that in the absence of that proper noun lies the difference between our own story and culture of celebrity and that which was created and consumed in the eighteenth century. That is, Reynolds and his contemporaries did not inhabit a world full of celebrities as we think of them today, but they were nonetheless extremely interested in, and avid consumers of, some of the attributes of celebrity that we ourselves still recognise.

It is, though, within the etymology and pedigree of the words 'celebrated' and 'celebrity' themselves that we can peel away some of their layers of meaning in the eighteenth century and begin to distinguish celebrity from its close companion – and often rival – fame. In the eighteenth century someone possessing celebrity was at a simple level someone celebrated, the centre of a celebrating throng, a person surrounded, the object of joyous attention. Celebrity was about being with others, together, adored in the here and now by an audience. Fame, since classical times, had also been about recognition and achievement, but it had always had an unearthly quality that went along with and survived its worldliness, a touch of immortality, of death, remembrance and a place in history.

What happened in the first half of the eighteenth century was, I believe, a process by which a nascent culture of celebrity was beginning to exist side by side with an existing culture of fame. Sometimes the two overlapped, often they were directly in opposition.

But between about 1763, when the Peace of Paris ended the Seven Years War and opened Britain and continental Europe to one another again, and the mid-1780s, when the political and moral climate began to harden in the run-up to the French Revolution, something approaching a cult of celebrity did sweep Europe, catching in selected members of all sorts of groups and elites, from actors to aristocrats, courtesans to naval captains, magicians, soldiers, politicians and preachers. It was feverish, sensationalist and evanescent, driven underground at the century's end by religious revival, war, the collapse of optimism in many fields of endeavour, and the harsh moral climate that was the result.

Three things came together at the turn of the seventeenth century in London that created a climate in which the seeds of this new culture germinated and grew: a limited monarchy, the lapse of the Licensing Act and a public interested in new ways of thinking about other people and themselves. Other countries may have had one or more of these things. Holland, for instance, had a free press but a limited audience, while France had a plethora of writers and readers investigating new forms of identity thrown up by the turbulent debates and discoveries of *philosophes* and natural scientists, but a monarchy that still dominated politics and culture. So it was in London, by accident much more than design, that the conditions were right for an explosive growth of interest in the sort of earth-bound and limited fame that celebrity represented.

In 1688 the Protestant monarchs William and Mary accepted the English throne under certain conditions that Parliament defined and laid out in the Bill of Rights in the following year. In doing so they symbolically and actually placed themselves under a degree of Parliamentary control. In 1701, the Act of Succession, which more or less arbitrarily conferred the British Crown on the Protestant Hanoverians, stripped any lingering clouds of the divine away from the monarchy, making it quite clear that Parliament chose kings and could, if it so wished, depose them as well. The Hanoverians were a stolid lot, entirely lacking the creepy magnetism of their predecessors the Stuarts, and they were kept on a tight financial rein by a watchful Parliament. Once installed, and all too human, they made few attempts to accrue to themselves the sort of mystical

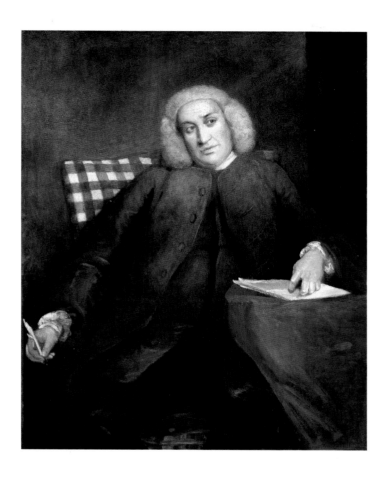

fig.27
Samuel Johnson 1756–7
Oil on canvas, 127.6 x 101.6
National Portrait Gallery, London

authority that French monarchs, for instance, still asserted. George I had little interest in his new country, George II, after a grand coronation, lapsed into a similar indifference, and by the time George III came to the throne in 1760, what cultural authority and mystical aura was left in the court had drained away into the vibrant commercial spaces of the capital city. Theatre, the crucible of celebrity, had for two centuries existed in London beyond the ambit and control of the court. From the 1730s onwards, as the court shrank in importance, all kinds of spaces for entertainment proliferated alongside it. It was from the performers and the audiences of these new centres of power – Parliament included – that the stars of celebrity culture would emerge, at once earthly and touched with the mystery and magic that kings used to have.

At about the same time as Parliament limited the monarchy, the Licensing Act, which controlled the numbers of printing presses, was allowed to lapse. After that, anyone became free to set up a printing business, and broadsheets, newspapers, pamphlets, books and prints were soon being produced in great numbers. By 1770 there were sixty newspapers printed in London every week, and a sophisticated network of news-gathering and distribution had developed right across the nation.[1] The law of personal libel was so weak as to be non-existent. Almost anything could be written about almost anyone, and newspapers needed to take only the most cursory of precautions when they discussed the actions or opinions of individuals (though they had to exercise some caution when it came to the Crown and to the institutions of government). By the 1750s public figures were casually referred to in the press by the initials of their names or titles, while the King was simply called 'a certain great personage', or 'a very great personage'. If these short-cuts were used, no slander or gossip was unprintable, no accusation needed to be justified. So when, in 1769, the newspapers reported that, 'an assignation at the White Hart at St Albans between L— G— and a certain great D—e, was disconcerted by the forcible intrusion of my lord's gentlemen', readers would easily have identified the 'great Duke' as the King's brother the Duke of Cumberland, and his lover as the society beauty Lady Grosvenor. Understanding that they had been caught together by Lord Grosvenor's servants, and certain that there would be a scandal and

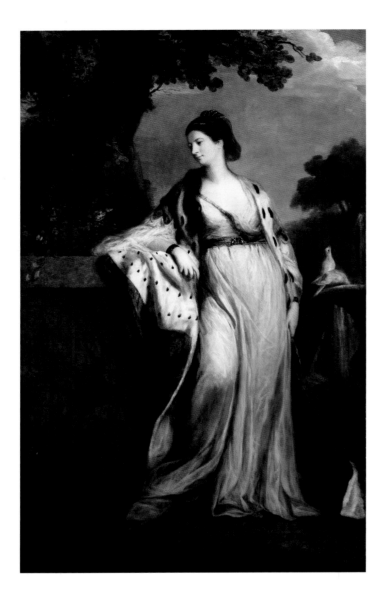

fig.28
Elizabeth Hamilton, Duchess of Hamilton and Argyll 1758–9
Oil on canvas, 238.5 x 147.5
Lady Lever Art Gallery, Port Sunlight

probably a lawsuit, readers would have looked forward with salacious anticipation to the next chapter of their sorry story.

So it was that a free press and a very weak libel law created a climate of speculation and gossip far freer than we have today, far more direct, personal and scurrilous. Information, paid for by eager editors, poured into publishers' offices, and straight into type. Readers were discovering the heady pleasures of scandal in high places, newspapers the commercial and political value of linking stories about private life to attacks upon individuals, governments and the Crown. The public was also ready to put this sort of information into a literary context. Ever since the Restoration of the Monarchy in 1660, 'secret histories', which told scandalous stories of immorality at court and in other high places, had been extremely popular. Biographies of notorious and famous individuals, and the very notion of fixed character as a literary construct that could be used in a plot, were also becoming commonplace. The great age of biography and of the novel – which usually depended for its plotting and moral framework on the connections between private life and public events of one sort or another – was just beginning. Readers were ready and eager for life to imitate literary form and the other way round. So, by the 1750s, all sorts of people who wanted notoriety were leaking to or placing in the press intimate or scandalous details of their own lives. Celebrity was born at the moment private life became a tradeable public commodity. It had, and still has, a more feminine face than fame, because private life, and the kind of virtue around which reputations could pivot, were both seen to reside in femininity and in women.

If fame, as some writers, statesmen and heroes still sought it, depended on posthumous memory and reputation, celebrity was defined in the present, in an environment where novelty and sensation were everywhere and much to be desired. Celebrity was transient and febrile, created in the embrace between an audience or readers eager for entertainment and public figures who wanted recognition, adoration and wealth. 'I wrote not to be fed, but to be famous', the novelist Laurence Sterne (cat.33) declared after he had become the most talked-about writer of his day, and the fame he sought was not, he implied, the imprimatur of the future

but the applause of the present.[2] As the poet Samuel Johnson (fig.27), a trenchant critic of what he saw as a feverish modernity, wrote in 1749:

Unnumber'd Suppliants croud Preferment's Gate,
Athirst for Wealth and burning to be great,
Delusive Fortune hears th'incessant Call,
They mount, they shine, evaporate, and fall.[3]

In this new climate, anyone with the skills to use the press and play to the audience might become, however briefly, celebrated. Thus the captivating aristocratic Gunning sisters, whose distinguishing feature was that there were two of them, were sent on a carefully managed progress from their home in Ireland to England in 1750 to be launched on the marriage market. As they travelled from Hertfordshire to Windsor, stories about their astonishing beauty appeared in the press. By the time they reached the capital crowds gathered in parks to see them and prints, poems and numerous column inches were devoted to them for several months. Six months after their arrival, advance notice of a visit they were to pay to Vauxhall Gardens brought eight thousand spectators there to see them. Early in 1752, Elizabeth married the Duke of Hamilton, Maria the Earl of Coventry (fig.28).

At the other end of the social scale, the courtesan Kitty Fisher (cats.50 and 51) also used the press to create and sustain her reputation. Having burst on the scene as a vivacious nineteen-year-old in 1758 and found herself constantly written-up by the daily newspaper, the *Public Advertiser*, Kitty staged a public accident in Hyde Park where crowds had gathered to watch her ride, falling off her horse and exposing her pretty thighs. This trashy appeal to the public desire for sensation, so like the television antics of minor celebrities today, produced an avalanche of print, and her prices and the social standing of her clients rose in response.[4] Firmly established as the most fashionable courtesan of the season, she paid her first visit to Reynolds's studio, and had herself painted leaning forward as if over the lip of a balcony or a theatre box, with an open letter in front of her (fig.29). No longer a shrewd and clever professional, she became in the painting, and the many thousands of prints engraved from it, an innocent Juliet, her viewers a thousand Romeos looking on. She was soon back at the studio, signalling

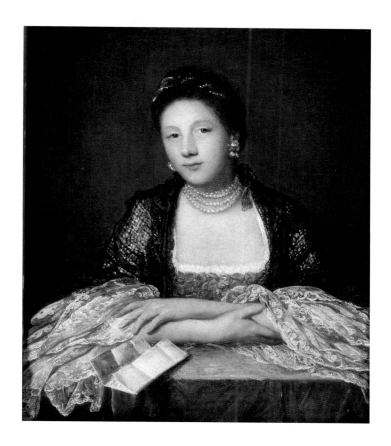

fig.29
Kitty Fisher 1759
Oil on canvas, 75 x 62.8
Petworth House, Sussex, The National Trust

her success and prosperity, and this time she was painted as a queen. Wealthy and sensuous, she posed as Cleopatra dropping a pearl into a cup of wine (see cat.50). Before she reached thirty, though, she was dead, and lingered in the popular memory only by virtue of a bleak little rhyme that mixed sexual innuendo with the message that money and fame would not last:

Lucy Locket lost her pocket,
Kitty Fisher found it;
There was not a penny in it,
Only ribbon round it.

By the 1760s the sort of celebrity that brought people out on the streets and guaranteed frequent mentions in the newspapers had ceased to be conferred mainly on women. In the following two decades men as well as women became the object of fascination, and groups that had hitherto sought posthumous fame or worldly glory through offices or titles began to exploit and be noticed in the press, in prints and by the public. Charles James Fox (cat.41), the opposition politician and the most famous public figure of the second half of the century, became instantly celebrated when first he appeared in the House of Commons in 1769, and his blue wigs, red shoes, extravagant gambling, determined womanising, brilliant speeches and overwhelming charm were the stuff of speculation and gossip for decades. His jowly face adorned mugs, jugs, handkerchiefs, prints and lockets right up until his death in 1806 (fig.30). Similarly, when the philosopher and historian David Hume went to Paris as the ambassador's secretary in 1765, crowds turned out to see him and he was lionised and given far more attention than his employer, Lord Hertford. More spectacularly, when Hume played host to Jean-Jacques Rousseau (fig.31) a year later, he noticed that at the theatre even the King and Queen seemed to spend more time gazing at his guest than at the stage. Rousseau, though, was in paranoid flight from the very publicity he had helped to create about himself. In response to the overwhelming attention of the London public he took himself off to the wilds of Derbyshire and began to write his *Confessions*, in which he demanded the right to be heard on his own terms rather than to become a site for others' imaginings. Inevitably, the *Confessions*, which

ET PRÆTEREA NIHIL

fig.30
Attributed to James Sayers (1748–1823)
Charles James Fox 1782
Pencil, pen, ink and watercolour on paper, 28.1 x 23.4
Tate. Purchased as part of the Oppé Collection with assistance from the National Lottery through the Heritage Lottery Fund 1996

contained pages and pages of the sort of intimate revelations that were, and are, the stuff of celebrity narratives, merely increased both the fame and the opprobrium heaped on Rousseau after his death.[5]

Whether they declared it or not, Rousseau and Hume were after more than the sort of celebrity that made them objects of such popular attention. Both wanted, through their written works, to have an impact on the way their contemporaries thought and behaved, an achievement beyond the magnetism of their presence and personalities. Both too – and here they were unlike Fox, who displayed a relaxed indifference to his personal celebrity and to the way posterity might imagine him – wrote autobiographies in which they presented themselves as they wished to be seen, both alive and dead. Here, they were bidding for a different sort of fame, a fame of lasting achievement and remembrance. This age-old formulation of fame ran parallel to the newer culture of celebrity, sometimes gaining from it, sometimes deliberately turning away from it.

Some took this elevation of achievement over applause even further. From the mid-century onwards commentators and readers began to be extremely interested in anonymous achievement that seemed to insist upon the work itself as the uniquely valuable production. Yet anonymity was itself a kind of negative celebrity, a celebrity that came from speculation rather than recognition, secrecy rather than public acclaim. That was the fame of the novelist Fanny Burney, the poets James Macpherson and Thomas Chatterton, and of the notorious journalist Junius. All four wrote using pseudonyms; Burney called herself simply 'A Lady', Chatterton and Macpherson invented Rowley and Ossian respectively, while Junius wrapped himself in a latinate name associated with satires on public life. From 1769 to 1772 Junius held the reading public enthralled by letters in the *Public Advertiser* that were addressed to public figures and which used the revelations of private life that lay at the heart of the cult of celebrity to stir political controversy and make a series of defiantly radical political demands.[6] Macpherson and Burney were unmasked, Chatterton had famously died by the time he became really famous, but Junius was never definitely identified, and to this day this mystery has continued to guarantee his fame.

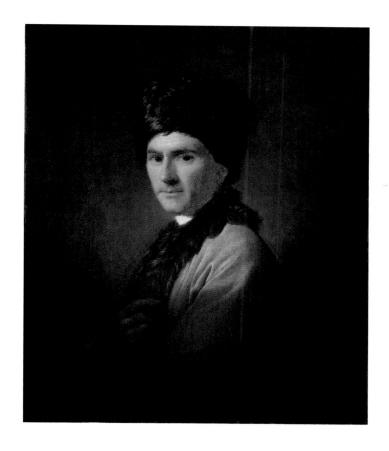

fig.31
Allan Ramsay (1713–84)
Jean-Jacques Rousseau 1766
Oil on canvas, 74.9 x 64.8
National Gallery of Scotland, Edinburgh

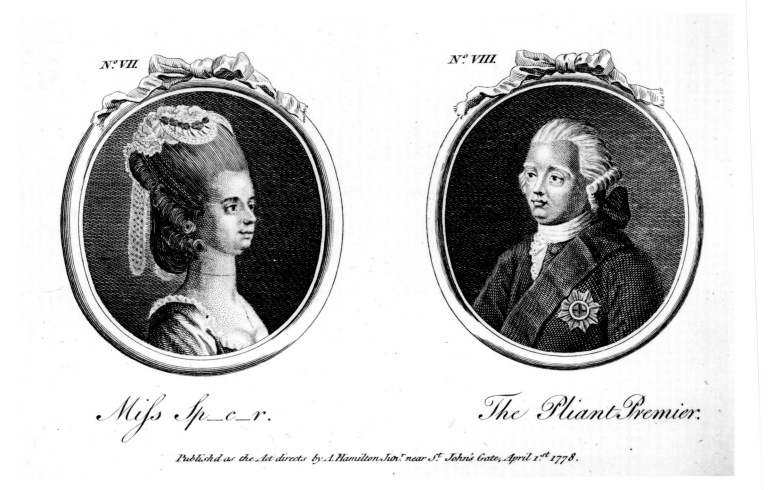

fig.32
'Miss Sp_c_r' and 'The Pliant Premier'
From the *Town and Country Magazine*, April 1778

One reason for the endurance of old forms of fame and for the fascination with anonymity was that the narrative of celebrity, when it emerged alongside the culture it described, was a morality tale, a rise and a fall which had no redemptive ending. And this was an old story too, of vanity and transience, human folly and human misery. If on the one hand, as the *Town and Country Magazine*, the age's first and best scandal sheet (fig.32), liked to declare, 'On eagles' wings immortal scandals fly / While virtuous actions are but born and die', on the other, courtesans' memoirs, poems about the thirst for fame and scores of sentimental novels told another story.[7] 'I have known the highest splendour of elegant prostitution', wrote the famous courtesan Ann Sheldon (or her ghostwriter) in her *Authentic and Interesting Memoirs*, 'I have experienced all the giddy pleasures that mingle with the mercenary gratification of libidinous passion. I have been admired, courted, and even loved; and now I feel upon what slender, transitory objects, the short lived prosperity of the public woman depends.'[8]

This was 1787, with the American colonies lost and the French Revolution looming. The culture of celebrity, like a brilliant hot-house flower, was beginning to fade. Some of its elements would survive in the personality cults surrounding established national figures and military heroes like Nelson and Wellington and in the popularity of literary figures. It was there too in the notoriety of the poet Lord Byron, though it was a measure of just how much the moral climate had changed by 1815 that revelations about Byron's private life brought not more fame and interest but opprobrium and exile. But a full-blown culture of celebrity would reappear only at the end of the nineteenth century, when new readers and mass forms of entertainment like the music hall and the cinema demanded new idols. Then, gradually, celebrities as we know them today would emerge and new stories of longing and fulfilment would entwine themselves around them.

Fascinatingly and presciently, though, Reynolds did produce one image of celebrity in which some of our modern narrative seems to be inherent. This was his picture of Omai (cat.67), painted in 1776 at the height of the celebrity cult. It was, and remains, Reynolds's most

famous painting precisely because it was more than a portrait and continues to be a picture in which we see some of our own longing and desire for grandeur, for simplicity, for otherworldliness and natural beauty. In Reynolds's huge image, Omai is both sophisticate and innocent, celebrity and savage, an eloquent but mute subject whose lack of the English language and inability to write allowed his audience and the picture's viewers to make him a site for their own imaginings. Barefooted and dressed in a heavy folded toga, which could be his own clothing but carries overtones of both senatorial and biblical robes, Omai, described at the time as a prince in his own South Sea world, opens his hand to the viewer in a pose seen in many aristocratic portraits of the day. But in so doing he exposes his tattoos and the courtly pose is transformed into that of innumerable *noli me tangere* paintings.[9] Omai's tattoos become stigmata, his bare feet like the feet of the risen Christ. He seems at once sacrificial victim and vision of immortality. To use the tellingly religious modern term, Omai becomes an icon, perhaps the first to be invested with some of our own celebrity story.

Notes

[1] Figures taken from the *Middlesex Journal* of July 1770.
[2] Quoted in Braudy 1986, pp.13–14.
[3] Samuel Johnson, *The Vanity of Human Wishes*, London 1749. My title is taken from Thomas Gray's 'Elegy Written in a Country Churchyard', an enormously popular lugubrious vanitas poem published in 1750. Contemplating the headstones of the unknown prompts Gray to think of death as a great leveller, and that even 'the paths of glory lead but to the grave'.
[4] For more on this incident, and Kitty Fisher's career, see Bleackley 1909, pp.54–80.
[5] David Hume, *My Own Life. The Life of David Hume, Esq. written by himself*, London 1777. Jean-Jacques Rousseau, *The Confessions*, London 1782.
[6] For the failure to identify Junius and the continued speculation about his identity, see the excellent introduction in John Cannon (ed.), *The Letters of Junius*, Oxford 1978.
[7] *Town and Country Magazine*, July 1770, vol.1, p.401.
[8] *Authentic and Interesting Memoirs of Miss Ann Sheldon (now Mrs Archer). A lady who figured, during several years, in the highest line of Public Life, and in whose History will be found, all the vicissitudes, which so constantly attend on Women of her Description. Written by herself*, London 1787.
[9] Compare, for instance, the pose and clothing in the famous contemporary *noli me tangere* painted by Anton Raphael Mengs for the Warden and Fellows of All Souls College, Oxford between 1769 and 1771, as well as many earlier examples.

Catalogue

Martin Postle
Mark Hallett

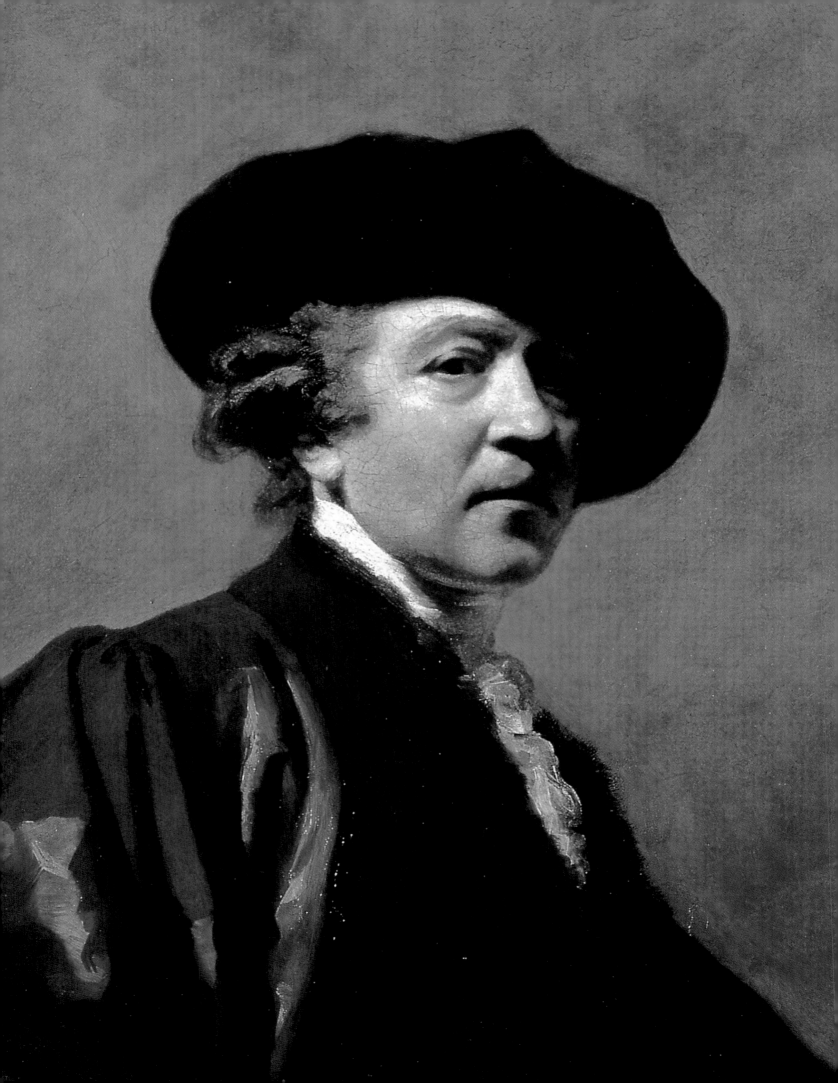

Reynolds and the Self-Portrait

The self-portrait holds a unique place in the history of art. From Leonardo da Vinci and Albrecht Dürer to Vincent van Gogh and Edvard Munch, the self-portrait has been used by critics as a means of evaluating the psyche of the artist – as if the image acts as a mirror to the soul. In certain instances, not least in the self-portraits of van Gogh, there is a sense in which the artist is using the image as a way of expressing their inner torment. More often than not, however, the self-portrait has performed a public function, being used to bolster the artist's social status and to provide a benchmark for his professional prowess. Certainly, when we consider all Reynolds's self-portraits together, they reinforce the impression that he promoted his own image in order to shape his reputation, thus ensuring that his face, which expressed confidence, authority and intelligence, was closely allied to his fortune.

Joshua Reynolds was fascinated by his self-image, by the persona he projected to the outside world, and quite literally by his own face, which he portrayed in some thirty paintings and drawings made over half a century. Comparisons with other prolific self-portraitists are inevitable, not least Rembrandt, who exerted a tremendous influence on Reynolds's art from an early age. Like Rembrandt, Reynolds would at times use his own face for character studies, notably the figure of 'Terror' in the background of his portrait *Mrs Siddons as the Tragic Muse* (see cat.69), and the adoring shepherd in his *Nativity* (cat.6). For the most part, however, Reynolds's self-portraits were related to his public life, his position in society and the honours he had accrued, both as an artist and as a leading figure in the British cultural establishment.

Reynolds's first known self-portrait was a modest pencil drawing (Private Collection), probably made upon his arrival in London in 1740 to begin his apprenticeship. Over the next few years he explored the genre on several occasions in self-portraits that above all reflected the common interest among his peers in the engraved portraits of Rembrandt. But while Rembrandt remained an important stylistic model, Reynolds's own approach to the genre of self-portraiture differed. At times, like Rembrandt, he used himself as a model to explore facial expression. Reynolds's self-portraits also related to his public persona, and reflect his ambitions as an artist, aesthete and intellectual. However, unlike Rembrandt, who used the self-portrait to convey his emotions and anxieties, Reynolds seldom dropped the mask.

The portraits exhibited here were part of a hard-headed public-relations exercise, and each was painted at a key moment in Reynolds's public life. The earliest (cat.1) was painted during the late 1740s as an advertisement for his skills when he was an up-and-coming artist in London. The second (cat.2), which was until recently completely unknown, shows the artist in Italy shortly after his arrival in Rome. Others, too, were painted to celebrate significant watersheds in the artist's life: as the President of the Royal Academy, as author of *Discourses on Art*, as the premier artist of the British School and as the country's leading cultural figure. In one of his later self-portraits (cat.7) he wears spectacles. This not only indicates that by this time his sight was failing, but is also an expression of his intellectual powers and his status as a man of vision.

MP

1. *Self-Portrait c.1747–8*

Oil on canvas, 63 x 74

National Portrait Gallery, London

According to Reynolds's friend Edmond Malone, this self-portrait was painted before Reynolds went to Italy, probably around 1748 (Malone 1819, vol.1, p.lxxviii). It is a work of tremendous virtuosity, as well as one of the most creative responses to the art of Rembrandt produced by any European artist of the eighteenth century. It is a painting that brims with confidence and self-belief, and one that demonstrates at a stroke that Reynolds's concept of 'imitation' had already transcended the level of the mere pastiche that satisfied so many of his peers. Like Hogarth's great self-portrait of 1745 (Tate), the present work is a manifesto of the artist's aims and ambitions: Reynolds casts himself in the role of a man of vision, who uses the art of the past in order to look to the future.

Reynolds had been exposed to the portraiture of Rembrandt during the 1740s through his master, Thomas Hudson, and through the artist and collector Arthur Pond. It was through Pond, and fellow members of the collectors' club, that Hudson assembled his own collection of Old Master prints and drawings. And it was to this club that Hudson probably introduced Reynolds in the mid-1740s. Hudson, Pond and other members of the collectors' club particularly admired Rembrandt, whose reputation grew rapidly during this period, not least because of the increased numbers of his works that were being imported into the country (see White, Alexander, D'Oench 1983, pp.1–17, 20–5). His portraits were particularly admired and were emulated by a number of British artists in their portraits of collectors and men of letters, as well as their own self-portraits.

The early history of this portrait is unknown, as are the circumstances that surround its creation. It was first engraved in 1795 by Samuel Reynolds (no relation), at which time it belonged to Thomas Lane, whose country house, Coffleet, was very close to Joshua Reynolds's birthplace in Plympton St Maurice, Devon. Lane, who was magistrate for Devon and High Sheriff, had apparently entertained Reynolds, Johnson, Burke and Garrick at his home (Penny 1986, p.176); although it is not certain when he acquired the present painting. Reynolds's pupil, James Northcote, included it in his allegorical picture, *The Worthies of England* (1828; Foundling Hospital Museum, London). Here Reynolds is represented in a 'Cabinet of Fame'

alongside other famous Britons, including King Alfred, the Black Prince, Shakespeare, Bacon, Milton, Locke, Newton, Dryden, Pope and Johnson (Shawe-Taylor 1987, p.6). Northcote also used an engraving of the portrait as the frontispiece to his biography of Reynolds, which was first published in 1813.

The format of the present portrait – its width exceeds its length – is unusual. Indeed, early engravings by Samuel Reynolds (1795) and Robert Cooper (1813), which differ in size from the existing portrait, appear to support the supposition that it has, at some point, been cut down. However, a close comparison of the painting with Cooper's print reveals that the engraver has elongated the image in order to make it conform to traditional portrait conventions. Samuel Reynolds's print, too, masks the dimensions of the portrait by enclosing it in a *trompe l'oeil* frame. Another possible explanation is more straightforward: while the composition is unconventional, it is painted on a standard thirty-by-twenty-five-inch canvas, known as a 'head'. Given the radical nature of the portrait, perhaps Reynolds had simply turned his stretcher on its side?

MP

Provenance
Thomas Lane of Coffleet by 1795; Christie's 24 May 1845 (62); Joseph Sanders of Johnston Hall; his sale, Christie's 15 May 1858 (40), bought by the National Portrait Gallery.

Literature
Northcote 1818, vol.1, p.304, note; Malone 1819, vol.1, p.lxxviii, note; Cotton 1856, pp.59–60, 272; Leslie and Taylor 1865, vol.1, p.34; Graves and Cronin 1899–1901, vol.2, pp.790–1; Whitman 1903, vol.3, p.78; Waterhouse 1941, p.39; Mannings 1975, p.219; Yung 1981, p.472; White, Alexander, D'Oench 1983, p.34; Mannings 1992, pp.13–14; Mannings and Postle 2000, vol.1, p.46, vol.2, fig.43; Ingamells 2004, pp.393–4.

Engraved
S.W. Reynolds 1 February 1795; Robert Cooper (from a drawing by John Jackson) 24 June 1813 (reversed); S.W. Reynolds (in present format) 1823.

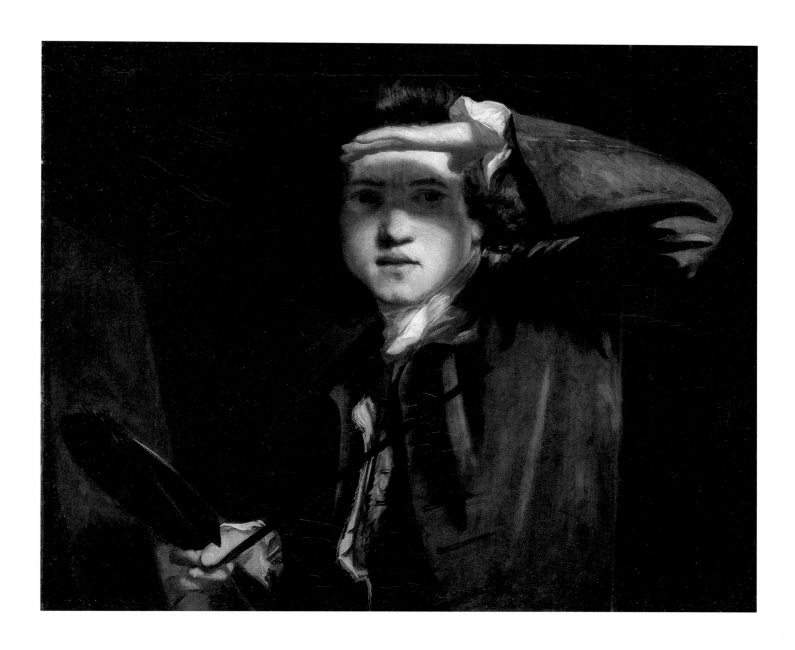

2. *Self-Portrait c.1750*

Oil on canvas, 63.5 x 48

Yale Center for British Art, Paul Mellon Fund

This early self-portrait is among the most exciting Reynolds discoveries of recent years, as well as being a historically important image of the artist. It emerged from a British private collection in 2001, when it was identified as a hitherto unknown self-portrait made in Rome, probably in 1750, during Reynolds's formative years in Italy. By the mid-1740s, Reynolds was already in the habit of painting his own portrait, invariably in the manner of Rembrandt, whose portraiture exerted a powerful influence upon a host of British artists at that time. Although Reynolds travelled to Italy to study the art of the Italian Old Masters, the example of Rembrandt continued to shape his painting. Among the copies he listed making in Rome was an unidentified self-portrait by Rembrandt, which he made on 20 April 1750 in the Palazzo Corsini (Cotton 1859, p.1). Below this entry, sometime between the end of April and 30 May 1750, Reynolds noted: 'My own picture' and 'Iacimo's picture'; references perhaps to a self-portrait and a portrait of 'Iacimo' (possibly a fellow artist). David Mannings has tentatively suggested that a self-portrait by Reynolds in the manner of Rembrandt, in which the artist wears a broad-brimmed hat, may have been made in Italy, although in the opinion of the present author this is more likely to have been an earlier work of the 1740s (see Mannings 1992, p.15, no.4).

Prior to the discovery of this work, the only surviving self-portrait that Reynolds was known to have made in Italy was a chalk drawing, inscribed 'Rome May 1750' (fig.33); a date which corresponds closely to Reynolds's memorandum concerning the aforementioned self-portrait. The drawing, which was purchased by the British Museum as a work by John Astley (Reynolds's travelling companion in Italy), is strikingly similar to the present picture, the slight upward tilt of the head lending the image an air of confidence bordering on arrogance. The face in both the painting and the drawing is also noticeably leaner than in other self-portraits by the artist, suggesting that Reynolds may have lost a little weight during his Italian sojourn.

The whereabouts of the present self-portrait up until the nineteenth century are uncertain. According to James Northcote, writing in 1818, there was then in Rome 'an extraordinary fine [*sic*] portrait of Reynolds, painted by himself when in his studies in that city, and left by him

in the house where he lodged at that time' (Northcote 1818, vol.1, p.43). In addition, in March 1803, the picture dealer, James Irvine, exported from Rome an unidentified 'Ritratto di Reynoldi dipinto da sei' (Brinsley Ford Archive, Paul Mellon Centre, London). Either one of these pictures – assuming they are separate works – may relate to the present rediscovered self-portrait.

MP

Provenance
Possibly, Sir Thomas Lawrence sale, Christie's 15 May 1830 (17); 'Sir Joshua Reynolds – His own Portrait when young', sold to Strutt; by descent; Christie's, South Kensington, 6 September 2001 (62), withdrawn; Christie's 12 June 2002 (31), bought by the Yale Center for British Art, New Haven.

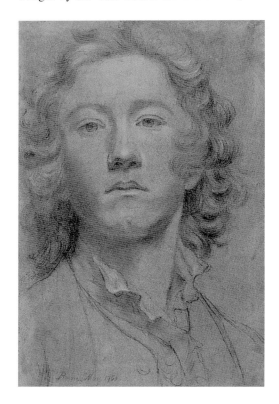

fig.33
Self-Portrait 1750
Chalk on paper, 41.1 x 27.4
The British Museum, London

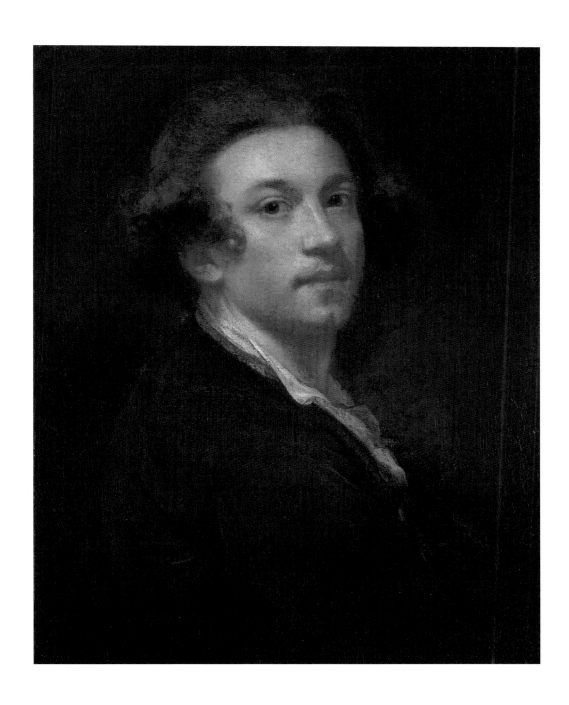

3. *Self-Portrait c.1756*

Oil on canvas, 76.2 x 63.5

Lent by the Trustees of the Rt. Hon. Olive, Countess Fitzwilliam's Chattels Settlement,
by permission of Lady Juliet Tadgell

This is among the most Italianate of Reynolds's self-portraits. The red cloak, trimmed with a dark fur collar, resembles the kind of exotic outer-garment, worn in central European countries, that was adopted by Grand Tourists, and often features in portraits of gentlemen and men of letters: examples include Anton von Maron's portrait of Johann Winkelmann (Kunstsammlungen Weimar), and George Willison's portrait of James Boswell (Scottish National Portrait Gallery, Edinburgh), both painted in Rome during the 1760s. In this respect, this picture is also reminiscent of Reynolds's portrait of his pupil, Giuseppe Marchi (cat.58), as well as that of the Italian engraver, Francesco Bartolozzi (cat.59).

The sketchiness of this portrait, particularly that of the red draperies, indicates that it is unfinished. As David Mannings has suggested, it probably dates from the mid-1750s, when Reynolds was in his early to mid-thirties. His windswept hair adds a touch of drama to the portrait, a device he repeated in later self-portraits, notably in the one he painted about ten years later upon being made a member of the Dilettanti Society. Reynolds's appearance in this portrait can be compared to the description of the artist by his friend Edmond Malone in an account written shortly after his death: 'He was in stature rather under the middle size; of a florid complexion, and a lively and pleasing aspect; well made, and extremely active. His appearance at first sight impressed the spectator with the idea of a well-born and well-bred English gentleman' (Malone 1819, vol.1, pp.lxxvi–ix).

It is around the time that Reynolds painted the present portrait that it is possible, for the first time, to gain an accurate impression of his daily routine as a painter, because we have his first surviving pocket book, dating from 1755. This was the journal in which he kept a record of his professional appointments and social engagements. Collectively, these books tell us that by now Reynolds had established the punishing work schedule that was to be one of the principal contributing factors to his success over the next forty years. Often working seven days a week for nine months of the year, Reynolds had little time, other than during the summer, to concentrate upon more speculative works. It is interesting to note, however, that he still found ample time to paint his own portrait.

Provenance
Earl Cowper, at Panshanger Park, by 1885; by descent; sold Christie's 24 November 1998 (40).

Literature
Boyle 1885, pp.213–25; Graves and Cronin 1899–1901, vol.2, p.796; Waterhouse 1941, p.61; Mannings 1992, p.18; Mannings and Postle 2000, vol.1, p.47, vol.2, fig.181; Ingamells 2004, p.394.

Engraved
W. Ridley (stipple, in an oval, omitting the hand) 1 April 1792.

MP

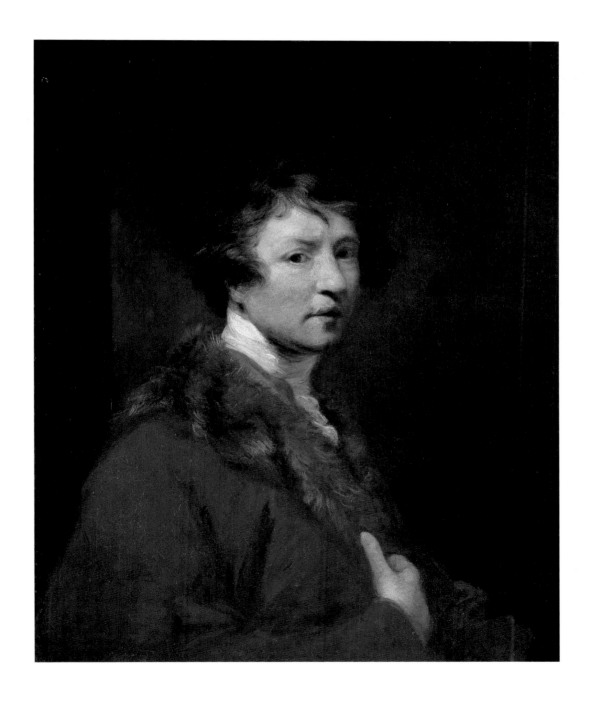

4. *Self-Portrait* 1775

Oil on wood, 71.5 x 58

Uffizi Gallery, Florence

Joshua Reynolds had been elected a member of the Accademia di Belle Arte, Florence, in September 1752, shortly before his departure from Italy. Twenty years later, the artist Johan Zoffany, who was then working in Florence, proposed that Reynolds should be invited to present his portrait to the Royal Gallery. The painting, intended to be hung in the gallery of self-portraits established by the Dukes of Florence, was clearly important to Reynolds, who abandoned his first attempt (now in Tate's collection) when the composition was quite far advanced. The robes he wears are those of a Doctor of Civil Law, the honorary degree that Reynolds had been awarded two years earlier by the University of Oxford. In his hands he holds drawings by Michelangelo, upon which he inscribed 'Disegni del Divino'. On the back of the painting Reynolds attached a label on which he listed in Latin the roll call of his public honours and titles: 'Joshua Reynolds, Eques Auratus / Academiae Regiae Londini Proeses, / Juris Civicilis [*sic*], apud Oxoniensis Doctoer [*sic*]; / Regiae Societatis, Antiquariae, Londini Socius, / Honorarius Florentinas apud Academiae Imperialis socius, / nec non oppidi natalis, dicti Plimpton Comitatu Devon, / Praefectus, Iusticiarius Morumque Censor. / Seipse Pinxit anno 1775' (Ingamells and Edgcumbe 2000, p.61, n.2).

On its arrival in Florence, Reynolds's self-portrait was, according to Luigi Siries, Keeper of the Gallery, revered almost as if it were a holy relic. Admirers included Zoffany, who could not apparently 'refrain from running to embrace the portrait of Reynolds' (Whitley 1928, vol.1, pp.313–14). Even so, when Reynolds's former pupil, James Northcote, met Zoffany in Italy a few years later he found that Florentine painters were saying spiteful things about Reynolds's portrait, 'helped on by Zoffany who tells them not only its present defects but that it will soon fade and appear quite dreadful – when Sir Joshua was the greatest friend Zoffany found in England!' (Whitley 1928, vol.2, p.310).

In January 1776 Reynolds wrote to the Director of the Royal Gallery, Giuseppe Pelli, acknowledging the Duke of Tuscany's admiration of the portrait, and again in the summer, thanking the Duke for the gold and silver medals he had sent him, which were decorated with the portrait of the Duke and the inscription 'merentibus'. As Pelli had informed Reynolds, 'these Medals are coined expressly to be presented to those who have acquired great reputation by their Talents and more especially demand his Royal attention' (Ingamells and Edgcumbe 2000, p.63, n.1).

MP

Provenance
Painted at the invitation of the Grand Duke of Tuscany for the Medici Collection at Florence.

Literature
Northcote 1818, vol.2, pp.5–7; Malone 1819, vol.1, p.lxxvii, note; Leslie and Taylor 1865, vol.2, pp.165–7; Graves and Cronin 1899–1901, vol.2, p.801; Whitley 1928, vol.1, pp.313–15, vol.2, pp.310–11; Waterhouse 1941, p.66; Cormack 1968–70, p.169; Mannings 1992, pp.26–7; Mannings and Postle 2000, vol.1, pp.49–50, vol.2, fig.1149; Ingamells 2004, p.395.

Engraved
Charles Townley 30 June 1777; etching by Carlo Faucci 1778, from a drawing by Francesco Corsi; John Keyes Sherwin 14 October 1784; C. Lasinio; J. Cochrane 1847; A. Scott 1877.

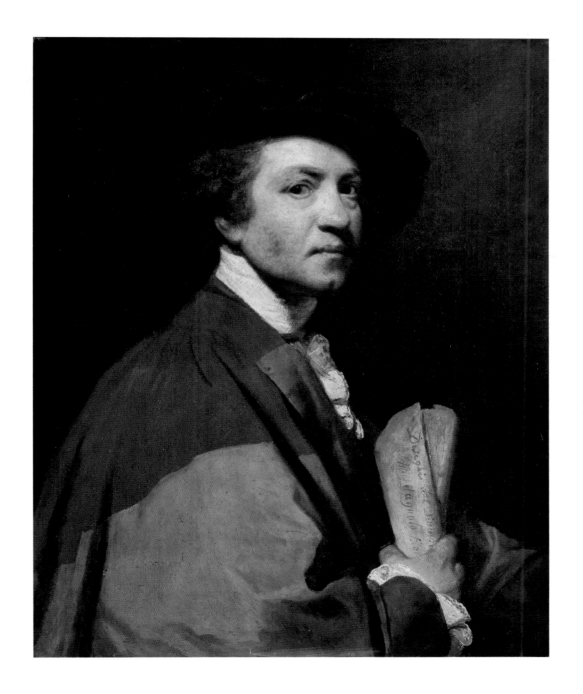

5. *Self-Portrait c.*1779–80

Oil on wood, 127 x 101.6

Royal Academy of Arts, London

This self-portrait was painted probably in 1779 or 1780, on the occasion of the move of the Royal Academy to prestigious new premises at Somerset House designed by William Chambers, architect and Treasurer of the Academy. Several artists contributed works to furnish the interior, including Reynolds, who provided an allegorical painting, *Theory*, for the library ceiling, full-length portraits of George III and Queen Charlotte, a portrait of Chambers (all Royal Academy of Arts, London), and this self-portrait. Both the self-portrait and the portrait of Chambers (see cat.82) were painted on wooden panels, which suggests that they were conceived as integral aspects of the decor of Somerset House. A drawing by Chambers indicates that they were to be placed on either side of the chimneypiece in the Assembly Room (Penny 1986, pp.284–5). These pendant portraits, which depict Reynolds and Chambers in their respective public roles as President and Treasurer, acted as substitutes for the living presence, as well as a reminder of the power these two individuals wielded within the institution.

Reynolds considered the composition of his self-portrait carefully, rejecting his first attempt in which he portrayed himself seated in profile with a paper inscribed 'The President and Council of the Royal Academy' (see Mannings and Postle 2000, vol.1, p.50, vol.2, fig.1333). In the final version, Reynolds stands beside a bust of Michelangelo. His pose is partly derived from Van Dyck, although, as David Mannings has observed, the overall composition resembles Rembrandt's celebrated *Aristotle Contemplating a Bust of Homer* (1653; Metropolitan Museum of Art, New York), which some years later belonged to Reynolds's friend, Abraham Hume (Mannings 1992, p.5). Reynolds would, no doubt, have appreciated the comparison of himself and Michelangelo with Aristotle and Homer. The portrait, painted when Reynolds was at the peak of his powers and the undisputed leader of the country's artistic community, exudes an air of swaggering self-confidence. Whether or not it was Reynolds's intention, even the shadowy bust of Michelangelo appears to nod in deference towards him.

As in the portrait for the Uffizi Gallery (cat.4), and several other portraits of the 1770s, Reynolds here wears his doctoral robes and cap. Of all honours heaped on Reynolds, his doctorate perhaps afforded him the greatest personal satisfaction. Many of his friends had already been awarded doctorates, including Thomas Percy, Charles Burney (cat.48) and Oliver Goldsmith (cat.43). Samuel Johnson (cat.47) had received honorary doctorates from both Trinity College, Dublin, and Oxford. He, however, insisted on referring to himself as 'Mr Johnson' (Boswell 1934–50, vol.2, pp.331–3).

MP

Provenance
Painted for the Royal Academy of Arts.

Literature
Northcote 1818, vol.2, p.89; Malone 1819, vol.1, p.lxxvii, note; Hamilton 1884, pp.57–8; Graves and Cronin 1899–1901, vol.2, pp.803–4; Waterhouse 1941, p.64; Steegman 1942, p.34; Penny 1986, pp.287–8; Mannings 1992, p.30; Mannings and Postle 2000, vol.1, p.51, vol.2, fig.1330; Ingamells 2004, p.395.

Engraved
Valentine Green 1 December 1780; Joseph Collier 10 July 1874; A. Smith 1 March 1794; Charles Turner 1797; H. Meyer 8 May 1809; N. Schiavonetti 21 May 1810; William Bond 20 January 1811; R.W. Sievier 1 February 1820; S.W. Reynolds; and others.

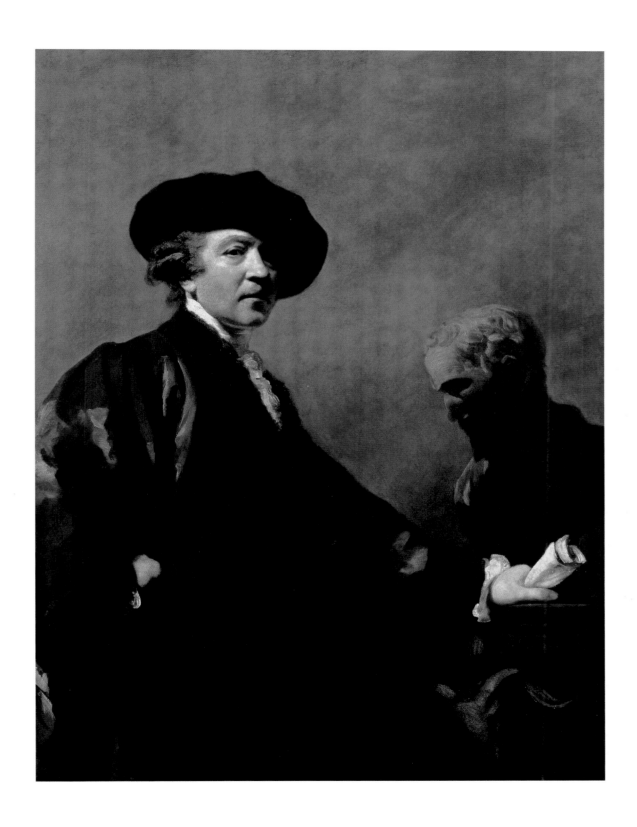

6. *Self-Portrait with Thomas Jervais, 'Adoration of the Shepherds'* by 1785

Oil on canvas, 209.5 x 83.7

Lent by the Trustees of the Rt. Hon. Olive, Countess Fitzwilliam's Chattels Settlement, by permission of Lady Juliet Tadgell

This is one of Reynolds's designs for the west window of the chapel at New College, Oxford, which he made in collaboration with the glass painter, Thomas Jervais (d.1799), between 1777 and 1785. Jervais's original brief had been to replace a number of glass panels around the chapel. However, at Jervais's suggestion, Reynolds succeeded in persuading the college authorities to allow him to replace the entire west window with his design for a nativity scene and attendant figures of the Cardinal and Christian Virtues. The commission to design the window was to have been given to Reynolds's fellow Royal Academician, Benjamin West, who was already experienced in this type of work. However, owing to the intervention of Reynolds's friend, Joseph Warton, the commission was given instead to Reynolds (see Postle 1995, p.169). Perhaps not entirely coincidentally, Reynolds had exhibited Warton's portrait at the Royal Academy shortly before he accepted the commission in July 1777.

Reynolds used his friends and relations as models in his designs for the window. The Virgin in the central panel was the singer Elizabeth Linley, who had recently become the wife of Reynolds's friend, Richard Brinsley Sheridan. Saint Joseph was based upon Reynolds's celebrated model, George White, who, as one critic observed, was readily recognised as 'our old acquaintance Count Hugolino, who was starved with his children in a former exhibition, but with less aggravated features, and in better care' (Mannings and Postle 2000, vol.1, p.546). In the flanking panel on the left, Reynolds and Jervais played the parts of startled shepherds. In this respect Reynolds was following a tradition whereby generations of European artists had incorporated their own features into both sacred and profane commissions, often as a form of elaborate signature. Nevertheless, a critic writing in the *St James's Chronicle* (22–5 October 1785) deplored the device as egotistical, criticising Reynolds for including himself and Jervais as 'Parties in the Adoration, and yet *looking* at those who come to admire two such excellent artists'.

The critical response to Reynolds's window was mixed. Horace Walpole (cat.32) remarked upon the marked difference between the style of Jervais's work and the existing glass in the chapel: 'The old and new are mismatched as an orange and a lemon; nor is there room enough to retire back and see half of the new; and

Sir Joshua's washy Virtues make the "Nativity" a dark spot from the darkness of the shepherds, which happened, as I knew it would, from most of Jarvis's [*sic*] colours being transparent' (Mannings and Postle 2000, vol.1, p.546). Even Reynolds was ambivalent about the end result, although this did not prevent him from encouraging his friend Thomas Warton (brother of the aforementioned Joseph) to write a poem entitled *Verses on Sir Joshua Reynolds's Painted Window at New College*, *Oxford*, which he published in 1782. Here he commended Reynolds's classical style:

Thy powerful hand has broke the Gothic chain,
And brought my bosom back to truth again:
To truth, whose bold and unresisted aim
Checks frail caprice, and fashion's fickle claim.

In truth, Warton actually preferred Gothic to classical style. Nonetheless, he was happy to propagandise on Reynolds's behalf. He even agreed to the latter's suggestion that he should amend the original title page of the poem by inserting Reynolds's name; for as Reynolds told him, 'if the title page should be lost it will appear to be addressed to Mr. Jervais' (Postle 1995, p.182).

MP

Provenance
Mary, Marchioness of Thomond sale, Christie's 19 May 1821 (60), bought by Earl Fitzwilliam; by descent.

Literature
Malone 1819, p.lxxviii, note; Hamilton 1884, p.153; Graves and Cronin 1899–1901, vol.3, pp.1181–2; Köller 1992, pp.24–5; Postle 1995, p.169; Mannings and Postle 2000, vol.1, p.548, vol.2, fig.1660.

Engraved
G.S. and J.G. Facius 1785.

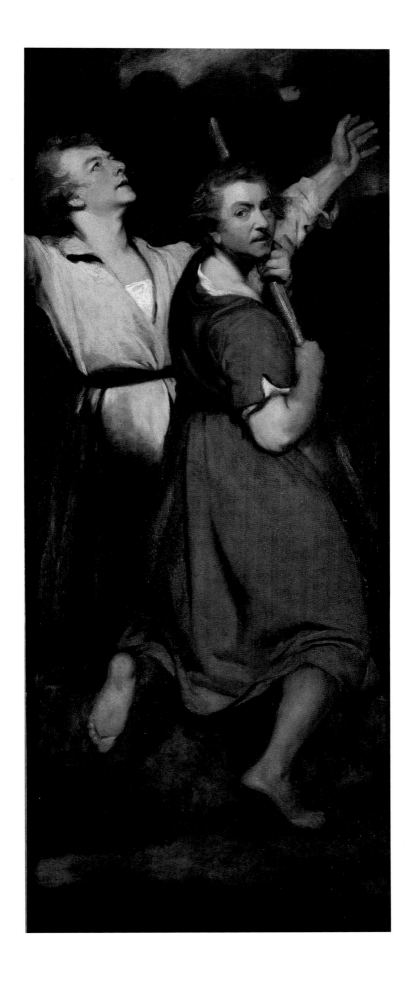

7. *Self-Portrait c.*1788

Oil on wood, 75.2 x 63.2

Lent by Her Majesty Queen Elizabeth II

Edmond Malone stated that this self-portrait showed the artist 'exactly as he appeared in his latter days, in domestick [*sic*] life'. That Reynolds presented copies of the portrait to Malone and Edmund Burke certainly suggests it was how he wished to be seen by his closest friends (see Mannings and Postle 2000, vol.1, pp.52–3). In daily life Reynolds wore spectacles; an examination of two pairs belonging to him has revealed that he was short-sighted, and would have needed them to paint and to read (see Hudson 1958, pp.207–8; Penny 1986, p.337). Spectacles had been common since at least the Middle Ages, although it was comparatively rare for portrait subjects to be depicted wearing them. Significantly, however, there was an established tradition of artists' self-portraits in spectacles, including Luca Giordano and Velázquez. More recently, the French painter, Jean-Siméon Chardin, had painted a whole series of bespectacled self-portraits. Of course, there was a very practical reason for artists to wear spectacles. For, while it was possible to read using an eyeglass, as in James Barry's portrait of Giuseppe Baretti of 1773 (John Murray Collection), an artist – holding a brush in one hand and a palette in the other – needed both hands free to paint.

In the eighteenth century spectacles appear far more frequently in satirical prints than in portraits. Edmund Burke, who also wore spectacles, only appears in caricatures with them on, and Reynolds, too, when satirised was also shown with spectacles (see Godfrey 2001, pp.86–7). Yet, while spectacles can connote poor eyesight, they are also related to vision; as in Reynolds's sister Frances's portrait of the bespectacled translator, John Hoole, which 'convey'd into his eye the celestial fire which glows into his translations' (Wendorf and Ryskamp 1980, p.187). Given these associations, Reynolds's decision to portray himself in spectacles was not related simply to his self-image as a painter, or even to his appearance in 'domestick life', but to the image he held in even higher esteem – that of a philosopher, and man of vision.

In the summer of 1789 failing sight in his left eye compelled Reynolds to stop painting. By the autumn his eyesight was being discussed regularly in the press, the *Morning Post* reporting on 9 September, 'that some artists who want to bring their own puny talents into estimation have magnified the state of Sir Joshua's disorder in order

to injure his reputation, and profit, if possible, by the idea that his faculties begin to suffer too materially to admit of any future works of extraordinary vigour and beauty'. Two days later it added, 'Sir Joshua Reynolds is not *blind* to artifices of certain insidious painters who want to pity him out of his profession, nor will the world of taste be blinded by their reports into a preference of their flimsy talents'. By the end of the year, however, Reynolds's sight had deteriorated further, and he had completely lost the use of his left eye. By the time of his death in February 1792 he was virtually blind.

MP

Provenance
Given to George, Prince of Wales (later George IV) in 1812 by Reynolds's niece, Mary, Marchioness of Thomond.

Literature
Northcote 1818, vol.2, p.245; Malone 1819, vol.1, p.lxxvii, note; Waagen 1838, vol.2, p.376; Waagen 1854, vol.2, p.24; Graves and Cronin 1899–1901, vol.2, pp.804–5; Aspinall 1938, vol.1, p.120; Waterhouse 1941, p.80; Steegman 1942, p.34; Millar 1969, pp.98–9; Waterhouse 1973, p.48; Mannings 1992, pp.34–5; Mannings and Postle 2000, vol.1, pp.51–2, vol.2, fig.1538; Ingamells 2004, pp.395–6.

Engraved
Caroline Watson (stipple) 1 March 1789; G. Clint (mezzotint) 1 November 1799; S.W. Reynolds December 1833; Euphrasie Picquenot; W. Gilles.

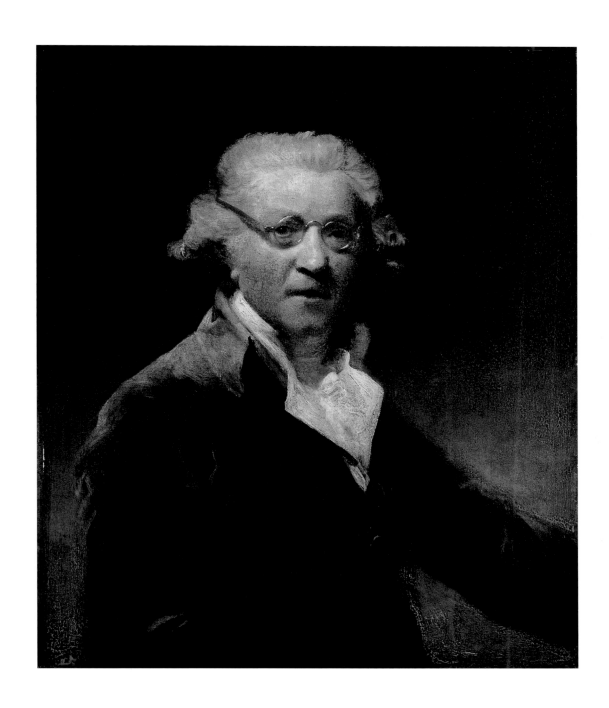

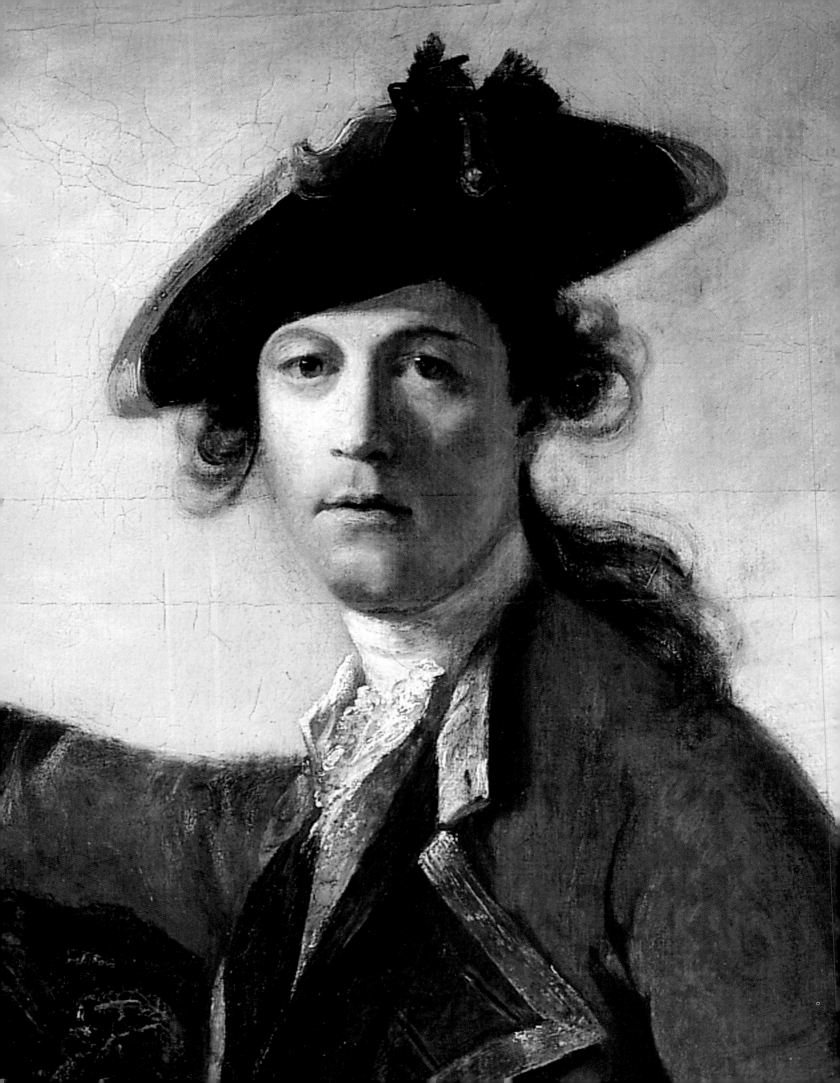

Heroes

For much of Reynolds's career, Britain was at war. Conflicts such as the War of the Austrian Succession (1740–8), the Seven Years War (1756–63) and the American War of Independence (1776–83) shaped the society and culture within which Reynolds worked and the pictures that he painted. The artist executed numerous portraits of the commanders and officers who had fought in these campaigns, and in doing so he contributed to a powerful form of martial celebrity that emerged in this period. During the second half of the eighteenth century, the heroic victors and victims of the battlefield and the sea were relentlessly chronicled and visualised. They were written about in books, newspapers, journals, pamphlets, broadsheets and ballads, and pictured in paintings, engravings, monuments and woodcuts. Furthermore, the image of the soldier and sailor was on continual display, paraded in the exhibition room, the print shop, the cathedral and the street. Reynolds's military and maritime portraits, in both painted and reproduced form, played an important role in stimulating and sustaining this phenomenon, and helped craft a new, complex image of the martial hero.

Reynolds's military portraits also exemplify his desire to use portraiture to communicate more than the similitude of a likeness and the clues to a character: they are pictures that, even as they promote the supposedly heroic virtues and achievements of particular individuals, also gesture to some of the most important events in contemporary British history. In doing so, they engage with the shifting ambitions and anxieties of the nation served by the men he painted. A picture like that of Captain Robert Orme (cat.11), who is shown standing near the scene of a notorious massacre, powerfully articulates the combination of fortitude and anxiety felt within British society during the first, doom-laden year of the Seven Years War, while Reynolds's portrait of Augustus Hervey (cat.13) conveys the patriotic confidence generated by the victorious battles that drew the same conflict to an end. Meanwhile, Reynolds's great full-length portrait of the Marquess of Granby (cat.15), painted in the years after this war had ended, expresses not just the perceived virtues of a celebrated commander, but also the qualities claimed by Britain itself as it sought to manage a new empire.

Finally, these pictures show Reynolds replenishing many of the most venerable conventions of military portraiture whilst simultaneously pursuing a continual process of artistic experimentation and innovation. The management of light and shade, colour and composition, expression and posture found within paintings such as those of Commodore Keppel (cats.9 and 17), was regularly praised by contemporaries in terms of this duality. On the one hand, Reynolds was lauded for having successfully emulated such great predecessors as Van Dyck; on the other, he was described as having taken British portraiture in strikingly new directions. This combined achievement also helped ensure that his paintings of commanders and officers worked equally well in a variety of venues, ranging from the ancient seats of the English aristocracy to the more accessible, novel spaces of the metropolitan exhibition room. Wherever they were displayed, Reynolds's martial portraits could be appreciated as compelling depictions of heroic individuals, as reassuring allegories of patriotic resilience and magnanimity, and as ambitious works of modern art, deserving of the most stringent forms of aesthetic scrutiny.

MH

Robert Orme 1756 (detail of cat.11)
National Gallery, London

8. *Captain the Hon. John Hamilton c.*1746

Oil on canvas, 130 x 102

Abercorn Heirlooms Settlement

This picture, traditionally dated to the mid-1740s, and thus to the first decade of Reynolds's working life, portrays a naval captain who appears to have become a good friend of the artist. In Reynolds's glamorous portrait, Hamilton (d.1755) sports a moustache, a busby hat and a flamboyant fur coat. Juxtaposed against a raging sea, he offers a striking alternative to the imagery of genteel politeness that dominated contemporary portraiture. Intriguingly, Reynolds had already depicted Hamilton in a guise that gently contravened pictorial convention: in *The Eliot Family* of 1745 the captain is seen smiling out at the viewer whilst carrying a child on his back, disturbing what is otherwise a highly formalised and static grouping. The present portrait, however, gestures to more heroic actions. Hamilton, in particular, was associated with a shipwreck that had occurred in 1736 when, as a lieutenant accompanying George II on a return trip from Hanover, his boat, the *Louisa*, had been destroyed in a storm. Hamilton remained on board until everyone had escaped to safety, and was the last man to be rescued. The ship seen floundering in the background of Reynolds's portrait must represent the *Louisa* and clearly functions as a visual prompt, reminding the viewer of Hamilton's bravery.

Hamilton wears the uniform of a Hungarian Hussar, a class of officers that had come to prominence thanks to their contribution to Britain and Austria's cause during the War of the Austrian Succession (1740–8). As Aileen Ribeiro has noted, their 'costume and military exploits became familiar themes in English newspapers' and 'interest in the war on the continent helped in the adoption of the Hungarian Hussar uniform as a popular masquerade costume, notably in the middle years of the eighteenth century' (Penny 1986, p.187). The details of this outfit, which include a richly decorated dagger thrust into a patterned sash, contribute to the exotic glamour expressed by Reynolds's portrait, whereby Hamilton is defined not so much as an English gentleman but as an adventurer and man of the world, cloaked by the signs of the foreign, and aligned with the dangerous narratives of the sea. Hamilton's pose and gaze, and such details as his busby's rakish tilt, confirm his cosmopolitan swagger and unconventionality. Finally, the portrait is distinguished by an unusually vibrant display of painterly handling: the upper left background is made up of a turbulent sea of brushstrokes, while the texture of Hamilton's fur coat is communicated through jabbing streaks of paint. This technical flamboyance, which complements the bravura conveyed by the captain himself, suggests that Reynolds saw this work as an opportunity to catch the public eye. His strategy seems to have worked: according to his friend and biographer, Edmond Malone, this was the picture that first brought the artist a degree of celebrity (Malone 1819, vol.1, p.x).

MH

Provenance
By descent to the present owner.

Literature
Malone 1819, vol.1, p.x; Leslie and Taylor 1865, vol.1, p.28; Graves and Cronin 1899–1901, vol.2, pp.418–19; Waterhouse 1941, pp.5, 37, 119; Penny 1986, pp.165–6; Mannings and Postle 2000, vol.1, pp.237–8, vol.2, fig.22.

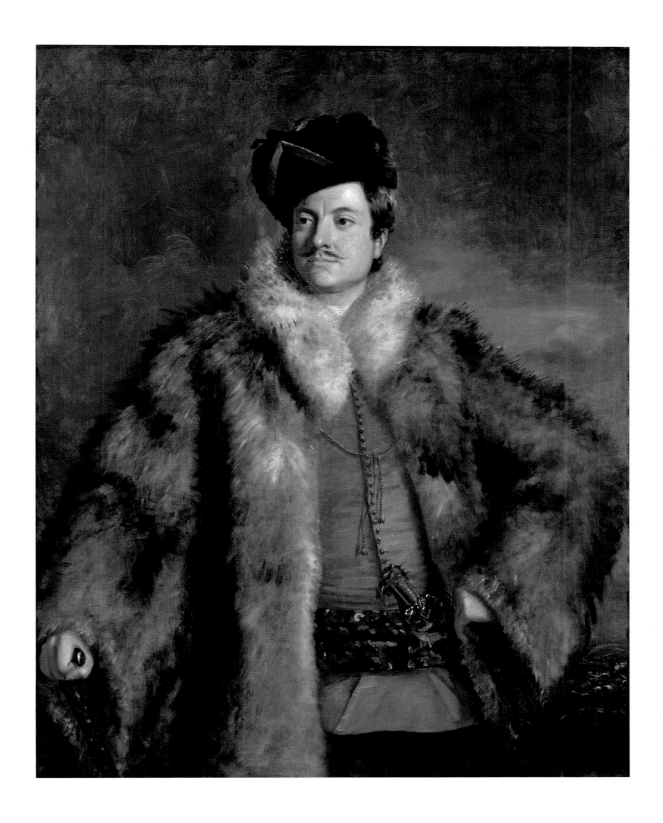

9. *Augustus, 1st Viscount Keppel* 1752–3

Oil on canvas, 239 x 147.5

National Maritime Museum, London

Reynolds painted this portrait of Augustus Keppel (1725–86) immediately after his return from Italy in 1752. Early biographical accounts concur that it succeeded in launching Reynolds's career, a close friend claiming that through this work 'he was not only universally acknowledged to be at the head of his profession, but to be the greatest painter that England had seen since Vandyck [*sic*]' (Malone 1819, vol.1, pp.xxiii–xxiv). Reynolds's decision to paint Keppel's portrait was dictated partly by friendship and gratitude, for Keppel had in 1749 given Reynolds free passage to the Mediterranean aboard his ship. His choice of subject was also surely related to Keppel's status as a celebrated naval hero and a man of influence: he was the son of the 2nd Earl of Albemarle, as well as the cousin of the Duke of Richmond, one of the country's leading aristocrats and an influential patron of the arts.

As his pupil, Giuseppe Marchi, recalled, Reynolds went to considerable trouble over the composition, even repainting the whole facial area – a fact confirmed by modern X-rays (Penny 1986, p.181, fig.54). It was not the head, however, but the pose of the figure that captured the imagination of Reynolds's contemporaries: 'The public, accustomed to see [*sic*] only the formal tame representations which reduced all persons to the same standard of unmeaning insipidity, were captivated with this display of animated character, and the report of its attraction was soon widely circulated' (Farington 1819, p.41).

In portraying Keppel as an 'animated character' and a man of action, Reynolds wished to highlight the qualities of leadership and heroism that Keppel had already demonstrated during his career. Keppel had joined the navy as midshipman at the age of ten. In 1740 he had accompanied Lord Anson on his epic round-the-world voyage. A few years later, in 1747, his ship was wrecked off the French coast while in pursuit of the enemy – an incident that, according to another of Reynolds's pupils, formed the narrative for the present picture (Northcote 1818, vol.1, p.62). In order to present Keppel as a heroic figure, it was thus vital for Reynolds to transcend the customary convention of presenting his subject in the 'polite' pose of an officer and gentleman.

As the Victorian artist Charles Robert Leslie noted, Keppel's pose in the present picture was based on a drawing Reynolds had made of a statue of Apollo. This drawing, now untraced, was described by Leslie as 'youthful, and Apollo-like, and seems to hold a lyre in the left hand, or it may be a fiddle, for Reynolds's sketch is very slight' (Leslie and Taylor 1865, vol.1, pp.106–7). The drawing, and Reynolds's subsequent portrait, were clearly based upon a version of a statue of Apollo holding a lyre by the seventeenth-century French sculptor, Pierre Legros the Younger (see Postle 1995, p.15, fig.7). Legros's statue of Apollo, together with its pendant, *Marsyas*, were much sought after in mid-eighteenth-century England, where they were reproduced in bronze and, more crudely, in the form of lead garden statuary (Baker 1985, pp.702–6). Reynolds could also have seen versions of this statue in Italy and in Paris. However, it is significant that the 1746 sale of Jonathan Richardson's collection included 'the Apollo of Mons. *le Gros*'.

MP

Provenance
Earls of Albemarle until 2 May 1888 when sold to Agnew's, who sold it 19 May 1888 to the Earl of Rosebery at Dalmeny House; his sale Christie's 5 May 1939 (114) bought in; sold afterwards to Sir James Caird, by whom presented to the National Maritime Museum in 1939.

Literature
Northcote 1818, vol.1, pp.62–5; Malone 1819, vol.1, p.xxiii; Farington 1819, p.41; Leslie and Taylor 1865, vol.1, pp.105–6; Stephens 1867, pp.7–8; Hamilton 1884, pp.42–3; Graves and Cronin 1899–1901, vol.2, pp.538–9; Steegman 1933, pp.29–30, 96–7; Waterhouse 1941, pp.9–10, 39; Archibald 1961, p.77; Waterhouse 1965, p.31; Waterhouse 1973, p.18; Solkin 1986, pp.42–9; Postle 1995, pp.11–18; Mannings and Postle 2000, vol.1, pp.287–8, vol.2, pl.10, fig.70.

Engraved
Edward Fisher, published 20 November 1759, lettered: 'J Reynolds pinxit 1752'.

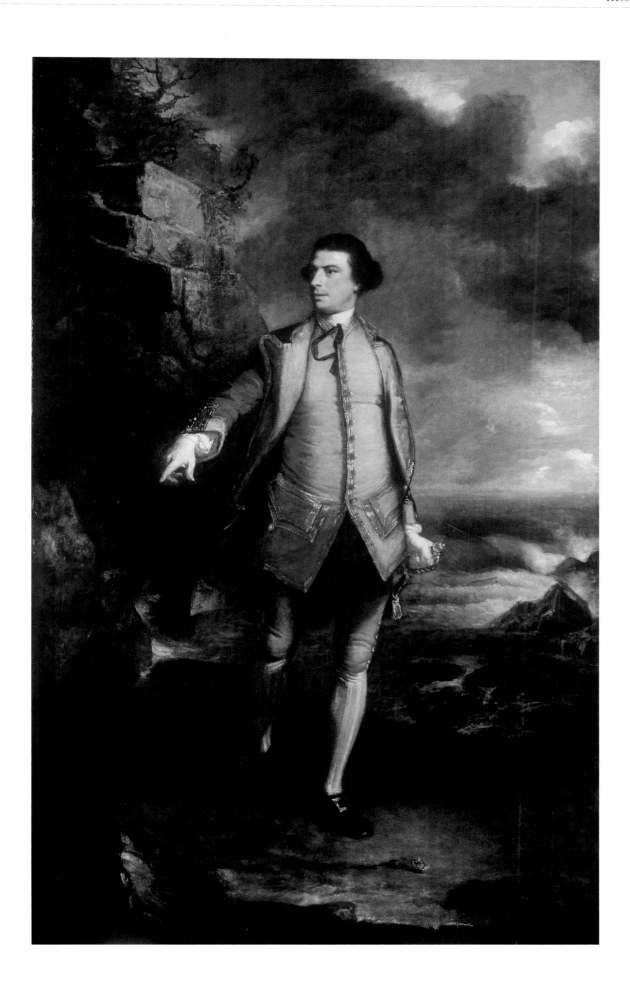

10. *Lord Cathcart* 1753–5

Oil on canvas, 124 x 99

Manchester Art Gallery

In a letter of October 1753 Lord Cathcart (1721–76) described this portrait's progress: 'Again with Mr Reynolds, and was disagreeably surprised with the figure. After some reasoning he came to the opinion that it would not do. I breakfasted with him and stood to him a good while. I thought it was much improved, and he was extremely satisfied with the alteration so we parted in great good humour' (quoted in Whitley 1928, vol.1, p.59). These comments suggest the extent to which such men as Cathcart controlled how they were represented. However, they also indicate, more obliquely, that Reynolds, a relatively young artist who had just set up practice in London, was pursuing a strikingly new and experimental form of portraiture – one which clearly had the capacity to unsettle such sitters as Cathcart. While the manner in which Cathcart is posed owes much to an earlier portrait of Henry Clarke painted by the artist's teacher Thomas Hudson (Smart 1992, pl.94), Reynolds's picture also offered a sharp contrast to those produced by his competitors in the London art market, particularly in its deployment of light and shade, its exploitation of the possibilities of setting, and its play with the dynamics of bodily presentation and withdrawal.

Cathcart was an aristocrat and soldier who, over the previous decade, had been wounded no fewer than three times in a succession of armed conflicts. Most seriously of all, he had been shot in the face when acting as *aide-de-camp* to the Duke of Cumberland at the Battle of Fontenoy of 1745, and Reynolds's portrait shows off the black silk lunette patch he subsequently used to cover up his scar. Intriguingly, Reynolds does not show Cathcart standing on a battlefield, as this biography might lead us to expect. Instead, he occupies what seems to be an imaginary setting, reminiscent in its architecture and light of an Italianate church or public building, but stripped of any distinguishing details. Within this generalised, slightly enigmatic environment, Cathcart is depicted in a fascinatingly split manner. From one perspective, his portrayal is that of a man boldly presenting himself to the viewer. Emerging out of the shadows, and standing between two curtains that seem almost to have been deliberately parted to reveal him, Cathcart addresses us with a confident smile and gesture. Light studiously falls on those parts of his body and dress that signal his aristocratic status, his military calling and his heroism: the silk patch on his

skin, the glittering breastplate, the braiding of his red uniform, the exquisite ruff around his wrist, the extended, refined, right hand. At the same time – in a strategy highly characteristic of Reynolds's portraiture in this period – Cathcart's portrayal is also shaped by a deliberate form of pictorial, bodily and tonal withdrawal. He is resolutely separated from the spectator by a balustrade, and half of his face is cloaked in shadow. His upper torso, twisted away from the viewer and plunged into darkness, is almost unreadable, and his left hand is entirely hidden from view.

In the history of portraiture, such devices had regularly been used to convey the more private, introspective aspects of a subject's character. In this instance, they allow Reynolds to suggest the existence of a hidden, less ostentatious side to Cathcart, one that eschews public performance and that is instead aligned with those quiet, emptied and darkened spaces that lie about him in this portrait. On this reading, Cathcart can be understood not only as a confident young soldier and a richly garbed nobleman, but also as someone with a sensibility attuned to the sombre architectural grandeur of the building in which he stands.

MH

Provenance
Painted for the sitter; by family descent to Major-General the Earl Cathcart, from whom bought by Manchester Art Gallery 1981.

Literature
Graves and Cronin 1899–1901, vol.1, pp.156–7; Waterhouse 1941, pp.10, 38, 120; Waterhouse 1966–8, p.146; Einberg 1987, pp.220–1; Mannings and Postle 2000, vol.1, pp.122–3, vol.2, fig.91.

Engraved
James McArdell and Richard Houston 10 July 1770; Richard Houston 1770 (reduced).

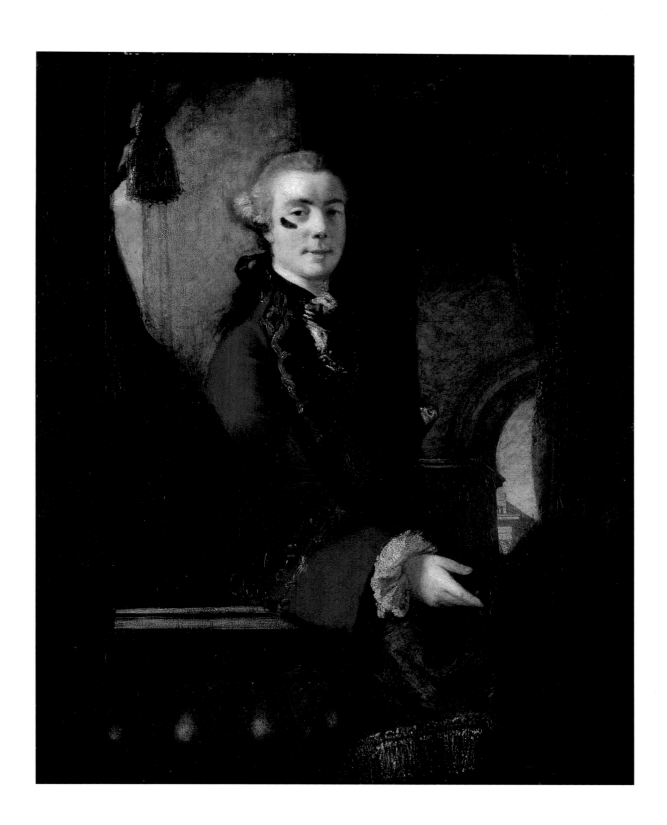

11. *Robert Orme* 1756

Oil on canvas, 239 x 147

National Gallery, London

This famous full-length portrait, which in many ways stands as a military counterpart to the naval portrait of Augustus Keppel painted some four years earlier (cat.9), depicts the thirty-year-old Captain Robert Orme (1725–90). He wears the uniform of the Coldstream Guards and stands next to his horse in the darkened corner of an American forest. In the background, a battle takes place – flashes of red indicate the uniforms of other British soldiers, while gun smoke swirls into the air. This distant scene refers to the catastrophic British defeat that took place in North America in the summer of 1755. On 9 July of that year, an army of more than two thousand British and American troops, led by General Edward Braddock and travelling towards the French-held Fort Duquesne, was decisively ambushed by a far smaller force of French soldiers and American Indian warriors near the Monongahela River. Orme was one of Braddock's three *aides-de-camp*, and with his commander was caught in the devastating cross-fire that rained down on the exposed troops from the surrounding woodland. By the end of the attack, nearly nine hundred British and American soldiers were dead. Braddock was fatally wounded, a number of officers were killed and scalped; Orme himself was shot in the leg. The defeat, news of which started seeping through to the London press in August, profoundly shocked the nation.

Reynolds seems to have executed this portrait as a speculative venture, and it stayed in the artist's possession until 1777. In depicting Orme, Reynolds focuses on a figure who, since his recovery from injury and return to England in late 1755, seems to have gained a certain degree of status within elite circles as a heroic survivor of the massacre. Reynolds's portrait not only reinforced Orme's contemporary celebrity, but also offered a remarkable encapsulation of the conflicting stories of heroism and horror that had emerged from the debacle at Monongahela. In particular, Reynolds brilliantly plays off two different facial expressions against each other within the portrait. It is helpful to look at each half of Orme's face in turn to appreciate this fully. The illuminated half of his face (fig.34) appears to offer an ideal of the resolute and reassuring English army officer, whose calm gaze, firm jaw and subtly upturned mouth bespeak discipline and fortitude. But turning to the other, shadowed half of his face (fig.35), it is as if we are confronted with another person entirely. Orme's eye flutters nervously

upwards, as if distracted by the screams piercing the forest, or by the mental image of the bloody battlefield lying behind him. His strained mouth, rather than carrying the hint of a smile, is pulled downward with anxiety. This, it seems, is the face of a man who, only minutes beforehand, had watched as his friends and comrades were, in the words of a contemporary newspaper, 'cut to pieces' (*Whitehall Evening Post*, 23–6 August 1755). Reynolds thus combines a facial iconography suggestive of the manly English fortitude necessary to revenge such attacks with one expressive of the terrible experience of defeat and barbarity.

MH

Provenance
5th Earl of Inchquin, 1777; by descent to 5th Earl of Orkney; Orkney sale Christie's 10 May 1863 (62), bought by Sir Charles Eastlake for the National Gallery.

Literature
Northcote 1818, vol.1, pp.65–6; Graves and Cronin 1899–1901, vol.2, pp.711–12; Waterhouse 1941, p.41; Davies 1959, pp.81–2; Cormack 1968–70, p.156; Waterhouse 1973, pp.18, 37; Potterton 1976, p.106; Shawe-Taylor 1990, p.38; Egerton 1998, pp.206–9; Mannings and Postle 2000, vol.1, p.358, vol.2, pl.11, fig.216; Hallett 2004a, pp.41–62.

figs.34 and 35
Details of cat.11, showing the illuminated left side and shadowed right side of Captain Orme's face.

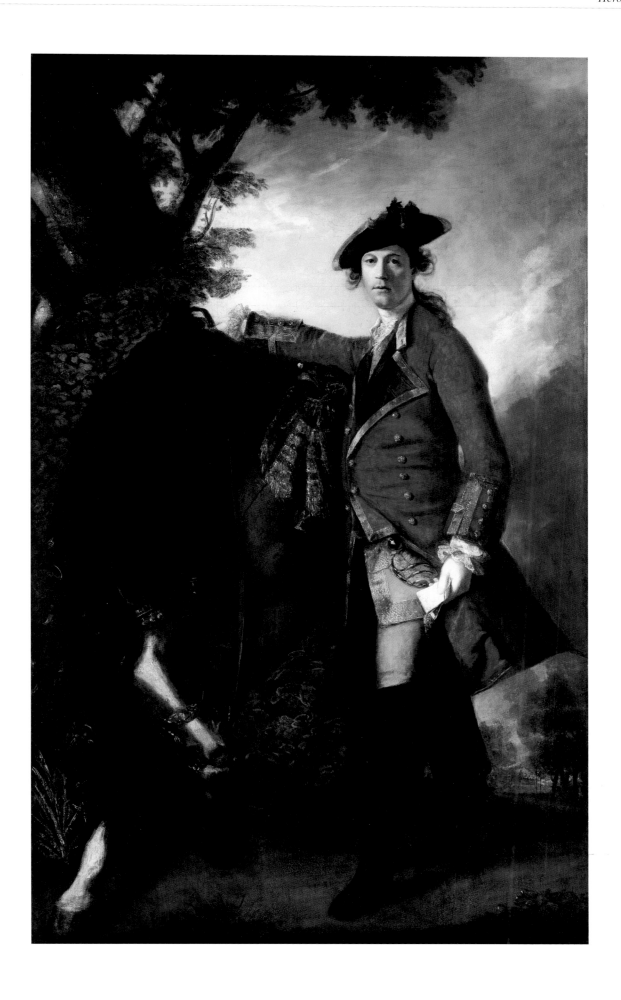

12. *Admiral Rodney c.*1761

Oil on canvas, 127 x 101

Lord Egremont

George Brydges Rodney (1719–92), born into an aristocratic and military family, was to become one of the most distinguished British naval commanders of the eighteenth century. He first came to national prominence in the summer of 1759 when, as a newly appointed Rear-Admiral, his ships destroyed a flotilla of French invasion barges berthed at Le Havre. Reynolds had a single portrait appointment with Rodney later that year, and a series of appointments in 1761, when this painting – which may have been begun a number of years earlier – seems to have been completed. 1762 saw the publication of James Watson's mezzotint of Reynolds's portrait, which clearly sought to capitalise on Rodney's growing fame: in that same year his fleet, together with a large ground force, had successfully attacked Martinique in the West Indies, and captured St Lucia, Grenada and St Vincent.

Reynolds, who had regularly painted portraits of naval officers since the mid-1740s, depicts Rodney in his Rear-Admiral's uniform, standing near a rocky outcrop that overlooks the sea, his right hand resting on the anchor that was a conventional symbolic prop in such naval portraits. The artist seeks to convey an impression of authority and of refinement. Rodney's outstretched right arm directs our eye to both the anchor and the distant sea – and thus to his profession and accomplishments – while the rugged environment communicates the rigours of his calling. At the same time, Rodney's unusually refined facial features and hairstyle, the delicate play of light across his uniform's glittering brocade, and the studied pose of his foreshortened left arm – which has its pictorial origins in Van Dyck's aristocratic portraiture of the previous century – work together to suggest an almost exquisite poise. Intriguingly, the memoirist Nathaniel Wraxall described Rodney as 'more elegant than seemed to become his rough profession. There was even something that approached to delicacy and effeminacy in his figure, but no man manifested a more temperate and steady courage in action' (Wraxall 1904, p.190). If Reynolds's portrait of the thirty-eight-year-old Rodney seems to capture this duality, it is worth noting that a number of his other images of younger army and navy officers from this period also celebrate similar combinations of martial achievement and aristocratic sensibility. In doing so, they countered a widespread view that such officers

were, in Samuel Bever's words, 'rude and ignorant' (Anon. [Samuel Bever], *The Cadet: A Military Treatise, by an Officer*, London 1756, p.131). Instead, they suggested that Britain's aristocratic elite, rather than being enfeebled by luxury, as a number of influential commentators also claimed, could still provide heroic military and naval leaders for the nation.

MH

Provenance
Belonged before 1828 to 'a gentleman' who had it restored by William Redmore Bigg RA, and who sold it to Lord Egremont (John Constable, *Correspondence*, ed. R.B. Beckett, London 1962–8, vol.3, p.60: letter to Charles Leslie, dated 17 January 1832); thence by descent.

Literature
Graves and Cronin 1899–1901, vol.2, pp.839–40; Baker 1920, p.103; Waterhouse 1941, p.50; Mannings and Postle 2000, vol.1, p.397, vol.2, fig.253.

Engraved
James Watson 1762.

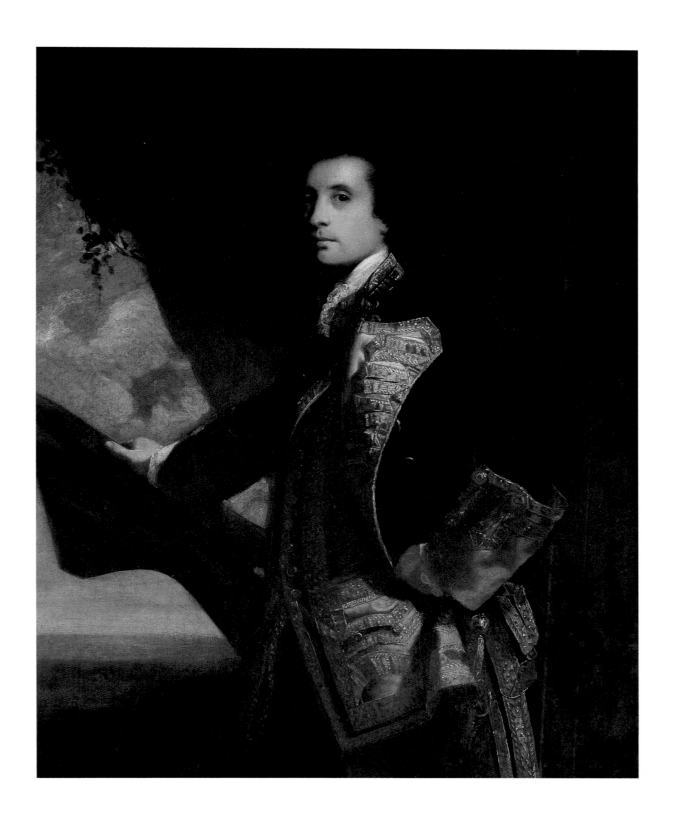

13. *Augustus Hervey, 3rd Earl of Bristol* 1762

Oil on canvas, 126 x 100

St Edmundsbury Borough Council, Manor House Museum

This striking portrait of Augustus Hervey (1724–79) was painted in the autumn of 1762 and reproduced as a print the following year: its bold design, in which Hervey's body and tilted sword are dramatically silhouetted against a smoking landscape and swirling clouds, would have ensured that it stood out from afar in both painted and graphic form. The painting celebrates Hervey's involvement in the successful attack on Moro Castle, Havana, in July 1762, which is depicted taking place in the background. Hervey had not only participated in the attack on Moro Castle itself, but, in order to ensure the safe passage of British land forces, had also captured a nearby castle that defended the River Coximar. In Reynolds's picture, he addresses the spectator with a direct, almost aggressive gaze, displays an unsheathed sword, and rests his hand on a plan of the distant castle, complete with the signs and names of the ships that are depicted in the distance. Portrayed as if still engaged in the activities that surround him in the painting, he is clearly meant to be understood as a man of action and of authority. The drama of the portrait is accentuated by a variety of formal and expressive devices: Hervey's sword seems almost to slice the clouds that swirl overhead, his upper torso is strikingly spot-lit, as if illuminated by a flash of gunpowder, and his face, caught in this same pool of light, is bisected into sharply contrasting areas, the shadowed half of which carries an especially determined, even belligerent, expression.

Produced during the victorious final months of the Seven Years War, this confrontational portrait seems to communicate not only Hervey's success as a naval leader, but also a wider set of meanings intrinsic to that particular historical moment. This is an image that expresses the jingoistic patriotism that was being promoted throughout British culture at this time. The portrait also suggests a ruthless form of colonial dominance, in which the Cuban landscape is pictorially buried beneath the weight of a stridently martial iconography. More prosaically, Reynolds's portrait alerts us to the networks of naval patronage that the artist relied upon throughout the first decades of his career. Significantly, when fighting in the West Indies, Hervey sailed under Rear-Admiral Rodney, whom Reynolds had painted the previous year (cat.12), and then came under the immediate command of the portraitist's old friend and patron

Commodore Augustus Keppel, whose 1752–3 portrait had first brought Reynolds widespread fame (cat.9). Only a few years previously, Hervey's ship had been part of a fleet led by another of the artist's long-standing patrons and close friends, George Edgcumbe. Word of mouth evidently played an important part in the success of Reynolds's career as a naval portraitist. The intense rivalry between such men when it came to claiming credit for Britain's maritime victories would no doubt also have played its part – ensuring their portraits were visible in the public eye was a central part of cementing these naval commanders' reputations.

MH

Provenance
Probably given to the town by the sitter.

Literature
Graves and Cronin 1899–1901, vol.2, pp.462–3; Farrer 1908, p.58, no.2; Waterhouse 1941, p.51; Mannings and Postle 2000, vol.1, p.255, vol.2, fig.620.

Engraved
Edward Fisher 1763; S.W. Reynolds.

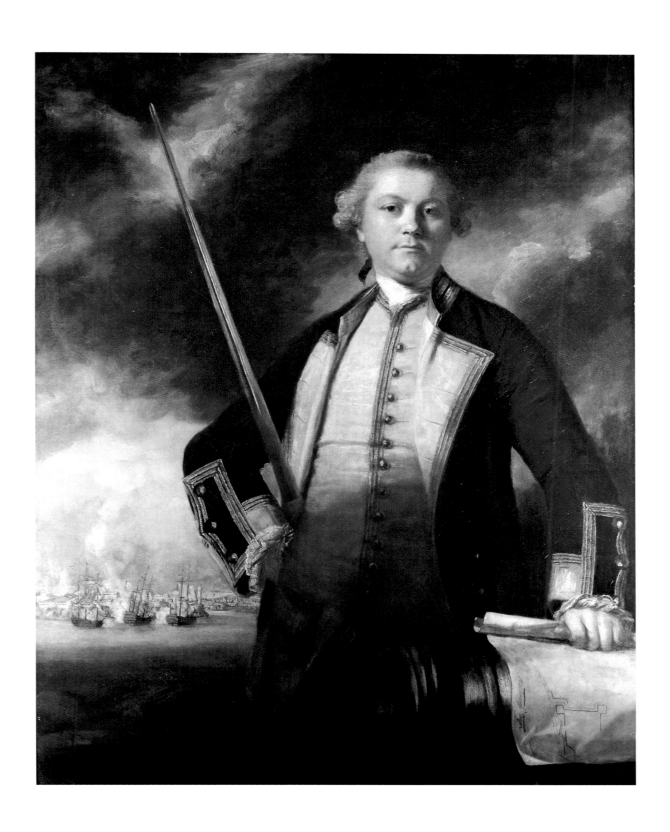

14. *John, 1st Earl Ligonier* 1756

Oil on canvas, 129 x 102

Courtesy of the Council of the National Army Museum. Purchased with the generous assistance of the National Heritage Memorial Fund

Reynolds here depicts Lord Ligonier (1680–1770), one of eighteenth-century Britain's greatest military leaders, who, despite being some seventy-six years old when this portrait was painted, had yet to be granted his greatest honour – that of commanding the British army during the Seven Years War against France. Ligonier's career, however, had already encompassed service under the Duke of Marlborough at the beginning of the century, as well as a central role in the Battle of Fontenoy of 1745. He was made a Knight of the Bath in 1743, and Reynolds's portrait shows him wearing the ribbon and star of this Order. Given this glorious past, it is notable that the artist does not picture Ligonier in an obviously heroic manner, such as was to be the case in the great equestrian portrait of the same sitter that Reynolds exhibited at the Society of Artists in 1761. Rather, Reynolds paints the elderly soldier in a way that combines the rhetoric of military command, expressed most obviously by the authoritative gesture of his right arm, with a more subdued mode of portrayal. Represented either at dusk or after night has fallen, Ligonier is situated on a secluded mountain top, and though he dominates the shadowed landscape visible in the picture's background, he is shown far removed from the flames that flicker rather illegibly in the distance. His expression suggests his mood is both alert and contemplative, while the play of light on his body is telling: if the active swivel of Ligonier's head to his right means that his face is illuminated, it is striking that, were he to look back at us, at least half of his face would be bathed in the murky shadows that envelop the stilled left side of his upper body.

The muted effect generated by these aspects of the picture can perhaps best be explained by noting the sense of crisis felt in mid-1750s Britain, when a series of defeats and massacres at the hands of the French and their allies seemed to presage the imminent collapse of the British military. Given these circumstances, it is perhaps no surprise that Reynolds, in his pictures of those military and naval commanders who were charged with defending the nation at this time, chose to avoid too vainglorious a tone. Instead, such pictures as this portrait of Ligonier combine a sombre, almost melancholy character (no doubt accentuated by the fact that its colours have subsequently faded) with a more reassuring iconography of military experience and

intellectual command. The portrait seems to suggest that Ligonier, from his solitary vantage point, will devise and implement the kinds of military strategy necessary to ensure Britain's ultimate victory.

MH

Provenance
The sitter's natural daughter Penelope married Lt-Col. Arthur Graham: their daughter Elizabeth married Francis Lloyd; thence by descent to Lt-Col. H.W. Lloyd; acquired by the National Army Museum 1976.

Literature
Graves and Cronin 1899–1901, vol.2, p.584; Waterhouse 1941, p.40; Waterhouse 1966–8, p.154, Mannings and Postle 2000, vol.1, pp.306–7, vol.2, fig.208.

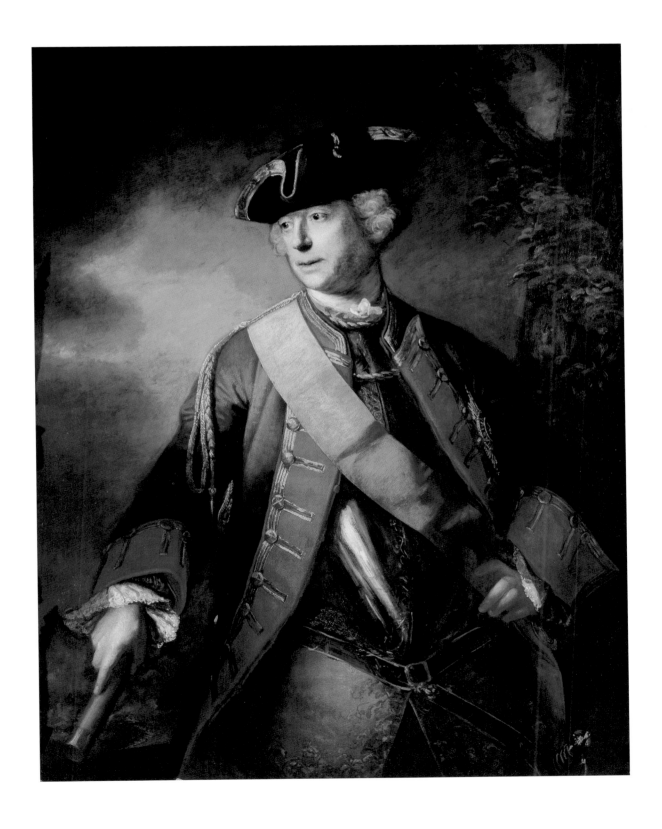

15. *John Manners, Marquess of Granby* 1763–5

Oil on canvas, 247.5 x 210.2

Collection of The John and Mable Ringling Museum of Art, Sarasota,
The State Art Museum of Florida

Reynolds submitted this portrait of Lord Granby (1721–70) to the Society of Artists exhibition of 1766, alongside that of another contemporary military hero, General Jeffrey Amherst (fig.13). Both pictures, painted soon after the successful conclusion of the Seven Years War against France (1756–63), express a muscular form of heroism that is tempered by references to the more private virtues of magnanimity and individual honour. In this case, Reynolds depicts the Commander-in-Chief of British Forces in Europe during the War standing on the battlefield at Vellinghausen, the scene of a major victory against the French in July 1761. Granby is depicted as a figure of Herculean strength and solidity, with something of the colossal presence and physical authority found in classical statues of martial gods and great commanders. His identity as a heroic figure is reinforced by the venerable symbolism of the breastplate strapped to his torso and by the pictorial attention given to the details of his general's jacket, which is resplendent with the sartorial signs of military authority. This stirring sense of command and alertness is further communicated by the manner in which the Marquess, his page and his horse stand on a rise that offers a commanding view of the surrounding landscape: all seem intensely alert to the activities around them. It is not only that the trio's bodies face in different directions, but also that their eyes – even the horse's – are shown sweeping across the smoking battlefield.

There is another way of understanding this image. It is signalled by the note Horace Walpole made in his catalogue to the Society of Artists exhibition of 1766: 'Given to Marshall Broglio'. The Marshall Duke of Broglie had commanded the French forces at Vellinghausen and, as a newspaper reviewer noted, Granby commissioned the painting for him. As such, this is a portrait that demands to be understood not only as a patriotic image of a famous English general in action, but also as a gift to a defeated, but honoured, opponent. Significantly, Reynolds shows Granby dismounted, and as such assuming a very different character to that which he would have enjoyed had he been depicted on horseback. On this reading, which is powerfully supported by earlier representations of magnanimous victory such as Velázquez's great *Surrender at Breda* (1634–5; Prado, Madrid), we are witnessing Granby as he momentarily turns away from the battle that rages behind him. Having stepped down from his horse he stands, metaphorically at least, at the same level as his defeated opponent, Broglie, to whom he now presents himself as a fellow-soldier, a respectful opponent and a private man. The symbolism of Granby's hands seems to confirm this interpretation: one remains gloved, a reminder of his just-interrupted 'public' activity as a man clasping the reins of his horse in battle; the other has just been bared, to reveal Granby in a more magnanimous guise, ready, as it were, to shake the hand of his defeated foe.

MH

Provenance
The Marshall Duke of Broglie; The Duke of Berghes, Chateau de Rannes, Normandy; C.J. Wertheimer, London, 1900; Duveen, from whom bought by Ringling in New York, 1927.

Literature
Northcote 1818, vol.1, p.204; Graves and Cronin 1899–1901, vol.1, pp.382–3; Waterhouse 1951, p.57; Mannings and Postle 2000, vol.1, p.322, vol.2, pl.56, fig.773.

Engraved
James Watson; S.W. Reynolds.

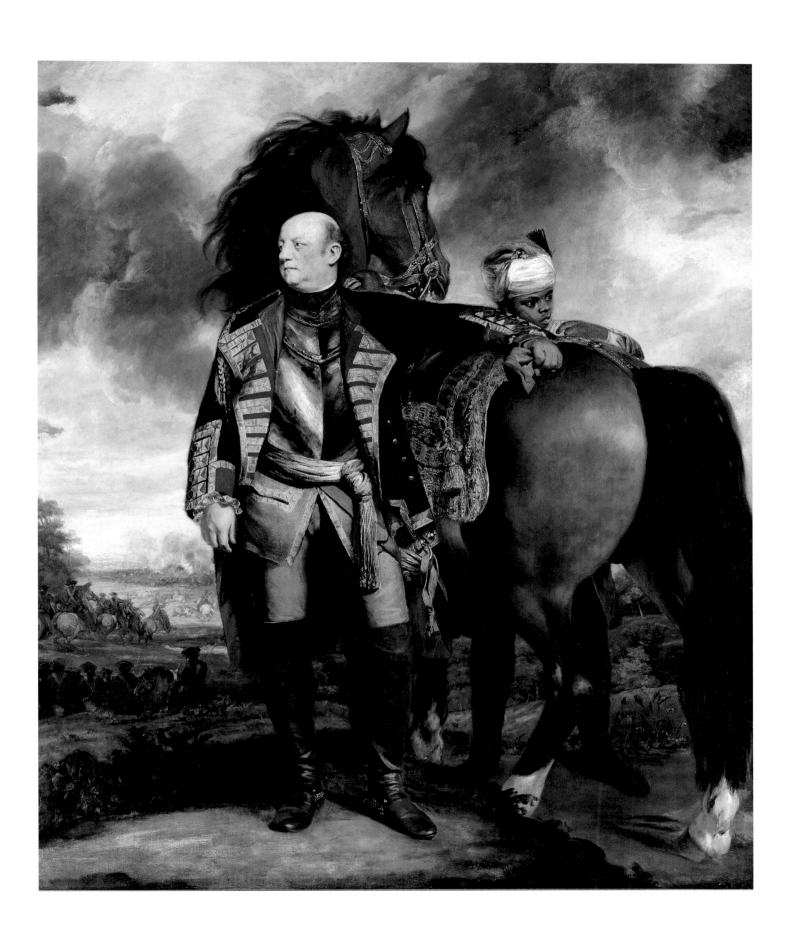

16. *John Burgoyne* 1766

Oil on canvas, 127 x 101.3

The Frick Collection, New York, Purchased 1943

Reynolds profited from the fact that senior army and navy officers in this period occasionally commissioned portraits marking the respect they felt for a fellow-officer or an opponent. Thus, the artist's portrait of the Marquess of Granby (cat.15) was commissioned as a gift for a defeated but honoured French general; similarly, George, 1st Marquess Townshend, who had served under Granby, commissioned from Reynolds a second version of the Granby picture and a new portrait of another of his former commanders, the Anglo-German general, Frederick, Count of Schaumburg-Lippe (1766–7 and 1764–7; both Royal Collection). Schaumburg-Lippe, in turn, commissioned this portrait of John Burgoyne (1722–92), presumably to celebrate the success and friendship the two men had enjoyed during their recent military campaign in Portugal.

John Burgoyne was a flamboyant soldier, known to his troops as 'Gentleman Johnny' thanks to his good manners and affability. In his later life he was also prominent as a successful playwright, and on his death was given a hero's burial in Westminster Abbey. Even so, his adult life had begun inauspiciously when, in 1743, he had courted scandal by eloping with Lady Charlotte Stanley, daughter of the Earl of Derby. Although Lord Derby disapproved of the liaison, he eventually relented and helped Burgoyne purchase a commission in the army. In 1762 Burgoyne was sent to Portugal as brigadier-general, to assist the Portuguese in their campaign against Spain's armies. In July, his troops dramatically captured the town of Valencia d'Alcantara, and in October they stormed the entrenched camp of Villa Velha, which brought the Portuguese campaign to its end.

Reynolds's portrait exemplifies the imagery of martial dominance enjoying wide currency in the immediate triumphal aftermath of the Seven Years War. It offers a suggestive parallel to the maritime portrait of Captain Augustus Hervey (cat.13), which was composed in a similar manner and has the same triumphal air. Here, Burgoyne towers above a battlefield filled with massed ranks of cavalry and infantrymen, while in the distance there is the skyline of a town, presumably Valencia d'Alcantara. The details of this fiery scene, together with the tumultuous, darkened sky, provide a dramatic pictorial narrative and symbolic backdrop, against which Burgoyne's figure is boldly presented in red, black and silver. He wears the uniform of the cavalry troop he himself had raised in 1759, the 16th Light Dragoons: one hand rests upon a tasselled, ornate sword, and the other holds a helmet decorated with the royal initials. While his body is turned directly to the viewer, and is shown as if relatively relaxed, his head and eyes turn to his right, as if distracted by the sound or sight of a nearby encounter on the battlefield. As is so often the case in his military portraiture, Reynolds fuses the pictorial languages of aristocratic poise and military command, enriching his work through such telling details as the turn of a head and the calmness of a hand. These aspects of the portrait are aligned with a particularly stripped-down form of pictorial colouring and composition, in which the artist exploits the visual effects generated by the juxtaposition of broad masses of bold colours, and crafts a taut formal interplay between Burgoyne's strikingly geometrical, regimented bodily outline and the edges of the rectangular, tightly abutting pictorial frame.

MH

Provenance
Paid for by Count la Lippe, the sitter's superior officer; by descent to the Princes of Schaumburg-Lippe at Buckeburg Castle, Germany, where inventoried *c.*1900 as by Benjamin West; sold (?1926) to P. Rusch of Dresden; J.P. Morgan, bought from his estate, through Knoedler & Co., New York, for the Frick Collection.

Literature
Graves and Cronin 1899–1901, vol.1, p.129; Waterhouse 1941, p.57; Frick 1968, pp.90–4; Mannings and Postle 2000, vol.1, pp.113–14, vol.2, pl.62, fig.874.

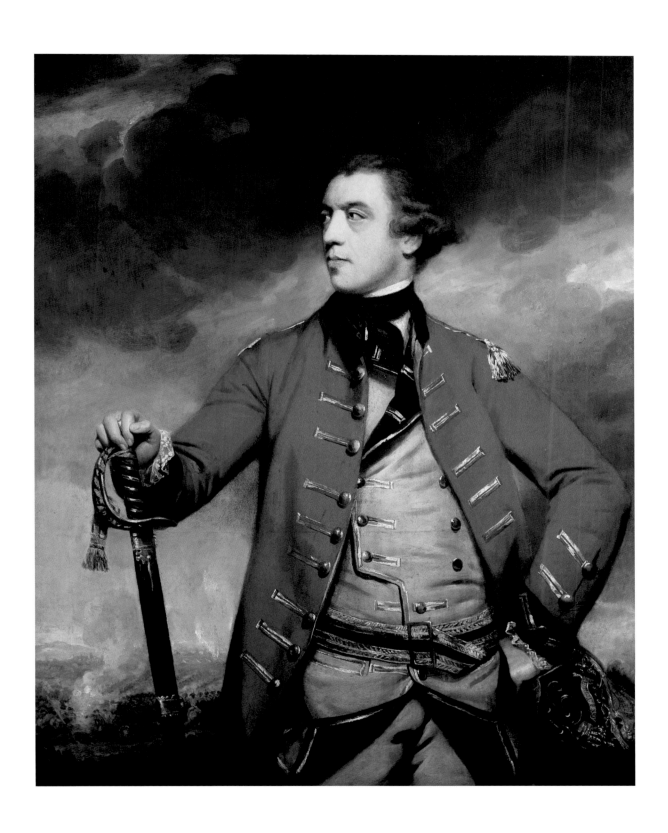

17. *Augustus, 1st Viscount Keppel* 1781–3

Oil on canvas, 124.5 x 99.1

Tate. Purchased 1871

Reynolds painted this portrait between 1781 and 1783 for the lawyer, Thomas Erskine, who had successfully defended Augustus Keppel (1726–86) during his celebrated court martial of 1779. Keppel's stance and expression appropriately exude defiance, his left arm propped upon his hip and his right hand firmly grasping the hilt of his sword. Framed against the sea and setting sun, he stands resolute, his body anchored on the rocky promontory. He appears, as Desmond Shawe-Taylor has acutely observed, the visual embodiment of William Hayley's lines in his *Epistle to Keppel* of 1779:

O ye! Our Island's Pride! And Nature's boast!
Whose peerless valour guards and gilds our coast.

Shawe-Taylor has also speculated that Keppel's expression, which he describes as 'resolute and almost comically bad-tempered', may have derived from the face of Neptune in Bernini's *Neptune and Triton* (1620; Victoria and Albert Museum, London; Shawe-Taylor 1990, p.47). Certainly, Reynolds admired Bernini's statue; so much so that a few years later he purchased it.

In January 1778 Keppel had been promoted to Admiral of the Blue, the third highest rank in the British Navy. Later that year he was involved in a skirmish with the French fleet off Ushant, a small island near Brest, at the entrance to the English Channel. Keppel had been forced to retreat, apparently as a result of the failure of his rear divisional commander, Vice-Admiral Hugh Palliser, to respond to his command (Crossland 1996, pp.42–8). The affair was quickly blown up in the press as a party political matter, with Keppel representing the Whigs and Palliser the Court party. As a result, Keppel was brought before a court martial at Plymouth, where a 'guilty' verdict could have resulted in the death penalty. The trial, which opened in January 1779, resulted in Keppel's honourable acquittal.

Although the battle had been fought in the courtroom rather than at sea, it was reckoned to be one of Keppel's most significant victories, especially by his close friends among the Rockingham Whigs, who regarded the trial as an attempt by the administration of Lord North to discredit one of their heroes. To his political allies Keppel was the epitome of the archetypal Whig grandee, a man who was, as Burke put it, 'decorated with honour, and fortified by privilege' (Leslie and Taylor 1865, vol.2, p.238).

The day after his acquittal Reynolds wrote to congratulate Keppel, telling him he had 'taken the liberty, without waiting for leave, to lend your picture to an engraver, to make a large print from it' (Ingamells and Edgcumbe 2000, p.81). The engraving was duly made by his pupil William Doughty (fig.23). Keppel also commissioned a new portrait of himself from Reynolds, in his flag-officer's undress uniform, and with his hand resting prominently upon the pommel of his sword (returned to him following the court martial). This portrait was replicated several times by the artist, versions being presented to his lawyers John Lee and John Dunning, and to Edmund Burke (see Mannings and Postle 2000, vol.1, pp.289–90). A replica also appears to have been made for Thomas Erskine, although this was not, as has often been supposed, the present picture, which was a separately commissioned portrait.

MP

Provenance
Painted for Thomas, afterwards Lord, Erskine, at whose sale bought by Peacock; Thomas Wright, his sale Christie's 7 June 1845 (52), bought Stephenson for Sir Robert Peel; acquired by the National Gallery with the Peel Collection 1871; transferred to the Tate Gallery 1919.

Literature
Waagen 1854, vol.1, p.414; Cotton 1859, pp.70, 95; Leslie and Taylor 1865, vol.2, p.235; Graves and Cronin 1899–1901, vol.2, pp.543–4; Waterhouse 1941, p.72 and pl.214; Cormack 1968–70, p.157; Shawe-Taylor 1990, pp.46–8; Mannings and Postle 2000, vol.1, p.290, vol.2, pl.92, fig.1367.

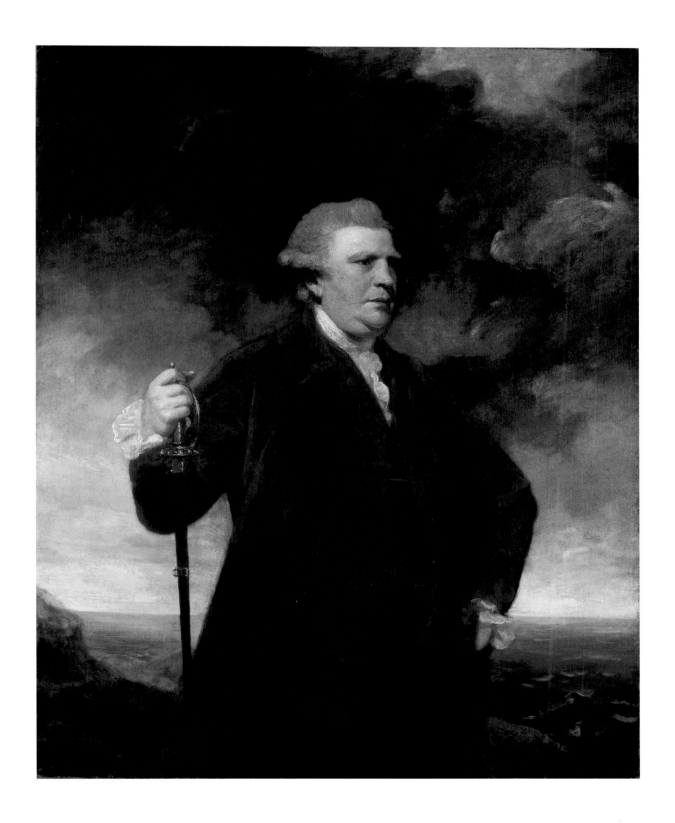

18. *George Augustus Eliott, Lord Heathfield* 1787

Oil on canvas, 142 x 113.5

National Gallery, London

Just weeks before he sat for this painting, General George Eliott (1717–90) had been granted the title of Lord Heathfield, a reward from the state for his remarkable achievements as Governor of Gibraltar over the previous decade. Heathfield had become a national hero after he and his troops successfully defended the peninsula against a three-year siege and blockade mounted by the Spanish and French between 1779 and 1782. This ordeal culminated in a spectacular victory for the Rock's exhausted defenders in September 1782, when their cannon set fire to a flotilla of heavily armed Spanish ships, brought into the harbour to pound the British garrison into submission. The destruction of these floating batteries was followed a month later by the arrival of a British fleet under Lord Howe, which brought an end to the siege, and began a period of national rejoicing, in which Eliott was lauded for his indomitable leadership. Eliott was invested with the Order of the Bath in the following year, and finally returned to England after a ten-year term of duty in 1787, the year that Reynolds painted this portrait.

Significantly, the artist's patron in this instance was not Heathfield himself, but John Boydell, the print entrepreneur and London alderman. Boydell wished to display the picture in a patriotic gallery of pictures he planned to install at the Guildhall, and to exploit commercially Lord Heathfield's celebrity through the sale of prints after the painting. Reynolds crafted for Boydell an image marked by a brilliant economy of means. Heathfield is depicted supervising the defence of the Rock from an elevated, solitary bastion, shrouded by black smoke, and bracketed by two of the cannon that wreaked such havoc on the floating batteries. The old soldier gazes out resolutely, his ruddy, weatherbeaten face and sheer physical presence succinctly communicating the implacability and resilience of the British defence of the island. Heathfield's tight grip upon the huge key is clearly meant to symbolise both his and his nation's dogged loyalty to its colony. Significantly, as Judy Egerton has remarked, Gibraltar itself had in the past been given such names as 'The Key' and 'The Lock' (Egerton 1998, p.231). Such analogies are futher reinforced by the gold chain that wraps itself twice around Heathfield's right knuckle. Meanwhile, his left hand is left open, perhaps – as Desmond Shawe-Taylor has suggested – to indicate that the

Governor is contemptuously tapping the key in the face of enemy assault or, alternatively, to imply the more generous, open-handed form of colonial rule that Heathfield's fierce defence of the island was protecting, and that shall return once the siege has been lifted.

As well as satisfying Boydell, Reynolds himself made good use of the picture, maintaining his long-standing practice of sending such heroic military portraits to exhibition. *Heathfield* was one of his major submissions to the 1788 Royal Academy, and hung close to another of his dramatic military portraits, *Colonel George Morgan* (National Museum of Wales, Cardiff), in which Morgan is depicted standing on another rocky outcrop, similarly framed by black smoke and juxtaposed with the sea. Visitors to that year's exhibition were thus offered the chance to enjoy a double pictorial commemoration of military heroism by Britain's leading portraitist, one that encouraged the spectator to look back and forth between these two stalwart figures, and to appreciate their portraits both as exceptional works of art and as patriotic symbols of British fortitude.

MH

Provenance
Painted for Alderman John Boydell, who gave it to the Corporation of the City of London, 1794; acquired 1809 by his nephew Josiah who sold it to Sir Thomas Lawrence, 1809; J.J. Angerstein; bought by the National Gallery in 1824.

Literature
Northcote 1818, vol.2, p.235; Graves and Cronin 1899–1901, vol.2, pp.455–6; Waterhouse 1941, p.79; Shawe-Taylor 1990, p.49; Postle 1995, pp.54, 305, 322, n.98; Egerton 1998, pp.228–33, Mannings and Postle 2000, vol.1, pp.180–1, vol.2, pl.115, fig.1507.

Engraved
Richard Earlom 1788.

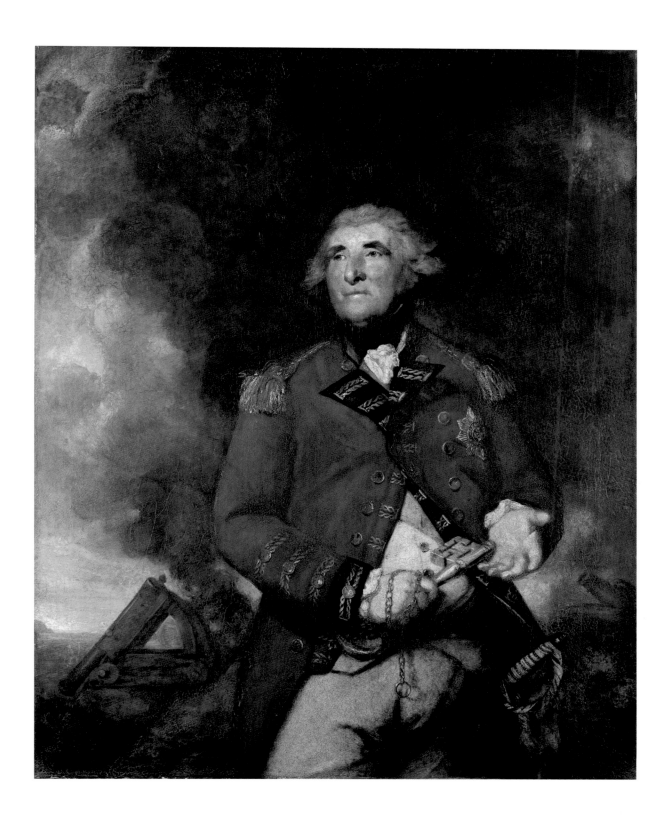

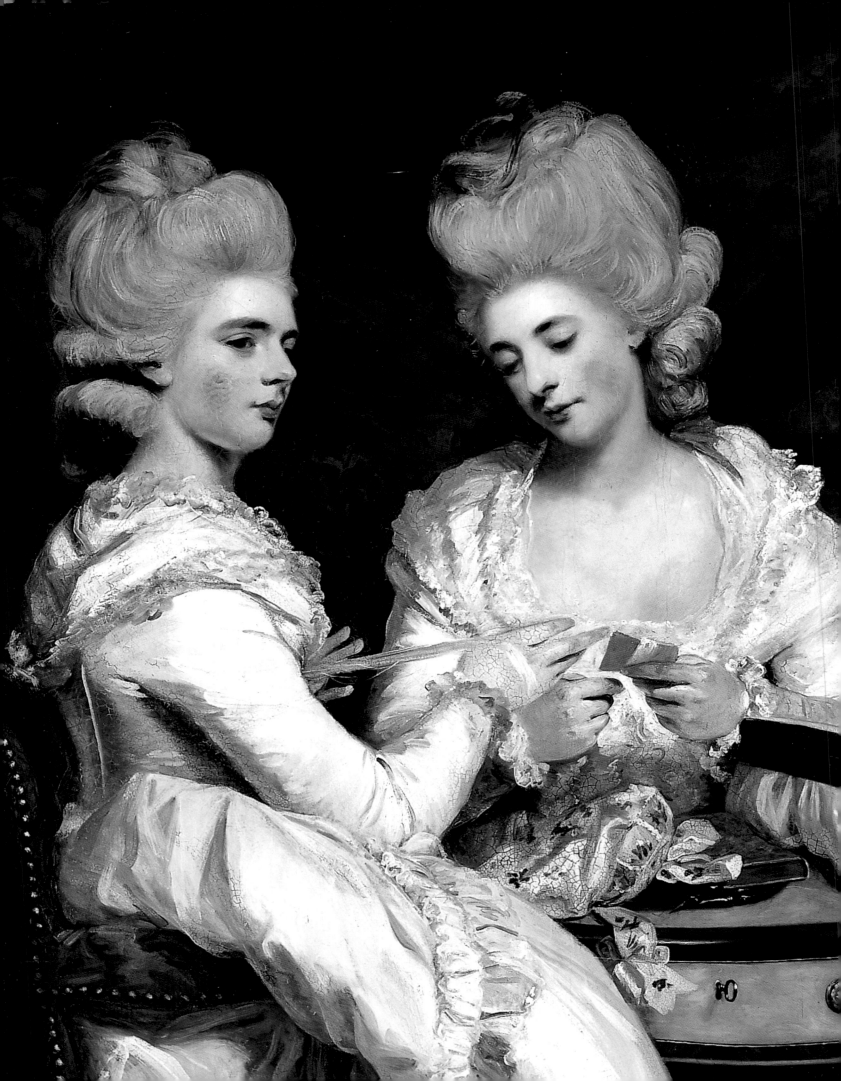

Aristocrats

As with the most successful portraitists of the age, Reynolds assiduously cultivated a network of aristocratic patrons, whose portraits he painted and whose dynastic and political ambitions he implicitly endorsed. Although he painted a wide cross-section of fashionable society, Reynolds's most influential patrons were ultimately those Whig aristocrats who challenged the hegemony of the King and the power of the Crown. During his twenties, Reynolds courted the aristocracy and landed gentry of Devon and Cornwall, notably the Edgcumbe and Eliot families. Through the Edgcumbes, he gained introductions to the most influential Whig families, notably the Keppels; his friend Augustus Keppel (cats.9 and 17), for instance, was not only a successful naval officer, but the son of the Earl of Albemarle. On his return from Italy in 1752, Keppel used his political and social contacts to secure for Reynolds the patronage of major Whig families – the Cavendishes, Russells, Spencers and Wentworths.

When George III – the 'patriot king' – acceded to the throne in 1760, Reynolds also hoped for Royal patronage. However, it quickly transpired that the King's preference lay with the Scots painter, Allan Ramsay. Faced with this impasse, Reynolds continued to strengthen his ties to the Whig party. In fulfilling this ambition he was greatly assisted by his friend Edmund Burke (cat.45), the writer and politician, who was at that time emerging as the scourge of the Court party. It was no doubt through Burke that Reynolds also gained the patronage of Lord Rockingham (cat.22), leader of the Whig opposition and, for a brief moment in the mid-1760s, Prime Minister. Despite George III's dislike of Reynolds, he was nevertheless elected as the first President of the Royal Academy in 1768. He was also the first major portrait painter in the history of British art to receive a knighthood, in spite of his indifference to Royal protocol, and the personal enmity of the King.

At the Royal Academy during the 1770s, Reynolds celebrated the allure of the aristocracy through a series of spectacular full-length portraits of titled women, pictures that consciously recalled the 'beauties' painted by the Court painters of the previous century, Sir Peter Lely and Sir Godfrey Kneller. Throughout his fifty-year career, Reynolds often painted several generations of the same family, and produced portraits of the same aristocratic personage in both childhood and maturity. His portraits adeptly served to portray the strength and continuity of particular dynasties, through grand family portraits as well as pictures of duchesses and countesses with small children and babies. In these latter works, he eschewed the formal vocabulary of official portraiture in favour of images displaying intimacy and tenderness. Inspired, in part, by the theme of the Madonna and Child found in Old Master paintings, these portraits also celebrated 'modern' attitudes towards motherhood adopted by progressive figures such as the Duchess of Devonshire (cat.29).

By the early 1780s many of Reynolds's aristocratic patrons, whom he now counted as personal friends, were pinning their hopes of gaining political power and advancement at Court on the King's son, George, Prince of Wales. Despite the fact that he had been sworn in as Painter to the King in 1784, Reynolds enthusiastically joined the entourage of the Prince, who, despite his charm and good looks, was a consummate fantasist and serial adulterer. He was also heartily disapproved of by his father. Reynolds painted the Prince's portrait in various guises: as heir to the throne (cat.31), as a swashbuckling military hero (fig.5), and even as a fashionable 'pin-up' (cat.30). By his death, Reynolds's success in courting the aristocracy was unparalleled in modern times. While his arch-rival, Thomas Gainsborough, had received a modest burial in a quiet churchyard, attended by a few close friends, Reynolds's body was borne to the grave in state by ten pall-bearers. They numbered three dukes, two marquesses, three earls, a viscount and a baron.

MP

The Ladies Waldegrave 1780–1 (detail of cat.27)
National Gallery of Scotland, Edinburgh

19. *The Ladies Elizabeth and Henrietta Montagu* 1763

Oil on canvas, 152.5 x 114

Collection of the Duke of Buccleuch and Queensberry KT

Reynolds sent this double portrait to the 1763 Society of Artists exhibition, one of four works another of which was a picture of the celebrated courtesan Nelly O'Brien (see cat.52). Noting this, we can suggest that Reynolds's portrait of the aristocratic, unmarried and youthful Montagu sisters – Elizabeth (1743–1827) was at the time twenty years old and Henrietta (1750–66) thirteen – provided a striking point of comparison with that of their worldly counterpart hanging nearby. Comparing the portrait of the Montagu sisters with that of O'Brien allows us to recognise the ways in which Reynolds's images of female aristocratic sitters were subtly aligned with, and yet distinguished from, those picturing less obviously respectable women such as courtesans. Intriguingly, the two images initially look rather similar: in particular, Elizabeth Montagu's informal pose, flowing dress, exposed shoulder and direct address to the viewer suggest that she, like O'Brien, is meant to be appreciated as an embodiment of youthful female beauty and desirability. If such details highlight the physical attractiveness of a highly eligible young aristocrat, the comparison with the courtesan's portrait also points to the ways in which Reynolds ensured that Lady Elizabeth was quickly distinguished from her more dubious counterpart.

Significantly, Elizabeth Montagu lacks the jewellery that bedecks O'Brien's hair, neck and wrist, suggesting that she remains untainted by either vanity or a love of luxury. More importantly, Lady Elizabeth is depicted as someone enjoying the pure, filial tenderness of a sisterly relationship, rather than as someone whose entire public identity was defined by her sexual relationships with men. In the portrait of O'Brien, the mythological character Danaë is depicted in carved relief on the side of the stone block upon which she leans. This must have acted as a compelling visual link for an eighteenth-century viewer, for whom the carved figure would have been synonymous with tales of prostitution. In contrast, the stone upon which Lady Elizabeth's left arm rests remains bare, and her right arm protectively embraces her younger sister, who looks up to her with a very different kind of adoration to that invited by her painted neighbour in the exhibition room. Thus, even though she is given some of O'Brien's sensuous

glamour, Lady Elizabeth is also studiously distanced from the narratives of promiscuous sexuality signified by the courtesan.

MH

Provenance
By descent.

Literature
Graves and Cronin 1899–1901, vol.2, p.656; Waterhouse 1941, p.53; Mannings and Postle 2000, vol.1, p.338, vol.2, fig.732.

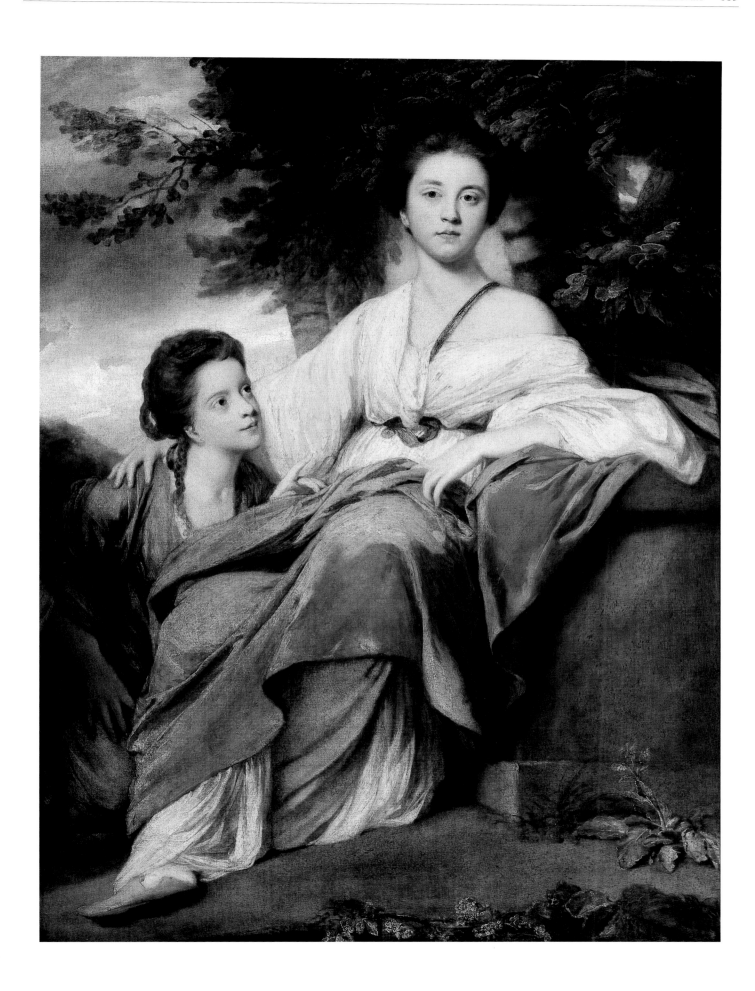

20. *Caroline, Duchess of Marlborough and her Daughter, Lady Caroline Spencer* 1764–7

Oil on canvas, 127 x 101

His Grace the Duke of Marlborough, Blenheim Palace

This portrait of Caroline, Duchess of Marlborough (1743–1811), was commissioned from Reynolds by George, 4th Duke of Marlborough, to celebrate the birth of Lady Caroline Spencer (1763–1813) in October 1763. It was intended, from the outset, to be displayed in the context of one of the country's finest Old Master collections, at Blenheim Palace, Oxfordshire. The attitudes of the Duchess and her daughter were based upon the figure of a mother and child in one of the lunettes in the Sistine Chapel depicting Christ's ancestors. These figures, which Reynolds would only have seen from a distance when he visited the Sistine Chapel in the 1750s, would have been accessible to him through the well-known engravings of Adamo Scultori, first published in the late sixteenth century (see Penny 1986, p.348, fig.91). Reynolds softened the severity of Michelangelo's image through the introduction of a second Old Master source, Raphael's celebrated *Madonna della Sedia* (*c*.1514; Pitti Palace, Florence). From this painting, he derived the slightly bowed head of the mother, looking out towards the viewer, as well as the shawl around her shoulders and the ornate carved chair-back. The Duchess herself is clothed in classical robes, which further accentuate the portrait's deliberate evocation of antiquity. It was a form of dress Reynolds often adopted in his portraits of aristocratic women, especially during the 1760s. In doing so, Reynolds aspired ostensibly to transcend the vagaries of contemporary fashion. These 'timeless' draperies, however, served to confirm the status of these titled individuals within the upper echelons of society.

Caroline, Duchess of Marlborough, was the only daughter of John Russell, 4th Duke of Bedford, and his second wife, Gertrude. The Russells had been patrons of Reynolds since the 1750s, when he had painted Lady Gertrude's portrait. Later in the decade he painted the Duke's portrait, as well as that of Lady Caroline, who was then engaged to the Duke of Marlborough (Mannings and Postle 2000, vol.1, pp.400–1, 422). The marriage of Caroline Russell to George Spencer, 4th Duke of Marlborough, in August 1762 represented the union of two of the nation's leading aristocratic dynasties, both with strong affiliations to the Whig party. Reynolds, by this time, had also painted the Duke of Marlborough's portrait, as well as those of other members of the Spencer family. Over the next fifteen years

or so, Reynolds became in all but name the official portraitist to the Marlborough family.

In 1775 Reynolds exhibited a portrait of the Duke and Duchess's younger children, Lord Henry and Lady Charlotte Spencer, at the Royal Academy, a work which became known as *The Young Fortune-Teller* (Huntington Art Gallery, San Marino). A year or so later he painted a full-length portrait of the Duchess. This picture, for which no payment is recorded, remained with Reynolds (see Mannings and Postle 2000, vol.1 p.422), suggesting that it may have been painted of his own volition, rather than as a commissioned portrait. In 1778 the Duke of Marlborough and his family became the subject of the most ambitious group portrait of Reynolds's entire career (fig.39). This animated portrait depicts the Duke and Duchess, together with their six children, in a grand baroque interior, reminiscent of the family's ancestral home, Blenheim Palace, where it still hangs today. Occupying a matriarchal role at the centre of the composition is the Duchess, by then a leading light in fashionable London society, as well as the organiser of lavish private theatricals at Blenheim. At the extreme right stands her daughter, Lady Caroline, by now an attractive, self-assured teenager.

MP

Provenance
By descent.

Literature
Leslie and Taylor 1865, vol.1, p.237; Hamilton 1884, p.117; Graves and Cronin 1899–1901, vol.2, p.625; Penny 1986, pp.226–7, 347–8; Wind 1986, p.20, figs.1–2; Mannings and Postle 2000, vol.1, pp.422–3, vol.2, fig.815.

Engraved
James Watson, published 20 May 1768; Richard Houston, 15 July 1769; 'H Fowler' (an alias of Richard Purcell); S.W. Reynolds.

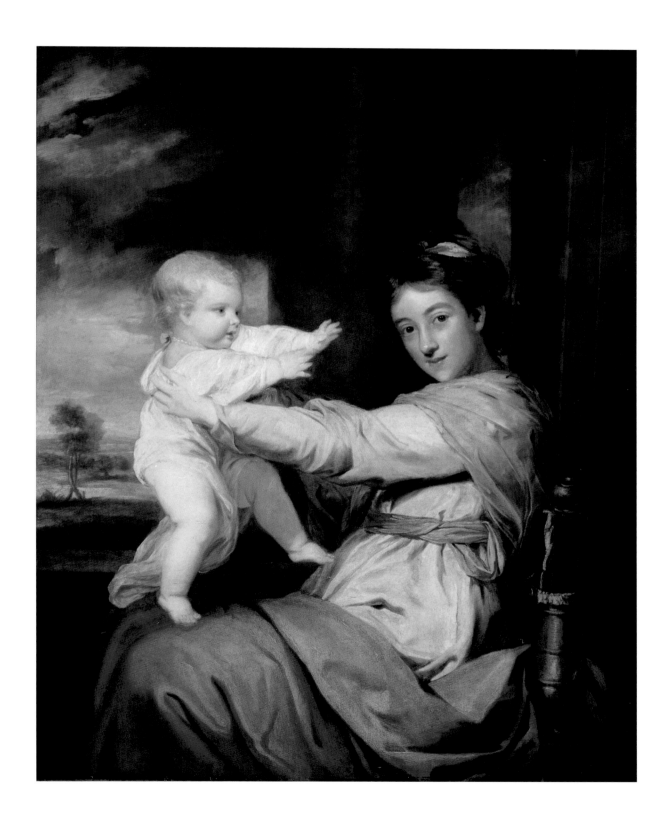

21. *John Murray, 4th Earl of Dunmore* 1765

Oil on canvas, 238.1 x 146.2

Scottish National Portrait Gallery, Edinburgh

Unlike his contemporary Allan Ramsay, whose Scottish connections led to his painting a number of portraits of aristocrats and soldiers in Highland dress, Reynolds painted only one such picture – that of John Murray (1730–1809). Interestingly, Reynolds seems to have produced this work as a speculation, possibly with the aim of using it as a 'show picture' to hang in his own gallery. The portrait draws upon an iconography of martial, aristocratic Scottishness that was developed by artists such as Ramsay. As recently as 1763 Ramsay had painted a full-length portrait of William, the 18th Earl of Sutherland and a lieutenant-colonel in a Highland regiment, in similar fashion (The Sutherland Trust). Both men are shown wearing a kilt, feathered bonnet and patterned socks, carrying a sword, and standing in a similarly rugged landscape. The dress worn by Sutherland and Murray was not dictated merely by familial and national tradition, but also by recent political and military crises. Following the Jacobite rebellion of 1745–6, the Dress Act of 1747 had made the wearing of such Highland clothing illegal for all, with the exception of officers and soldiers serving in Scottish military regiments. This Act, repealed only in 1782, meant that, when Ramsay and Reynolds painted such portraits, the appearance of plaid in images of the Scottish ruling elite had become symbolic not of rebellion, but of the burgeoning political and military links being fostered between the Scottish aristocracy and the British State.

In Reynolds's portrait Murray wears the Highland dress of the 3rd Regiment of Foot Guards, a regiment with which his family had enjoyed a long association, and which had recently seen European service during the Seven Years War. Striding authoritatively forward, he clasps a sheaf of weapons to his chest, and is framed by the storm clouds that Reynolds regularly used to dramatise his military portraits. Here, however, these dark clouds swirl not over a battlefield, but over a landscape that is presumably meant to represent the Scottish Highlands. At one level, this environment can be appreciated as one of rugged beauty, its features conforming to contemporary ideals of the Scottish landscape. At another level, Murray's setting can be understood as resonant of Scotland's recent history. Here it is worth noting the prominently placed detail of the blasted tree-trunk on the left, complete with its violently snapped branch, and the clump of withered and torn leaves introduced into the

picture's foreground. Tellingly, this botanic iconography of breakdown and of death is juxtaposed with signs of natural regeneration: the cluster of leaves standing in the crook of trunk and broken branch, the flowers that emerge from the shadows at the base of the old tree. This imagery of collapse and renewal fits the broader story that patriotic, loyalist defenders of the British State wished to tell about the Scottish Highlands themselves. These loyalists argued that the Highlands, brutalised and depopulated during the terrible conflicts of 1746–7, were now being governed and restored to order by a new generation of Scottish noblemen loyal to the crown – men like Murray himself, who was later to become the Crown Governor of New York and Virginia. Yet, intriguingly, Reynolds's portrait seems to linger as much on the dark side as on the bright side of the landscape, as if to suggest that this is a person, and a territory, still marked by the scars of battle, and by the memory of past conflicts.

MH

Provenance
Greenwood's 16 April 1796 (42) bought by Inchiquin; Thomond sale 19 May 1821 (46) bought by W. Woodburn; at Dunmore Park by 1827; thence by descent to Charles W. Murray, Kishorn, Strathcarron, Ross-shire; loan to SNPG 1938; purchased by SNPG from Mrs Helen Zipperlen 1992 with help from National Art Collections Fund and National Heritage Memorial Fund.

Literature
Graves and Cronin 1899–1901, vol.1, p.268; Waterhouse 1941, p.56; Smailes 1990, p.96; *National Art Collections Fund Review* (year ended 31 Dec. 1992) no.41; Mannings and Postle 2000, vol.1, p.347, vol.2, pl.61, fig.834.

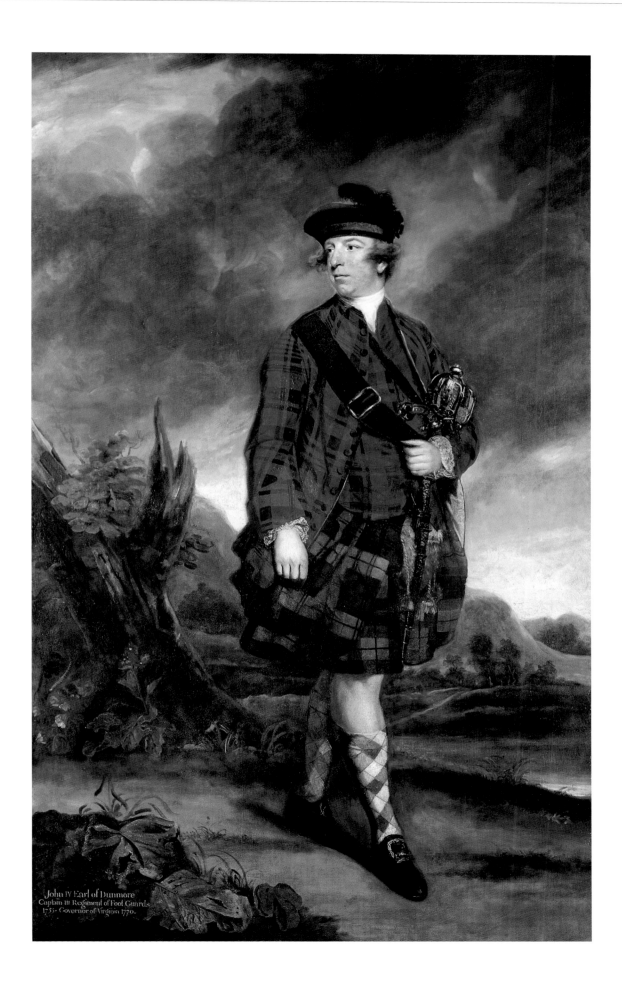

John IV Earl of Dunmore
Captain III Regiment of Foot Guards
1755. Governor of Virginia 1770.

22. *Charles Watson Wentworth, 2nd Marquess of Rockingham* 1766–8

Oil on canvas, 239 x 148

Lent by the Trustees of the Rt. Hon. Olive, Countess Fitzwilliam's Chattels Settlement, by Permission of Lady Juliet Tadgell

From the late 1750s onwards, Reynolds enjoyed close links with the Whig party and this portrait features the leading Whig politician of the mid-1760s, the Marquess of Rockingham (1730–82). Rockingham belonged to one of the country's great landed families, the Wentworths, who, together with a number of other aristocratic dynasties such as the Cavendishes, made up a Whig aristocratic alliance that wielded enormous political power for much of the century. Rockingham himself had recently resigned as Prime Minister after heading the short-lived Whig administration of 1765 to 1766. He remained highly active in politics, heading another government in the months before his death in 1782. Reynolds seems to have begun this picture late in 1766, alongside an unfinished painting representing Rockingham seated informally with his secretary Edmund Burke (Fitzwilliam Museum, Cambridge). In the painting shown here, Rockingham is presented, by way of contrast, in his 'public' capacity, wearing the elaborate robes and historically resonant costume of the prestigious Order of the Garter, which dates back to the fourteenth century. The details of his dress, together with the grandiloquent classical columns that stand behind him, serve to promote Rockingham's lineage and political authority: he is, the picture implies, a modern successor to the great aristocrats and statesmen of British and classical history.

Of particular interest is the circular, classically decorated table to the left of the painting, which is bestrewn with a clutter of papers, folios and books, and surmounted by a feathered quill. The implication here is that Rockingham has been busily drafting a speech or legislative document, energetically consulting a range of relevant materials in the process – Reynolds even depicts a bookmark emerging from the pages of the thick volume that lies at the base of the table leg. The fruit of this intensive activity, we can plausibly infer, is the manuscript or document that Rockingham holds in his outstretched right hand. It is easy to imagine that he will later unfurl and speak from this document, or one like it, on the floor of the Houses of Parliament. Furthermore, Rockingham is granted a distant gaze, implying that his thoughts have moved away from his immediate environment, while his senatorial pose rehearses the kind of stance he would adopt whilst giving a speech in Westminster. Yet even as such details subtly allude to

Rockingham's participation in the world of politics, Reynolds's portrait also seems to idealise political leadership as an essentially solitary and meditative activity. The once and future Prime Minister, having assumed the robes and responsibilities of high office, stands secluded and alone, as if pondering the great issues of the day.

MH

Provenance
By descent to the 10th Earl Fitzwilliam (d.1979); passed to Lady Juliet Tadgell (née Fitzwilliam).

Literature
Smith 1828, vol.2, p.296; Waagen 1854, vol.3, p.338; Graves and Cronin 1899–1901, vol.2, p.837; Waterhouse 1941, p.58; Mannings and Postle 2000, vol.1, p.467, vol.2, fig.905.

Engraved
Edward Fisher 1 July 1774.

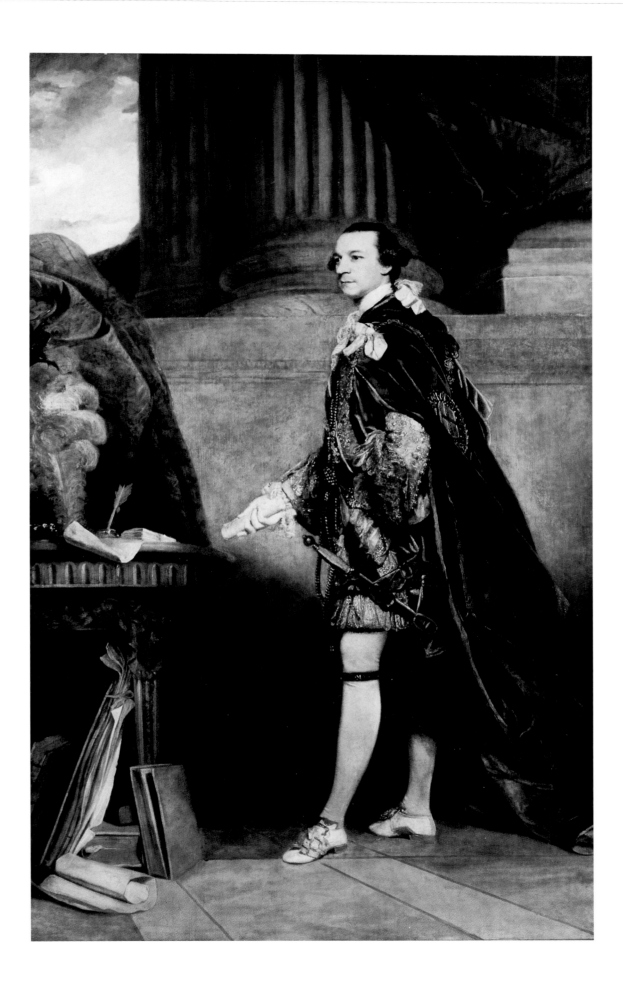

23. *John Joshua and Elizabeth Proby* 1765

Oil on canvas, 119.4 x 96.5

Elton Hall Collection

John Joshua Proby (1751–1828) probably first met Reynolds in 1765, when, as a teenager, he sat for the present portrait with his younger sister Elizabeth (1752–1808). Although neither the young Proby nor Reynolds would have been aware at the time, their relationship was to be of great mutual benefit, to Reynolds's international career, and to Proby's reputation as a collector of discernment. In this portrait Reynolds depicts the Proby children as young adults. John Joshua was, as his father's only surviving son, heir to the family's titles and estates, while his sister, also a young teenager, was already of marriageable age.

Proby's father, John, 1st Baron Carysfort, who had recently married a wealthy Irish heiress, sat for his portrait to Reynolds in the mid-1750s, sporting a dashing white satin 'Van Dyck' costume, his pose based upon the figure of Lord Russell in Sir Anthony Van Dyck's double portrait of Lords Digby and Russell (*c*.1637; Althorp). Ten years later, in his portrait of the Proby children, Reynolds was influenced by the double portrait by Rubens of his two sons (*c*.1625; Palais Lichtenstein, Vienna), the elder of whom Reynolds used as the model for John Joshua's pose and for his elaborate 'Van Dyck' costume (see Borenius and Hodgson 1924, no.86). Both the portrait of Lord Carysfort and that of his children were inspired by the example of the Old Masters. At the same time, their flamboyant outfits, reminiscent of dress worn at masquerades, marked out the members of this aristocratic family as belonging to fashionable contemporary society.

On the death of his father, who had reduced the family fortunes through his gambling, John Joshua Proby looked to Reynolds to guide his taste. As well as commissioning family portraits from Reynolds, he purchased several 'fancy pictures'. These included *Mrs Hartley as a Nymph with a Young Bacchus* (cat.53), as well as a version of *A Strawberry Girl* (Mannings and Postle 2000, vol.1, p.565). As Nigel Aston has observed, it may have been the 'lure of celebrity' rather than any aesthetic criterion that had attracted Proby to the portrait of the sensuous Mrs Hartley (Aston 1988, p.206). In 1784 Proby also purchased Reynolds's most overtly erotic painting, *A Nymph and Cupid* (Tate), popularly known as 'The Snake in the Grass'.

In 1783, following the death of his first wife, Proby embarked upon a diplomatic career in Russia, at the court of Catherine the Great. Two years later he secured Reynolds a prestigious commission from the Empress to paint a history painting of his own choice. The resulting picture was *Infant Hercules Strangling the Serpents* (The Hermitage State Museum, St Petersburg), which he completed in 1788. Proby also succeeded in selling two of Reynolds's subject pictures, including a version of *A Nymph and Cupid*, to Prince Grigori Aleksandrovich Potemkin, Russian general and erstwhile lover of the Empress. Proby, who was made 1st Earl of Carysfort in 1789, continued to take an interest in Reynolds's art after his death, and purchased an unfinished study of Kitty Fisher at Reynolds's posthumous studio sale (see Mannings and Postle 2000, vol.1, p.189). He also built up a fine collection of Italian and Dutch Old Masters. Unfortunately, since his son and heir had been certified as insane following wounds received in battle, Lord Carysfort authorised his executors to sell, at their discretion, any of his paintings after his death aside from his own family's portraits. His pictures by Reynolds, barring the portraits and the sketch of Kitty Fisher, were duly sold.

MP

Provenance
By descent.

Literature
Graves and Cronin 1899–1901, vol.2, pp.774–5; Borenius and Hodgson 1924, no.86; Waterhouse 1941, p.56; Aston 1988, pp.205–10; Prochno 1990, pp.108–10; Mannings and Postle 2000, vol.1, p.386, vol.2, fig.836.

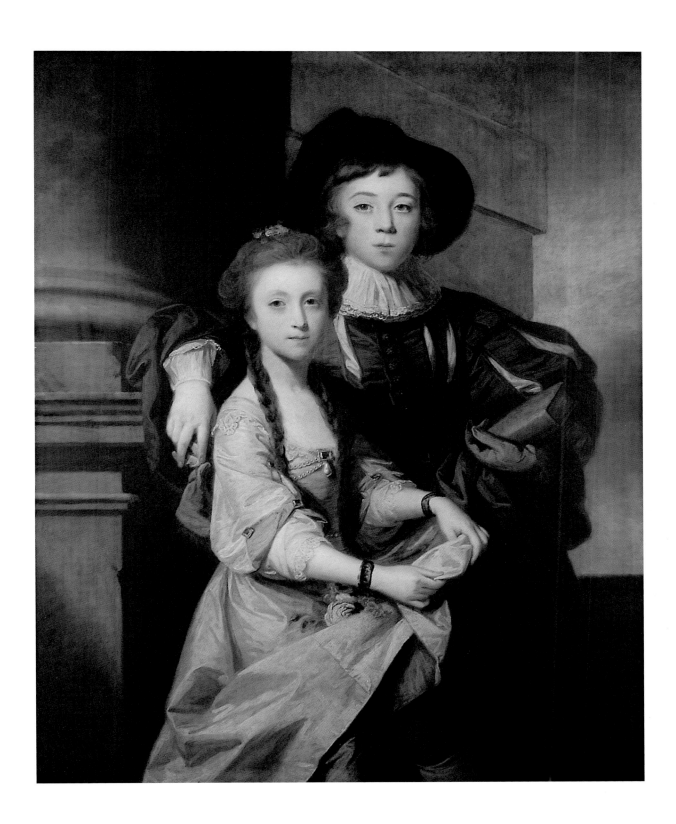

24. *Jane Fleming, afterwards Countess of Harrington c.1775*

Oil on canvas, 236 x 144

The Earl and Countess of Harewood and the Trustees of the Harewood House Trust

Jane Fleming (1755–1824) was the younger daughter of Sir John Fleming of Brompton Park, Middlesex, and the sister of the flamboyant Seymour Dorothy Fleming, who gained notoriety under her married name, Lady Worsley (cat.55). In 1770, following the death of their father, Lady Fleming (as their mother continued to call herself) married the Yorkshire sugar magnate, Edwin Lascelles, at whose estate, Harewood, she and her daughters went to live. At this time Lascelles was completing work on a new house, with lavish interiors designed by Robert Adam. By the mid-1760s, in addition to his own portrait, Lascelles had commissioned a full-length portrait of his nubile young relative, Jane Hale, in the character of 'Euphrosyne' (see Mannings and Postle 2000, vol.1, pp.233–4). Around 1775, by which time she was twenty, Jane Fleming became the subject of the present work, the second grand mythological portrait by Reynolds at Harewood.

In this painting Jane Fleming stands in profile, wearing a white silk gown with a gold embroidered sash at her waist. Her hair is coiffured in a toned-down form of the latest fashion, which demanded an elaborate headdress of pearls, plumes and assorted rich fabrics. In her hand she proffers a garland of flowers, her figure set against an early morning sky, amid a wooded glade. The portrait was, like that of Jane Hale at Harewood and numerous other aristocratic female full-length portraits by Reynolds, a deliberate exercise in what Reynolds referred to in his fifth Discourse of 1772 as the 'Historical Style', which endowed the figure with the 'simplicity of the antique air and attitude'. At the same time, it was important that the young women in such pictures were recognisable to their peers since, through the medium of Reynolds's portraiture, they entered the pantheon of the most desirable 'beauties' of the age. Jane Fleming's portrait, exhibited at the Royal Academy in 1775, provided a means for Reynolds to demonstrate the Historical Style. For his subject, and her family, it presented her to fashionable society, and no doubt placed her firmly on the marriage market. Well connected and endowed with good looks, Jane Fleming was also a woman of wealth in her own right, as co-heir to Sir John Fleming's lands and property.

Reynolds achieves the transformation of Jane Fleming into a creature of mythological proportions, as Desmond Shawe-Taylor has observed, through her personification as Aurora,

goddess of the dawn. As he explains, Reynolds has adapted the traditional iconographical trappings of Aurora for his portrait, including 'a dress of white, red and orange to evoke the colour changes in a dawn sky'. Jane Fleming was evidently pleased with the result, for three years later she had her portrait painted once more by Reynolds, again at full length in flowing draperies (Huntington Art Gallery, San Marino). In 1779 she married Charles, 3rd Earl of Harrington, a liaison which resulted in seven sons and four further portraits by Reynolds, including one of her military husband heroically attired in armour (1782; Yale Center for British Art, New Haven), and her own portrait, with her two eldest sons (1784–7; Yale University Art Gallery).

MP

Provenance
Painted for the sitter's mother, Mrs Lascelles (formerly Lady Fleming), afterwards Lady Harewood; Henry, 2nd Earl of Harewood; thence by descent.

Literature
Graves and Cronin 1899–1901, vol.2, p.438; Borenius 1936, p.168, no.412; Shawe-Taylor 1990, p.157; Mannings and Postle 2000, vol.1, p.431, vol.2, pl.78, fig.1281.

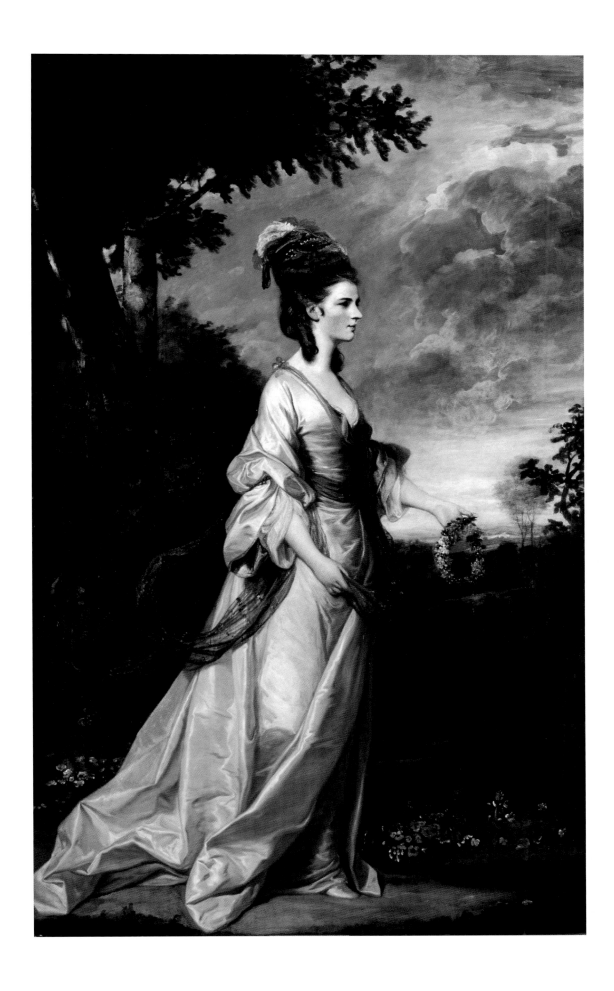

25. *Lady Bampfylde* ?1776–7

Oil on canvas, 238.1 x 148

Tate. Bequeathed by Alfred de Rothschild 1918

Catherine Moore (*c*.1754–1832), the elder daughter of Admiral Sir John Moore, married Charles Warwick Bampfylde on 9 February 1776. Several months later, in August 1776, Bampfylde succeeded his father as 5th Baronet. The present portrait was presumably commissioned to celebrate the couple's marriage. Lady Bampfylde is dressed in flowing white draperies, a pansy in her bosom; her right hand gestures towards a white lily, the time-honoured emblem of purity. Lady Bampfylde's pose, with her right arm extended across her torso towards the lily and her left arm artfully placed upon the stone plinth, is a witty adaptation of the famous statue of the Venus de' Medici, or Venus Pudica, here reversed. In the classical statue the goddess's hands are positioned to cover her breasts and genitalia, simultaneously emphasising her chastity and her sexuality. Here Reynolds has slightly lowered the left arm, while the gesturing right arm casts an artful shadow across the area of the lower torso.

Despite the idealised image presented in Reynolds's portrait, Lady Bampfylde's marriage was not happy. Even before he succeeded to the baronetcy Lady Bampfylde's husband had frittered away two-thirds of his estate through the 'follies and extravagances of youth' (Lonsdale 1988, p.22). By 1778 rumours of lavish expenditure and infidelity on the part of Lady Bampfylde surfaced in a satirical poem, *Warley*, by George Huddesford:

But amongst the throng we shall find, to be sure,
The extravagant daughter of old Sir J— M—;
'Tis yon skittish filly in want of a Rider,
So fond of the *Levere't* squatting beside her.

Although Huddesford went on to state somewhat disingenuously that hers was a case of mistaken identity, it does not, as has been observed, 'diminish the offensiveness of the satire, which goes on to assert that Sir Charles himself is ruined financially' (Lonsdale 1988, p.22). This poem satirised the current mania for militarism, focused upon the encampment at Warley, Essex, which had become a popular attraction among fashionable society in the summer of 1778 (see also cat.55). Lady Bampfylde, presumably, was among the visitors there. Significantly Huddesford was a close friend of Lady Bampfylde's brother-in-law, John Bampfylde

(cat.36), whose family had disowned him following his decline into insanity.

Despite their marital problems, Lady Bampfylde eventually produced a son and heir, George Warwick Bampfylde, who was born in 1787. She also gave birth to a second son, although afterwards she and her husband separated. In the spring of 1823 a former servant fatally wounded Sir Charles in Montague Square, London, before turning the gun on himself. 'On hearing of the dreadful wound of Sir Charles Bampfylde', her obituary noted, 'Lady Bampfylde, who had lived for several years in a state of separation from her husband, repaired to London to attend upon Sir Charles, and to administer to his comfort' (*Gentleman's Magazine* 1832, pp.468–9). Sir Charles died on 19 April 1823. Lady Bampfylde died nine years later, on 20 March 1832, at her home in Egham, Surrey.

MP

Provenance
By descent to the 2nd Lord Poltimore; sold before 1899 to Agnew's; Alfred de Rothschild, by whom bequeathed to the National Gallery 1918; transferred to the Tate Gallery 1949.

Literature
Leslie and Taylor 1865, vol.2, p.185; Hamilton 1884, p.80; Graves and Cronin 1899–1901, vol.1, pp.46–7; Waterhouse 1941, p.67, pl.182; Davies 1959, p.126, no.3343; Cormack 1968–70, p.147; Penny 1986, pp.277–8, no.106; Shawe-Taylor 1990, pp.159–60, p.161; Mannings and Postle 2000, vol.1, p.71, vol.2, pl.83, fig.1179.

Engraved
Thomas Watson 1 May 1779; S.W. Reynolds.

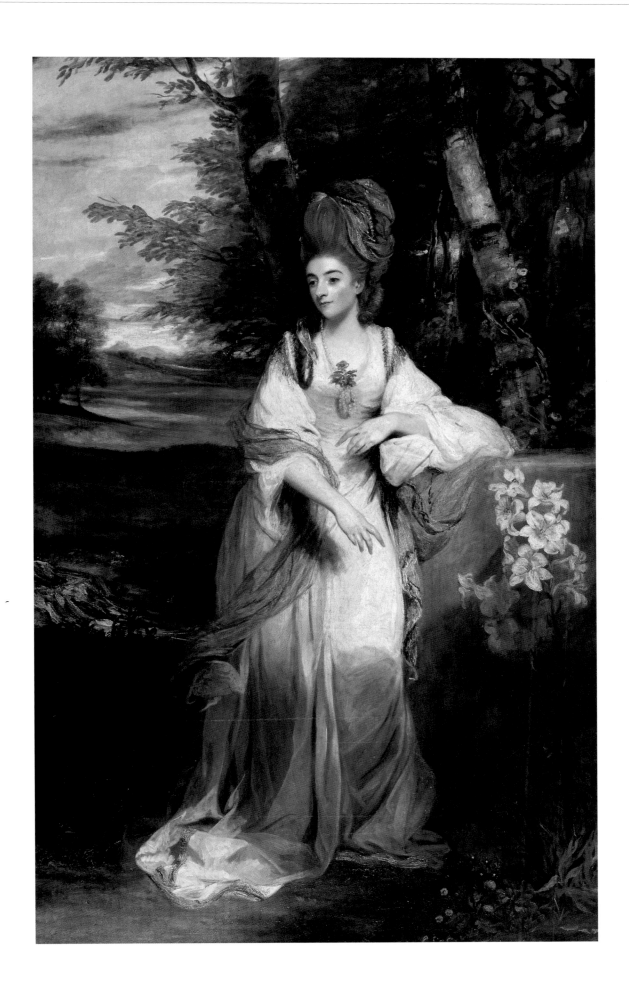

26. *Lady Talbot* 1781

Oil on canvas, 234.3 x 146

Tate. Bequeathed by Sir Otto Beit 1941

In the London *Morning Herald* of Saturday 16 February 1782, the engraver Valentine Green took out an advertisement to promote the latest additions to a series of mezzotints he had been publishing in instalments since 1779, entitled *A Series of Beauties of the Present Age, engraved from pictures painted by Sir Joshua Reynolds.* Green also used this advertisement to announce that he was already working on yet another plate – 'plate XI' – for his series, taken from Reynolds's painting of 'the Right Hon. Lady Charlotte Talbot'. Green went on to publish his print of *Lady Talbot* on 1 May 1782, exploiting the fact that the painting from which his mezzotint derived had just been put on display at that year's Royal Academy exhibition. The fact that both the painted and printed versions of this portrait were simultaneously placed on public view in the city, the latter explicitly described as depicting a contemporary 'beauty', confirms that Reynolds's portraiture of women from the elite classes, such as *Lady Talbot*, circulated well beyond the realms of aristocratic society, and included images that played an active role in the visual and celebrity culture of contemporary London.

In his portrait, Reynolds returned to a pictorial formula that had first brought him prestige and success in the 1760s, in which he depicts aristocratic women making some kind of address or offering to the statues of classical gods or goddesses (see also cat.71). Here, Lady Talbot (1754–1804) is shown in Grecian dress, having just poured a libation of oil onto a sacrificial tripod standing near a statue representing the goddess Minerva. This deity, also known as Pallas Athena, variously symbolised wisdom, learning and the arts, and Talbot is thus linked with these attributes by association. At the same time, Lady Talbot is given the passive and elegant pose, the elongated and decorously exposed body and the captivating half-smile that were the conventional components of the painted – and engraved – 'beauty'. In this respect, she stands in a line of pictorial succession that stretches back to the famous series of aristocratic 'beauties' painted in seventeenth-century England by such artists as Sir Anthony Van Dyck, Sir Peter Lely and Sir Godfrey Kneller. At the 1782 exhibition, meanwhile, she was coupled with another full-length female portrait painted by Reynolds, *Lady Elizabeth Compton* (National Gallery of Art, Washington), which had been reproduced as a mezzotint by Valentine Green at the end of the previous year, and advertised as 'plate IX' in his series of *Beauties of the Present Age.*

MH

Provenance
Earl of Shrewsbury at Ingestre Hall, bought 30 January 1896 by Agnew's and sold 30 April 1896 to Alfred Beit; bequeathed (subject to Lady Beit's life interest) to the National Gallery by Sir Otto Beit 1941; since transferred to the Tate Gallery.

Literature
Graves and Cronin 1899–1901, vol.3, p.951; Waterhouse 1941, p.74; Mannings and Postle 2000, vol.1, p.439, vol.2, fig.1349.

Engraved
Valentine Green 1782.

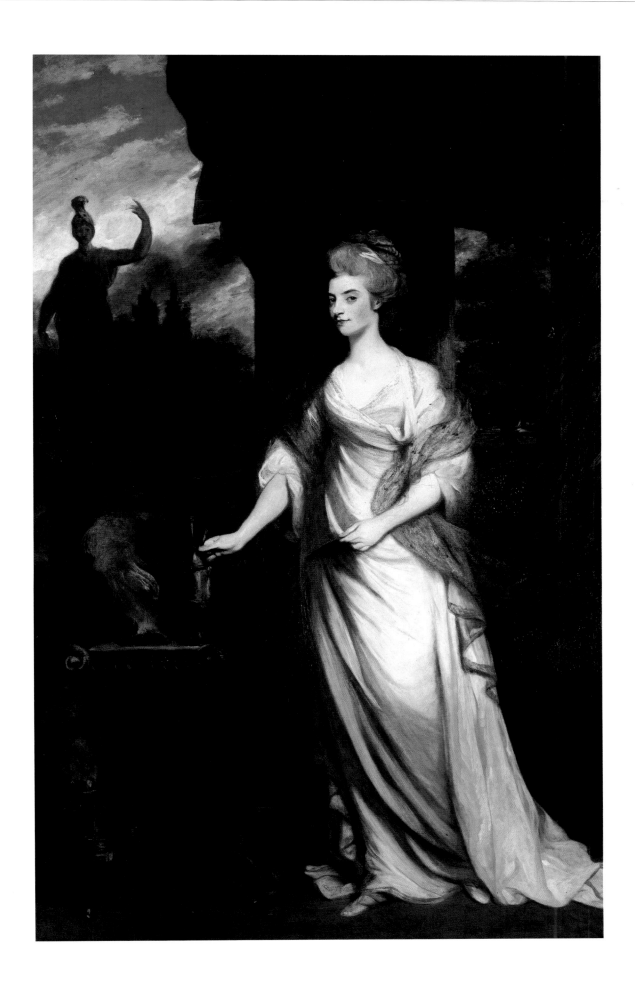

27. *The Ladies Waldegrave* 1780–1

Oil on canvas, 143.5 x 168

National Gallery of Scotland, Edinburgh

This famous portrait of the three Waldegrave sisters, painted for their great uncle, Horace Walpole, to hang in his house in Strawberry Hill, depicts, from the left, Lady Charlotte Maria (1761–1808), Lady Elizabeth Laura (1760–1816) and Lady Anna Horatia (1762–1801). In a letter of May 1780, Walpole mentions that 'Sir Joshua has begun a charming picture of my three fair nieces, the Waldegraves, and very like. They are embroidering and winding silk.' Significantly, the sisters, all of whom were to wed in the years that followed, were unmarried when the painting was commissioned. Their group portrait, exhibited at the Royal Academy in 1781, can thus be understood as advertising their eligibility and desirability as future wives. Both individually and collectively, the Waldegrave sisters embody contemporary ideals of feminine accomplishment, fashionability and beauty. In the picture, Reynolds shows the different stages of the traditional female accomplishment, needlework, which is here pictured as a collaborative activity. Maria and Laura respectively hold and wind threads of white silk, while Horatia is shown with a tambour and a tambour hook, transforming the same white silk into the translucent lacework that falls rather beautifully over the table edge. As well as an elegant accomplishment in and of itself, the sisters' activity of transforming raw threads of silk into an exquisitely embroidered material allegorises the wider processes of refinement and transformation that they themselves had undergone in their upbringing, and that they would bring to any future marital alliance. More directly, the portrait flaunts the sisters' fashionable adherence to the sartorial and cosmetic dynamics of whiteness: their elaborately swirling hair is dressed with white powder, they wear white muslin dresses of the latest style, and their skin, other than the studiously applied patches of pink blusher that adorn their cheeks, is almost marmoreal in its paleness. Meanwhile, their physical beauty is emphasised by the way in which Reynolds, deliberately evoking the classical iconography of the Three Graces, shows each sister in a different but equally flawless aspect.

At first glance, the artist also seems keen to communicate the sisters' modesty. In particular, the absorbed poses and expressions of Laura and Horatia function to indicate a shyness that would have been regarded as highly becoming. At the same time, Reynolds, in his depiction of Maria, also manages to suggest something rather different: that the Waldegrave sisters were fully cognisant of the fact that they, as beautiful young women, were being constantly scrutinised and appreciated by others. Rather than bowing her head and looking inwards, Maria seems to cock her head upwards and to her right, as if she has just heard someone entering, or as if she has become suddenly aware of our presence as viewers, even as we remain outside her immediate field of vision. Her expression and body language, we can conclude, help bring both this group of women and their portrait out of the private, self-absorbed world they otherwise seem to occupy, and gesture outwards to the more public sphere of marriage markets and exhibition spaces where they were also very much at home.

MH

Provenance
Painted for Horace Walpole who left it to his cousin, Mrs Damer; acquired from her with other contents of Strawberry Hill by 6th Earl Waldegrave 1811; Strawberry Hill sale, 21st day, 18 May 1842 (35) bought in; bequeathed by Frances, Widow of 7th Earl, to her fourth husband Chichester Fortescue, later Carlingford, who sold it, via Sir Francis Bolton, to Agnew's in June 1886; Agnew's sold it to Daniel Thwaites of Blackburn, whose daughter Elma Amy married 1888 Robert Armstrong Yerburgh; their son R.D.T. Yerburgh was created 1929 1st Baron Alvingham from whom the picture was bought, through Agnew's, by the National Gallery of Scotland with help from the National Art Collections Fund 21 November 1952.

Literature
Leslie and Taylor 1865, vol.2, pp.294–6; Graves and Cronin 1899–1901, vol.3, pp.1017–19, 1430; Waterhouse 1941, p.72; Thompson and Brigstocke 1970, p.81; Waterhouse 1973, p.12; Shawe-Taylor 1990, p.117; Mannings and Postle 2000, vol.1, pp.456–7, vol.2, fig.1340, pl.102.

Engraved
Valentine Green 1781.

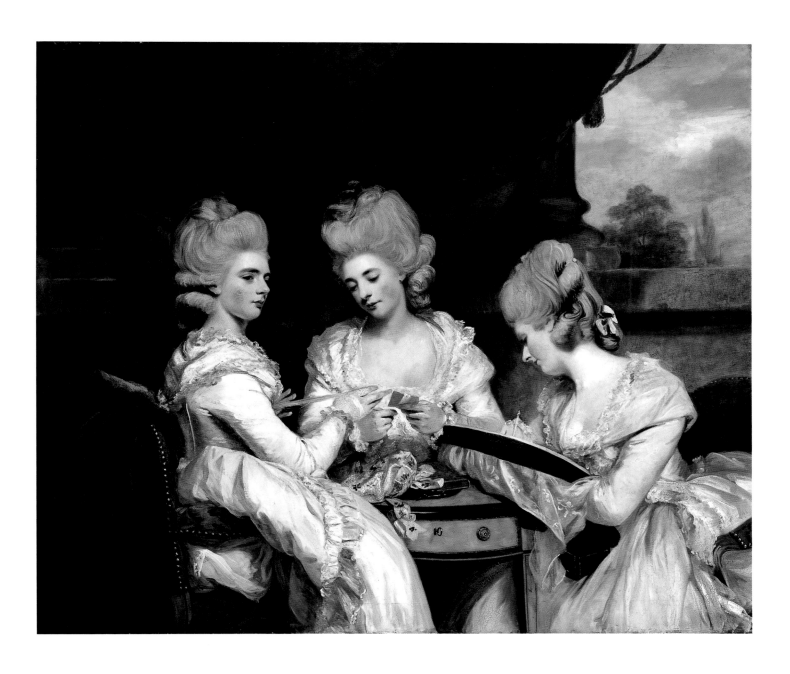

28. *Lavinia, Countess Spencer* 1781–2

Oil on canvas, 75 x 62.2

Earl Spencer, Althorp

This portrait of Lavinia, later Countess Spencer (1762–1831), begun only weeks after the sitter's marriage to George John, Viscount Althorp, pictures her wearing what a critic described as 'a fancy head-dress, and corresponding drapery' (*Morning Herald and Daily Advertiser*, 2 May 1782). The picture's striking concentration on the forms, materials and textures of fashionable dress is indicative of Reynolds's increasing focus on such matters in his female portraiture during this period. Here, the framing headdress, the succession of ribboned bows, and the numerous layers of clothing that so luxuriantly envelope Lady Spencer's upper body, make her seem something like a precious, carefully wrapped gift. From within her elaborate cocoon of clothing, Lady Spencer addresses the viewer with a confident, direct expression. This directness, combined with the portrait's sharp tonal contrasts and simplified shapes – note how the oval of the Countess's face is played off against the diamond-shaped borders of her headdress – must have helped reinforce the picture's impact not only when displayed at home, but also when it was exhibited in the Academy's Great Room in 1782.

Intriguingly, Reynolds's submission to that year's exhibition included a number of other female portraits that echoed this picture's celebration of youthful beauty and fashionable 'fancy' dress. One of these depicted the famous actress and royal mistress Mary Robinson wearing an extravagant feathered hat and a revealing black dress (Waddesdon Manor, The National Trust). More particularly, in the Great Room, Lady Spencer's portrait was hung very close to the artist's exotic painting, *Mrs Baldwin* (cat.68), in which Reynolds's subject is shown with a remarkable, towering headdress, and wearing the multicoloured caftan that she had recently worn to a ball given by the King. We can conclude that, at the 1782 exhibition, Reynolds's portrait of Lady Spencer was not only intended to be appreciated on its own terms, but also as part of a colourful, glamorous and theatrical parade of fancy-dress female portraits painted by the President, which was studiously distributed across the Great Room's walls.

Provenance
Painted for Charles, 1st Earl Lucan; his daughter Lady Anne Bingham (d.1840); Sarah Lady Lyttelton who presented it to her brother John Charles, 3rd Earl Spencer; thence by descent.

Literature
Graves and Cronin 1899–1901, vol.3, pp.918–19; Waterhouse 1941, p.73; Garlick 1974–6, no.528; Mannings and Postle 2000, vol.1, pp.428–9, vol.2, pl.103, fig.1361.

Engraved
C.H. Hodges 1784.

MH

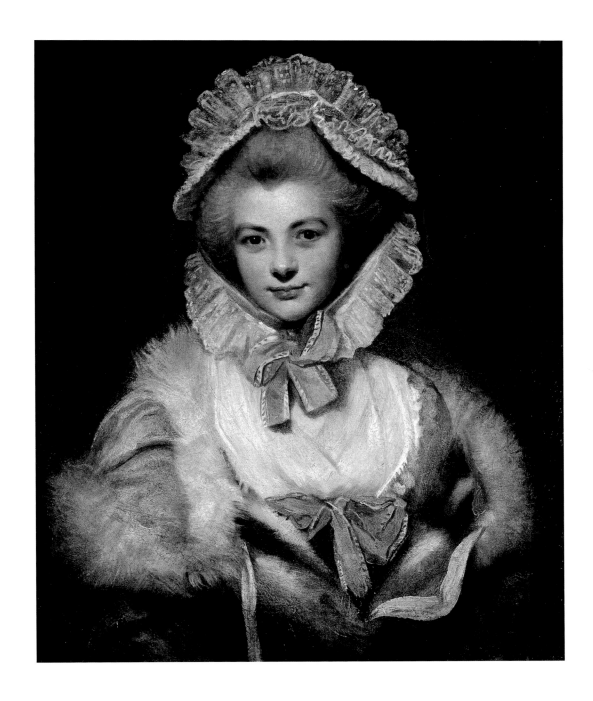

29. *Georgiana, Duchess of Devonshire and her Daughter, Lady Georgiana Cavendish* 1784

Oil on canvas, 112.4 x 140.3

Trustees of the Chatsworth Settlement, Chatsworth

Georgiana, Duchess of Devonshire (1757–1806), was one of the most celebrated aristocratic women of the day, continually described in the press as a vivacious, trend-setting and high-living leader of fashionable society. She was also a regular subject of portraits shown at the Royal Academy. Thomas Gainsborough, for example, displayed a portrait of the Duchess of Devonshire in 1783 (National Gallery of Art, Washington), while Reynolds himself had submitted a famous full-length of the Duchess in 1776 (fig.15; see cat.79). This regular form of pictorial exposure helped ensure that she remained in the public eye, and provided exhibition audiences with the opportunity to track her continually changing image from year to year. However, this portrait, exhibited at the Royal Academy in 1786, whilst suggesting the artist's and sitter's continuing willingness to exploit the narratives of celebrity, also marks a significant shift in her representation. In this painting, the Duchess is now defined not principally as a glamorous and fashionable 'beauty', but as a doting mother.

To explain this change, we can point to the fact that, immediately before this picture was painted, the Duchess had become mired in a highly public controversy concerning the role of women in high society. This was prompted by the fact that she was taking an unusually active involvement in contemporary politics. Throughout that spring, she campaigned on the London streets for the election of the famous Whig politician Charles James Fox (see cat.41) to a parliamentary seat at Westminster. Her perceived transgressing of gender boundaries – this kind of campaigning was traditionally confined to men – together with the easy manner she had supposedly displayed to her social inferiors brought vitriolic opprobrium from many quarters of the press. The Duchess's political activities also generated a stream of graphic satires depicting her in a highly unflattering light, including works that suggested she had wilfully neglected her role as a mother. Reynolds's portrait of the Duchess and her daughter was begun only weeks after Fox's campaign had ended, and can partially be understood as a systematic attempt to counter the acidic criticism she had recently attracted. The painting deliberately distances the Duchess from the spheres of politics and fashion. She is promoted as a devoted mother firmly established in the domestic sphere, while her chosen dress,

one of mourning for her recently deceased father, powerfully suggests her sense of filial responsibility.

At the same time, the imperatives of dynasty seem also to be in play. Significantly, the child depicted, Lady Georgiana Cavendish (1783–1858), was the Duchess's first, and Reynolds's image is one that commemorates a new birth, and an addition to the family tree, as much as it promotes a newly domestic role for the Duchess herself. This dual function is nicely communicated by Reynolds's decision to give mother and child an almost equal weight within the picture space, as well as by the fact that knowledgeable viewers, including the Duchess herself, would have been fully aware that this portrait offered an animated sequel to Reynolds's earlier portrait of Georgiana and her own mother (1759–61; Althorp), painted when she was two, and widely available as an engraving.

MH

Provenance
Painted for the 5th Duke of Devonshire; thence by descent.

Literature
Graves and Cronin 1899–1901, vol.1, pp.248–9; Waterhouse 1941 pp.19, 77; Penny 1986, pp.311–12; Mannings and Postle 2000, vol.1, pp.124–5, vol.2, fig.1425.

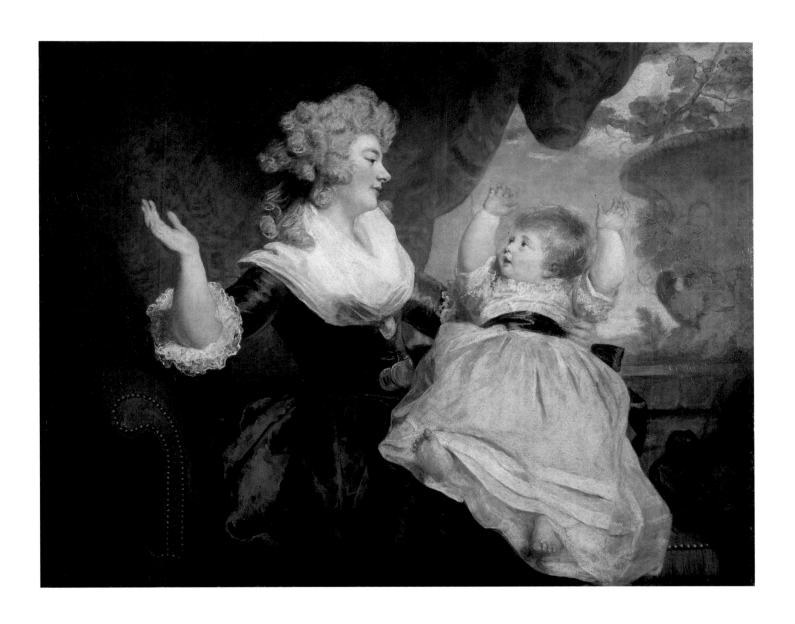

30. *George IV as Prince of Wales* 1785

Oil on wood, 75.6 x 61.6

Tate. Purchased 1871

Reynolds writes of this picture of George, Prince of Wales (1762–1830), in a letter to Charles, 4th Duke of Rutland, in May 1785, when he notes that 'I have sent a head of the Prince to the Exhibition which I hear is much approved off [*sic*]. He dined with the Academy at our Great dinner before the opening of the Exhibition ... The Prince behaved with great propriety, we were all mightily pleased with him' (Ingamells and Edgcumbe 2000, pp.139–40). As well as communicating the generally positive response his picture had attracted, the letter also conveys the trepidation that the Academy's President had felt before the Prince's arrival at that year's Academy dinner. That Reynolds might have been nervous is understandable – the Prince was well known as a notoriously unreliable, excessive and bibulous personality, and had failed to turn up at all to the previous year's dinner, despite being billed as the guest of honour. That he had 'behaved with great propriety' at the 1785 dinner was clearly a relief, but the anxieties that underpin the artist's words make it clear that Reynolds, in portraying the Prince, found himself engaging with, and helping shape, the public identity of a highly controversial, and unpredictable, national figure.

Reynolds's attempt to craft a public persona for the Prince had begun in earnest the previous year, when he had exhibited a huge equestrian portrait of the royal heir, in which he is depicted as a heroic, virile and public-minded young warrior (fig.5). While the earlier painting sought to counter a widespread criticism of the Prince – that rather than being an inspiring leader of men he was in fact an extravagant, debauched and self-obsessed dandy – the following year's exhibit forges a very different identity for him. Here we see the young Royal seemingly revelling in his dubious celebrity rather than seeking to deny it. This modestly sized portrait integrates the public iconography of the star and band of the Order of the Garter with a far more intimate, almost flirtatious depiction of the Prince, in which he hovers close to the picture plane, flaunts his glamorous looks, hairstyle and dress, and pouts provocatively at the viewer. Given this form of visual address, it is perhaps no surprise that, when the picture was displayed in the 1785 exhibition, Reynolds's Prince was continually described by satirical critics as looking out at, and being courted by, the young women who were pictured in works hanging nearby (see the author's essay in this catalogue, pp.45–7).

This sense of a portrait that seeks to glamorise rather than deny the Prince's reputation as a hedonistic young man-about-town is deepened when we explore its provenance. The Prince gave the picture as a gift to the Groom of his Bedchamber, Wilson Gale Bradyll, one of his closest allies and a regular participant in George's notorious escapades. Thus, the *General Evening Post* of 10–12 February 1785 notes that the Prince and Bradyll formed part of a party of twelve men who had dressed as friars for a fashionable masquerade. They arrived at 11.30 at night and left five hours later to carry on their festivities at the Pantheon, a celebrated London pleasure-dome. For Bradyll, we can suggest, this portrait would have offered an appropriately convivial and flamboyant visual reminder of the boon companion with whom, on so many occasions, he had caroused the night away.

MH

Provenance
Wilson Gale Bradyll; his son's sale at Christie's 23 May 1846 (45), bought Seguier for Sir Robert Peel; bought with the Peel collection by the National Gallery 1871; since transferred to the Tate Gallery.

Literature
Graves and Cronin 1899–1901, vol.3, pp.1020–1; Waterhouse 1941, p.76; Ingamells and Edgcumbe 2000, pp.139–40; Hackney, Jones, Townsend 1999, pp.146–51; Mannings and Postle 2000, vol.1, pp.216–17, vol.2, fig.1454.

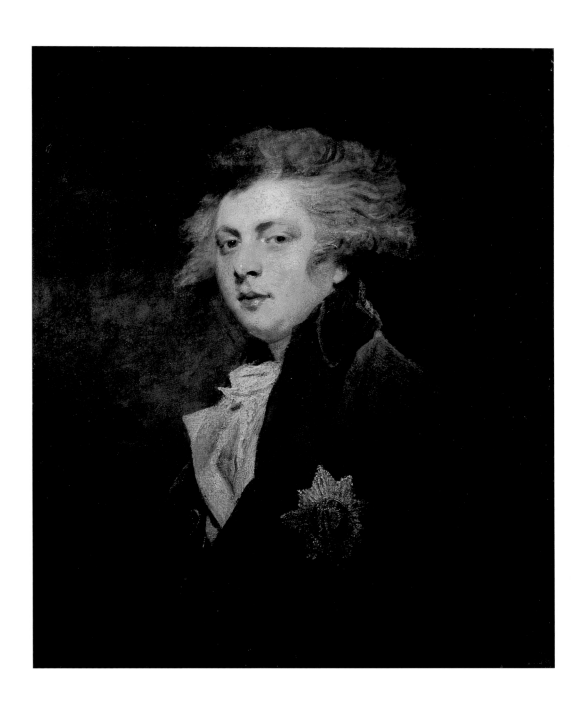

31. *Prince George with Black Servant* 1786–7

Oil on canvas, 239 x 148

His Grace the Duke of Norfolk, Arundel Castle

In May 1785 Reynolds noted that he had begun a full-length portrait of Louis Philippe Joseph, Duke of Orléans, for the Prince of Wales and that 'the Prince is to sit for him' (Ingamells and Edgcumbe 2000, pp.139–40). Reynolds exhibited the portrait of Louis Philippe the following spring at the Royal Academy (see cat.84). At the same time, he began work on the portrait of the Prince. This occupied Reynolds off and on for a year, and the press followed its progress with avid interest. In January 1787, the *World* noted: 'The *Prince of Wales* is standing a companion to Mrs Fitzherbert. He is to be in His Garter robes; but at present none of the drapery appears. The countenance alone has been worked upon and the work is in the finest manner.' The painting was still unfinished when a correspondent for the same newspaper saw it just two weeks before it was to be exhibited at the Royal Academy (see the *World*, 12 April 1787).

At the Royal Academy the portrait was given pride of place in the Great Room; Pietro Martini's engraving of the exhibition shows the Prince and Reynolds standing directly beneath the portrait (see cat.87). Even so, the press slated the picture. Criticism was not directed so much at the Prince but at the figure of the black servant leaning across to adjust his ceremonial robes. The *World* suggested ironically that a black servant was performing the task because the impoverished Prince could not afford a white servant. 'His Highness', it added, 'seems to take it very patiently, and the black is pushing him about as he pleases' (1 May 1787). The following day the *Morning Herald* chimed in: 'The Prince is in his robes of state and a Black appears to be in the act of stripping them off. Some say the black above mentioned is the prototype of Mr Rolle, and others apply it to a person of still higher consequence in the state.' John Rolle, Tory MP for Devonshire, was renowned for his bumptious behaviour and crass interventions on behalf of Pitt's ministry. At the time he was the hero of 'The Rolliad', a satirical epic published by the *Morning Herald* to ridicule Pitt's government. Rolle was also, incidentally, a friend of Reynolds.

Black servants had frequently featured in Reynolds's portraits, most recently in *Charles Stanhope, 3rd Earl of Harrington* (Yale Center for British Art, New Haven) shown at the Royal Academy in 1783. Their customary role in such portraits involved holding unobtrusively the reins of their masters' horses, or carrying their weaponry. In the present picture, however, the black servant has a more prominent role; one critic complained that it looked as though he was 'measuring the Prince for a pair of breeches' (Whitley Papers, British Museum, vol.1, f.72). When the painting returned to Reynolds's studio after the exhibition, the *World* attempted to exonerate Reynolds and the Prince of Wales, and shifted the blame onto the universally unpopular Duke of Orléans, stating that it was not 'his Royal Highness, nor Sir Joshua, but his Grace's idea of grace, that has to answer for the introduction of the aforesaid black' (27 November 1787).

The black servant had been introduced into the painting at the very last moment, days before the painting was due to be exhibited. Perhaps, as the *World* intimated, Reynolds had complied with a recommendation from the Duke of Orléans. Even so, he may have been aware that it would court controversy, not least because at that time there was fierce debate generated by the anti-slavery lobby, which had formed the Abolition Society in England in 1787.

MP

Provenance
Bought from Reynolds's heirs by George, Prince of Wales, who gave it to the Earl of Moira in April 1810; sold Phillip's 26 February 1869 (204), bought by the Countess of Loudoun, whose daughter, Flora Paulyna, married the 15th Duke of Norfolk; thence by family descent.

Literature
Leslie and Taylor 1865, vol.2, pp.505–6; Graves and Cronin 1899–1901, vol.3, pp.1021–2; Waterhouse 1941, p.79; Waterhouse 1973, pl.103; Mannings and Postle 2000, vol.1, pp.216–17, vol.2, fig.1496; Solkin 2001, pp.48, 232, fig.3.

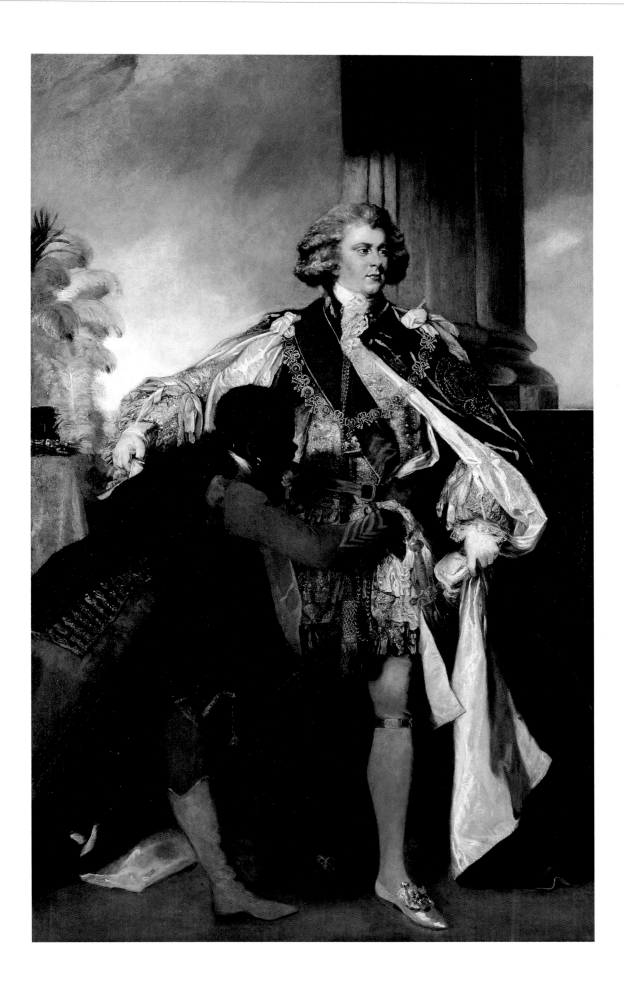

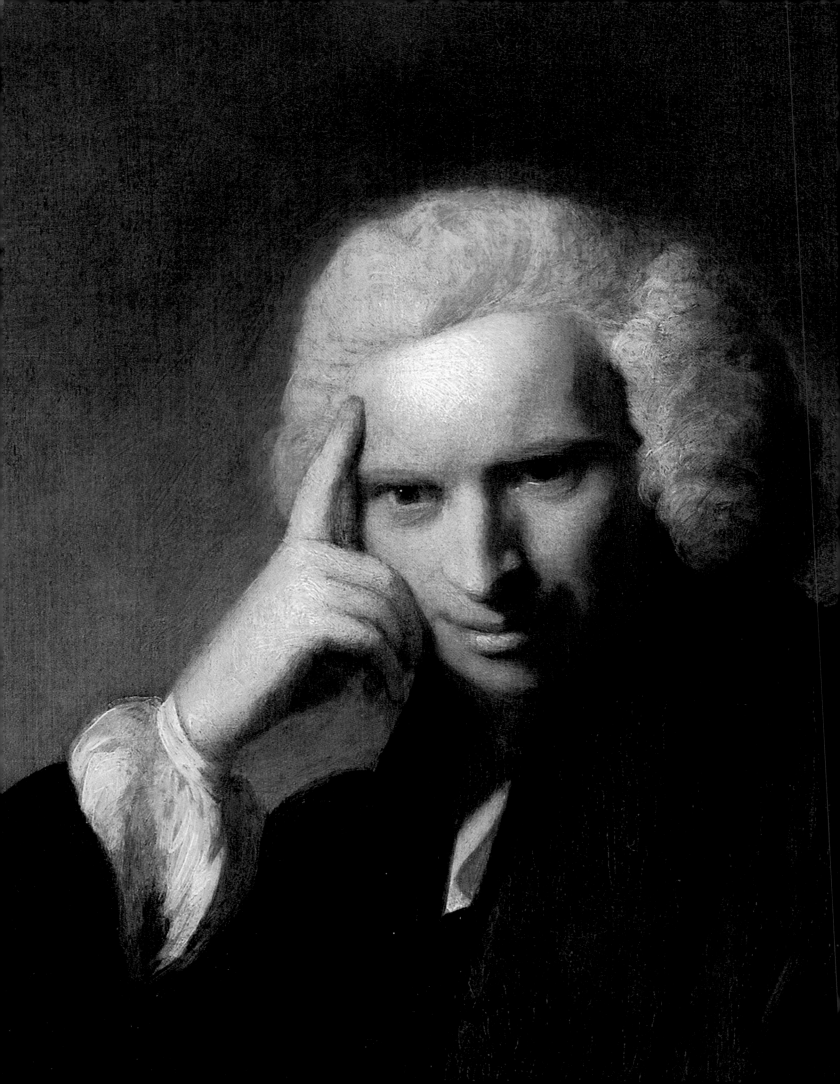

The Temple of Fame

The concept of the famous as an elite group of individuals marked out by their superior talents was nurtured in eighteenth-century Britain in both literature and the visual arts. In 1715, Reynolds's hero, Alexander Pope, wrote *The Temple of Fame*, in which he mused upon an imagined gallery of portrait sculptures of the six greatest classical authors. In the decades that followed, a real 'Temple of Fame' for British authors was established in Poets' Corner at Westminster Abbey, culminating in the erection of John Michael Rysbrack's statue of Shakespeare in 1741. By this point there was a booming trade in the production of busts of famous men, which were installed in both private residences and public places, notably the library of Trinity College, Cambridge, which featured Francis Bacon and Isaac Newton. At Stowe in the 1730s, a 'Temple of British Worthies' was created by William Kent (fig.3), while in 1743 the engravers Jacobus Houbraken and George Vertue published *The Heads of Illustrious Persons of Great Britain*. It was against this background that Reynolds opted to associate with the most famous men of his age. Gifted with charm and diplomacy, Reynolds assiduously entertained them in his home, introduced them to one another, and through his portraits and the prints that were made from them, confirmed their celebrity status.

From the 1750s Reynolds began to form friendships with leading figures in the literary and intellectual world. They included the moralist and writer Samuel Johnson, the playwright Oliver Goldsmith, the politician Edmund Burke and the country's leading actor David Garrick. By the mid-1760s Reynolds formalised their association through the foundation of the Literary Club, which became known simply as 'the Club'. Over the years the Club's reputation as the crucible of London's intellectual life grew, to the point that it eclipsed even the most distinguished societies, whose members – aristocrats and gentlemen alike – sought ultimate recognition through membership of this elite coterie. In the 1770s Reynolds began to paint a series of portraits of his intellectual circle for the brewer Henry Thrale, to be housed in his library in Streatham, south London – the 'Streatham Worthies' (see pp.165–79).

While members of the Club, and the individuals represented in the 'Streatham Worthies', represented the hub of Reynolds's social and intellectual world, he was also well acquainted with a range of eminent literary figures, such as the novelist Laurence Sterne (cat.33) and the aesthete Horace Walpole (cat.32). Reynolds painted Sterne's portrait in 1760, at the very moment that the writer first tasted fame; while Walpole ordered no fewer than three separate versions of his portrait from Reynolds, to coincide with the promotion of his career as a gentleman scholar. Similarly, in later years, the aspiring literary hostess, Mary Monckton, commissioned Reynolds to paint her full-length portrait (cat.37), as a means of promoting her salons and attracting the notice of London's most fashionable celebrities.

A number of those whom Reynolds portrayed already enjoyed significant public reputations, notably the Whig grandee, Charles James Fox (cat.41), and the playwright-turned-politician, Richard Brinsley Sheridan (cat.42). It is notable, however, in both instances, that Reynolds painted their portraits at key moments in their careers. This underlines the fact that timing was one of the most important factors in his continuing success – the ability to provide the public with an unforgettable image at the very moment they most craved it. Indeed, it was argued by Reynolds's supporters that while other artists could convey physical appearance, Reynolds provided a summation of an individual's intrinsic merits. Reynolds did not simply paint people who were famous, he revealed to his audience the reasons for that fame. The painter and writer Henry Fuseli, for one, admired Reynolds's ability to capture Sterne's unique brand of humour, Garrick's comic brilliance, or the 'mental and corporeal strife' endured by Samuel Johnson. 'On that broad basis', he concluded, 'the portrait takes its exalted place between history and the drama.'

MP

Laurence Sterne 1760 (detail of cat.33)
National Portrait Gallery, London

32. *Horace Walpole* 1756

Oil on canvas, 127 x 101.6

National Portrait Gallery, London

By the mid-1750s Horace Walpole (1717–97) was busily carving out his reputation as a writer and aesthete. The youngest son of Sir Robert Walpole, the country's Prime Minister, Horace had been educated at Eton and King's College, Cambridge. In 1739 he set out for mainland Europe with the poet Thomas Gray. His two-year Grand Tour took him to France and Italy, where he spent time in the major artistic cities, Florence, Rome and Venice. On his return Walpole spent time at the family home, Houghton Hall, with its fine collection of Old Master paintings. There he began to write on art, notably penning his *Aedes Walpolianae*, a scholarly appreciation of European painting. He also began to collect. In 1747, following the death of his father, Walpole took possession of 'Chopp'd Straw Hall' in Twickenham, west of London, which he transformed into the masterpiece of Gothic Revival architecture, Strawberry Hill.

In Reynolds's portrait, Horace Walpole's connoisseurial credentials are displayed by means of the unfurled print depicting the large stone eagle that he had acquired in Rome from the Boccapadugli Gardens – an emblem of intelligence and nobility (see Penny 1986, pp.189–90). The quill, of course, refers to Walpole's career as a writer. At this time Walpole was in the final stages of completing his *Catalogue of Royal and Noble Authors of England*, which was to be published in 1758. It was surely with these high-flown literary aspirations in mind that Reynolds raised his subject's right hand to his chin, the same gesture used by Louis François Roubiliac in his statue of Shakespeare, made for David Garrick's garden at Hampton, and completed in 1758.

Of Walpole, who was an aristocrat as well as an aesthete, it was remarked that 'the *Gentleman* is never lost in the author' (see Shawe-Taylor 1987, p.33). In Reynolds's portrait, Walpole's status as a gentleman is underlined by the elegant attitude of his left arm, which consciously recalls the aristocratic portraits of Sir Anthony Van Dyck. Walpole's social status as a gentleman-scholar rather than a professional writer was confirmed when he seized the copper plate and all the impressions of James McArdell's mezzotint engraving of the portrait, with the instruction that it should be inscribed 'Horace Walpole, youngest son of Sir Robert Walpole, Earl of Orford' (see Mannings and Postle 2000, vol.1, p.459). Presumably, Walpole wished to ensure that he could personally take charge of distributing his image privately among those qualified to appreciate his gifts, rather than being gawped at by the *hoi polloi* in the windows of print shops. Walpole also commissioned three separate versions of the portrait from Reynolds in order that he could distribute it to a select few. The present one was apparently painted for his London agent, Grosvenor Bedford; another was made for his brother-in-law, Charles Churchill (1756; Art Gallery of Ontario, Toronto), while a third was probably given to his cousin, Francis Seymour Conway (1757; Marquess of Hertford, Ragley).

MP

Provenance
Apparently painted for Grosvenor Bedford, Walpole's London agent; still with the Bedford family in 1847, when Sir Robert Peel declined to buy it; Lady Colum Crichton-Stuart; bought by the 3rd Marquess of Lansdowne before the Grosvenor Bedford sale of 1861; by descent until 1999 when purchased from Lord Lansdowne through a private treaty sale by the National Portrait Gallery.

Literature
Graves and Cronin 1899–1901, vol.3, pp.1024–5 (with incorrect provenance); Waterhouse 1941, p.41; Lewis and Adams 1968–70, no.A.13.2; Miller 1982, p.15; Mannings and Postle 2000, vol.1, p.459, vol.2, fig.229; Ingamells 2004, pp.368–9.

Engraved
McArdell 1757 (possibly this version); W. Bromley 1826.

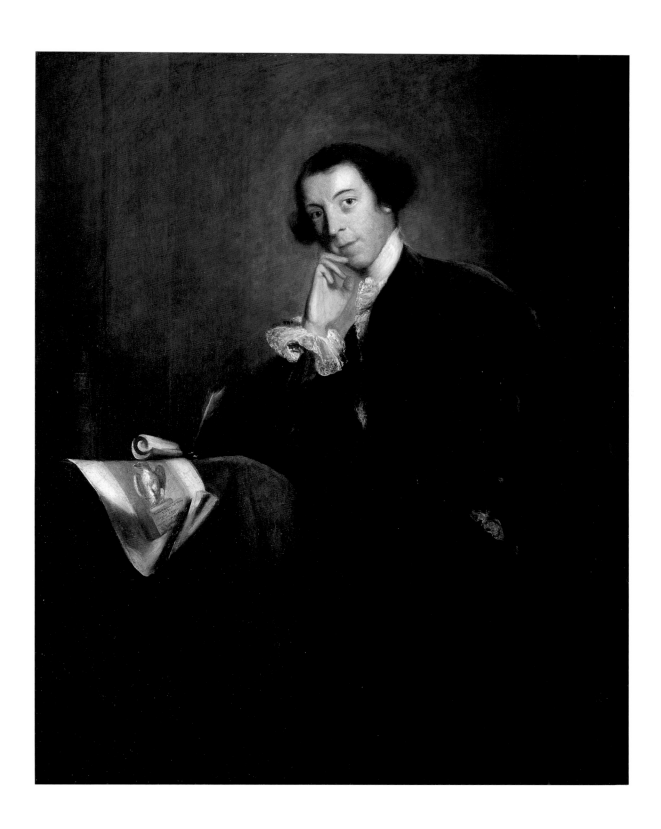

33. *Laurence Sterne* 1760

Oil on canvas, 127.3 x 100.4

National Portrait Gallery, London

Laurence Sterne (1713–68) published the first two volumes of his novel, *The Life and Opinions of Tristram Shandy*, at the beginning of 1760. This racy, irreverent book transformed Sterne's fortunes. Early in March 1760 he arrived in London, where he was fêted by fashionable society. As Horace Walpole observed the following month: 'The man's head indeed was a little turned before, now topsyturvy with his success and fame' (Walpole 1937–83, vol.15, p.66). By then Sterne was sitting for his portrait to Reynolds. In the spring of 1761 Sterne's portrait was exhibited at the Society of Artists annual exhibition, together with a print after it by the mezzotint engraver, Edward Fisher. According to Sterne, when he volunteered to pay for the portrait, Reynolds 'desired me to accept it as a tribute (to use his own elegant and flattering expression) that his heart wished to pay to my genius' (Leslie and Taylor 1865, vol.1, p.193, n.1). Yet, the portrait remained with Reynolds, who displayed it in his own picture gallery (see Mannings and Postle 2000, vol.1, p.387).

In the portrait Sterne wears a wide-sleeved black gown over a double-breasted cassock; around his neck is a black preacher's scarf. On the table lies a sheaf of papers, one of which is inscribed with the title of his new novel, another with the words 'J Reynolds/pinx^t 1760'. It is Sterne's expression, however, that commands the viewer's principal attention. Through the device of the secretive half-smile, Reynolds captures the essence of Sterne's comic genius, which was satirical and not a little fiendish. Sterne's physiognomy and the gesture of the forefinger pressed against the temple were derived, according to Desmond Shawe-Taylor, from a painting of John the Baptist attributed to the studio of Leonardo da Vinci (after *c*.1509; Ashmolean Museum, Oxford). But whereas John the Baptist points to heaven as the source of his divine inspiration, the subversive Sterne gestures towards his own spot-lit cranium. 'As he points to heaven', states Shawe-Taylor, 'by way of his head, there is a Shandean ambiguity as to the real source of his inspiration – this recalls Tristram's father's claim to have discovered the exact location of the soul in the brain, in the "medulla oblongata"' (Shawe-Taylor 1987, p.48).

Sterne and Reynolds remained friends throughout the 1760s, and in volume three of *Tristram Shandy* the author imagined how one of his characters might have appeared had he adopted the type of pose found in Reynolds's portraits: 'his whole attitude had been easy – natural – unforced: Reynolds himself, as great and gracefully as he paints, might have painted him as he sat'. In February 1768 Sterne published his final novel, *A Sentimental Journey through France and Italy*, and, perhaps to celebrate the event, shortly afterwards dined with Reynolds. Within a month Sterne was dead. His body was disinterred by grave robbers and sold to the Professor of Anatomy at Cambridge University. Such was the course of his fame that, during an anatomical lecture at the University, Sterne was recognised by an admirer and subsequently reburied.

MP

Provenance
John, 2nd Earl of Upper-Ossory by 1801; bequeathed in 1823 (or given previously) to his nephew, 3rd Baron Holland; acquired by the 3rd Marquess of Lansdowne from Lady Holland in 1840; by descent to Lady Mersey, from whom it was acquired in 1975 through Agnew's for the National Portrait Gallery.

Literature
Northcote 1818, vol.1, p.169; Jameson 1844, p.330; Waagen 1854, vol.2, p.152; Cotton 1856, p.92; Leslie and Taylor 1865, vol.1, pp.192–3, n.284; Graves and Cronin 1899–1901, vol.3, pp.933–5, vol.4, p.1418; Whitley 1928, vol.1, pp.174–5; Cross 1929, pp.209–25; Waterhouse 1941, p.48; Kerslake 1977, pp.260–3; Yung 1981, p.541; Penny 1986, pp.199–200; White, Alexander, D'Oench 1983, p.36; Bosch 1994, pp.9–23; Mannings and Postle 2000, vol.1, p.435, vol.2, fig.514.

Engraved
Edward Fisher; S.F. Ravenet 1761; S.W. Reynolds; L. Archer (as full length).

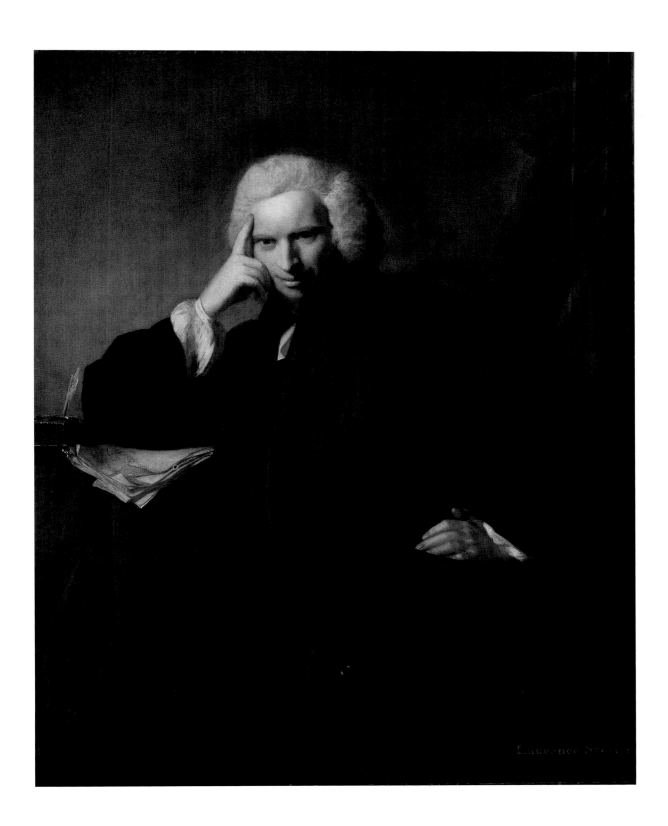

34. *George Selwyn* 1766

Oil on canvas, 99 x 76

Private Collection

George Selwyn (1719–91), politician, wit, gambler, self-confessed necrophile and satanist, was one of the most colourful characters in Georgian society. Born into a privileged background, Selwyn was educated at Eton College and the University of Oxford, from which he was eventually expelled for 'an irreverent jest'. Despite a conspicuous lack of interest in government and politics, Selwyn subsequently became a Member of Parliament and the beneficiary of several lucrative sinecures, which allowed him to indulge fully in his leisure pursuits. Although Reynolds was not especially close to Selwyn, they had a number of friends in common, notably Richard Edgcumbe, whom Reynolds had known since boyhood, and whom he had painted alongside Selwyn in a conversation piece for Horace Walpole's library (see Mannings and Postle 2000, vol.1, pp.177–8, vol.2, fig.471).

In the present portrait Reynolds successfully conveys Selwyn's deadpan expression, a contemporary noting how the effect of his *bon mots* 'when falling from his lips, became greatly augmented by the listless and drowsy manner in which he uttered them; for he always seemed half asleep' (Wraxall 1904, p.448). Selwyn's languid demeanour in the portrait is contrasted by the alertness of his pug dog, who transfixes the viewer with his beady eye. Selwyn was devoted to his pugs, particularly his favourite, Raton, who may be the dog featured here. The prominence of the pug in Selwyn's portrait recalls Hogarth's *Portrait of the Painter and his Pug* of 1745 (Tate). This may well be more than coincidence, since the pug dog was by then a recognised emblem of Freemasonry, and both Hogarth and Selwyn were dedicated Masons (for Hogarth's 'masonic' pug see Simon 1991, pp.372–3).

Aside from his reputation as a wit, Selwyn was celebrated for his penchant for devil worship and his predilection for coffins, corpses and executions, which he apparently at times attended disguised as a woman in order to avoid being identified. During his lifetime, anecdotes concerning Selwyn's obsession with death were legion. On one occasion he went to visit an old friend, Lord Holland, to enquire after his health. '"The next time Mr. Selwyn calls," Holland said, "show him up: if I am alive I shall be delighted to see him, and if I am dead he will be glad to see me"' (Jesse 1843–4, vol.1, p.5). Selwyn was also a core member of the Order of

St Francis, the notorious 'hellfire club', which held its pseudo-satanic orgies at Medmenham Abbey, Buckinghamshire. Other members included the Prime Minister Lord Bute, the radical politician John Wilkes, the club's founder Sir Francis Dashwood, the Earl of Sandwich and Benjamin Franklin. Although some members were interested in satanism, 'hellfire clubs' generally provided a pretext for drinking and fornication – not unlike a number of other gentlemen's clubs and societies of the eighteenth century.

Despite Selwyn's lurid public life, he was regarded as kind and thoughtful, and especially solicitous of the welfare of his adopted daughter, to whom he left his considerable fortune. According to his Victorian biographer, despite his irreligious ways, Selwyn 'died penitent, and at his own request the Bible was read to him throughout his last illness' (Jesse 1843–4, vol.1, p.30).

MP

Provenance
Perhaps painted for Lord Holland; the Duke of Queensberry sale 10 July 1897 (97), bought Asher Wertheimer; by 1899 the Earl of Rosebery; Rosebery sale Christie's 5 May 1939, bought in; by descent.

Literature
Graves and Cronin 1899–1901, vol.3, p.875; Waterhouse 1941, p.55; Waterhouse 1973, p.47; Penny 1986, p.231; Mannings and Postle 2000, vol.1, pp.409–10, vol.2, fig.884.

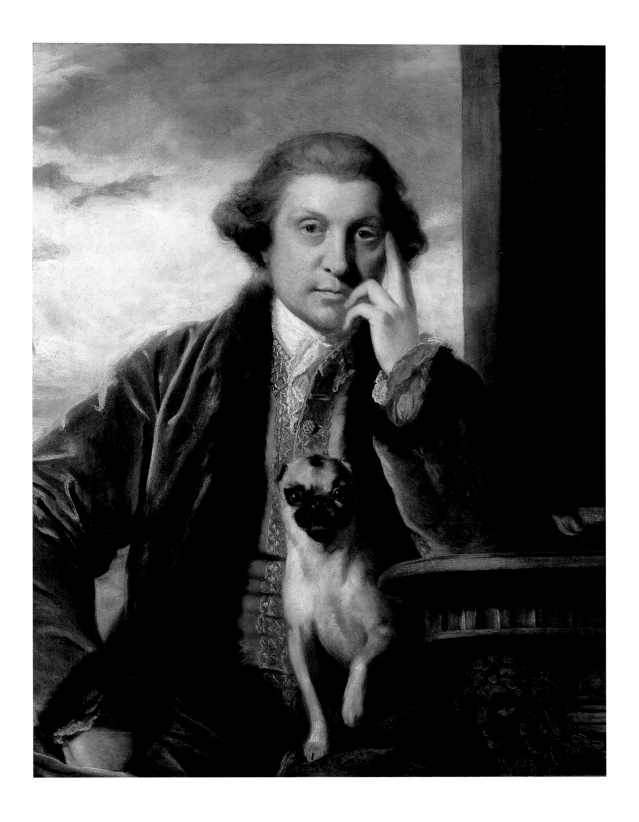

35. *David Garrick, as 'Kitely'* 1767

Oil on canvas, 79.8 x 64.1

Lent by Her Majesty Queen Elizabeth II

David Garrick (1717–79) was the most celebrated British actor of the eighteenth century. He also possessed, like Reynolds, a genius for self-promotion. He had first arrived in London with Samuel Johnson in 1737, gaining critical acclaim a few years later through his performance as Richard III in Shakespeare's eponymous play. By the end of the late 1740s he had established himself as the leading figure in the London theatre; an actor, playwright, producer and the joint owner of the capital's Drury Lane theatre. The present picture was painted at the height of Garrick's fame, in the late 1760s. By now Reynolds and Garrick socialised together frequently, sharing an interest in art, literature and intellectual company. Even so, Garrick was not admitted to the Club until some years later, Johnson fearing that 'he will disturb us by his buffoonery' (Yung 1984, p.107).

In the present portrait Reynolds captures Garrick's performance as Kitely, the merchant in Ben Jonson's comedy of 1598, *Every Man in his Humour*. According to the inscription upon the engraving made from Reynolds's painting in 1769, Garrick's expression relates specifically to Act 2, Scene 1, where the merchant suspects his wife of being unfaithful: 'Yea, every look or glance mine eye ejects / Shall check occasion.' Reynolds was not, however, simply illustrating a particular moment in Jonson's play. His portrait is concerned rather with demonstrating Garrick's ability to lose himself in a theatrical role, so that here, for instance, he becomes the personification of the jealous husband. Garrick had first acted the role of Kitely in 1751; since then he had made it his own. As the bluestocking, Mrs Montagu, wittily observed: 'Mrs. Montagu is a little jealous for poor Shakespeare; for if Mr. Garrick often acts Kitely, Ben Johnson will eclipse his fame' (Boswell 1934–50, vol.2, p.92, n.3).

Reynolds's relationship with Garrick was ambiguous. He painted his portrait on four separate occasions, as well as a double portrait of Garrick and his wife, Eva Maria (1772–3; National Portrait Gallery, London). Yet, while he admired Garrick's professional achievement, he made a damning assessment of his character after his death. Garrick was, according to Reynolds, 'a slave to his reputation', caring more about his own name than the welfare of others. 'The habit', wrote Reynolds, 'of seeking fame in this manner left his mind unfit for the cultivation of private friendship.

Garrick died without a real friend, though no man had a greater number of what the world calls friends' (Hilles 1952, pp.86–7). Perhaps, however, it was not Garrick's failure to keep his friendships in good order that irked Reynolds, but that he failed so conspicuously to contain his craving for fame within the accepted bounds of good taste.

MP

Provenance
Said to have been given to Edmund Burke by the artist; Burke's sale, Christie's 5 June 1812 (93), bought by Lord Yarmouth for the Prince Regent.

Literature
Graves and Cronin 1899–1901, vol.1, p.350; Waterhouse 1941, p.59; Millar 1969, pp.102–3; Wind 1986, p.34; Penny 1986, p.236; Mannings and Postle 2000, vol.1, pp.210–11, vol.2, pl.66, fig.916.

Engraved
J. Finlayson 1 February 1769.

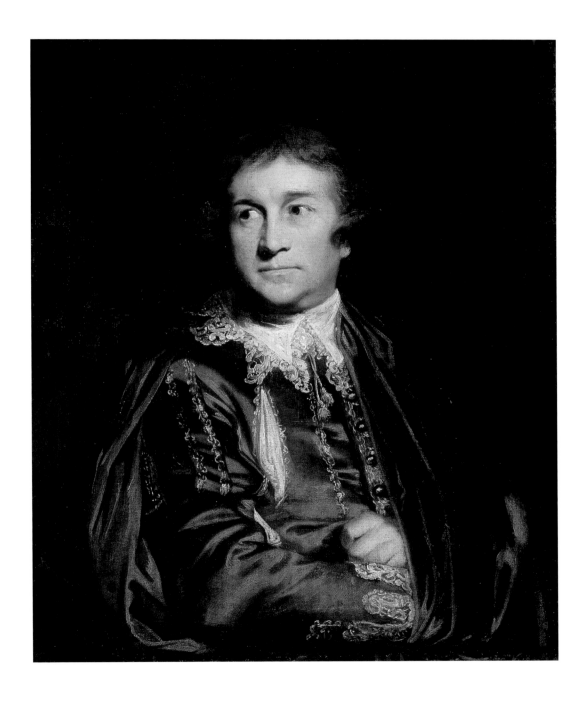

36. *Mr Huddesford and Mr Bampfylde* c.1778

Oil on canvas, 125.1 x 99.7

Tate. Presented by Mrs Plenge in accordance with the wishes of her mother, Mrs Martha Beaumont 1866

The portrait is a poignant record of the friendship between two young men, the satirist and amateur painter, George Huddesford (1749–1809) on the left, and John Bampfylde (1754–97), whose reputation as a musician and poet was shortly to be eclipsed by his trial for the attempted molestation of Reynolds's niece, and his subsequent decline into insanity. Huddesford and Bampfylde are depicted examining an engraving of Reynolds's portrait of Joseph Warton, a close friend of Reynolds, and Master of Winchester College, where both Huddesford and Bampfylde had been pupils. The composition, which generally recalls the portraiture of Sir Anthony Van Dyck, is also a deliberate evocation of the Renaissance friendship portrait, celebrating the fraternal bond between two young men.

Although Bampfylde and Huddesford were close friends, their personalities and fortunes differed dramatically. In 1771 Huddesford was awarded a fellowship at New College, Oxford, although he gave it up the following year, having 'married his girl friend hastily in London, carried away by youthful passion' (Lonsdale 1988, p.20). Shortly afterwards he studied portrait painting under Reynolds. Although he continued to paint in later life, it was as a writer of satirical verse that he was best known. He first gained notoriety with the publication of *Warley*, which he wrote at the time of this portrait, and which he dedicated to Reynolds, 'the first ARTIST in Europe'. Although he presents a serious demeanour in Reynolds's portrait, Huddesford had a comical appearance – a contemporary noted that his 'supposed resemblance to a horse was the occasion of much academical waggery'. The same writer asserted that Huddesford's 'letter-box was often filled with oats; and when he wished to have his portrait taken, he was sent to the famous Stubbs, the horse painter' (Smith 1845, pp.79–80).

John Codrington Warwick Bampfylde was the son of a baronet. A gifted musician, Bampfylde also harboured ambitions as a writer, although following his move to London in the mid-1770s, 'his feelings having been forced out of their natural and proper channel, took a wrong direction, and he soon began to suffer the punishment of debauchery' (Southey 1850, vol.2, pp.27–8). It was at this time that he fell in love with Reynolds's niece, Mary Palmer, who was then living with her uncle in Leicester Square. In December 1778 he published a book, *Sixteen Sonnets*, dedicated to Mary, and a few weeks later published an anonymous poem in a newspaper in which he compared himself unfavourably to her pet monkey (Lonsdale 1988, p.25).

He was rejected by Mary, but the following spring Bampfylde gatecrashed a supper party attended by Reynolds and his niece in Lincoln's Inn Fields. Having been ejected by the police, he turned up at Reynolds's door at two in the morning, where he was promptly arrested for disturbing the peace. Although the case was dropped, Bampfylde persisted: it was reported the following month that he 'came a few days since to Sir Joshua's, and on being answered in the negative, he desired the footman to tell her to take care, for he was determined to ravish her (pardon the word), whenever he met her' (Lonsdale 1988, p.29).

By this point Bampfylde was completely deranged. His family disowned him, although a musician friend eventually traced him to King Street, Holborn, where he was living in squalor, 'his shirt-collar black and ragged – his beard of two months' growth' (Lonsdale 1988, p.30). With the assistance of Bampfylde's mother, the friend ensured that he was provided with decent lodgings and an allowance, although his mental condition (which appears to have been hereditary) meant that he spent the rest of his life in a private mental asylum in Sloane Street. Bampfylde briefly recovered his sanity just before his death in December 1797.

MP

Provenance
Painted for George Huddesford who gave it to Mrs Martha Beaumont (d.?1860); passed to her daughter (later Mrs Plenge), who presented it, through Mr Hugh Barclay, to the National Gallery in 1866 in the name of her mother; transferred to the Tate Gallery in 1956.

Literature
Cotton 1859, pp.92–3; Leslie and Taylor 1865, vol.2, pp.203, 224; Graves and Cronin 1899–1901, vol.2, pp.488–9; Whitley 1928, vol.2, pp.157–9; Waterhouse 1941, p.69 and pl.194; Hudson 1958, pp.155–8, repr.; Davies 1959, p.118, no.754; Cormack 1968–70, p.155; Lonsdale 1988, pp.20–5; Mannings and Postle 2000, vol.1, p.71, vol.2, fig.1254.

Engraved
A.N. Sanders 1866; Sir Frank Short 1905.

37. *The Hon. Miss Monckton c.*1777–8

Oil on canvas, 240 x 147.3

Tate. Bequeathed by Sir Edward Stern 1933

In 1782 Fanny Burney memorably described an early encounter with Mary Monckton (1746–1840), the celebrated society hostess. She was 'between thirty and forty, very short, very fat, but handsome, splendidly and fantastically dressed, rouged not unbecomingly, yet evidently and palpably desirous of gaining notice and admiration. She has an easy levity in her air, manner, voice, and discourse, that speak all within to be comfortable; and her rage of seeing any thing curious may be satisfied, if she pleases, by looking in a mirror' (Burney 1842–6, vol.2, p.179). Miss Monckton's unconventional demeanour is vividly captured in Reynolds's witty portrait, which was commissioned by the sitter, still then a single woman. It would have been displayed in her mother's house in Charles Street, Berkeley Square, where Miss Monckton conducted her salons. In view of the pose she adopts in Reynolds's picture, it is important to stress that she was in the habit of receiving her party guests seated. Thus the portrait acted as a substitute when she was absent and, in her presence, as a reminder of this diminutive woman's engaging personality.

Mary Monckton was the only surviving daughter of John Monckton, 1st Viscount Galway, and his second wife, Jane. Her elder brother was the distinguished general, Robert Monckton, who had served as Wolfe's second-in-command in Quebec. However, Mary rapidly gained celebrity in her own right. Born in 1746, she lived, until her marriage, with her widowed mother. Well read and versed in the arts, she was regarded as amongst the most engaging of the capital's intellectual women, or 'bluestockings', collecting, as Burney observed, 'all extraordinary or curious people to her London conversaziones' (Burney 1842–6, vol.2, p.179). Prominent in her literary circle were Reynolds, Samuel Johnson, Edmund Burke, Richard Brinsley Sheridan, Horace Walpole and Mrs Siddons, all of whom also feature in the present exhibition.

In June 1786 Mary married the Earl of Cork. After her husband's death in 1798, Lady Cork, as she was now titled, continued to attract celebrities to her social gatherings, including the Prince Regent, Lord Byron, the poet James Hogg, and in later years Sir Walter Scott, Sir Robert Peel and the writer Sydney Smith. As the painter Charles Robert Leslie noted in his autobiography, the 'old lady, who was a lion hunter in her youth, is as much one now as ever' (Leslie 1860, vol.1, pp.136, 243).

Mary Monckton retained a prodigious memory into old age – one evening, at the age of eighty, she recited half a book of Alexander Pope's translation of Homer's *Iliad* while waiting for her coach. She was prone to kleptomania and 'when she dined out her host would leave a pewter fork or spoon in the hall for her to carry off in her muff' (*Dictionary of National Biography*, London 1909, vol.13, p.611). By the end of her life, Lady Cork's eccentricities were the stuff of legend, attracting the attention of the young Charles Dickens, who apparently drew upon them for the fictional character of Mrs Leo Hunter, the celebrated hostess and 'lion hunter' of *The Pickwick Papers*.

MP

Provenance
By descent to the sitter's great-nephew, Edward Philip Monckton of Fineshade Abbey, Northamptonshire; Monckton sale, Christie's 7 July 1894 (78), bought Agnew's for Sir Julian Goldsmid; his sale Christie's 13 June 1896, bought Agnew's for Sir Edward Stern; bequeathed to the National Gallery, with a life interest in the picture retained by Lady Stern (renounced 1946); transferred to the Tate Gallery.

Literature
Leslie and Taylor 1865, vol.2, p.278 and n.2, p.279; Hamilton 1884, p.119; Graves and Cronin 1899–1901, vol.2, pp.654–5; Waterhouse 1941, pp.68, 94, 103 and pl.190; Davies 1959, pp.85–6, no.4694; Penny 1986, pp.329, 331; Mannings and Postle 2000, vol.1, p.336, vol.2, fig.1241.

Engraved
Johann (John) Jacobé 1 January 1779.

38. *James Boswell* 1785

Oil on canvas, 76.2 x 63.5

National Portrait Gallery, London

Boswell's principal claim to fame is as author of the most celebrated biography in the English language, *The Life of Samuel Johnson*. A lawyer by training, James Boswell (1740–95) had arrived in London in 1762, where he decided to become a writer. From the outset he was indefatigable in his quest to make the acquaintance of famous people, as well as to enjoy himself, as his London journal reveals in graphic detail (see Boswell 1950, *passim*). Reynolds had known Boswell since at least the early 1770s, although it was not until after the death of Johnson in 1784 that the two men became especially close.

Although they had grown apart, Johnson's death caused Reynolds to re-order his friendships. During the summer of 1785 'the Gang' was formed by Reynolds, Edmond Malone, John Courtnay and James Boswell, all members of the Club and friends of Johnson (see Brady 1984, p.293). Boswell, in particular, took on the self-appointed role of being Reynolds's best friend. And in the summer of 1785, with an eye on the imminent publication of the *Journal of a Tour to the Hebrides with Samuel Johnson LL.D.*, he asked Reynolds to paint his portrait. Boswell proposed that payment for the work (fifty guineas) should be made in instalments over a period of five years out of his legal salary (see Penny 1986, pp.307–8). Reynolds, who was aware of Boswell's continual financial problems, eventually gave him the picture.

By now Boswell must have looked all of his forty-five years. Reynolds, however, appears to have done his best to dignify a constitution ravaged by continual bingeing and disease brought on by unbridled bouts of indulgence in casual sex. This was not lost on contemporaries when the picture was shown at the Royal Academy in 1787. 'This is a strong portrait', observed the *Morning Herald*, 'and shews an artist can do with paint more than nature hath attempted with flesh and blood, viz – put good sense in the countenance' (27 May 1787). At private dinner parties Reynolds enjoyed having the effervescent Boswell at his elbow, not least because of his 'happy faculty of dissipating that reserve which too often damps the pleasure of English society' (Farington 1819, p.83). In public Boswell basked in his association with Reynolds. Yet to outsiders he appeared a malign influence, notoriously on the occasion of their controversial appearance together at a public execution at Newgate Gaol in the summer of 1785. Boswell had a morbid fascination with executions, although Reynolds excused himself on the grounds that he was personally acquainted with one of the condemned men, a former servant of Edmund Burke (see the *Public Advertiser*, 7 July 1785).

In 1791, Boswell dedicated his *Life of Samuel Johnson* to Reynolds. 'If a work', he stated, 'should be inscribed to one who is master of the subject of it, and whose approbation, therefore, must ensure it credit and success, the Life of Dr. Johnson is, with the greatest propriety, dedicated to Sir Joshua Reynolds, who was the intimate and beloved friend of that great man; the friend whom he declared to be "the most invulnerable man he knew; whom, if he should quarrel with him, he should find the most difficulty how to abuse".'

MP

Provenance
By descent to Milo, 7th Lord Talbot of Malahide, who gave it to Sir Gilbert Eliot in 1949; sold by his son, Sir Arthur Boswell Eliot, Sotheby's 7 July 1965 (125), bought by Leger for the National Portrait Gallery.

Literature
Leslie and Taylor 1865, vol.2, pp.476–7; Graves and Cronin 1899–1901, vol.1, pp.99–100; Boswell 1928–34, pp.xvi, 104–6, 109, 120, 123, 278, note; Boswell 1976, pp.194–5; Yung 1981, p.59; Penny 1986, pp.307–9; Mannings and Postle 2000, vol.1, pp.97–8, vol.2, fig.1449; Ingamells 2004, pp.61–3.

Engraved
John Jones 17 January 1786.

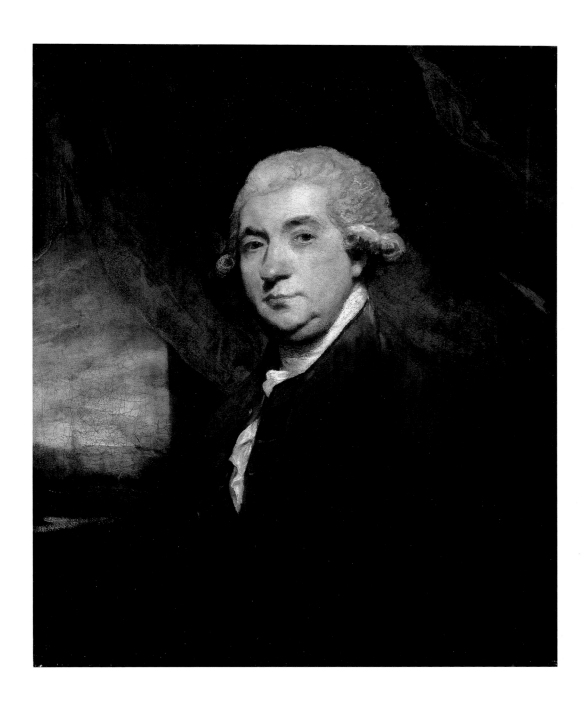

39. *Edward Gibbon* 1779

Oil on canvas, 73.6 x 62.2

Private Collection

'It was at Rome', recalled Edward Gibbon (1737–94), 'on 15 October 1764, as I sat musing amidst the ruins of the Capitol, while the bare-footed fryars [*sic*] were singing vespers in the Temple of Jupiter, that the idea of writing the decline and fall of the city first started in my mind' (Gibbon 1900, p.167). This idea occupied Gibbon for the rest of his life, and resulted in the publication of one of the greatest historical works of the eighteenth century, *The Decline and Fall of the Roman Empire*. Gibbon published his *magnum opus* in six volumes, between 1776 and 1788. By the time the first volume was published, Reynolds was already on close terms with Gibbon, who in 1774 had been elected to the Club, confirming his position in London's intellectual elite.

Gibbon and Reynolds, both confirmed bachelors, were kindred spirits. They enjoyed the conviviality of London's clubs, dined frequently together, gambled and attended masquerades. Their friendship appears to have strengthened in the mid-1770s, especially following the death of Oliver Goldsmith in 1774, who had been up until this point Reynolds's principal companion (see cat.43). Despite his propensity for hard work and his razor-sharp mind, Gibbon cultivated a persona that suggested a life of ease and idleness. As a mutual friend recalled: 'Mr Gibbon, the historian, is so exceedingly indolent that he never even pares his nails: his servant, while Gibbon is reading, takes up one of his hands, and, when he has performed the operation, lays it down, and then manages the other, the patient in the mean while, scarcely knowing what is going on, and quietly pursuing his studies.' Reynolds's portrait, according to the same source, was 'as like the original as it is possible to be' (quoted in Leslie and Taylor 1865, vol.2, p.280, n.1).

Reynolds admired Gibbon's powers of conversation, and composed an imaginary dialogue between Samuel Johnson and Gibbon over the relative merits of Garrick (Hilles 1952, pp.95–105). Johnson was less impressed, not least by what he perceived as Gibbon's irreligiousness. Horace Walpole, among others, noted his vanity, 'even about his ridiculous face and person' (Walpole 1937–83, vol.29, p.98).

Reynolds's portrait, exhibited at the Royal Academy in 1780, drew a number of comments, including a coarse epigram in the *St James's Chronicle* (see 22–4 and 29–31 July 1783). Gibbon, however, was very pleased with it, as Charles James Fox recalled when he paid him a visit in Lausanne several years later: 'Gibbon talked a great deal, walking up and down the room … every now and then, too, casting a look of complacency on his own portrait by Sir Joshua Reynolds, which hung over the chimney piece – that wonderful portrait, in which, while the oddness and vulgarity of the features are refined away, the likeness is perfectly preserved' (Gibbon 1900, p.331).

MP

Provenance
Said to have been taken to Lausanne; exchanged 1790 with his close friend, John Baker Holroyd, 1st Earl of Sheffield, for his own portrait, also by Reynolds; at Sheffield Place until it passed to the Earl of Rosebery in 1909.

Literature
Graves and Cronin 1899–1901, vol.1, pp.358–9; Waterhouse 1941, p.71; Mannings and Postle 2000, vol.1, pp.217–18, vol.2, fig.1298.

Engraved
John Hall 1 February 1780; and others.

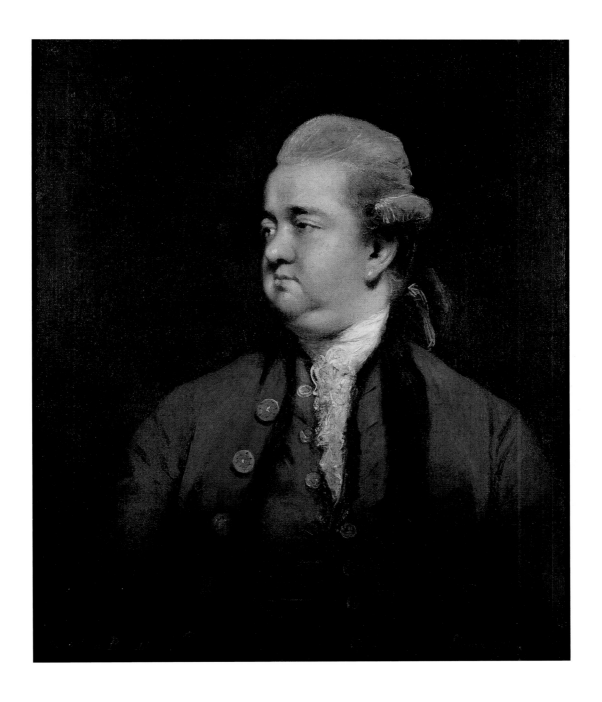

40. *Adam Ferguson* 1781–2

Oil on canvas, 76.5 x 63.8

Scottish National Portrait Gallery, Edinburgh

By the time Reynolds painted his portrait, Adam Ferguson (1723–1816) was among the most eminent philosophers and historians of the age. Educated at the Universities of St Andrews and Edinburgh, among Ferguson's earliest appointments was as chaplain to the Black Watch regiment. In 1745 he took part in the Battle of Fontenoy (see also cat.10), where he led a frenzied attack on the French forces. He remained with the army until 1754, when he took up the post of librarian at the Advocates' Library, Edinburgh. In 1759 he was appointed Professor of Natural Philosophy and, in 1764, Professor of Pneumatics (mental philosophy) and Moral Philosophy. A leading figure in the Scottish Enlightenment, Ferguson travelled abroad to Italy and to France during the 1770s, at which time he became acquainted with Voltaire. In 1778 the British government sent Ferguson to America, as secretary to the commission deputed to negotiate with the colonists.

At the same time, Ferguson was also establishing a literary reputation. In 1767 he had published his *Essay on the History of Civil Society*. This was followed up in 1783 by *History of the Progress and Termination of the Roman Republic*, and, in 1792, by *Principles of Moral and Political Science*, works that have led to him being labelled the father of modern sociology. Like Reynolds, Ferguson was a firm believer in the progress of humankind, using his knowledge of the classical world to advance arguments on the ameliorative nature of society. Clubbable by nature, Ferguson was in outlook and disposition very similar to those who formed Reynolds's intellectual circle; a factor that may well have motivated him to have this portrait painted by Reynolds.

Ferguson was delighted with the portrait, telling a friend in the early autumn of 1781: 'I have brought the Picture from Sir Joshua Reynolds it is a Master Piece & greatly Admired' (quoted in Mannings and Postle 2000, vol.1, p.186). By all accounts Ferguson was a striking figure, as a contemporary observed: 'His hair was silky and white; his eyes animated and light blue; his cheeks sprinkled with broken red, like autumnal apples, but fresh and healthy; his lips thin, and the under one curled … His gait and air were noble; his gesture slow; his look full of dignity and composed fire' (Cockburn 1856, pp.48–9; quoted in Mannings and Postle 2000, vol.1, p.185). Although he was resident in Edinburgh, where Johnson and Boswell met him in 1773, Ferguson also visited London from time to time. He called on Reynolds's studio several times in early 1782. In March that year Reynolds visited Ferguson at his lodgings near St James's, Piccadilly, at which time he took payment for the portrait.

MP

Provenance
Descended, via the sitter's son, to Rupert Benjamin, who inherited it under the terms of the will of his grandfather, Robert Hamilton Ferguson (d.1912); purchased by the Scottish National Portrait Gallery in 1992 through Historical Portraits Limited.

Literature
Leslie and Taylor 1865, vol.2, pp.351–2; Graves and Cronin 1899–1901, vol.1, pp.300–1; Mannings and Postle 2000, vol.1, pp.185–6, vol.2, pl.108, fig.1370.

Engraved
John Buego 23 October 1790; William Ridley (reversed).

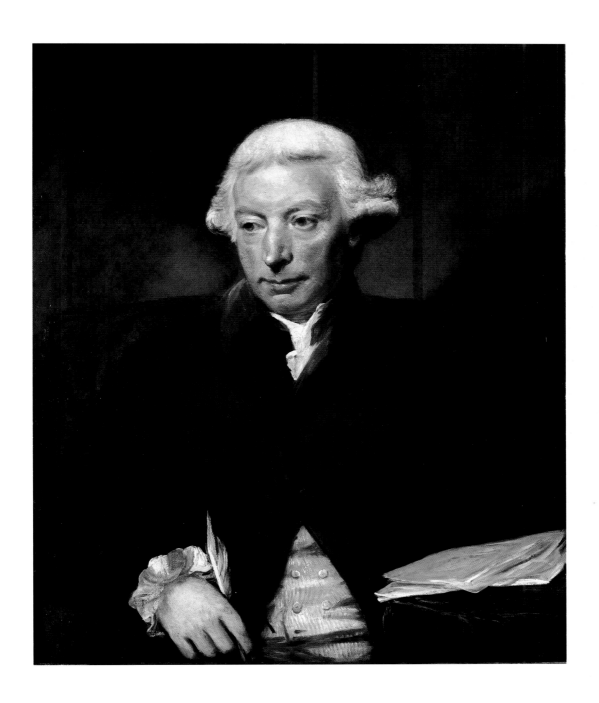

41. *Charles James Fox* 1782–3

Oil on canvas, 125 x 99

The Earl of Leicester and Trustees of the Holkham Estate

Charles James Fox (1749–1806) was amongst the most colourful and charismatic figures in Georgian society and politics. Reynolds, a close friend, had known him since he was a precocious schoolboy at Eton, at which time the artist had painted his leaving portrait (1762; untraced). By the mid-1770s Fox was increasingly linked with Reynolds's circle, and in the spring of 1774 Burke introduced him as a member of the Club. Towards the end of the decade Samuel Johnson, whose acquaintance with Fox was slight, complained that Reynolds was too much under the influence of Fox and Burke. 'He is under the *Fox star* and the *Irish constellation*. He is always under some planet' (Boswell 1934–50, vol.3, p.261).

In the years that followed, Fox was indeed the rising star of the Whig party. And from the moment he gained a post in Lord Rockingham's ministry in 1782 he pursued a policy designed to cause maximum discomfort to George III, and anyone else who got in his way. A year later, along with his political allies John Dunning and Henry, Lord Dundas, Fox sat to Reynolds for his portrait. The resulting painting was exhibited at the Royal Academy in 1784.

The decision to display Fox's picture in public, and the circumstances surrounding its creation, indicate that Reynolds was intent upon promoting the Whig cause. In December 1783, around the time that Reynolds would usually make a provisional list of the following year's exhibits, Fox, encouraged by Burke, was heading for a spectacular showdown with the King and his young Prime Minister, William Pitt. Three months later, in March 1784, George III dissolved Parliament, precipitating what has been described as 'the most acrimonious and bitterly contested election of the century' (L.G. Mitchell, *Charles James Fox*, Oxford 1992, p.70). By the time Fox's portrait was exhibited the following spring, canvassing was in full swing. A key figure in Fox's election campaign was Mrs Frances Crewe, to whose husband he presented this portrait.

Fox was acutely aware of the publicity value of this work in his current political battle. In the portrait Reynolds had placed several documents on the table before Fox. One of these was to have been his East India Bill, which, when Reynolds began the portrait, Fox was confident of winning. However, following Fox's defeat, Reynolds had diplomatically decided to leave the papers blank. Just before the opening of the exhibition Fox asked Reynolds to inscribe them not only with the title of his defeated East India Bill but his 'Representation of the Commons to the King, March 15, 1784'. Although the papers made reference to matters which were intrinsically related to his downfall, Fox told Reynolds that if they were left blank it might 'be misconstrued into a desire of avoiding the public discussion upon a measure which will always be the pride of my life' (Leslie and Taylor 1865, vol.2, pp.429–30). By including mention of the Bills, Reynolds's portrait projected an image of Fox in an act of defiance against the King's ministers. Reynolds readily complied with Fox's wishes and the inscriptions were added to the painting, the numerous replicas, and to the mezzotint engraving published later that year. Although Reynolds was not to know, Fox's failure to lead his party to victory in the 1784 election marked the beginning of the end of his political career.

MP

Provenance
Probably purchased by the sitter, who presented it to John, afterwards 1st Lord Crewe, who in turn gave it to the Earl of Leicester; by descent.

Literature
Cotton 1859, p.69; Leslie and Taylor 1865, vol.2, pp.429–30; Graves and Cronin 1899–1901, vol.1, pp.332–3; Waterhouse 1941, p.75; Mannings and Postle 2000, vol.1, pp.202–3, vol.2, fig.1380; Postle 2001, pp.120–1, repr.

Engraved
John Jones 1 November 1784; William Lane 1793; S.W. Reynolds.

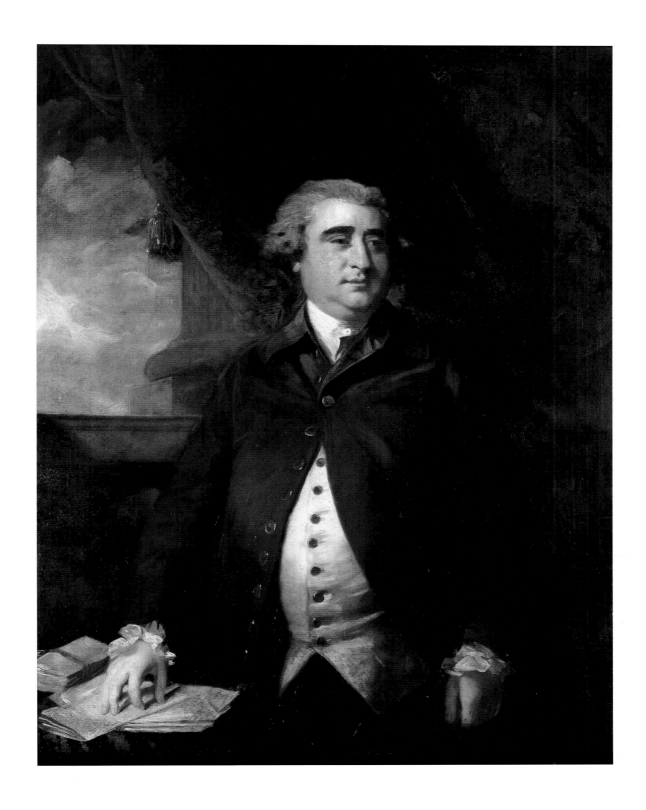

42. *Richard Brinsley Sheridan* 1788–9

Oil on canvas, 127 x 101

House of Commons, London

Richard Brinsley Sheridan (1751–1816), the brilliant author of *The Rivals* (1775) and *The School for Scandal* (1777), rose to fame as an actor, theatre manager and playwright. He is represented here in his later reincarnation as the greatest parliamentarian of the age. Sheridan had entered politics in 1780 on a platform of electoral reform. By this time he was intimate with two key figures in the Whig party, Edmund Burke (cat.45) and Charles James Fox (cat.41), whom he had got to know through their shared membership of the Literary Club. During the 1780s Sheridan's stature as a parliamentarian grew steadily, owing to his charismatic personality and formidable debating skills.

In 1787 Sheridan gave what came to be regarded by his contemporaries as the finest parliamentary performance of all time, his speech on the Begums of Oudh. 'All that he had ever heard', said Fox, 'all that he had ever read – when compared with it dwindled into nothing and vanished like vapour before the sun' (Kelly 1998, p.141). The speech, which focused on the venality of the British administration in India, precipitated the greatest trial of the eighteenth century, the impeachment of the Governor-General of Bengal, Warren Hastings. Reynolds began Sheridan's portrait in June 1788, just days after he had commenced his epic testimony in the Hastings trial. Sheridan's opening speech was delivered to a packed Westminster Hall. As he finished, he fell back into the arms of Burke. Gibbon remarked the following day, 'A good actor. I saw him this morning; he is perfectly well' (Kelly 1998, p.149). Reynolds, who must have taken a keen interest in the trial, did not live to see its completion, since Hastings was only acquitted in 1795, three years after the artist's death.

As in his portrait of Fox, Reynolds painted Sheridan as an orator, dressed in the trademark buff waistcoat and blue coat adopted at the time as a uniform by the Whig party. He worked on the picture sporadically in 1788, and again in the spring of 1789, when he exhibited it at the Royal Academy. Sheridan's portrait was enthusiastically received by the public, including Horace Walpole, who stated: 'Praise cannot overstate the merits of this portrait. It is not canvas and colour, it is animated nature' (Whitley 1928, vol.2, p.394). Sheridan himself was unimpressed, believing that Reynolds had emphasised certain facial flaws, notably his red, blotchy complexion. So concerned was Sheridan that his physical shortcomings would be replicated in the print being made from the portrait that he made frequent visits to the engraver, John Hall. As Hall's pupil remarked, while he could understand a female sitter being worried about such a matter, he was surprised that it 'should have had power to ruffle the thoughts of the great wit, poet and orator of the age' (Whitley 1928, vol.2, p.120).

MP

Provenance
Apparently given to Dr Morris, the sitter's doctor, and passed to his son, the Revd George Morris; by descent until sold Christie's 1 August 1957 (102), bought by Sabin Galleries Ltd, who sold it to Maureen, Marchioness of Dufferin and Ava; her executors' sale Christie's 25 March 1999 (345), acquired, through Historical Portraits Limited, by the House of Commons.

Literature
Raimbach 1843, p.9; Graves and Cronin 1899–1901, vol.3, p.978; Whitley 1928, vol.2, pp.119–20; Waterhouse 1941, p.81; Clifford, Griffiths, Royalton-Kisch 1978, p.56; Mannings and Postle 2000, vol.1, p.412, vol.2, fig.1553.

Engraved
John Hall 30 April 1790; E. Scriven 1814; R. Hicks; S.W. Reynolds; Charles Turner 1825 (part); and many later versions.

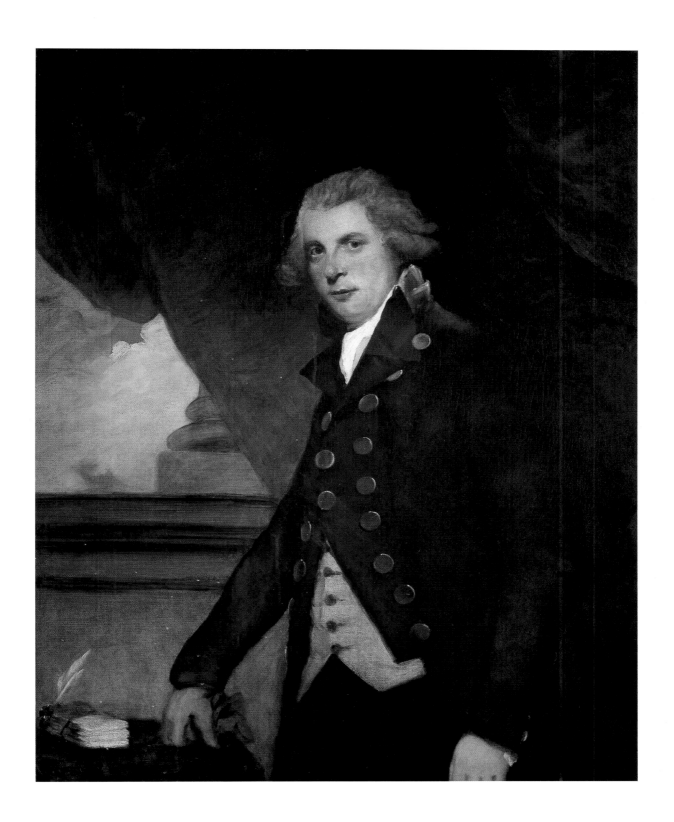

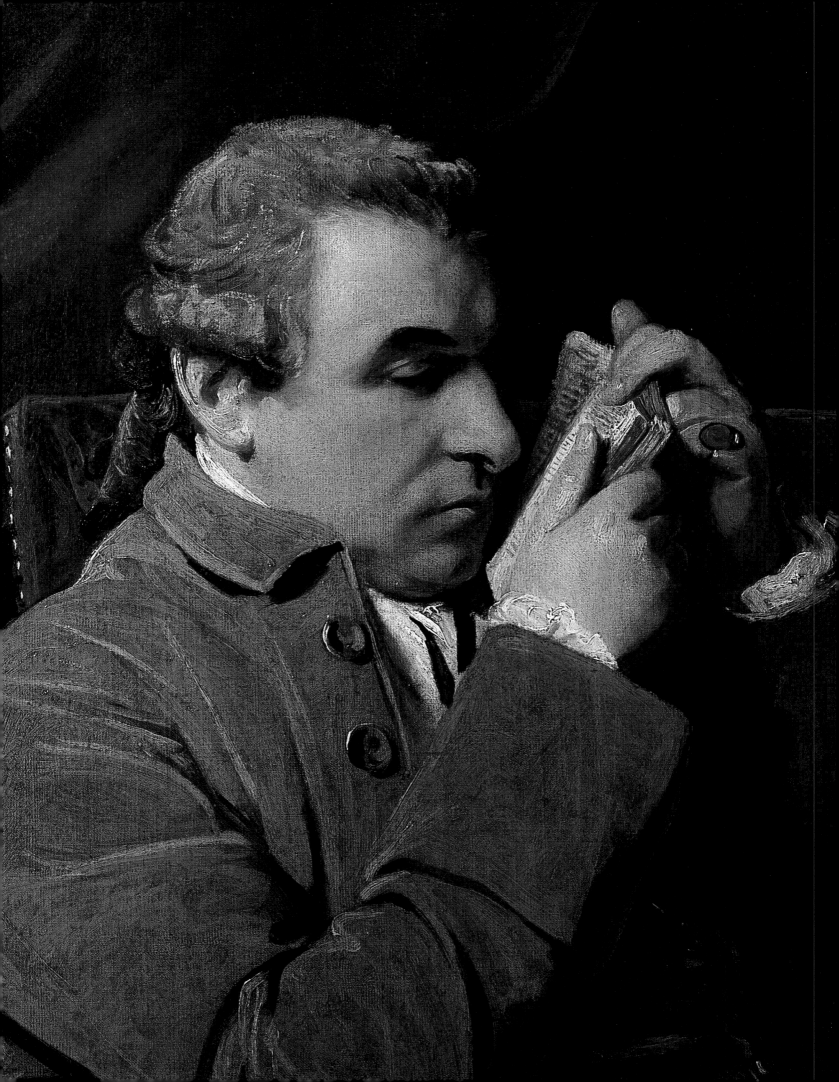

The Streatham Worthies

During the mid-1760s Samuel Johnson introduced Reynolds to Henry Thrale, a wealthy brewer with a taste for literary company. Over the next few years Thrale's home, Streatham Park in southwest London, became a country retreat for Johnson, Reynolds and other members of their intellectual circle. In 1771 Thrale remodelled his estate, improving the surrounding landscape with a lake, walled gardens, farm buildings and a summerhouse for the express enjoyment of Johnson. He also built a library containing books purchased on Johnson's recommendation, and portraits by Reynolds of his notable friends.

Reynolds's portraits for Henry Thrale were produced over a period of about ten years, beginning with the novelist and playwright, Oliver Goldsmith, and concluding in 1781 with the composer and music historian, Charles Burney. In between he produced portraits of Thrale himself, Johnson, David Garrick, Edmund Burke, Giuseppe Baretti, Arthur Murphy, Edwin Sandys, William Henry Lyttleton, Robert Chambers, and a self-portrait. In addition to these twelve bust-length male portraits Reynolds also painted a double portrait of Henry Thrale's wife, Hester, and her daughter Hester Maria ('Queeney'), which was designed to hang over the library's chimneypiece. The novelist and diarist Fanny Burney, a close friend of Mrs Thrale and daughter of Charles Burney, nicknamed Henry Thrale's collection of portraits the 'Streatham Worthies'. This was a reference to the celebrated 'Temple of British Worthies' at Stowe (see p.20 and fig.3), and an acknowledgement of the eminence of the individuals concerned.

Thrale's library formed part of a two-storey extension to Streatham Park, which comprised the library on the ground floor with a guest room for Johnson above. The library, which had a west-facing bow-front and three large windows, became the focal point of the Thrales's social life. Reynolds's portraits were positioned high on the walls, above the bookshelves, following the practice adopted in the celebrated painted frieze in the Upper Reading Room at the Bodleian Library, Oxford, and the arrangement of portraits in aristocratic libraries, such as Woburn, Badminton, Petworth and Chesterfield House, London (Hyde 1979, p.13). According to Fanny Burney, Thrale 'resolved to surmount these treasures for the mind [his books] by a similar regale for the eyes, in selecting the persons he most loved to contemplate, from amongst his friends and favourites, to preside over the literature that stood highest in his estimation' (Burney 1832, vol.2, p.180).

While Henry Thrale was in no doubt that the individuals he had chosen to 'preside' over his library included some of the finest minds of their time, his wife had certain reservations. Of Reynolds, for example, she observed:

> When Johnson by Strength overpowers our Mind,
> When Montagu dazzles, or Burke strikes us blind;
> To Reynolds for Refuge, well pleas'd we can run,
> Rejoyce in his Shadow, and shrink from the Sun.
> (Balderston 1942, vol.1, p.473)

Mrs Thrale also composed a table enumerating the qualities possessed by the various Streatham Worthies, and other celebrated friends. Not surprisingly, Samuel Johnson gained top marks for 'religion', 'morality' and 'general knowledge', while Garrick surpassed all others in 'person and voice' and 'manner'. Reynolds lagged well behind, scoring not a single point for 'scholarship', 'wit' or 'humor' (Balderston 1942, vol.1, pp.329–30). Henry Thrale died before the 'Streatham Worthies' were completed. His widow retained them, until debt eventually forced her to consign them to auction many years later, in 1816. As Fanny Burney noted, the price each one fetched was dictated by 'the celebrity of the subjects' – all of whom were now dead. Johnson once more prevailed, followed in descending order by Burke, Burney, Garrick, Goldsmith and Reynolds. To Mrs Thrale's intense disappointment her own portrait went cheaply, causing her to complain that it was worth twice the price 'even as a History-Piece' (Hyde 1979, p.22). MP

Giuseppe Baretti 1773 (detail of cat.44)
Private Collection

43. *Oliver Goldsmith* 1772

Oil on canvas, 76.2 x 64.1

National Gallery of Ireland, Dublin

In this portrait Reynolds depicts the writer Oliver Goldsmith (1728–74) in profile, much as he had portrayed his own father twenty years earlier (see fig.2). As with that portrait, Goldsmith's picture was also intended as a form of tribute, for Reynolds later recalled 'Dr. Goldsmith was, in the truest as most common sense of the word, a man of genius' (Hilles 1952, p.41). Reynolds's sister, Frances, however, thought Goldsmith's portrait to be 'the most flattered picture she ever knew her brother to have painted' (Northcote 1818, vol.1, p.326). This, the second of two versions of the portrait, was painted for Henry Thrale's collection of 'Streatham Worthies' (Mrs Thrale inscribed on the back of the picture 'Oliver Goldsmith/1772/Reynolds fec'). Reynolds replicated this picture, evidently with studio assistance, from the original portrait for which Goldsmith had sat around 1769 (Knole, Sevenoaks, Kent). That portrait had been exhibited in 1770, the same year in which Reynolds had secured Goldsmith's appointment as Professor of Ancient History at the Royal Academy. The post, which was unsalaried, caused the debt-ridden Goldsmith to remark wryly that 'honours to one in my situation are something like ruffles to a man that wants a shirt' (Northcote 1818, vol.1, p.171).

Reynolds had known Goldsmith since the early 1760s, when his writings had attracted the attention of Samuel Johnson. For the next ten years or so he worked in London as a prolific writer of poetry, plays and essays. He also undertook endless hackwork to stave off financial problems generated by his recklessness and unbridled generosity. Even so, he enjoyed considerable critical success, notably with his novel, *The Vicar of Wakefield* (1766); the comic play, *She Stoops to Conquer* (1773); and his poem, *The Deserted Village* (1770), which he dedicated to Reynolds: 'The only dedication I ever made was to my brother, because I loved him better than most other men. Since he is dead. Permit me to inscribe this Poem to you [*sic*].'

Unlike the majority of Reynolds's friends, Goldsmith found fame difficult to cope with and suffered from a crisis of confidence, especially in the company of the other eminent individuals whom Reynolds attracted into his *ménage*. Nor did his conversation match his literary abilities; Reynolds once observed that among those 'who knew him but superficially, many suspected he was not the author of his own works, whilst others pronounced him an idiot inspired' (Hilles 1952, p.41). A lifelong bachelor, he was for a while smitten by the teenage Mary Horneck, who was at that time part of Reynolds's social circle, and whom Reynolds may possibly have referred to cryptically in the back of his journal of 1771 as 'Goldsmith's Girl'.

Goldsmith died in 1774. Reynolds, as his executor, at first planned a grand funeral in Westminster Abbey, but this was abandoned owing to the scale of Goldsmith's debts. Yet, while Goldsmith was given a simple burial at the Temple Church, his fellow members of the Club commissioned the sculptor Joseph Nollekens to provide a monument to him in Poets' Corner in Westminster Abbey. Reynolds selected the precise spot: 'He thought himself lucky in being able to find so conspicuous a situation for it, as there scarcely remained another so good' (Northcote 1818, vol.1, p.326).

MP

Provenance
Painted for Henry Thrale's library at Streatham Park; his widow, Mrs Piozzi; sold with the contents of Streatham Park, by Squibb, Surrey, 10 May 1816 (60), bought for the Duke of Bedford; the Duke of Bedford sale, Christie's 19 January 1951 (133), bought in; sold by the Trustees of the Bedford Estates, Christie's 1 November 1994 (15), bought by National Gallery of Ireland.

Literature
Graves and Cronin 1899–1901, vol.1, pp.367–8 (confusing it with the portrait of Goldsmith at Knole); Cormack 1968–70, p.143; Hyde 1979, p.16; Tscherny 1986, pp.4–7, 10.

Engraved
?Giuseppe Marchi 1770; and others (probably from the earlier version at Knole, Kent).

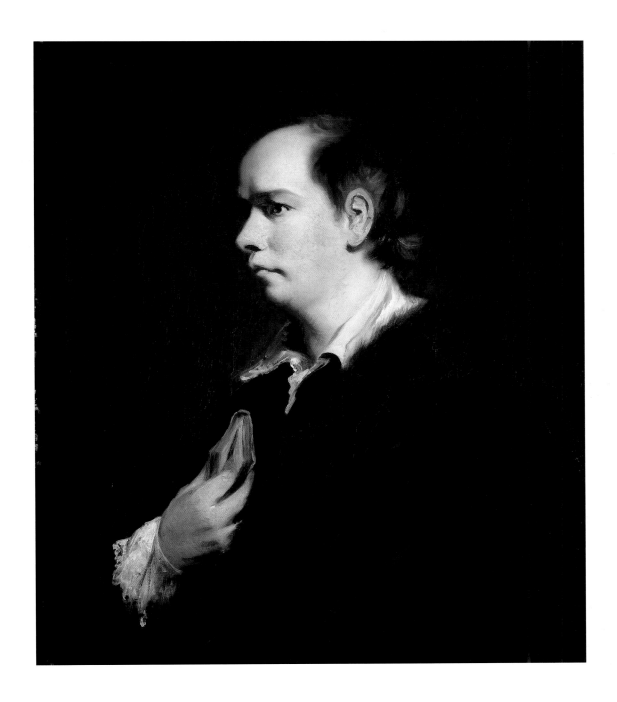

44. *Giuseppe Baretti* 1773

Oil on canvas, 73.7 x 62.2

Private Collection

This is among the earliest portraits to have been painted for Henry Thrale's library at Streatham Park. It was completed by mid-August 1773, when it was seen at Reynolds's house by the Scottish academic, James Beattie: 'It is a very fine performance, and took up just eight hours in painting' (Beattie 1946, p.82). The literary critic and translator Giuseppe Marc'Antonio Baretti (1719–89) grew up in Turin. He arrived in England in 1751, and in 1760 he published his popular *Dictionary of the English and Italian Language*. During the 1760s he travelled extensively through Europe, after which he published the celebrated *Travels through Spain, Portugal and France* of 1770. A friend of Reynolds's and Johnson's, he was by the early 1770s also employed as a live-in tutor in Italian and Spanish to the Thrales's eldest daughter, Hester Maria (see cat.49).

Reynolds's portrait, exhibited at the Royal Academy in 1774, presents Baretti as a scholar, totally absorbed in the world of letters. It should however be borne in mind that Baretti's public image at the time was still tarnished by his imprisonment for murder in 1769: he had narrowly escaped hanging after he stabbed a pimp to death in a violent street brawl (see Robinson 1992, pp.81–94). Reynolds was among those friends who had come forward as a character witness at Baretti's trial, stating not only that he was 'of a peaceable, quiet Disposition', but that he was also 'exceedingly near sighted' (Robinson 1992, p.3). Indeed, Duncan Robinson has suggested that the emphasis placed in the present portrait on Baretti's extreme short-sightedness may be related directly to Baretti's trial, where his semi-blindness had been used in mitigation by himself and his friends. Reynolds's portrait, therefore, through its awareness of external circumstances, could be construed as a means of reforming Baretti's public persona, erasing the acerbic, pugnacious elements of his character, and instead presenting an altogether more amiable image, one that sits harmoniously alongside his scholarly peers in Henry Thrale's library.

By the mid-1770s, Baretti was thoroughly integrated into the social and intellectual circle of Streatham Park. Unfortunately in the summer of 1776 he stopped visiting following a series of quarrels with Mrs Thrale, who shared his fiery temper. In her private journals she accused him, among other things, of turning her daughter against her, while he in turn libelled her publicly (see Balderston 1942,

vol.1, p.44, n.3). Although estranged from the Thrales, Baretti remained close to Reynolds. In 1769 Reynolds had appointed him Secretary for Foreign Correspondence at the Royal Academy, while in 1778 Baretti translated Reynolds's *Discourses* into Italian. Unfortunately, the Florentine publisher Luigi Siries (see cat.4) made considerable alterations to Baretti's text, on the grounds that it was too recondite to be understood by Italian artists. Baretti responded with characteristic venom: 'Because the artists of Florence are in your presumptuous opinion a pack of asses, my dear Signor Luigi Siries, superlative ass that you are, must you re-do a thing of mine, or rather un-do it, degrading the language, corrupting the style, distorting the thought, and polluting the whole with your imbecilities, that it may be intelligible to your long-eared brethren?' (Hilles 1936, p.55).

MP

Provenance
Painted for Henry Thrale's library at Streatham Park; his widow, Mrs Piozzi; sold with the contents of Streatham Park, by Squibb, Surrey, 10 May 1816 (65), bought George Watson Taylor; Christie's 13 June 1823, bought in; sold 1832 by Robins to Taylor acting for the Marquess of Hertford; exchanged by him in 1843 for a portrait by Reynolds of Lady William Gordon in Holland House; Lady Holland; thence by descent.

Literature
Burney 1842–6, vol.1, p.416, vol.2, p.5; Leslie and Taylor 1865, vol.2, p.76; Graves and Cronin 1899–1901, vol.1, pp.49–50; Waterhouse 1941, p.64; Hyde 1979, p.17; Robinson 1992, pp.81–94; Mannings and Postle 2000, vol.1, pp.72–3, vol.2, pl.72, fig.1067.

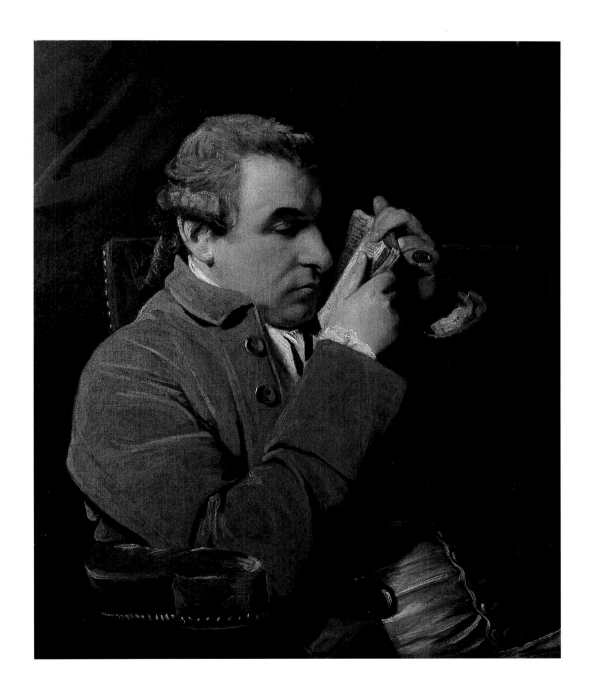

45. *Edmund Burke* 1774

Oil on canvas, 76.2 x 63.5

Scottish National Portrait Gallery, Edinburgh

Reynolds had first met Edmund Burke (1729–97) around 1757, following the publication of his book *A Philosophical Enquiry into the Origin of Our Ideas of the Sublime and Beautiful*, Burke's seminal treatise on the conflicting emotions aroused by pain, terror and the immensity of objects in nature. He maintained a close friendship with Burke for the remainder of his life, helping him out when he got into financial difficulties and patiently tolerating requests for assistance from his extended Irish family. At the same time, Burke was also, arguably, the single most important influence upon Reynolds's life and work. For while Samuel Johnson acted as Reynolds's mentor in the 1750s and 1760s, it was Burke who shaped the artist's views on society: he shared with him his philosophical and political creed, and gave him the confidence to pursue his career as a portraitist within the corridors of power. It was also Burke who effectively transformed Reynolds from an artist with sympathies for Whig ideals into the 'principal painter' to the Whig party.

From the early 1760s Burke and Reynolds frequently spent time in one another's company, notably as members of the Literary Club, of which they were founder members. One subject upon which Reynolds and Burke were in complete agreement was their antipathy towards the King. Although Burke's anti-monarchical stance was grounded in rational pro-constitutional arguments, he at times expressed his views in an uncompromising fashion – on one notable occasion an offended Goldsmith was forced to leave Reynolds's house owing to the vehemence of Burke's invective against George III (Hazlitt 1830, p.40). It was evidently Burke who suggested to Reynolds the subject of his first major history painting, *Ugolino and his Children in the Dungeon* (see fig.26), as Ugolino was regarded by Whigs such as Burke as a medieval counterpart to the modern 'liberty-loving English lord' (Yates 1951, p.253).

Owing to their lifelong friendship and the compatibility of their outlook on life, it was fitting that Burke should have written the first posthumous appreciation of Reynolds's life and work, which was penned as he sat in the artist's house in Leicester Square, just hours after his death: 'He was the first Englishman who added the praise of the elegant arts to the other glories of his country. In taste, in grace, in facility, in happy invention, and in the richness and harmony of colouring, he was equal to the great masters of the renowned ages. In portrait he went beyond them. He possessed the theory as perfectly as the practice of his art. To be such a painter, he was a profound and penetrating philosopher' (Northcote 1813, pp.371–3). It was appropriate that it fell to Burke to shape Reynolds's posthumous reputation. He had known Reynolds for almost thirty-five years, without, as he recalled, 'a moment of coldness, of peevishness, of jealousy, or of jar, to the day of our final separation' (Northcote 1818, vol.2, p.211).

MP

Provenance
Painted for Henry Thrale's library at Streatham Park; his widow, Mrs Piozzi; sold with the contents of Streatham Park, by Squibb, Surrey, 10 May 1816 (67), bought Richard Sharp, who bequeathed it to Mrs Drummond; the latter bequeathed it conditionally to the National Gallery of Ireland in 1930, from where it was transferred to the Scottish National Portrait Gallery in 1969.

Literature
Graves and Cronin 1899–1901, vol.1, pp.129–30; Waterhouse 1941, p.64; Hyde 1979, p.18; Smailes 1990, p.48; Mannings and Postle 2000, vol.1, p.114, vol.2, fig.1100.

Engraved
J. Hardy.

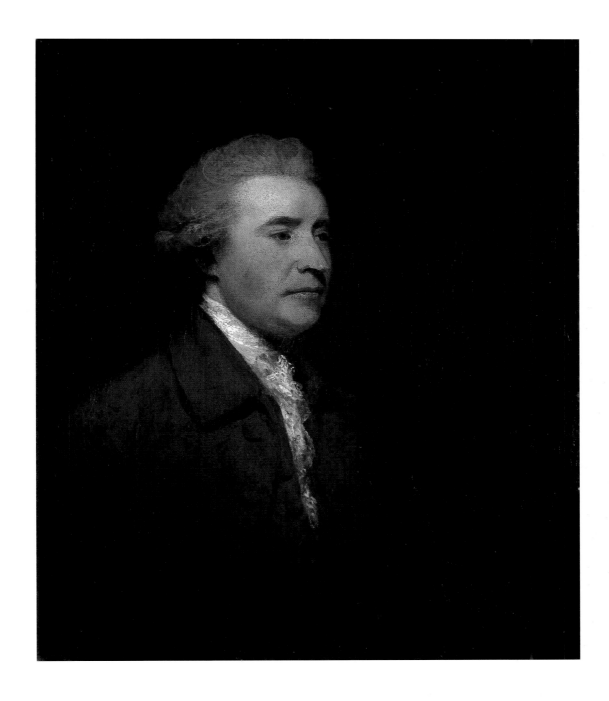

46. *Self-Portrait c.*1775

Oil on canvas, 74.9 x 62.2

Tate. Bequeathed by Miss Emily Drummond 1930

Reynolds painted this self-portrait for the library of Henry Thrale's house at Streatham Park. In the portraits Reynolds painted for Thrale, he sought to pinpoint the principal characteristics of his friends. Reynolds, who here draws attention to his own partial deafness, may also have been referring to his customary role as listener – usually to Johnson or Burke, who would often monopolise the conversation with their contrasting opinions. A further point of reference, as David Mannings has suggested, may have been Oliver Goldsmith's character study of Reynolds in his 1774 poem 'Retaliation':

To Coxcombs averse, yet most civilly steering;
When they judged without skill, he was still hard
 of hearing.
(Mannings 1992, p.28)

It was to this picture that Mrs Hester Thrale was evidently gesticulating when she praised Reynolds to Johnson for emphasising his own physical shortcomings. Johnson's memorable response was: 'He may paint himself as deaf if he chuses … but I will not be *blinking Sam*' (Yung 1984, p.112; see also cat.47).

It was during his stay in Rome in the early 1750s that Reynolds is traditionally supposed to have become partially deaf. 'His deafness', according to his friend Edmond Malone, 'was originally occasioned by a cold that he caught in the Vatican, by painting for a long time near a stove, by which the damp vapours of that edifice were attracted, and affected his head. When in company with only one person, he heard very well, without the aid of a trumpet' (Malone 1819, vol.1, p.lxxxix, note). While Reynolds's deafness may have been exacerbated by a chill caught while studying the art of Raphael and Michelangelo, his descendant, Sir Robert Edgcumbe, remarked that 'there is no doubt that deafness was hereditary in his family, as at least six others have suffered from similar deafness coming on at a comparatively early age' (Graves and Cronin 1899–1901, vol.4, p.1690). As Fanny Burney commented of one of Reynolds's nieces in the late 1780s, 'she is pretty, soft and pleasing, but unhappily as deaf as her uncle, Sir Joshua, which in a young female is a real misfortune' (Burney 1842–6, vol.4, p.176).

When Reynolds was out and about he generally carried a silver ear trumpet, as can be seen in Zoffany's celebrated painting *The Academicians of the Royal Academy* (see cat.86). Inevitably, the trumpet was the butt of a number of jokes. According to Mrs Thrale, 'somebody said at the Academy Meeting in the year 1778 – Sir Joshua carries his own Trumpet I see; Yes replies James but you may observe other People blow it for him [*sic*]' (Balderston 1942, vol.1, p.590). 'James' was perhaps the Royal Academician, James Barry, who was by then openly conducting a vendetta against Reynolds within the Academy. More innocuously, a newspaper reported a few years later that when attending the theatre a woman had enquired of Reynolds: 'What was the name of that instrument he appeared to play upon by means of his ear?' (*Morning Herald*, 4 February 1785).

MP

Provenance
Painted for Henry Thrale's library at Streatham Park; his widow, Mrs Piozzi; sold with the contents of Streatham Park, by Squibb, Surrey, 10 May 1816 (61); bought by Richard Sharp, who bequeathed it to his ward, Maria Kinnaird; by descent to Miss Emily Drumond, who bequeathed it to the National Gallery in 1930; transferred to the Tate Gallery.

Literature
Northcote 1818, vol.2, pp.3–4; Malone 1819, vol.1, p.lxxvii, note; Graves and Cronin 1899–1901, vol.2, p.802; Waterhouse 1941, p.66; Davies 1959, p.127; Hyde 1979, pp.16, 22; Wind 1986, p.73; Mannings 1992, pp.28–9; Mannings and Postle 2000, vol.1, p.50, vol.2, fig.1151; Ingamells 2004, p.395.

Engraved
S. Llewellyn 1884 (frontispiece to Edmund Gosse's edition of the *Discourses*).

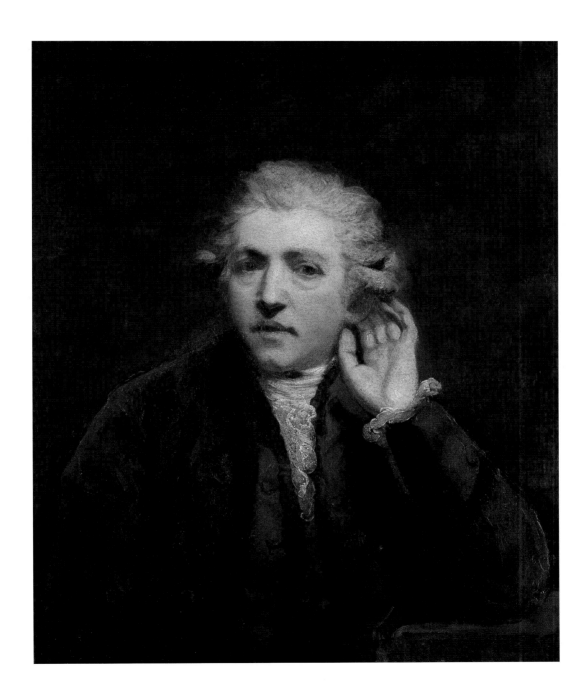

47. *Samuel Johnson c.1772–8*

Oil on canvas, 75.6 x 62.2

Tate. Purchased 1871

Reynolds first came across the writings of Samuel Johnson (1709–84) in 1752, when he had been transfixed by his biography of the poet Richard Savage, a convicted murderer. In the spring of 1755 Johnson published *A Dictionary of the English Language*, the *magnum opus* that secured his literary reputation. Within a few months he and Reynolds were on close terms. At first Reynolds found Johnson's frequent visits to his studio intrusive (Northcote 1818, vol.1, pp.79–80). Rapidly, however, Johnson was transformed from house-pest to household deity. Reynolds later recalled: 'For my own part I acknowledge the highest obligations to him. He may be said to have formed my mind and to have brushed off from it a deal of rubbish' (Hilles 1952, p.66). As a moralist, Johnson was deeply concerned with the double-edged sword of fame and celebrity. 'When once a man has made celebrity necessary to his happiness', he wrote, 'he has put in the power of the weakest and most timorous malignity, if not to take away his stisfaction, at least to withold it' (*The Rambler*, no.146, 10 August 1751). The attraction of Johnson to Reynolds, aside from his compelling personality and literary prowess, was his extensive social network. Dogged by an obsessive need for company, Johnson had already formed a wide-ranging circle of literary acquaintances including Giuseppe Baretti (cat.44), Thomas and Joseph Warton, and Bennet Langton, all of whom also became lifelong friends of Reynolds.

Despite his supposed indifference to the visual arts (occasioned in part by his poor eyesight), Johnson appreciated the purpose of Reynolds's portraiture: 'I should grieve to see *Reynolds* transfer to heroes and to goddesses, to empty splendour and to airy fiction, that art, which is now employed in diffusing friendship, in renewing tenderness, in quickening the affections of the absent, and continuing the presence of the dead' (*The Idler*, no.45, 24 February 1759). By this time Reynolds had already painted Johnson's portrait, seated and looking heavenwards as if for literary inspiration (fig.27). He painted him again the following decade, bareheaded, in profile and in the manner of a classical scholar, albeit exhibiting his eccentric hand gesticulations (fig.14). The present picture, the least flattering of Reynolds's three portraits of Johnson, was painted in the 1770s for Henry Thrale's library at Streatham Park. Reynolds's intention was, presumably, to convey the idiosyncratic manner of Johnson's conversation, which involved involuntary rolling of the head and shaking of the limbs; although, as it has been recently observed, the portrait also highlights the subject's physical discomfort 'instinctively attended by the fingering of buttons on a too tight waistcoat' (Tscherny 1986, p.4).

Although Reynolds and Johnson kept in touch, in later years they gradually grew more distant, especially as Reynolds gravitated towards the company of the Whig politician, Charles James Fox (cat.41), and other acolytes of the debauched Prince of Wales. Johnson also made friends with the Irish artist James Barry. While Barry had once been Reynolds's protégé, by the early 1780s he openly attacked him, ostensibly for Reynolds's failure to support Barry's agenda to promote history painting within the Royal Academy. Meanwhile, Johnson not only expressed open admiration for Barry, but invited him to a club he formed in December 1783 at a public house on the Strand. Reynolds, who valued his public profile, declined the invitation on the grounds that the club included some 'very odd people' (Hilles 1936, p.163).

MP

Provenance
Painted for Henry Thrale's library at Streatham Park; his widow, Mrs Piozzi; sold with the contents of Streatham Park, by Squibb, Surrey, 10 May 1816 (68), bought by G. Watson Taylor; Taylor sale by Robins at Erlstoke, 25 July 1832 (150), bought by Sir Robert Peel; bought by the National Gallery in 1871; transferred to the Tate Gallery.

Literature
Leslie and Taylor 1865, vol.1, p.147, n.3; Graves and Cronin 1899–1901, vol.2, pp.520–1; Powell in Boswell 1934–50, vol.4, pp.450–2; Waterhouse 1941, p.62; Davies 1946, pp.118–21; Hyde 1979, pp.10–25; Yung 1984, pp.117–18; Tscherny 1986, pp.4–10; Mannings and Postle 2000, vol.1, pp.281–2, vol.2, fig.1070.

Engraved
William Doughty 24 June 1779; T. Cook 1787.

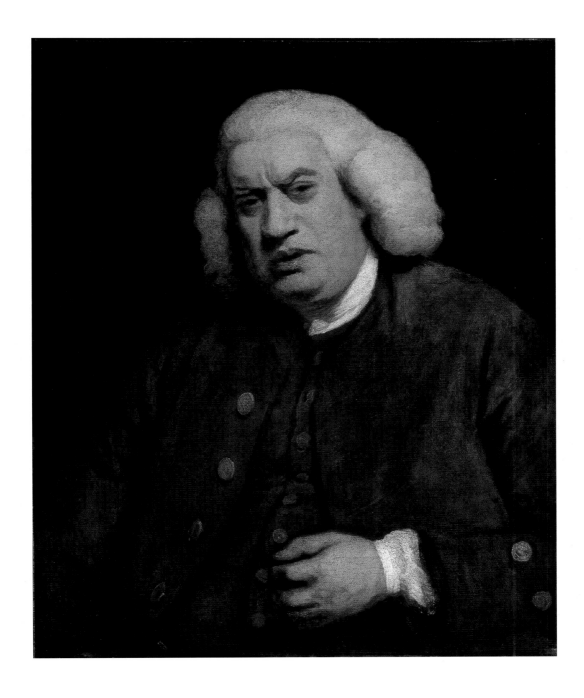

48. *Charles Burney* 1781

Oil on canvas, 74 x 61

National Portrait Gallery, London

Reynolds's portrait of the eminent music historian and composer Charles Burney (1726–1814) was the final portrait to have been commissioned by Henry Thrale for Streatham Park. Painted in 1781, it was, as his wife Hester commented, 'the last chasm in the chain of Streatham worthies' (Hyde 1979, p.14). The Thrales met Burney in 1776, when he replaced Giuseppe Baretti (cat.44) as music and Italian tutor to their daughter. Reynolds, however, had known Burney since at least the early 1770s, when he had published a series of travel books based upon his tours of France, Italy and Germany. These books included descriptions of his encounters with a host of famous figures, including the philosophers Voltaire and Rousseau, and the composers Gluck and C.P.E. Bach. It proved very popular: as Burney later recalled, the publication of his *German Tour* of 1773 was 'honoured with the approbation of the blue-stocking families at Mrs. Vezey's [*sic*], and Mrs. Montagu's and Sir Joshua Reynolds's, where I was constantly invited and regarded as a member' (Lonsdale 1986, p.128).

Unusually, Reynolds appears to have painted Burney's picture *in situ* at Streatham Park rather than in his studio, for as Mrs Thrale told Burney's daughter in early January 1781, her husband had '*ordered* your father to sit tomorrow, in his peremptory way, and I shall have the dear Doctor every morning at Breakfast'. A few days later she reported that Burney 'sits for his picture in the Doctor of Music's gown and Bartolozzi makes an engraving from it. Sir Joshua delights in the portrait' (Mannings and Postle 2000, vol.1, p.116). The likelihood that the picture was mostly painted in Streatham is supported by the evidence of Reynolds's pocket book, which records no studio appointments whatsoever between 1 and 9 January 1781, other than a single engagement with Burney on a Sunday morning at nine (this time probably in his own studio).

Reynolds painted Burney in his academic robes, an allusion to the Doctorate in Music he had been awarded by University College, Oxford, in 1769. A modest individual, Burney had at first shied away from using his title, refusing even to have it engraved upon his doorplate (Lonsdale 1986, p.79). His daughter, Fanny, wrote some years later that he 'never thinks of his authorship and fame at all, but … is respected for both by everybody for claiming no respect from anybody' (quoted in Lonsdale 1986, p.231).

Dr Burney, as tutor to the Thrales's daughter, Hester (see cat.49), was virtually a member of the family at Streatham Park; he was nevertheless paid handsomely for his services. His reputation as Europe's leading music historian was also growing, especially with the publication in 1782 of the second volume of his *History of Music*. In anticipation of the third and final volume, a friendly critic stated that his knowledge of contemporary music would make this volume as 'instructive to his musical readers, by regulating and correcting the public taste in music, as Sir Joshua Reynolds has done in a sister art' (Lonsdale 1986, p.270).

MP

Provenance
Painted for Henry Thrale's library at Streatham Park; his widow, Mrs Piozzi; sold with the contents of Streatham Park, by Squibb, Surrey, 10 May 1816 (66), bought by Burney's son, also Dr Charles Burney; by descent to Miss Burney; bought from J.C. Burney-Cumming by the National Portrait Gallery 1953.

Literature
Burney 1842–6, vol.2, pp.5–6; Leslie and Taylor 1865, vol.2, p.313; Graves and Cronin 1899–1901, vol.1, pp.134–5; Waterhouse 1941, p.72; Piper 1954, p.179; Hyde 1979, p.4; Yung 1981, p.81; Tscherny 1986, p.4 and n.7; Mannings and Postle 2000, vol.1, pp.115–16, vol.2, pl.97, fig.1352; Ingamells 2004, pp.80–2.

Engraved
Francesco Bartolozzi 1 April 1784; S.W. Reynolds; James Scott 1878.

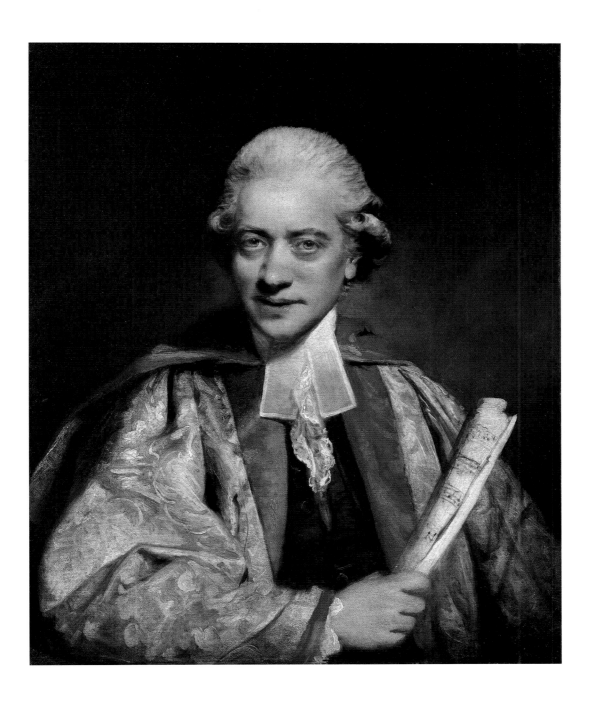

49. *Mrs Hester Lynch Thrale with her Daughter Hester Maria* 1777–8

Oil on canvas, 140.4 x 148.6

Beaverbrook Art Gallery, New Brunswick

Compared to other portraits by Reynolds for Streatham Park, the scale of this picture is slightly unusual, for while the figures are portrayed full length they are reduced in scale: this was because the portrait was designed to hang as an 'overmantel' above the library's chimneypiece. As such, it would have had a decorative function. However, Mrs Thrale (1741–1821), a strong-willed woman, was anything but decorative. Renowned for her sharp tongue and caustic wit, she criticised her own portrait in verse:

In Features so placid, so smooth, so serene,
What Trace of the Wit – or the Welch-woman's seen?
Of the Temper sarcastic, the flattering Tongue,
The Sentiment right – with th'Occasion still wrong.
What trace of the tender, the rough, the refin'd,
The Soul in which all Contrarieties join'd?
(Balderston 1942, vol.1, p.471)

She also wrote to her friend Fanny Burney about the portrait, complaining that 'there is really no resemblance, and the character is less like my father's daughter than Pharaoh's' (Yung 1984, p.113). In the event, Mrs Thrale's portrait was not hung with the other portraits in the library, on the pretext that her husband did not like it (Leslie and Taylor 1865, vol.2, p.313). This was not suprising perhaps since Reynolds derived Mrs Thrale's expression, pose and costume from his portrait of Mrs Catherine Bunbury (née Horneck) of 1773 (Private Collection).

Hester Lynch Salusbury had married the brewer Henry Thrale in 1763 out of duty to her parents, who had proposed the match. The couple divided their time between their townhouse in Southwark, near Thrale's brewery, and Streatham Park, a country house set in a hundred acres of land in southwest London. It was here, in 1765, that Mrs Thrale first met Samuel Johnson, who was to become her greatest friend. Unhappy in her marriage, Mrs Thrale found compensation through her activities as a society hostess and with her literary circle. Hester Maria (1764–1857), her eldest child, was a particular favourite of Johnson, who nicknamed her Queeney.

At around the time that Reynolds painted this portrait, Mrs Thrale began to jot down anecdotes concerning her friends and acquaintances; this she called her 'Thraliana'.

Among other things, she provided unflattering insights into Reynolds's character and private life. In 1789 she noted: 'I saw Joshua Reynolds last night at Byng's; we hardly looked at each other – yet I see he grows old, & is under the Dominion of a Niece: Oh! That is poor Work indeed for Sir Joshua Reynolds. I always told Johnson that they overrated that Man's mental Qualities' (Balderston 1942, vol.2, pp.728–9). By this time Mrs Thrale's husband had died, and she had married the Italian singer and composer Gabriel Mario Piozzi – much to the disgust of her former friends. She had also published, in 1786, her *Anecdotes of the Late Samuel Johnson, LL.D., during the Last Twenty Years of his Life*, the first biography of Johnson to appear in print. She did not, however, wish to publish the more controversial 'Thraliana', and told her adopted heir that he should burn it: 'But you may read it first, if t'will amuse You – only let it *Never* be printed! oh never, never *never*' (Balderston 1942, vol.1, pp.xvi–xvii). An unexpurgated version was finally published in 1942.

MP

Provenance
Painted for Henry Thrale's library at Streatham Park; his widow, Mrs Piozzi; sold with the contents of Streatham Park, by Squibb, Surrey, 8–12 May 1816 (58, withdrawn), bought by Samuel Boddington, his sale Christie's 9 June 1866 (311), bought by Louisa, Lady Ashburton; Mrs Hamilton McKown Twombly; her sale New York 1942; M. Knoedler and Company; bought by Lord Beaverbrook 1955.

Literature
Northcote 1818, vol.2, p.4; Burney 1832, vol.2, p.80; Cotton 1856, p.194; Piozzi 1861, vol.1, p.44, vol.2, p.173; Leslie and Taylor 1865, vol.2, p.313; Graves and Cronin 1899–1901, vol.3, pp.969–70; Steegman 1933, pp.76–7; Hyde 1979, pp.15–16; Tscherny 1986, p.4; Watson 1988, pp.60–2; Mannings and Postle 2000, vol.1, pp.443–4, vol.2, pl.89, fig.1248.

Engraved
E. Finden 1835 (Mrs Thrale only).

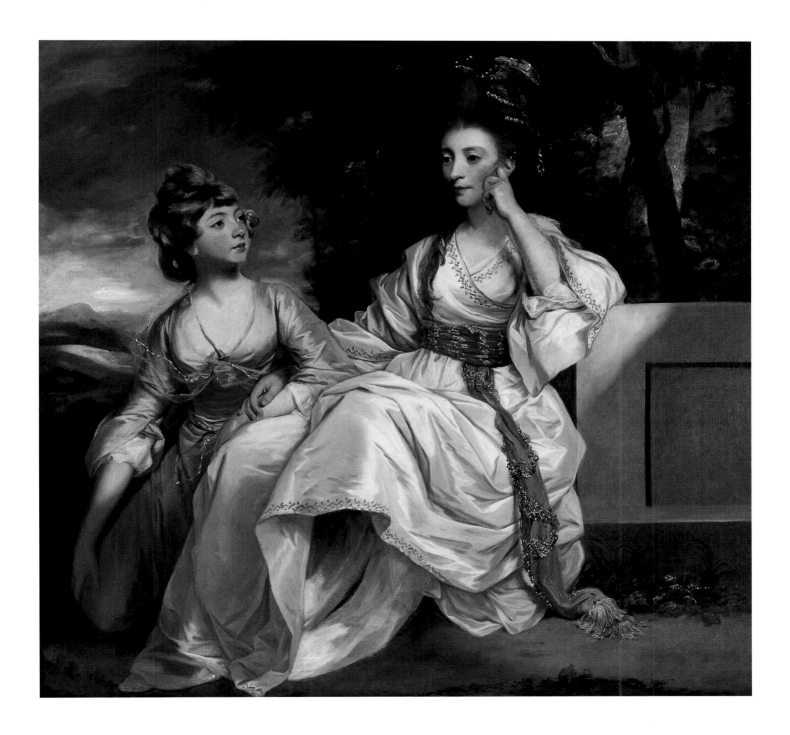

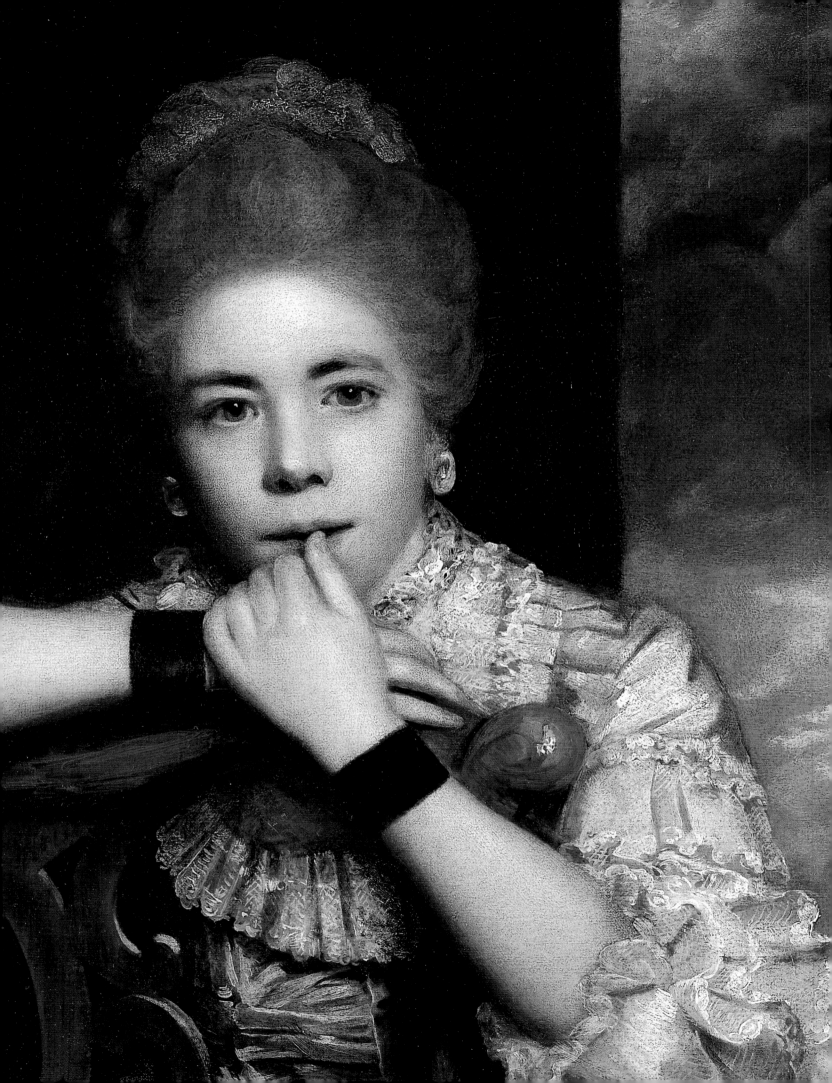

Painted Women

Among Reynolds's most successful paintings, in terms of the attention that they attracted at the time, were the portraits he painted of beautiful women: they included courtesans, actresses and habitués of the so-called *demi-monde*. The *demi-monde* consisted of women from the upper echelons of society, whose flagrant sexual conduct flouted polite codes of public behaviour. As this section reveals, Reynolds made a calculated effort from the 1750s onwards to associate his art with these 'painted women'. It was a choice that alienated him from more conservative quarters. However, it gained him tremendous publicity in fashionable male society, and ensured that he remained the most sought-after portraitist of the age.

For centuries artists had been commissioned to paint the portraits of women of 'easy virtue', often in historical and mythological guises. In the past, these women had been the mistresses of princes, courtiers and bishops, their images reserved for the delectation of a select and very private clientele. Reynolds's subjects, who came from all walks of life, distributed their favours more liberally, not least to Reynolds's friends. Through the medium of engraving, their images also reached a public that could only dream of liaisons with such exotic females.

In the late 1750s, London society was by turns scandalised and fascinated by the behaviour of the most celebrated courtesan of the age, Catherine 'Kitty' Fisher, whose exploits and affairs were trumpeted in broadsheets and ballads. Reynolds did not waste any time in making her acquaintance and during the following decade became a close friend, fuelling speculation that there was more to their relationship than simply artist and sitter. Over the years this pattern was repeated with other desirable women. As his pocket books reveal, Reynolds regularly noted down the names of courtesans as well as the addresses of London's various brothels and bagnios. His close relationships with a number of courtesans was a means of promoting their celebrity while at the same time placing himself at the centre of a modern 'symposium', whereby images of the most beautiful women of the age were to be found and admired in his studio and gallery.

As well as courtesans, Reynolds was also on intimate terms with many of London's leading actresses, notably Elizabeth Hartley and Frances Abington, women whose stage reputations were also allied to their uninhibited attitude towards sex. As with his portraits of courtesans, Reynolds's images of these women, which were invariably made of his own volition, were guaranteed to promote the individual's celebrity while also confirming the artist's own role in shaping their fortunes on the stage.

While Reynolds was the doyen of high culture, he was also keenly attentive to the vagaries of fashion and the less salubrious aspects of high society – the *demi-monde*. In this social sphere, where infidelity and indiscretion were the norm, the most revered figure was the 'demirep'. For such women, publicity was essential in order to fuel the fantasy purveyed by their extravagant behaviour. Reynolds, in spectacular portraits of women, such as Lady Worsley (cat.55) and Mrs Musters (cat.57), fanned the flames of public interest and boosted their celebrity even further.

MP

Mrs Abington as 'Miss Prue' 1771 (detail of cat.54)
Yale Center for British Art, New Haven

50. *Kitty Fisher as Cleopatra Dissolving the Pearl* 1759

Oil on canvas, 76 x 63

The Iveagh Bequest, Kenwood

Catherine Mary Fisher (or Fischer; d.1767) was, by the late 1750s, among the most celebrated courtesans in London. Her origins are unclear, being variously described as the daughter of a stay-maker or a Lutheran silver-chaser. Introduced into society by a British army officer, Ensign Anthony George Martin, she was by the late 1750s supported by a coterie of enthusiastic aristocrats and gentlemen, including Augustus Keppel (cats.9 and 17), through whom she may well have first met Reynolds. In 1759 Reynolds made two paintings of Fisher. In the present portrait she teasingly suspends a large pearl above a goblet of wine, a motif taken from the figure of Cleopatra in Francesco Trevisani's *Banquet of Antony and Cleopatra* (1702; Galleria Spada, Rome), which Reynolds had seen in Italy. Reynolds had taken care to copy Trevisani's depiction of Cleopatra right down to the highly ambiguous gesture of the hand exhibiting the jewel, for, as he would have realised, the gesture of holding the thumb and forefinger together to form an 'o' would also have been understood as signifying the sexual act. Thus, the jewel, which Kitty Fisher holds before the viewer, symbolises her potent sexuality.

The comparison between Cleopatra and Kitty Fisher was in other ways particularly apt. Cleopatra's legendary consumption of a pearl dissolved in wine before Mark Antony compares favourably with Kitty Fisher's notoriously extravagant behaviour, as recounted by the Italian adventurer Giovanni Giacomo Casanova, who met 'Keti-ficher', as he called her, while visiting London: 'She had on over a hundred thousand crowns' worth of diamonds … She was charming, but she spoke only English. Accustomed to loving only with all my senses, I could not indulge in love without including my sense of hearing … La Walsh told us that it was at her house that she [Fisher] swallowed a hundred-pound bank note on a slice of buttered bread which Sir Richard Atkins, brother of the beautiful Mrs. Pitt gave her. Thus did the Phryne make a present to the Bank of England' (Trask 1967–71, vol.9, p.208). This party trick was, apparently, performed by a number of the capital's courtesans, similar stories being circulated about Sophia Baddeley and Fanny Murray (Bleackley 1923, p.144).

Shortly after it was completed, Reynolds's portrait of Kitty Fisher as Cleopatra was replicated in two engravings, further fuelling the 'Fishermania' that was then sweeping London.

Young women wanted to dress and behave like Fisher and hacks wrote lewd verses about her, while her image was plastered across print shop windows. In March 1759, shortly before she met Reynolds, Fisher placed an advert in the press, protesting about her treatment: 'she has been abused in the public papers, exposed in Print Shops, and to wind up the Whole, some Wretches, mean, ignorant, and venal, would impose upon the public, by daring to publish her Memoirs' (Postle 1995, p.312, n.3). Like all celebrities, however, Fisher would have been more perturbed had she simply been ignored.

MP

Provenance
Purchased by Sir Charles Bingham, later 1st Lord Lucan (although he evidently did not take possession of the portrait); acquired by John Parker, 1st Lord Boringdon after 1775; by descent to the Earls of Morley; sold Christie's 3 June 1876 (43) to 'Howard' for Baron Ferdinand de Rothschild, who sold it 22 November 1888 to Agnew's, who sold it the same day to Sir Edward Guinness, afterwards 1st Earl of Iveagh; bequeathed to his third son, 1st Baron Moyne, 1927, by whom bequeathed to Kenwood 1946; accepted by the Greater London Council 1950.

Literature
Malone 1819, vol.1, p.lxii; Leslie and Taylor 1865, vol.1, pp.163–5, 173, 176; Graves and Cronin 1899–1901, vol.1, pp.307–8, vol.4, p.1309; Waterhouse 1941, pp.45, 121, pl.59; Murray 1965, p.25; Kerslake 1977, vol.1, p.75; Penny 1986, pp.195–6; Wind 1986, pp.182–5; Prochno 1990, p.173; Postle 1995, pp.3–5, 312, nts.3–5; Mannings and Postle 2000, vol.1, p.188, vol.2, fig.418; Pointon 2000, pp.17–19; Postle 2003, pp.24–6; Bryant 2003, pp.308–11; Pointon 2004, pp.79–83.

Engraved
Edward Fisher 1759; Richard Houston 1759; James Watson; S.W. Reynolds 1833.

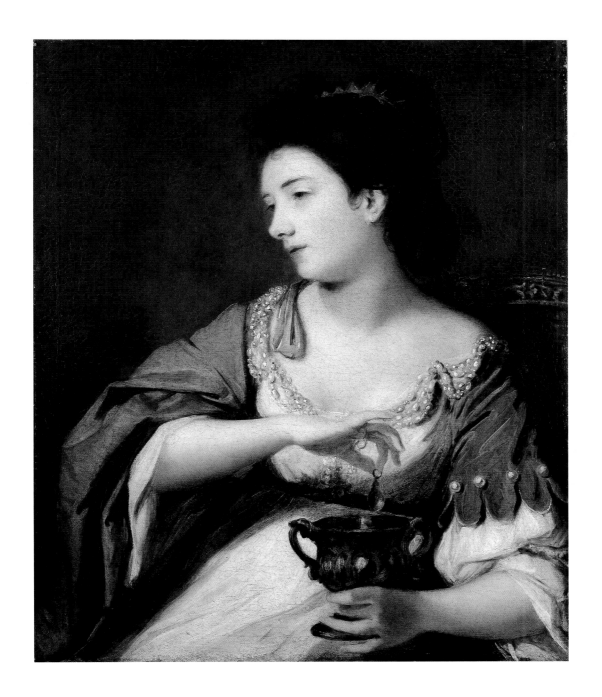

51. *Kitty Fisher c.*1763–4

Oil on canvas, 99 x 77.5

Trustees of the Bowood Collection

Reynolds's first recorded appointments with the courtesan Kitty Fisher occurred in April 1759, by which time, although 'scarce twenty', she already enjoyed tremendous celebrity as a courtesan. He was greatly enamoured by her, recording no fewer than twenty-two meetings with her that year. Some appointments were related to portraits he was making of her, others were social. The present painting, one of several unfinished portraits of Fisher, is among the most intimate – made, presumably, for the artist's pleasure. Fisher sits coquettishly in the artist's leather 'sitter's chair' with Reynolds's pet parrot perched upon her finger. Her lips are slightly parted as if she is sweet-talking to the bird, revealing the tender side to her nature. The loose handling of paint and the sketchiness of the figure suggest that the painting was the result of just a few hours of concentrated effort on Reynolds's part: even so, Fisher's hands are painted with a refinement unusual in Reynolds's portraiture.

In 1758, the year before Reynolds met Fisher, an anonymous writer observed that there was a 'gradation of whores in the metropolis: women of fashion who intrigue, demi-reps, good natured girls, kept mistresses, ladies of pleasure, whores, park-walkers, street-walkers, bunters, bulk-mongers' (quoted in O'Connell 2003, p.140). Kitty Fisher, a 'courtesan' rather than a mere prostitute, was by this reckoning a lady of pleasure since she was not maintained by any one individual. Indeed, according to a magazine memoir of 1770, Fisher was established in her own lodgings by a subscription from the members of Arthur's, an exclusive gentleman's club on St James's Street. Foremost among her admirers was Lord Ligonier (see cat.14), whose portrait Reynolds also painted on several occasions at this time. Aside from her beauty, Fisher was a lively conversationalist. According to one contemporary source she was also fluent in French – although Casanova turned down the opportunity to 'have her for ten guineas' because, although charming, she spoke only English (see Pointon 2004, p.78). 'It was impossible', stated the *Town and Country Magazine*, 'to be dull in her company, as she would ridicule her own foibles rather than want a subject for raillery' (Leslie and Taylor 1865, vol.1, p.163, n.1). Reynolds, too, continued to meet Fisher during the 1760s, fuelling speculation that his interest in her was not strictly professional (see p.24). However, it seems more likely that she regarded him as a confidant, and he found in her a friend and willing model.

Reynolds's last recorded appointment with Fisher was on 30 September 1766. Just over three weeks later she married John Norris, MP for Rye, Sussex. Norris, whose reputation was that of a rake and degenerate, apparently arranged for the marriage to take place in Scotland owing to his parents' opposition to the match (see Pointon 2004, p.77). However, the ceremony subsequently took place in London, at St George's Church in Hanover Square (Bleackley 1923, p.142). Fisher, who was Norris's second wife, went to live with him at his manor house, Hemsted, near Benenden in Kent. Evidently, she adapted well to her new position within the local squirarchy, as she became known for her acts of charity and her abilities as a horsewoman. Four months after her marriage she contracted smallpox. She died in Bath, presumably while seeking a health cure. She was buried on 23 March 1767 in the parish church of St George the Martyr, Benenden, dressed, according to her wishes, in her finest ball gown.

MP

Provenance
Inherited from the artist by Mary, Lady Thomond; her sale, Christie's 26 May 1821 (35), bought Thomas Phillips RA; his executors' sale, Christie's 9 May 1846 (39), bought Farrer for Lord Lansdowne; by descent.

Literature
Graves and Cronin 1899–1901, vol.1, pp.308–9; Waterhouse 1941, p.57; Kerslake 1977, vol.1, p.76; Mannings and Postle 2000, vol.1, p.189, vol.2, pl.53, fig.765.

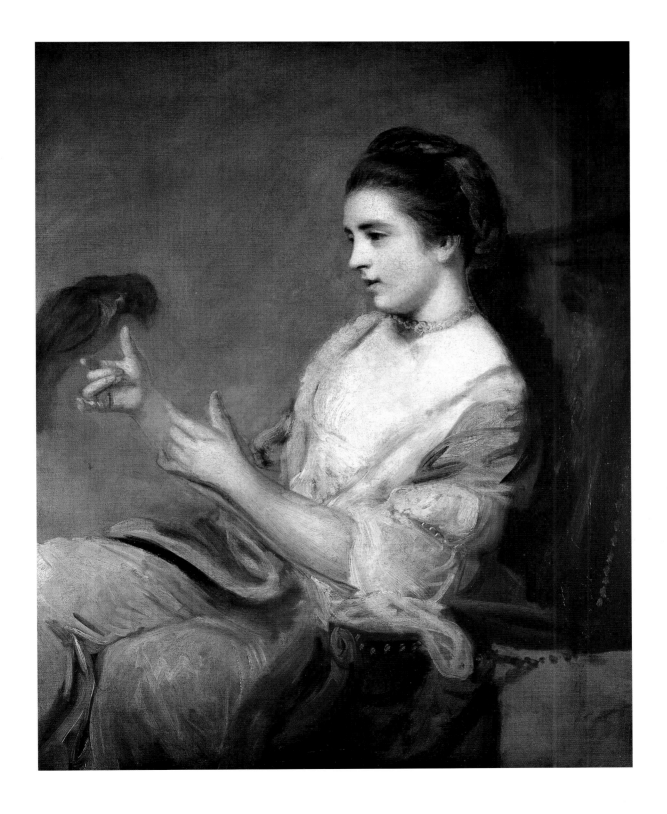

52. *Nelly O'Brien c.*1762–4

Oil on canvas, 125 x 100

Hunterian Museum and Art Gallery, University of Glasgow

This is one of two portraits of the courtesan, Nelly O'Brien (d.1768), painted by Reynolds in the early 1760s. In the other portrait (fig.8) she wears a fashionable silk dress and straw bonnet, and cradles a lap dog in her arms. Here she is dressed in a white gown with a pink drape across her legs, which has faded from its original crimson. To the right is a carved relief of Danaë, the princess of classical legend who receives a visitation from Jupiter in the form of a shower of gold; a reference presumably to O'Brien's role as courtesan. At that time it was remarked of O'Brien's fellow courtesan, Kitty Fisher: 'Your Lovers are the Great Ones of the Earth, and your Admirers are the Mighty: they never approach you, but like *Jove*, in a shower of Gold' (Penny 1986, p.193). In the portrait Nelly wears a ring on her marriage finger, although she was then mistress to Frederick St John, 2nd Viscount Bolingbroke, an unpleasant character known as 'Bully' becuase of his maltreatment of his wife, Lady Diana Spencer. Lady Spencer sat to Reynolds for her portrait around the same time as Nelly O'Brien. According to Horace Walpole, Bolingbroke instructed Reynolds to 'give the eyes something of Nelly Obrien [*sic*], or it will not do'. Walpole added: 'As he has given Nelly something of his wife's, it was but fair to give her something of Nelly's – and my lady will not throw away the present' (Walpole 1937–83, vol.10, pp.52–3).

Subsequently, O'Brien became the mistress of Sackville Tufton, 8th Earl of Thanet, who purchased her portrait by Reynolds for fifty guineas; possibly the present one. She also bore Thanet several children, the first of which was born in the winter of 1764. As Reynolds's friend, Gilly Williams, remarked: 'Nelly O'Brien has a son. It was christened yesterday. Bunny and his trull were sponsors. Now for his name; guess it if you can; it is of no less consequence in this country than Alfred; but Magill was so drunk he had like to have named it Hiccup!' (Jesse 1843–4, vol.1, p.339). 'Bunny' was Sir Charles Bunbury, husband of Lady Sarah Bunbury, whose full-length portrait Reynolds had painted in 1762 (Art Institute of Chicago). The identity of Bunbury's 'trull', or mistress, is unknown, although it may have been the celebrated courtesan, Polly Kennedy, to whom he was certainly attached in later years (see cat.75).

Reynolds first met Nelly O'Brien towards the end of 1760. By 1762, as David Mannings observes, 'hardly a week seems to have passed without Nelly appearing in Reynolds's studio' (Mannings and Postle 2000, vol.1, p.335). By now she and Reynolds were clearly on close terms, Reynolds referring playfully to her in his pocket book as 'My Lady Obrien [*sic*]'. In the spring of 1762 he exhibited her portrait at the Society of Artists, and by the summer his pocket book contained several reminders about 'Miss Obriens print [*sic*]', perhaps a reference to the engraving of the present picture made by James Watson. Around this time Reynolds also arranged an evening rendezvous with O'Brien in Pall Mall, 'next door this side the Star & Garter', the tavern where he usually met his fellow members of the Dilettanti Society. In 1763 Reynolds once more exhibited O'Brien's portrait, a 'very pretty picture' according to Walpole (Whitley 1928, vol.2, p.371). Reynolds continued to meet O'Brien during the 1760s, mostly in his studio, but on at least one occasion at an address near Park Lane. That she was his favoured model there is no doubt; whether she was also his mistress remains unknown.

MP

Provenance
Sir Thomas Baring by 1845; Edward Mills by 1858; by descent to Brigadier General R.J. Cooper; his sale Christie's 12 December 1947 (11), bought by W.H. Simpson; bequeathed to the University by W.A. Cargill 1970.

Literature
Graves and Cronin 1899–1901, vol.2, pp.703–4; Waterhouse 1941, p.55; Clifford, Griffiths, Royalton-Kisch 1978, p.44; Mannings and Postle 2000, vol.1, pp.355–6, vol.2, fig.668.

Engraved
James Watson; J. Wilson; C. Spooner; also smaller prints by Watson, S.W. Reynolds and Spooner.

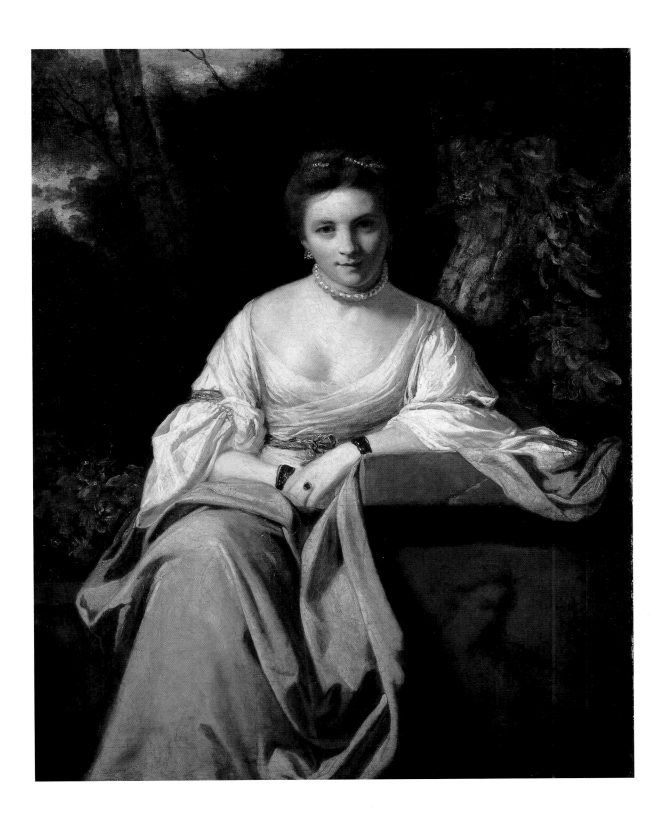

53. *Mrs Hartley as a Nymph with a Young Bacchus* 1771

Oil on canvas, 88.9 x 68.6

Tate. Presented by Sir William Agnew Bt 1903

By 1773, when Reynolds exhibited this painting at the Royal Academy, Elizabeth Hartley (1751–1824) was among the most fêted actresses on the London stage. Possessed with striking looks, a fine figure and flaming red hair, Mrs Hartley first came to public notice in Edinburgh where she performed a wide range of tragic roles towards the end of 1771, including Cordelia in *King Lear* and Desdemona in *Othello*. In the spring of 1772 one of David Garrick's talent scouts spotted her in Bristol. 'She talks lusciously', he reported, 'and has a slovenly good-nature about her that renders her prodigiously vulgar' (Highfill, Burnim, Langhans 1973–, vol.7, p.158). Shortly afterwards Garrick arranged her debut at Covent Garden. It is intriguing that by this time Reynolds already knew her, since she had modelled in his studio as early as the summer of 1771. While Reynolds praised her beauty, she responded that 'her face was freckled as a toad's belly' (Northcote 1818, vol.2, p.8).

Elizabeth Hartley, née White, was born in Somerset around 1750. A memoir of 1773 recorded that her parents 'occupied a position of great obscurity', and that it was while she was working as a chambermaid that Elizabeth became the mistress of a certain Mr Hartley, who had encouraged her to take to the stage (Highfill, Burnim, Langhans 1973–, vol.7, p.156). Her London debut in 1772 was as the eponymous heroine in *The Tragedy of Jane Shore* by Nicholas Rowe. It was probably the following summer that Reynolds painted her in this role, a work that remained unfinished (see Postle 1995, pp.39–40). By this time she had also modelled to him as a Madonna (a work said to have been made for Edmund Burke), and, here, as a nymph with a young Bacchus. This pose was based loosely upon Michelangelo's *Doni Tondo* (*c*.1504–6; Uffizi Gallery, Florence). Reynolds exhibited this picture of Mrs Hartley not as a portrait but with the title 'A Nymph with Young Bacchus', indicating that he promoted it as a subject or 'fancy' picture. At the same time, he was fully aware that the audience would recognise Mrs Hartley's by now famous face, and make the connection between the mythical nymph and the nubile young actress.

During the very time that Reynolds's picture hung on the walls of the Royal Academy, Mrs Hartley's name was bandied about the pages of London's daily newspapers following an incident that became known as 'The Vauxhall Affray'. In July 1773, while walking through Vauxhall Gardens, Mrs Hartley was accosted by three gentlemen, including Thomas ('Wicked') Lord Lyttelton and George ('Fighting') Fitzgerald. Angered by their insults, her companion, the Revd Henry Bate, engaged in a boxing match with one of Fitzgerald's servants, a professional prizefighter. Bate won the bout easily, earning him the sobriquet 'the Fighting Parson'. Shortly afterwards he married Mrs Hartley's sister.

MP

Provenance
John Joshua, 2nd Lord Carysfort 1774, his sale 24 June 1828 (63), bought by John Bentley of Birch House, Lancashire; John Naylor, who sold it 8 March 1879 through Agnew's to Alfred de Rothschild; Earl of Northbrook, who sold it 30 June 1894 to Agnew's; sold Agnew's 22 May 1895 to William Agnew, who gave it to the National Gallery in 1903; transferred to the Tate Gallery in 1919.

Literature
Northcote 1815, p.lxxviii; Malone 1819, vol.1, p.lxiv; Northcote 1818, vol.2, p.8; Graves and Cronin 1899–1901, vol.2, pp.444–6; Waterhouse 1941, p.63; Highfill, Burnim, Langhans 1973–, vol.7, p.157; Wind 1986, p.20, fig.6; Postle 1995, pp.13, 36–9, 42, 206; Mannings and Postle 2000, vol.1, pp.245–6, vol.2, fig.1029; Postle 2003, pp.35–9.

Engraved
Giuseppe Marchi 20 February 1773; G. Nutter 1 January 1800.

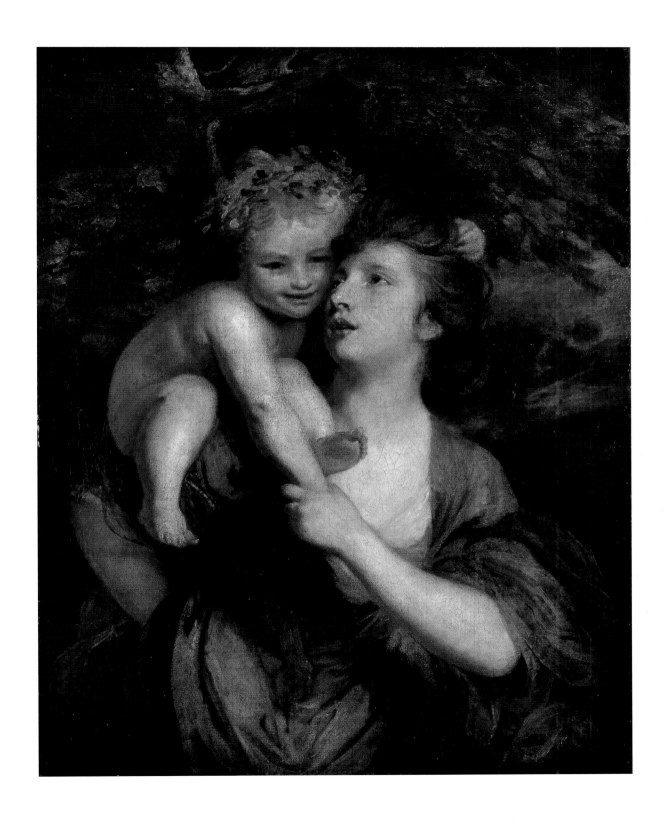

54. *Mrs Abington as 'Miss Prue'* 1771

Oil on canvas, 76.8 x 63.7

Yale Center for British Art, Paul Mellon Collection

Mrs Abington's rise from rags to riches, from obscurity to celebrity, follows a familiar pattern. Born in 1737, Fanny Barton (*c*.1737–1815), as she was then, grew up in Windmill Street, London, the daughter of an ex-soldier turned cobbler. Her mother died when she was fourteen, by which time Fanny was selling flowers and singing ballads in Covent Garden. Already a familiar figure on the streets, she was nicknamed 'Nosegay Fan'. Subsequently, she lodged in the household of a certain Mrs Parker, evidently a courtesan. There, as well as being schooled in the arts of seduction, she received lessons in etiquette and possibly also in French and Italian, before Mrs Parker's jealousy apparently forced her back onto the street. It was shortly afterwards, in the summer of 1755, that she began to pursue an alternative career in the theatre.

Reynolds's first recorded appointment with Mrs Abington was in the summer of 1764. By this time she had already married and separated from her husband, James Abington, a musician and bit-part actor, and had become the mistress of a wealthy Irish MP, James Needham, who died within a year, remembering her fondly in his will. She soon emerged as a leading comedienne, and as a trendsetter in contemporary fashion. It was at this time that Reynolds painted his first picture of her, a full-length portrait as Thalia, the Comic Muse (1764–8; Waddesdon Manor, The National Trust); a work which she probably commissioned as a form of advertisement. Reynolds may have painted more than one picture of her at this time, since she sat to him on nearly thirty separate occasions over the ensuing four years, and paid him more than enough money for a single full-length portrait.

Reynolds exhibited the present portrait at the Royal Academy in 1771. According to tradition, she is portrayed in the character of Miss Prue in William Congreve's bawdy comedy, *Love for Love*, a role she had made her own in the season of 1769–70. In the play Miss Prue is presented as a naïve and silly country girl, who is (willingly) seduced by Tattle, a predatory, half-witted dandy. In his painting Reynolds did not attempt to illustrate a particular moment in the play, and, indeed, the care that he lavished upon Mrs Abington's fashionable dress and lace ruffles indicates that her stage role ought not to detract from the fact that she was the real focus of attention. The point made by Reynolds

was that, like Miss Prue, Mrs Abington is a woman with an appetite for sensual pleasure, and that her success in the role was allied to her own personality. In the portrait she leans coquettishly over a Chippendale chair-back, on her lap a pet dog. Her thumb is poised suggestively before her slightly parted lips, a gesture which is at once vulgar and sexually charged.

It has been conjectured that Mrs Abington was for a time Reynolds's mistress (Musser 1984, p.184), although there is no evidence to back up this speculation. Certainly she was considered promiscuous. A gossipy account of life backstage, published in 1790, stated that Mrs Abington had a number of different houses for different lovers, some for pleasure and some for money, insinuating that she lived the life of the courtesan as well as the actress (cited in Musser 1984, p.181). Reynolds was very fond of her, and in 1775 booked forty seats for his friends at her benefit performance of Garrick's new farce, *Bon Ton, or High Life above Stairs*. Among those present was Samuel Johnson, who, owing to his physical infirmities, could not see or hear the performance properly. When asked (probably by Boswell) why he bothered to attend, Johnson replied, 'Because, Sir, she is a favourite of the publick; and when the publick cares the thousandth part for you that it does for her, I will go to your benefit too' (Boswell 1934–50, vol.2, p.330).

MP

Provenance
John, 2nd Lord Boringdon, at Saltram by 1813; by descent to the 3rd Earl of Morley; sold privately to Sir Charles Mills (later Lord Hillingdon); Hillingdon sale 23 June 1972 (116), bought by Agnew who sold it to Paul Mellon, by whom presented to Yale Center for British Art.

Literature
Leslie and Taylor 1865, vol.1, pp.392, 400, n.2; Graves and Cronin 1899–1901, vol.1, p.4; Musser 1984, pp.176–92; Cormack 1985, p.184; Penny 1986, pp.246–7; Mannings and Postle 2000, vol.1, pp.55–6, vol.2, pl.67, fig.1017; Postle 2003, pp.46–7.

Engraved
S.W. Reynolds (by S. Cousins) 1822; R.B. Parkes 1875.

55. *Lady Worsley c.*1776

Oil on canvas, 236 x 144

The Earl and Countess of Harewood and the Trustees of the Harewood House Trust

Throughout the late 1770s, Reynolds regularly exhibited full-length portraits of aristocratic women at the Royal Academy. These portraits, discussed elsewhere in this catalogue (cats.24–6), typically showed their subjects wearing pale, diaphanous and classicised dress, wandering with languorous grace through a pastoral English landscape. In 1780, the artist decided to submit a very different kind of full-length female portrait, that of Lady Worsley, to the year's Academy display – the first to be held at Somerset House (see cat.87). Reynolds clearly intended the portrait to make a dramatic impact in the Academy's spectacular new home: we can easily imagine that this work, partly thanks to its bold use of colour, would have stood out from its neighbours on the walls of the Great Room at the Academy, and would have been appreciated as a deliberately pointed contrast to the type of female full length with which Reynolds had become so closely associated in previous years. Rather than being draped in flowing antique garb, Lady Worsley wears a tightly fitting riding habit adapted from the uniform of her husband's regiment, the South Hampshire Militia. Here we encounter colours that are resolutely martial and modern: the strident red of her jacket and dress, and the inky black of her beaver hat. Most dramatically of all, her pose is strikingly 'masculine' in character, dominated by the sharp angle of her left elbow, and by the whip clasped provocatively in her right hand.

As has been long recognised, her costume can partly be explained by the emergence in the late 1770s of a new fashion amongst aristocratic women for dressing in masculine clothes, particularly uniforms. This fashion responded in an unusually direct way to contemporary events: war with the American colonies brought widespread military mobilisation as well as the threat of a French invasion. As David Mannings has noted, numerous aristocratic women temporarily took to wearing regimental colours, visiting army camps, dressing in a military style, and walking in a self-consciously masculine manner (Penny 1986, p.289). In his portrait of Lady Worsley, Reynolds not only recorded this new mode of female dress and behaviour, but also drew upon the conventions of male portraiture – here it is useful to relate the present picture to the artist's portrait of John Burgoyne, painted a decade or so earlier (cat.16).

Lady Worsley's portrait was intended as a pendant to a full-length portrait of her husband, Sir Richard Worsley (Private Collection), in which he, too, is dressed in the uniform of the South Hampshire Militia, standing in a comparably pastoral landscape. Even so, Lady Worsley's portrait alone was exhibited at the Academy, reinforcing the public perception of her as an independent, 'modern' woman, which seems in fact to have been the case. Only two years after her portrait was exhibited, Lady Worsley was famously taken to court for adultery by her husband, accused of having had an affair with one of his officers. The case became notorious, and it is perhaps no coincidence that the two pictures, as well as their subjects, had already become separated by the time Sir Richard went to court.

MH

Provenance
Edwin Lascelles, 1st Lord Harewood; by descent.

Literature
Leslie and Taylor 1865, vol.2, p.218; Graves and Cronin 1899–1901, vol.3, p.1070; Steegman 1933, pp.125–6; Waterhouse 1941, p.71; Waterhouse 1953, p.169; Waterhouse 1973, p.48; Penny 1986, pp.289–90; Mannings and Postle 2000, vol.1, p.483, vol.2, pl.86, fig.1205.

56. *Mrs Abington as 'Roxalana'* 1782–3

Oil on canvas, 74 x 65

Private Collection

This is the final portrait that Reynolds painted of the comic actress Frances Abington (*c.*1737–1815). He had first met her in the mid-1760s, when she had commissioned her portrait as the 'Comic Muse' (see Mannings and Postle 2000, vol.1, p.54, vol.2, fig.822). Now, almost twenty years later, with her fame assured, Reynolds painted her portrait gratis and presented it to her. As in his portrait of Mrs Abington as Miss Prue (cat.54), Reynolds loosely linked the composition to a theatrical role for which she was then currently celebrated. Here she is presented as Roxalana, the white English slave in Isaac Bickstaffe's play *The Sultan; or A Peep into the Seraglio* of 1775. As a newspaper observed, 'she is described in the act of drawing the Curtain when she surprises the sultan in his retirement' (*Morning Herald*, 27 April 1784). In the play, Roxalana makes her entrance in the first act by announcing ''Tis I', which evidently became a popular catchphrase of the time (see Balderston 1942, vol.1, p.122, n.5). Reynolds was a close friend of Mrs Abington, and must have been aware of her colourful past, including her youthful sojourn in the ménage of a London courtesan. Audiences, too, would presumably have delighted in making a link between the sensuous Roxalana and the actress, who had once experienced at first hand the exotic atmosphere of life in the bagnio.

In the 1780s Mrs Abington remained much in demand by theatregoers, even though, as one observer noted, Reynolds's portrait of the actress – by now in her late forties – was 'in point of age, a little flattering' (*Morning Post*, 28 April 1784). Yet, as a fellow critic stated: 'Who that looks on the portrait of Mrs Abingdon [*sic*], does not immediately trace the Muse of Comedy? The witching smile, the fascinating air, the roguish eye, the seductive blandishments of Thalia, are all most critically pictured in her accomplished representative' (*London Chronicle*, 29 April–1 May 1784). Charming, witty and attractive, Mrs Abington possessed, so it was said, an unrivalled 'talent for convincing the innermost heart of the spectators that she does not feel herself to be acting a part, but presenting reality in all its bitter truth, each trifling characteristic feature bearing witness to her powers of observation' (Lichtenberg 1938, pp.33–4). Aware of her commercial value as a crowd puller, she demanded large fees from theatre managers, as well as a generous clothes allowance, for she was also a much-fêted

fashion icon. To those who employed her professionally she could be manipulative, deceitful and temperamental. In exasperation David Garrick pronounced her 'the worst of bad Women'. Towards Reynolds, however, Mrs Abington was sweetness and light, and he in turn religiously attended her benefit evenings in the company of fellow members of the Club.

MP

Provenance
Presented by the artist to the sitter, and by her to James, Earl of Fife; by descent to the 1st Duke of Fife; his daughter, HRH Princess Arthur of Connaught, Duchess of Fife; bequeathed by her to Peter Vaughan 1958; sold privately through Hazlitt, Gooden and Fox.

Literature
Fife 1807, p.16; Hamilton 1884, p.77; Graves and Cronin 1899–1901, vol.1, p.5; Waterhouse 1941, p.75; Mannings and Postle 2000, vol.1, p.56, vol.2, fig.1396; Perry 2003, pp.60–1.

Engraved
John Keyes Sherwin 1 February 1791; S.W. Reynolds.

57. *Mrs Musters as 'Hebe'* 1782

Oil on canvas, 238.8 x 144.8

The Iveagh Bequest, Kenwood

Sophia Catherine Musters (d.1819) first sat for her portrait to Reynolds in 1777, following her marriage the previous year to John Musters of Colwick Hall, Nottinghamshire. In that first portrait (Petworth House, The National Trust), she stands demurely in a woodland glade, with her devoted pet spaniel. Since that time, however, Mrs Musters and her husband had grown apart. While he pursued his interest in field sports, and remodelling his country house, she preferred the heady social scene of London and Brighton. By 1779, she had become a focal point of fashionable society, Fanny Burney noting that she was 'an exceedingly pretty woman, who is the reigning toast of the season' (Burney 1994, pp.381–2). Inevitably, she attracted the attention of the capital's most notorious womanisers, including George, Prince of Wales.

The Prince's desire to seduce Mrs Musters led him also to covet her portrait, as part of his collection of celebrated 'beauties' of the Court. Curiously, he managed to acquire it with the collusion of Reynolds, who in 1779 requested its return from Mr Musters, ostensibly to make some improvements to the composition. At this time it was also engraved by Valentine Green (see Hamilton 1884, p.122). According to a story told in the latter part of the nineteenth century by a descendant of Mrs Musters, Reynolds resisted attempts by Mr Musters to reclaim the portrait, on the pretext that it had been stolen. Having returned Musters's money to him, Reynolds then apparently passed on the portrait to the Prince of Wales. The portrait remained in the Prince's collection until his death, when it hung at the Royal Pavilion, Brighton.

Reynolds painted the second portrait, shown here, in 1782. It still belonged to him three years later, when he chose to exhibit it at the Royal Academy. As Julius Bryant has recently observed, there was a marked contrast between the earlier 'country house' portrait and the sensuous *Mrs Musters as 'Hebe'*, 'with the implication that she had found the freedom to enjoy her admirers in the interim' (Bryant 2003, p.352). Whether Reynolds painted the portrait of Mrs Musters of his own volition is uncertain. It is unlikely that it was commissioned by her estranged husband, especially since he went so far as to have her painted out of the couple's equestrian portrait by Stubbs, substituting her figure for that of a sporting vicar (see Bryant 2003, p.352).

Mr Musters did eventually purchase *Mrs Musters as 'Hebe'* in 1788. However, he apparently faced stiff competition from Wilbraham Tollemache (later 6th Earl of Dysart), who wanted it as a companion to Reynolds's *Thaïs* (fig.9) (Postle 1995, p.46). It is significant, therefore, that by this time Reynolds had hastily painted a replica of *Mrs Musters as 'Hebe'*, unusually made up from eight separate pieces of canvas sewn together (?c.1784; Highclere Castle, Hampshire). This second version he retained until his death. In the meantime, Mr and Mrs Musters had resolved their differences. Once back in Nottinghamshire, Mrs Musters pursued her interest in painting, producing among other things a window for the local church containing copies of Reynolds's 'Virtues' for the west window of New College, Oxford.

MP

Provenance
By descent in the Musters family; Colwick Hall sale 12 December 1850 (681), bought in; sold by J.C. Musters 3 July 1888 privately through Christie's to Agnew's, who sold it to Sir Edward Guinness, afterwards 1st Earl of Iveagh.

Literature
Leslie and Taylor 1865, vol.2, p.374 and n.472; Graves and Cronin 1899–1901, vol.2, pp.683–4; Whitley 1928, vol.2, p.393; Waterhouse 1941, p.76; Murray 1965, pp.29–30; Shawe-Taylor 1990, pp.172–3; Postle 1995, p.46; Mannings and Postle 2000, vol.1, p.349, vol.2, pl.112, fig.1391; Bryant 2003, pp.352–8.

Engraved
Charles H. Hodges 20 October 1785; S.W. Reynolds.

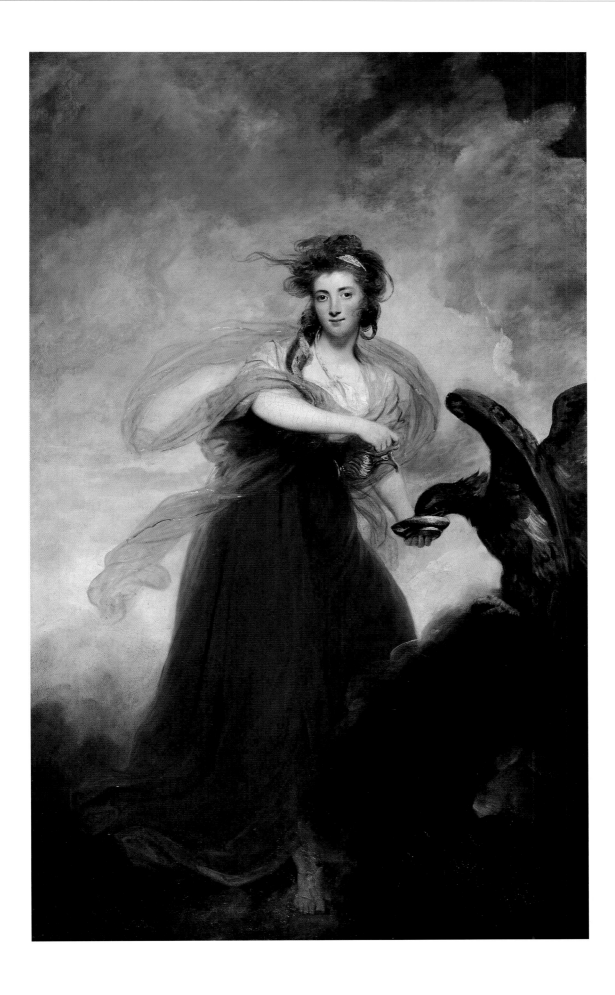

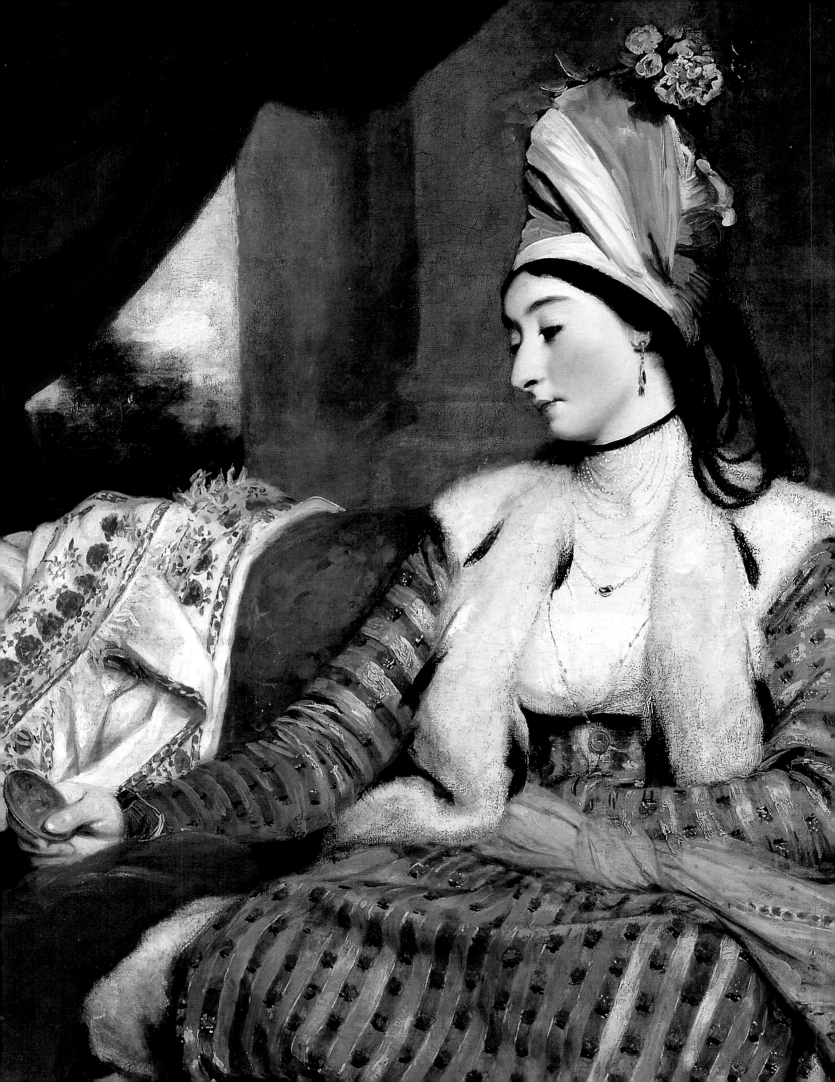

The Theatre of Life

Reynolds entered enthusiastically into the maelstrom of fashionable London society. As a portraitist, he had an abiding awareness that success depended upon an intimate knowledge of the prevailing trend, or what was then known as the 'ton'. And while he worked hard during the day, Reynolds devoted his evenings to entertainment, visiting clubs, masquerades, balls and the theatre. These social occasions enabled Reynolds to enlarge his wide network of contacts, spot new talent and pick up the latest gossip.

During the eighteenth century the theatre underwent a remarkable transformation. When Reynolds arrived in London in 1740, theatre revolved around two licensed playhouses at Covent Garden and Drury Lane, as well as countless 'unofficial' venues in pleasure gardens, tents and markets around the city. At the heart of this world was Reynolds's friend, David Garrick, who was instrumental in improving the quality and professionalism of contemporary theatre, through a combination of his own example on stage and his business acumen. Throughout his career, Reynolds, too, was alive to the possibilities that theatre offered him, not so much in terms of re-creating actors in character, but in capitalising upon their star status. This, for example, was the impetus behind *Garrick between Tragedy and Comedy* (cat.60) of the early 1760s, and his late portrait of the celebrated diva, Mrs Billington (cat.70).

While attending the theatre was one of the most popular entertainments for a broad spectrum of society, a more rarefied and interactive theatrical experience was provided by the masquerade. Introduced to England from Italy at the beginning of the eighteenth century by the Swiss count, John James Heidegger, London masquerade culture was, from the early 1760s, shaped by the Venetian-born opera singer, Mrs Theresa Cornelys, who held her celebrated assemblies at Carlisle House in Soho. Here individuals from all backgrounds could mix indiscriminately and incognito to gossip, flirt and conduct clandestine sexual liaisons. Habitués of the masquerade also competed to be seen in the most outrageous costumes: young men would attend dressed as nuns, duchesses as milkmaids and prostitutes as princesses. As in his theatrical portraits, Reynolds elided his awareness of contemporary culture with a knowledge of the traditions of Old Master painting. Thus, for example, in his double portrait of *Colonel Acland and Lord Sydney 'The Archers'* (cat.61), he successfully combined fashionable masquerade costume with a composition based upon the art of Titian.

The masquerade was a form of adult entertainment, although its influence was also disseminated, through Reynolds's portraits, to representations of children. From the 1760s, especially as he began to exhibit his work in public, Reynolds relied increasingly upon the conventions of the masquerade in his child portraiture. By the mid-eighteenth century there was a general willingness, among portrait painters and their patrons, to produce more naturalistic images of childhood. At the same time there was a desire, notably on the part of more fashionable clientele, to endow their children with the same celebrity status to which they themselves aspired. This was an important factor in the creation of works such as Reynolds's most flamboyant child portrait, *Master Crewe as Henry VIII* (cat.62).

The increased opportunities for foreign travel, and the close diplomatic and economic ties enjoyed by Britain with various nations at the time, meant that exotic costume also became increasingly fashionable. This was especially the case with Persian and Turkish garb; thus those who had first-hand experience, such as the Turkish-born Mrs Baldwin (cat.68), flaunted their fashionable credentials to envious bystanders. Even in London, however, there were more opportunities for viewing at first hand individuals from non-European cultures. The various diplomatic embassies by Native Americans (see cat.65), and, most significantly, the visit to England in the mid-1770s of the young Polynesian, Omai (cats.66 and 67), are excellent examples. Here, as ever, Reynolds was at the forefront of fashion, providing images that were at once memorable and definitive. Yet, ultimately, he was creating an ephemeral fiction of celebrity, which, in the case of visiting Native Americans or, indeed, the Polynesian, Omai, bore scant relation to the values or aspirations of the individuals portrayed.

MP

58. *Giuseppe Marchi* 1753

Oil on canvas, 74 x 63

Royal Academy of Arts, London

Giuseppe Filippo Liberati Marchi (*c.*1735–1808) came to London with Reynolds when he returned from Italy in the autumn of 1752. His precise date of birth is unknown, but he was apparently about fifteen years old when Reynolds met him (Farington in Malone 1819, vol.1, p.cli). Indeed, in Venice Reynolds had referred to Marchi as the 'boy' (ms. sketchbook, British Museum, LB 13, f.73 verso). Reynolds had met Marchi in Rome, where they had shared lodgings in the Piazza di Spagna. From Rome Marchi had accompanied Reynolds on the remainder of his Italian sojourn, and on to France. At this time Marchi's loyalty had been severely tested, for when Reynolds reached Lyons in September 1752, he found himself able to afford only one coach fare to Paris. Marchi was obliged to follow behind on foot (Malone 1819, vol.1, p.clix).

The present painting of Marchi was apparently the first picture made by Reynolds on his return to London; it is a work in which he sought to combine the tonal mastery of Rembrandt with the richness of Venetian colour. Reynolds evidently displayed it in his 'shew room' or gallery, where it was inspected by his peers including his master, Thomas Hudson, and his painter-friend, John Astley. Hudson concluded that it was inferior to Reynolds's pre-Italian works, 'upon which Marchi noticed a smile on the face of Astley, who doubtless perceived in the remark, the jealousy which still rankled in his mind' (Farington 1819, p.40). The picture had a more dramatic impact on the portraitist Jack Ellys, who upon seeing it, 'cried out in rage – "Shakespeare in poetry, and Kneller in painting, damme!" and immediately ran out of the room' (Northcote 1818, vol.1, p.54). Ellys, an artist of mediocre talents, was not, perhaps, best placed to criticise Reynolds's picture – especially as he had more or less relinquished painting to become the King's Lion Keeper.

Although Marchi was the subject of Reynolds's picture, the portrait was a generic image of an exotic youth, rather than the image of a specific individual, a reading supported by a contemporary reference to it as 'the Turkish Boy' (Northcote 1818, vol.1, p.54). Even so, by the early 1750s, perhaps buoyed up by the display of his 'portrait' in Reynolds's studio, Marchi clearly considered himself far more than a mere assistant. As Reynolds remarked at the time, 'Giuseppe is grown so intolerably proud that I fear we shall not keep long together he is above being seen in the streets with any thing in his hand' (Postle 1995a, p.17). Yet, with the exception of a brief period in the late 1760s, Marchi stayed with Reynolds for the next forty years, acting as his principal studio assistant, which involved painting draperies and accessories, and making copies of his pictures in oils and in print form.

After Reynolds's death the faithful Marchi organised the sale of his studio contents, which proved a mammoth task. A lifelong bachelor, Marchi lived quietly in the company of a few artist friends. Nonetheless he proved invaluable to Reynolds's early biographers, Edmond Malone and Joseph Farington, to whom he provided detailed information on Reynolds's studio life. Marchi died in 1808, and was interred in the vault of St Anne's church, Soho, next to the infamous hell-raiser, Lord Camelford, who had been killed in a duel at the age of twenty-nine; as Marchi's friend, Thomas Hearne, observed, 'Men of very different characters' (Farington 1978–84, vol.9, p.3257).

MP

Provenance
Marchi's sale, Squibb's 30 June 1808 (44); bequeathed to the Royal Academy in 1821 by Henry Edridge ARA.

Literature
Gentleman's Magazine 1808, p.372; Northcote 1813, p.32; Northcote 1815, p.xvii; Leslie and Taylor 1865, vol.1, pp.100, 249; Whitley 1930, p.16; Steegman 1933, pp.28–9; Waterhouse 1941, p.39; Gerson 1942, p.449; White, Alexander, D'Oench 1983, pp.23, 25; Mannings and Postle 2000, vol.1, pp.326–7, vol.2, fig.77.

Engraved
J. Spilsbury 1761; R. Brookshaw (reversed); A. Wilson; A.N. Sanders 1865.

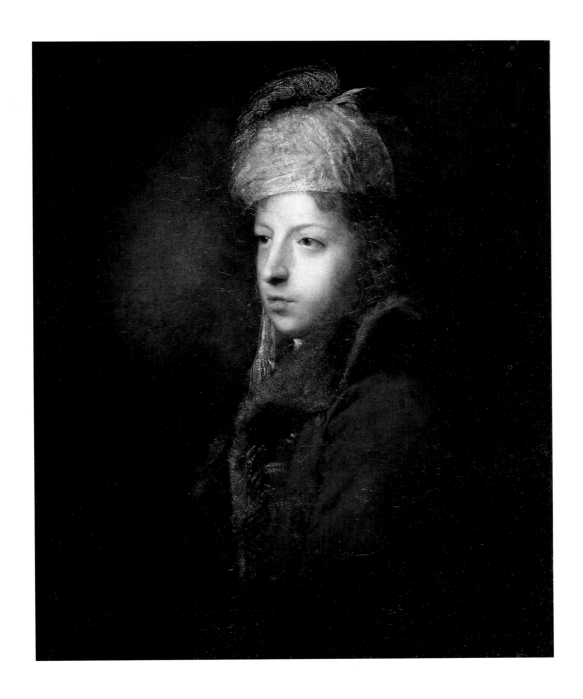

59. *Francesco Bartolozzi* ?c.1771–3

Oil on canvas, 76 x 63

Saltram, The Morley Collection (The National Trust)

By the 1770s Francesco Bartolozzi (1727–1815) enjoyed an international reputation as one of Europe's finest line and stipple engravers. He was also a celebrated figure in fashionable London society. As this portrait reveals, he was possessed with good looks, which he evidently used to his advantage in his vigorous pursuit of the opposite sex. As late as 1787, when Bartolozzi was sixty, Thomas Gainsborough observed, in characteristically earthy fashion, 'Why will Bartolozzi … spend his last precious moments f—g a young Woman, instead of out doing all the World with a Graver; when perhaps all the World can out do Him at the former Work?' (Hayes 2001, p.168).

Born in Florence, Bartolozzi trained first as a goldsmith with his father, before entering the Accademia di Belle Arti. In 1745 he moved to Venice, where the engraver and printseller Joseph Wagner employed him to engrave works by contemporary Italian painters and by the Old Masters. In particular, Bartolozzi's engravings after Guercino were greatly admired, and prompted an invitation to England in 1764 to engrave drawings by that artist in the Royal Collection. In 1768 he was elected a founder member of the Royal Academy, although, since engravers were technically not eligible for membership, he was admitted as a painter. In England, Bartolozzi increasingly specialised in stipple engraving, a technique that involved building up an image with thousands of tiny dots to produce a smooth, soft-focused image. His preferred subjects were mythologies and female allegorical figures, often based on the work of Italian Old Masters, as well as works by contemporary London artists including Angelica Kauffman, Reynolds, and his close friend and compatriot, Giovanni Battista Cipriani.

In 1779 the Grand Duke of Tuscany offered Bartolozzi a pension to return to his native Florence, but he preferred to remain in England (Whitley 1928, vol.2, p.315). By the late 1780s Bartolozzi's output was extensive, and he ran a large studio with up to fifty pupils and assistants. He continued to work in London until 1802, when, at the age of seventy-five, he moved to Lisbon, following the offer of a pension and a knighthood from the Prince Regent of Portugal. According to Bartolozzi, although he had been successful in England, he had also been dogged by debt and overwork. In Lisbon, as he told an English visitor, 'I can go to Court, see the King, have many friends, and on my salary can keep my horse and drink my wine. In England it would not allow me a jackass and a pot of porter' (Brinton 1903, p.57). Although no engravings from Bartolozzi's time in Portugal are known, his signed prints continued to be published in London.

According to an inscription on the back of the picture frame, apparently in the handwriting of Reynolds's pupil and biographer, James Northcote, this portrait of Bartolozzi was painted in 1771 for Mrs Hester Thrale (see cat.49). There is no evidence, however, to suggest that Mrs Thrale commissioned it, especially since all the other portraits she owned were purchased by her first husband, Henry Thrale. Even so, she certainly knew Bartolozzi in later life since he was a friend of her second husband, the Italian musician Gabriel Mario Piozzi. Shortly before her marriage to Piozzi in 1784 – to which most of her British friends objected – Mrs Thrale met Bartolozzi in London, while the following year, in Milan, she received a visit from Bartolozzi's son, Gaetano, an engraver and musician (see Balderston 1942, vol.2, p.611, n.1, and p.632).

MP

Provenance
?Mrs Hester Thrale; Earls of Morley, by descent; acquired by the Treasury in part payment of death duties in 1957 following the death of the 4th Earl of Morley.

Literature
Graves and Cronin 1899–1901, vol.1, p.59; Waterhouse 1941, p.62; St John Gore 1967, p.20; Mannings and Postle 2000, vol.1, p.77, vol.2, fig.1091.

Engraved
Robert Marcuard 20 April 1784 (oval); Thomas Watson 24 September 1785; F.G. Haid.

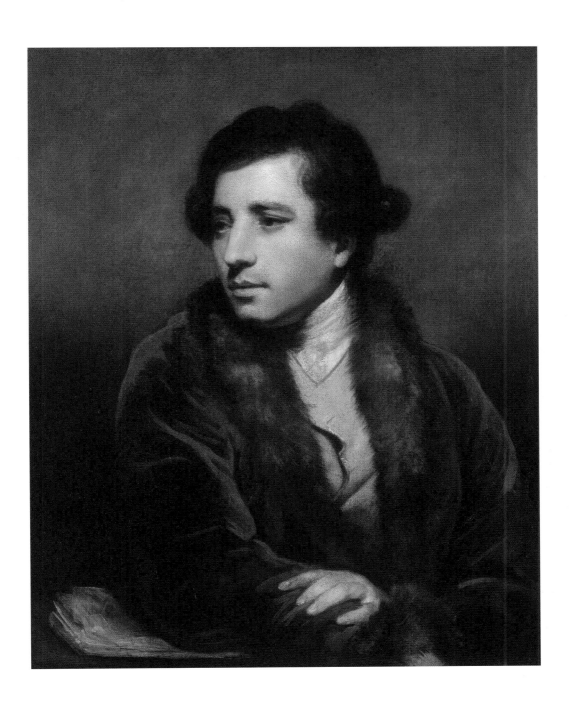

60. *Garrick between Tragedy and Comedy* 1760–1

Oil on canvas, 148 x 183

Rothschild Family Trust

In early 1760 Reynolds began work on a portrait, exhibited the following year at the Society of Artists as 'Mr Garrick, between the two muses of tragedy and comedy'. This was without doubt his most ambitious picture to date, and among the most important of his entire career. While it is likely that Reynolds had approached Laurence Sterne the previous year to paint his portrait, the idea of portraying Garrick between Tragedy and Comedy evidently came from the actor himself as Horace Walpole noted at the time: 'Reynolds has drawn a large picture of three figures to the knees, the thought taken by Garrick from the judgement of Hercules' (Hilles and Daghlian 1937, p.61). For while most actors at the time specialised in comic or tragic roles, the versatile Garrick was thought equally gifted in both spheres of his profession.

Since the 1740s David Garrick (1717–79) had featured in a string of self-promotional paintings and associated engravings, notably in Hogarth's monumental portrayal of the actor as Richard III (1745; Walker Art Gallery, Liverpool). As recently as 1760, Francis Hayman had exhibited *Garrick as Richard III* (Somerset Maugham Collection, National Theatre, London) at the Society of Artists, while the following year James McArdell showed his mezzotint, *Mr Garrick in the Character of King Lear*, after a painting by Benjamin Wilson. However, unlike these other pictorial manifestations, Reynolds's painting was firmly rooted in the traditions of Western art and literature rather than the conventions of the contemporary British stage. The composition was influenced by a number of discrete visual sources, ranging from works by Rubens and Guido Reni to those by the English artist, William Dobson. The figures of Comedy and Tragedy, painted respectively in the style of Antonio Correggio and Reni, represent the choice open to the artist between the seductive allure of colour and the strictures of line.

While the story of Hercules at the crossroads derived from a story told by the classical author, Prodicus, Reynolds (and possibly Garrick) evidently drew inspiration from another classical work, Ovid's *Amores* – the text that most closely mirrors Reynolds's parodic intent. In the first poem of the third book, Ovid enters a sacred grove in which he is accosted by the Muses of Elegy and Tragedy. While Tragedy berates the poet, Elegy – who wears a skimpy gown – smiles slyly at him. Ovid turns to Tragedy to plead his cause:

'Please, Tragedy, allow your bard a breather.
You are eternal toil, her wants are short'.
She gave me leave. Quick, Loves, while I've the leisure!
A greater work is waiting to be wrought.
(quoted in Kenney 1991, p.66)

Rather than obeying the immediate strictures of Tragedy, Garrick, like Ovid, wanders off to enjoy a more pleasurable, if brief, encounter with Comedy, before returning to more serious business.

MP

Provenance
Bought from the artist by George Montagu-Dunk, 2nd Earl of Halifax; Earl of Halifax (deceased) sale, Christie's 20 April 1782 (75), bought by John Julius Angerstein, in whose family it remained until after 1872; bought from Wertheimer by Agnew's 11 June 1885 for Sir N. de Rothschild 1885; thence by descent.

Literature
Edwards 1808, p.188; Northcote 1818, vol.1, p.105; Malone 1819, vol.1, p.lxii; Hamilton 1831, vol.1, n.p.; Beechey 1835, vol.1, pp.156–7; Cotton 1856, p.70; Leslie and Taylor 1865, vol.1, p.205; Graves and Cronin 1899–1901, vol.1, pp.350–1; Waterhouse 1941, pp.12, 48, 50; Moore 1967, pp.332–4; Hilles 1967, pp.146–7; Waterhouse 1973, pp.21–2; Mannings 1984, pp.259–83; Busch 1984, pp.82–99; Wind 1986, pp.35–9, 182, 184; Postle 1990, pp.306–11; Postle 1995, pp.20–32; Mannings and Postle 2000, vol.1, pp.209–10, vol.2, pl.42, fig.531.

Engraved
Edward Fisher 1762; Valentine Green ?1769; J.E. Haid; Richard Purcell; Charles Corbutt; Anthony Cardon 1811; and many others with compositional variations.

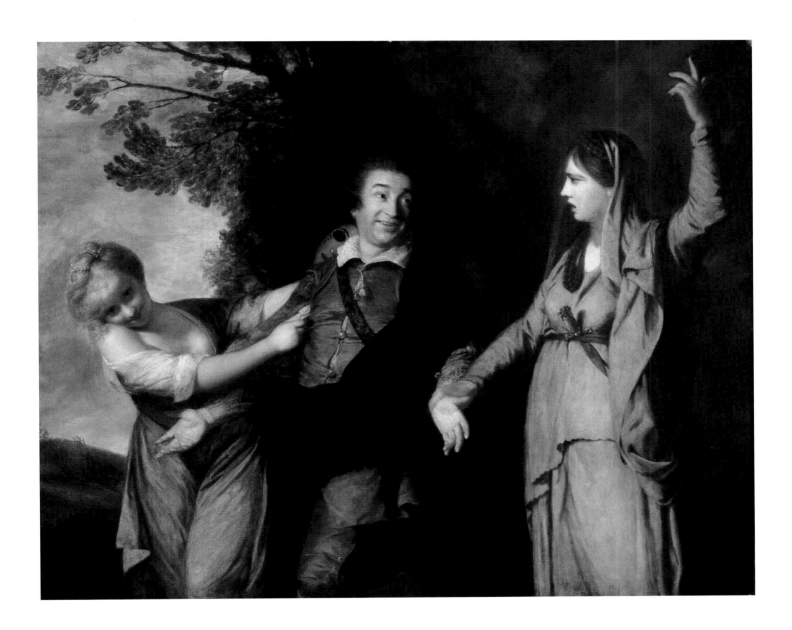

61. *Colonel Acland and Lord Sydney, 'The Archers'* 1769

Oil on canvas, 236 x 180

Private Collection

This extraordinary portrait was exhibited at the Royal Academy in 1770 and depicts two young aristocrats, Dudley Alexander Sydney Cosby, Lord Sydney (1732–74), shown on the left, and Colonel John Dyke Acland (1746–78), represented leaping forward on the right. The resulting painting shows the two men dashing through a forest as if taking part in a medieval or Renaissance hunt: they are wearing quasi-historical dress, and leave in their wake a trail of dead deer and game.

The brandishing of bows is not quite as anomalous as it might seem, for the latter decades of the eighteenth century witnessed a sustained resurgence of enthusiasm for archery within aristocratic culture. This interest culminated in the formation in 1781 of a prestigious body devoted to the sport, the Royal Toxophilite Society, created by the Baronet and antiquarian Sir Ashton Lever, a neighbour of Reynolds's in Leicester Fields. In 1782, the writer Fanny Burney paid a visit to Lever's house, where she found that he had 'dressed not only two young men, but himself, in a green jacket, a round hat, with green feathers, a bundle of arrows under one arm, and a bow in the other, and thus, accoutred as a forester, he pranced about; while the younger fools, who were in the same garb, kept running to and fro in the garden, carefully contriving to shoot at some mark' (quoted in Penny 1986, p.242). Even if Burney's pejorative description of the scene at Lever's house seems to describe a farcical re-run of the activities depicted in Reynolds's double portrait, her words, taken alongside Reynolds's painting, suggest the extent to which privileged young men in this period were identifying themselves with the historic, romantic and virile figure of the archer.

Significantly, the inclusion of a pile of game to the left of Reynolds's composition underlines the point that the two archers in the portrait are not common 'foresters' but men of noble blood, exploiting their aristocratic right to hunt. In so ostentatiously relating Acland and Sydney to an earlier historical period, Reynolds's painting conjures up a homo-social fantasy of an older, more chivalrous era, in which young, fleet-footed lords were able to run together through ancient forests, and engage in such suitably 'manly' activities as hunting and firing their arrows in perfect rhythm.

In 1865, Reynolds's Victorian biographer, Tom Taylor,

related the story that Acland and Sydney were close friends who had made the Grand Tour together and who, in order to record their relationship, had asked Reynolds to paint their portrait. According to Taylor, they had subsequently quarrelled 'before the picture was well finished, and each declined paying for it and taking it home. Thus it came into the hands of the Earl of Carnarvon' (Leslie and Taylor 1865, vol.1, p.348, n.4). While the story may have some basis in fact, Acland and Sydney did not make the Grand Tour together – nor is there any record of Sydney having made the Grand Tour at all. Indeed, the nature of their relationship remains unknown. Acland was a politician and soldier who fought in the war against the American colonists, while Sydney pursued a diplomatic career until his death by suicide in 1774. Finally, it is worth noting that Reynolds painted this portrait in August, a time he reserved principally for works painted of his own volition rather than commissioned portraits. It is possible, therefore, that the picture was purchased by Acland's widow, not merely to settle a debt owed to Reynolds but in remembrance of her recently deceased husband, who had died at the age of thirty-two from a paralytic stroke, possibly as a result of serious wounds he had received in the recent war.

MH/MP

Provenance
Acquired from the artist in 1779 by the estate of Colonel John Dyke Acland; passed to his daughter, Elizabeth Kitty Acland, thence to her husband, Henry George Herbert, 2nd Earl of Carnarvon; thence by descent to George, 5th Earl of Carnarvon, removed from Highclere Castle, Newbury; sold Christie's 22 May 1925 (110), bought for a member of the Acland family, Mrs Mervyn Herbert; thence by descent; sold by the Trustees of the Tetton Heirlooms Estate 14 June 2000 (5).

Literature
Leslie and Taylor 1865, vol.1, p.348; Graves and Cronin 1899–1901, vol.1, pp.7–8; Waterhouse 1941, pp.16, 60; Waterhouse 1973, p.26; Penny 1986, p.242; Mannings and Postle 2000, vol.1, p.58, vol.2, pl.68, fig.961; Mannings 2000, pp.26–9.

62. *Master Crewe as Henry VIII c.1775*

Oil on canvas, 139 x 111

Private Collection

Master John Crewe (1772–1835) was the eldest son of Reynolds's influential Whig patrons, John Crewe and his wife Frances Ann. Reynolds exhibited this portrait at the Royal Academy in 1775. The boy's pose and costume are modelled upon Hans Holbein the Younger's famous portrait of Henry VIII, which formed part of a dynastic mural he painted in 1537. Although the mural was destroyed in a fire at Whitehall Palace in the late seventeenth century, the image of Henry VIII survives today in the form of a preparatory drawing (*c*.1536–7; National Portrait Gallery, London), as well as in painted copies and engravings. While Reynolds copied the essential elements of Henry's dress, he omitted a number of details, notably the prominent codpiece that had underlined Henry's potency. As the discarded jacket on the chair behind him indicates, Master Crewe is wearing fancy dress – the kind of costume then adopted by adults at fashionable masquerades. As Horace Walpole remarked in 1770 of a masquerade at Mrs Cornelys's, Carlisle House, Soho, 'we have had a crowd of Henrys the Eighth, Wolseys, Vandykes, and harlequins' (Walpole 1937–83, vol.23, p.193). Even so, Reynolds's portrait was unique, and Walpole in particular admired it: 'Is not there humour and satire in Sir Joshua's reducing Holbein's swaggering and colossal haughtiness of Henry VIII to the boyish jollity of Master Crewe?' (quoted in Penny 1986, p.269).

Reynolds had known Master Crewe's mother, Frances, since her childhood, when he had painted an allegorical portrait of her alongside her brother as Cupid and Psyche (1760–1; Private Collection). She had later posed for him as a teenager as Saint Geneviève, and also with her friend, Mrs Bouverie. This painting was a portrait subtitled by Reynolds 'Et in Arcadia Ego' (*Mrs Crewe and Mrs Bouverie* 1767–9; Private Collection), indicating that Reynolds wished it to be viewed as a meditation upon death and mortality. Thus, the Crewes were by the mid-1770s confirmed supporters of Reynolds's distinctive mode of historical portraiture. Mrs Crewe was also one of London's most active socialites. She was a habituée of Mrs Cornelys's, where she first appeared as a Spanish nun, and where she and Mrs Bouverie subsequently appeared cross-dressed as young men, 'the fierce smart cock of their hats much admired' (Leslie and Taylor 1865, vol.1, pp.392, 434). With such a flamboyant mother, it is not surprising that the three-year-old Master Crewe would be expected to follow in the family footsteps.

Reynolds was affiliated to the Crewes by virtue of their patronage but also because of their shared political creed. Increasingly, Reynolds was drawn into Whig society, where Mrs Crewe was held in particular esteem. During the celebrated Westminster election of 1784 Mrs Crewe, alongside the Duchess of Devonshire (cat.29) and other Whig ladies, dressed in buff and blue, the colours of the American Independents. Reynolds, who at the time publicly backed the Whigs through his propagandist portrait of Fox (cat.41), attended Mrs Crewe's victory party, where he would presumably have joined in the famous toast 'true blue and Mrs Crewe'.

MP

Provenance
Painted for John, afterwards 1st Lord Crewe; by descent.

Literature
Malone 1819, vol.1, p.lxv; Leslie and Taylor 1865, vol.2, p.157; Stephens 1867, p.51; Graves and Cronin 1899–1901, vol.1, pp.210–11; Waterhouse 1941, p.66; Waterhouse 1973, p.28; Paulson 1975, p.88; Penny 1986, p.269; Shawe-Taylor 1990, p.215; Mannings and Postle 2000, vol.1, p.153, vol.2, fig.1132.

Engraved
John Raphael Smith 10 December 1775; S.W. Reynolds.

63. *Miss Crewe c.*1775

Oil on canvas, 137 x 112

Private Collection

Reynolds probably painted this portrait of Frances Crewe (?1767–?75) in 1775. The picture remained unfinished because, as David Mannings has noted, the child probably died while it was being completed. And, although the picture was acquired by the Crewe family, Reynolds does not appear to have asked for payment (Mannings and Postle 2000, vol.1, p.152). Indeed, it was probably because of the child's untimely death that the picture was not exhibited in public until the mid-nineteenth century. In this sense the fate of the painting's subject was closely related to the relative obscurity of the portrait – unlike that of her brother, which achieved instant fame. Nonetheless it has come to epitomise a certain type of child portrait for which Reynolds became celebrated during the 1770s.

Although *Miss Crewe* was conceived as a portrait, the pictorial language employed here – and the response that it was designed to evoke in the adult viewer – is closely allied to the genre of the 'fancy picture', which Reynolds was then exploring in studies of beggar children. It was a genre that had its roots in seventeenth-century European painting, through, for example, the art of Dutch Old Masters, and that of the Spanish artist, Bartolomé Murillo (1618–82). Of Reynolds's fancy pictures, the best known, and the closest in conception to the present portrait, is *A Strawberry Girl*, a version of which Reynolds exhibited at the Royal Academy in 1773 (see Mannings and Postle 2000, vol.1, pp.564–6). In *A Strawberry Girl* a young child is portrayed carrying a basket on her arm, much like the one in the present portrait. In the former picture, however, the child is at work rather than at play, an urchin from the streets, not the offspring of the aristocracy. *Miss Crewe* may bear a superficial resemblance to a 'strawberry girl', yet the rich fabric of her costume confirms her lineage. Even so, in the way that he elided the genre of portraiture and the fancy picture, Reynolds's pictorial strategy was not dissimilar to the subterfuge and obfuscation carried out by adults within the confines of the masquerade, where identities were cheerfully traded, and the conventional hierarchies of class and social status deliberately confused.

Provenance
Painted for John, afterwards 1st Lord Crewe; by descent.

Literature
Graves and Cronin 1899–1901, vol.1, p.211; Waterhouse 1941, pp.65, 124; Waterhouse 1973, p.28; Penny 1986, p.270; Mannings and Postle 2000, vol.1, p.153, vol.2, fig.1133.

MP

64. *A Child's Portrait in Different Views: 'Angels' Heads'* 1786–7

Oil on canvas, 74.9 x 62.9

Tate. Presented by Lady William Gordon 1841

Frances Isabella Keir Gordon (1782–1831) was the only daughter of Lord William Gordon and his wife Frances Ingram-Shepherd. She was also the niece of Lord George Gordon, who had been responsible for sparking the violent anti-Catholic demonstrations of 1780, the so-called 'Gordon Riots'. Reynolds painted this portrait in the summer of 1786, and although Frances Gordon did not herself achieve any personal fame during her lifetime, her portrait was to become one of Reynolds's most celebrated works.

The principal compositional source for the picture appears to have been a red chalk drawing of four cherubs' heads by the Italian seventeenth-century artist Carlo Maratti, which Reynolds had acquired in 1779 at the studio sale of Thomas Hudson, and which is now in the British Museum (1872-10-12-3295). Reynolds admired Maratti's draughtsmanship, praising him in his eighth Discourse for his 'Academical Merit', although he considered him to be deficient in his handling of colour. Reynolds may also have relied upon his own painting, *A Child with Guardian Angels* (Private Collection), which he had exhibited at the Royal Academy in 1786, only months before he began work on the present picture.

The first public reference to the picture appeared in *The Times* on 24 October 1786, when a critic saw it in Reynolds's gallery. Here it was observed that the 'grouping of four likenesses of the little cherubic Gordon into one picture, is among the prettiest portrait ideas that have ever been conceived'. Several months later, on 9 January 1787, the *World* noted that the 'four heads, in one frame, of Lord William Gordon's child, are gone home'. However, a subsequent sitting for Miss Gordon in March 1787 suggests that the painting had in the meantime been returned to Reynolds, not least because in the completed picture there are five heads; the additional one presumably having been added during this final appointment with Miss Gordon.

The picture was exhibited by Reynolds at the Royal Academy in 1787 as 'A child's portrait in different views; a study'. Here it won universal praise. As one newspaper pronounced: 'The hand of nature never formed a finer face than this:– not like the general run, the *formae quotidianae* of cherubims, with ruddy cheeks and round unmeaning faces, but sentiment, expression, and clearness, and warmth of colouring, that all must feel, but which the President of

the Royal Academy can alone describe' (*Whitehall Evening Post*, 3–5 May 1787).

Frances Gordon's mother outlived her daughter by ten years, and on her death in 1841 she bequeathed this picture to the National Gallery. There it was extensively copied: the annual registers of copies kept by the National Gallery from 1846 to 1895 record no fewer than 314 full-size copies in oil. The appeal of *'Angels' Heads'* to Victorian taste is indicated by its reproduction on decorative items, such as the cover of an ivory-bound prayer book. Numerous photographic reproductions also exist, with titles such as 'The Cherub Choir'. More recently, an image of the picture was used on a First Day Cover to promote the National Society for the Prevention of Cruelty to Children's 'Year of the Child'. Perhaps the most unusual modern replication of the image is on badges awarded until recently to student midwives at St Mary's Hospital, Manchester.

MP

Provenance
By descent to Lady William Gordon, who presented it to the National Gallery in 1841; transferred to the Tate Gallery in 1951.

Literature
Malone 1819, vol.1, p.lxix; Waagen 1854, vol.1, p.365; Leslie and Taylor 1865, vol.2, p.505; Hamilton 1884, p.102; Pulling 1886, pp.61, 84; Graves and Cronin 1899–1901, vol.1, p.372; Whitley 1928, vol.2, p.82; Waterhouse 1941, pp.103, 277, repr.; Davies 1959, pp.115–16, no.82; Waterhouse 1973, p.182, pl.110; Penny 1986, p.349; Mannings and Postle 2000, vol.1, p.221, vol.2, fig.1494.

Engraved
P. Simon, in stipple 1789; W. Ward, ARA; S.W. Reynolds; S. Cousins, RA; J. Scott 1875; R.S. Clouston 1889.

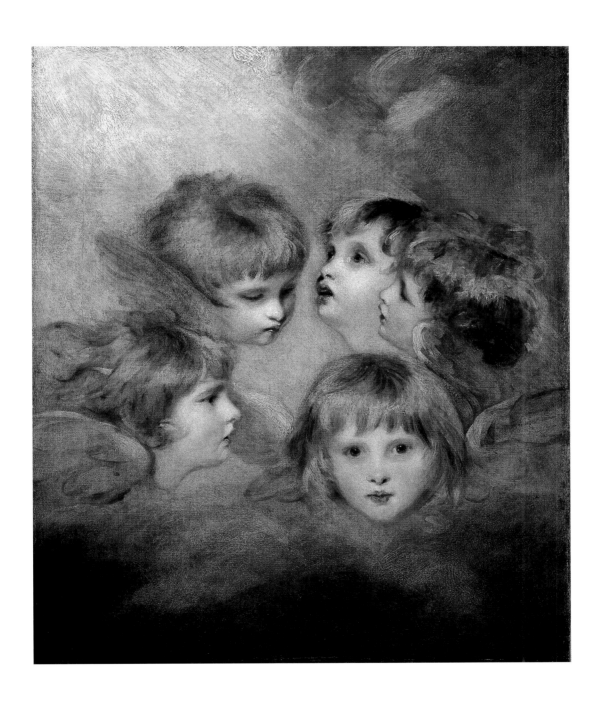

65. *Scyacust Ukah* 1762

Oil on canvas, 122 x 90

Gilcrease Museum, Tulsa, Oklahoma.
Gift of the Thomas Gilcrease Foundation, 1963

In early July 1762 several London newspapers reported that 'the Cherokee chiefs are sitting for their pictures to Mr Reynolds'. At the time Reynolds jotted down a morning appointment with 'The King of Cherokees' in his pocket book, and, a few days later, an afternoon visit, presumably from the same individual. The result of these two brief encounters was the present portrait. Reynolds's subject was the leader of a three-man delegation of Cherokees who had come to England on a diplomatic mission, in order to cement relations between the British administration and the Cherokees of the Ohio Valley region. The portrait is entitled *Scyacust Ukah*, although at the time the so-called King of the Cherokees was known variously as Ostenaco, Outacity, Skiagusta Oconesta, Judge Friend and Man Killer (Pratt 1988, p.141). Quite what Reynolds and the Cherokee warrior-chief made of one another we cannot tell, although the fact that the Native American's interpreter had died on the journey to England suggests that verbal communication between the two was limited.

In Reynolds's portrait Scyacust Ukah has a benign aspect, in marked contrast to the portrait painted by Francis Parsons of another member of the delegation who aggressively brandishes a large scalping knife (see Pratt 1988, fig.4). Around his neck he wears a silver gorget and the 'peace medal' awarded to him by the British following their recent treaty. As Stephanie Pratt has observed, his richly embroidered attire and the pipe-tomahawk, which he holds up like a marshal's baton, lend him the air of a European military commander. Indeed, at the time a contemporary compared him favourably to Britain's most distinguished soldier: 'He strongly resembles the Marquis of Granby, and I assure you in many instances gives masterly strokes of great courage, a sense of true honour, and much generosity of mind' (Pratt 1988, p.147).

The Cherokee delegation attracted intense interest during their stay in London, the highlight of which was an audience with the King, George III. In addition to Reynolds's portrait, prints were made of all three visitors, as well as songs and written accounts, such as the one quoted above. The men inevitably became great objects of curiosity, prefiguring the commotion surrounding the presence in England of the Polynesian Omai a decade later (see cat.66). Although the Cherokees were in London on business, their diplomatic status was diminished by their inability to communicate with their hosts. Attention was therefore centred, inevitably, upon their exotic physical appearance, and the frisson surrounding the potential threat they were perceived to pose as 'primal creatures only barely restrained by European civilization from outrageous behaviour' (Pratt 1988, p.145). Reynolds, too, was motivated by curiosity, as well as the desire to add them to his expanding collection of celebrities. His picture was, as far as we can tell, painted of his own volition, and probably hung in his gallery, until, perhaps, public interest in the Cherokees had evaporated, and their visit had been reduced to just another footnote in history.

MP

Provenance
Marquess of Crewe, Crewe Hall, Cheshire; sold privately to Mr Dudley-Wallis; bought by Thomas Gilcrease in the 1940s from a New York dealer (Gilcrease Museum files).

Literature
Leslie and Taylor 1865, vol.1, pp.213–14; Graves and Cronin 1899–1901, vol.4, p.1353; Pratt 1988, pp.133–50; Mannings and Postle 2000, vol.1, p.408, vol.2, pl.47, fig.640.

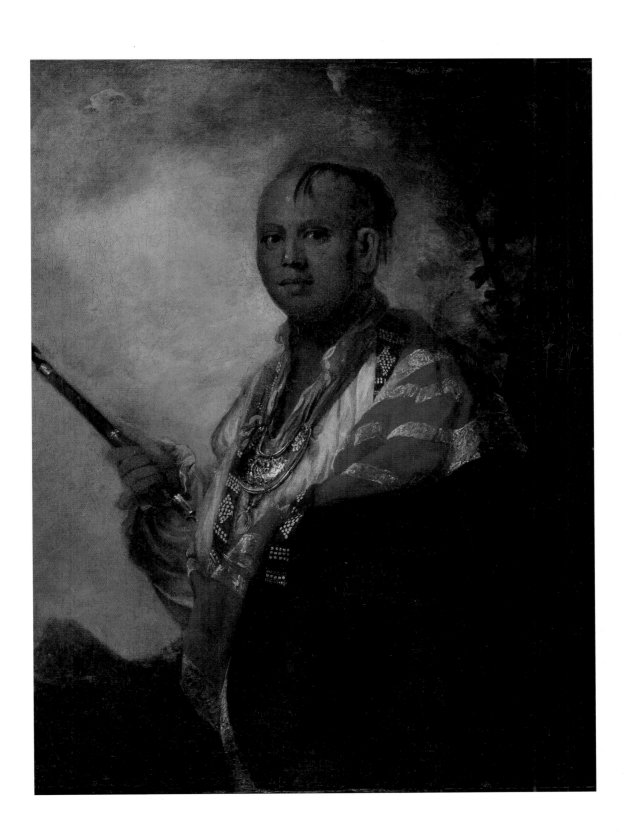

66. *Sketch for 'Omai' c.*1775–6

Oil on canvas, 60.4 x 52.7

Yale University Art Gallery, Gift of the Associates in Fine Arts

This oil sketch may be the painting sold in Reynolds's posthumous studio sale as 'First head of Omai'. Certainly, it is the only known oil painting by Reynolds of this celebrated subject, other than the large full-length portrait exhibited at the Royal Academy in 1776 (cat.67). The differences between the present study of Omai and the finished painting are instructive. Although the angle of the head is the same in both pictures, in the oil sketch Omai's facial features are more pronounced; his nose is larger and flatter, his jaw squarer and his lips more full. His expression is proud, even defiant, whereas in the final picture he is benign, almost gentle. And in the final picture, of course, he wears a turban. A comparison with other contemporary portraits of Omai by British artists, notably by William Hodges, Nathaniel Dance and Reynolds's pupil, William Parry, indicates that Reynolds's oil sketch is a more accurate depiction of Omai than the final portrait, in which he is presented in an idealised manner, a figure of nobility and refinement (for the portraits by the other artists mentioned see McCormick 1977, figs.16, 29 and pl.2). This is not surprising since, as Reynolds's contemporaries noted, he was quite indifferent to likeness, and as he himself remarked in his fourth Discourse, it was 'very difficult to ennoble the character but at the expense of the likeness, which is what is generally required by such as sit to the painter'.

Descriptions of Omai's physical appearance vary. According to Captain Cook he was 'dark, ugly and a downright blackguard', while Fanny Burney thought him 'by no means handsome', but with a 'pleasing countenance' (McCormick 1977, pp.53, 125). Cook disliked Omai and had not been in favour of bringing him to England, while Burney was biased towards Omai since he was a friend of her brother. A more objective description was provided by a cleric who met him briefly. He noted that Omai's complexion resembled 'that of an European, accustomed to hot climates: His features are regular – his eyebrows large & dark – His Countenance is often illuminated by a most unaffected smile – His Hair black & dressed in the english fashion' (McCormick 1977, p.102).

Precisely when Reynolds made this oil sketch is unknown, since his pocket books for the years 1774 to 1776 are missing. His friendship with Joseph Banks would have gained him an introduction to Omai at any time he wanted,

although the fact that he did not exhibit the final portrait until the spring of 1776 suggests that it was made either earlier that year, or in the autumn of the previous year. There is also a related pencil sketch of Omai, traditionally ascribed to Reynolds (?1776; National Library of Australia). However, the refined technique is quite unlike that of Reynolds, who did not generally make preparatory drawings of this kind. It may, therefore, be by another hand, possibly based upon the present painting. In the early nineteenth century the oil sketch belonged to the banker and collector, John Steers, and in 1803 was seen in Steers's collection by the artist, John Hoppner, who was 'much captivated by the sketch … which He thought as fine as Titian' (Farington 1978–84, vol.6, p.2139).

MP

Provenance
?Greenwood's 14 April 1796 (51), bought by Clarke; in the collection of John Steers by 1803; sold by Steers, Christie's 3 June 1826 (45), bought by Revely; sold by G.J. Revely, Christie's 23 June 1873, bought by Cox; Randall Davies; given to Yale University Art Gallery by the Associates in Fine Arts, September 1936.

Literature
Graves and Cronin 1899–1901, vol.2, p.708; Tinker 1937, pp.45–7; Tinker 1938, pp.56–8, repr.; McCormick 1977, pp.171, 173–4; Mannings and Postle 2000, vol.1, p.357, vol.2, fig.1190.

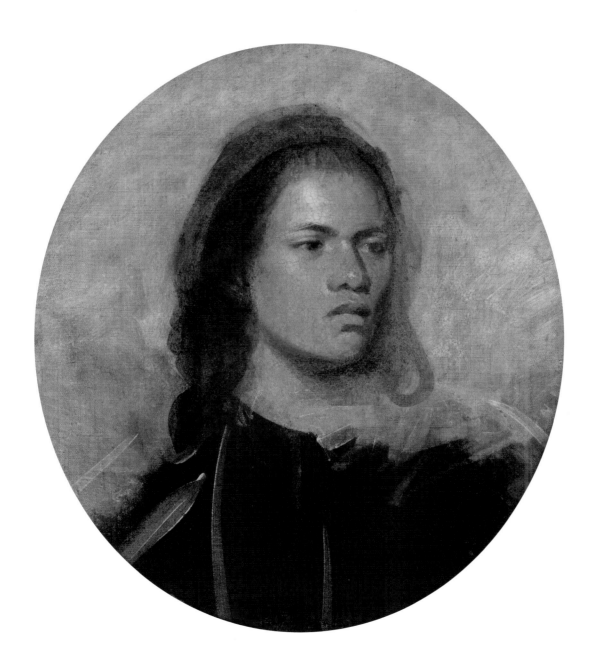

67. *Omai c.*1776

Oil on canvas, 236 x 145.5

Private Collection

Mai (*c.*1753–?79), or 'Omai' as he was called by his British hosts, was a young Polynesian who was given a passage from Tahiti to England in 1774. On arrival he was put under the governance of his official patrons, the Earl of Sandwich, First Lord of the Admiralty, and the scientists Daniel Solander and Joseph Banks, who had met Omai on an earlier visit to the South Seas. The intention in bringing him to England was vaunted as scientific: to evaluate his responses to 'civilised' Western virtues. Omai's own reasons for making the journey were entirely different, and related to his ambition to gain British support in defeating those who had driven him from his native island of Raiatea, sequestered his family's land, and apparently murdered his father. Yet, although his visit had a serious purpose, he quickly became a source of curiosity and amusement.

Given his celebrity status, it was natural that Reynolds should wish to paint Omai's portrait, which he exhibited at the Royal Academy shortly after Omai's return to the South Sea Islands in 1776. In Reynolds's portrait Omai wears flowing white robes, clothes that to European eyes resemble a classical toga. However, as Pacific historians have pointed out, they do relate to Tahitian dress, the sash and the turban probably being made of *tapa*, a cloth made from tree bark (Turner 2001, p.27). The robes were probably of Omai's own creation, designed to reinforce the view that he was of high rank in his own society. Omai's pose recalls Reynolds's earlier full-length portrait of Augustus Keppel (cat.9), which, in turn, was based upon a figure of Apollo. Omai is thus endowed with what Reynolds refers to in his eleventh Discourse as a 'general air of the antique'. At the same time, Reynolds makes no attempt to disguise the tattoos on Omai's hands and arms, which remain in full view 'for the sake of likeness'. Unlike those in the portrait of Keppel, Omai's gestures do not imply command but rather are used to display, like stigmata, the body markings that indelibly single him out from his European counterparts (see Guest 1992, p.106). Thus, Reynolds ennobles Omai using the vocabulary of Western art, while at the same time drawing attention to the features which distinguish him from Western society.

During the two years that Omai spent in England, he was courted by fashionable society, including the Royal Family. He was also introduced to members of Reynolds's circle, including Samuel Johnson, Mrs Thrale and Giuseppe Baretti.

As Mrs Thrale remarked, when Baretti played chess with Omai, 'You would [have] thought Omai the Christian, and Baretti the Savage' (Balderston 1942, vol.1, p.48). Fanny Burney was impressed by him, 'for his manners are so extremely graceful, and he is so polite, attentive and easy, that you would have thought he came from some foreign Court.' Contributing to this impression, when Omai met Burney he was wearing a satin-lined velvet suit, a bag wig, lace ruffles 'and a very handsome sword which the King had given to him' (Burney 1913, vol.1, p.334). Omai's patrons were criticised in some quarters for parading him as a foppish gentleman or 'Maceroni'. Worse, there were rumours that they encouraged his sexual promiscuity, notably at the home of the rakish Lord Sandwich, where he used his 'animal powers … with freedom and success' (McCormick 1777, p.184).

When Captain Cook returned Omai to the South Sea Islands in 1776, he refused to take him to Raiatea, fearing that Omai would incite further bloodshed in order to regain his property and avenge his father's death. Instead he settled him on the neighbouring island of Huahine, where he was provided with a suit of armour, various weapons and a vegetable garden. He is said to have died three years later.

MP

Provenance
Greenwood's 16 April 1796 (51), bought by Michael Bryan; Frederick, 5th Earl of Carlisle, at Castle Howard, Yorkshire, by 13 August 1796; thence by descent; sold by the Trustees of the Will of Lord Howard of Henderskelfe Deceased, Sotheby's 29 November 2001 (12).

Literature
Manners 1813, vol.1, p.92; Neale 1819–23, vol.5, n.p.; Waagen 1838, vol.3, p.205; Waagen 1854, vol.3, p.323; Leslie and Taylor 1865, vol.2, pp.104–6; Graves and Cronin 1899–1901, vol.2, pp.707–8, vol.4, p.1639; Tinker 1938, pp.56–8; Waterhouse 1941, pp.66, 124; Luke 1950, pp.497–500; Burke 1976, p.205; McCormick 1777, pp.173–4; Joppien 1979, pp.81–136; Guest 1992, pp.101–34; Mannings and Postle 2000, vol.1, p.357, vol.2, pl.101, fig.1191; Turner 2001, pp.23–9.

Engraved
Johann (John) Jacobé 1777.

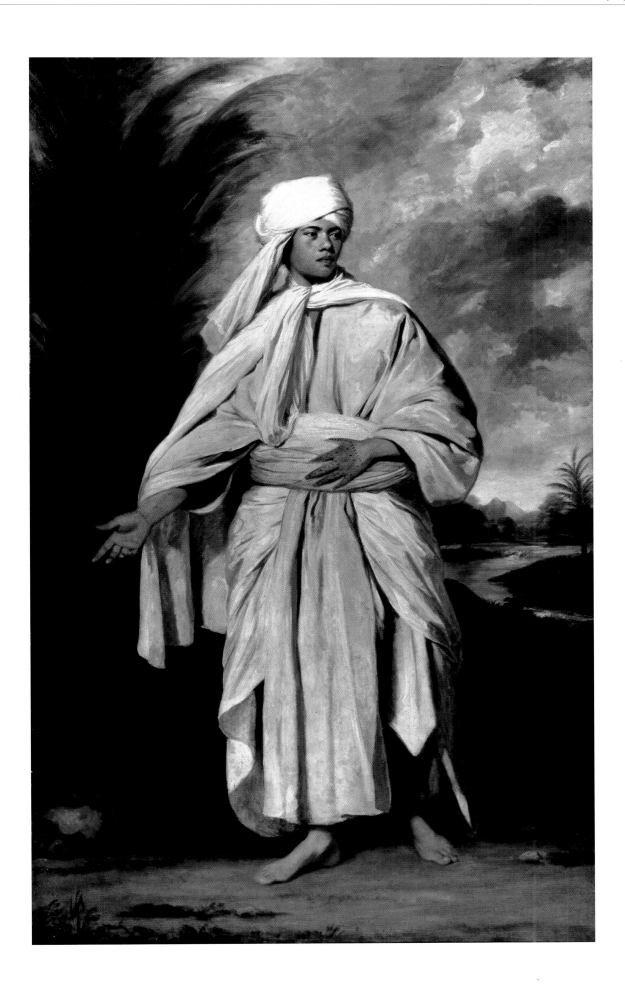

68. *Mrs Baldwin* 1782

Oil on canvas, 141 x 110

Compton Verney House Trust (Peter Moores Foundation)

Jane Baldwin (1763–1839) was just nineteen years old when she sat to Reynolds for this flamboyant portrait. Born in Smyrna, of British parents, she had for some years been the wife of a wealthy merchant, George Baldwin, who had married her when she 'had scarcely emerged from childhood' (*Gentleman's Magazine* 1839, p.657). In 1780 he took her to Vienna, where she was introduced to the Court of Joseph I. Entranced by her beauty, the Emperor commissioned her portrait bust by Giuseppe Ceracchi (see cat.88), while his Chancellor, Wenzel von Kaunitz, among the most influential politicians in Europe, ordered a full-length portrait. As a result, by the time Mrs Baldwin arrived in London the following year, she was already something of a celebrity.

Although Jane Baldwin had no Eastern European blood (her parents were from Yorkshire), she made the most of her exotic background, which earned her the sobriquet the 'pretty Greek'. The costume she wears in Reynolds's portrait was one that she adopted on special occasions in London, notably at a ball given by George III. Although it was evidently regarded as genuine Eastern European attire at the time, Mrs Baldwin's eye-catching outfit is, as the costume historian Aileen Ribeiro notes, 'a fancy dress', composed of a green and gold caftan, over which is worn a sleeveless ermine gown (Ribeiro 1984, p.232). A pictorial precedent for *Mrs Baldwin*, of which Reynolds may have been aware, is Sir Anthony Van Dyck's portrait of Teresia, Lady Shirley (1622; Petworth House, The National Trust), the Circassian wife of the Persian Ambassador to the Pope. However, while Van Dyck may have influenced Reynolds, it was the immediate presence of Mrs Baldwin that shaped the composition, not least her risqué cross-legged pose, which evokes the sensuous realm of the bagnio.

Reynolds painted Mrs Baldwin's portrait late in the winter of 1782, and exhibited it a few months later at the Royal Academy as 'Portrait of a Grecian lady'. As Mrs Baldwin recalled, Reynolds had experienced problems in painting the portrait, making three unsuccessful attempts 'which he successively defaced'. Nor did Mrs Baldwin, who was notoriously quick-tempered, improve matters, since after sitting to him for a few hours 'she always grew restless and cross, which used to vex Reynolds, who did not know how to amuse her' (*Gentleman's Magazine* 1839, p.657).

Eventually, he painted the picture at her home, and when she once more became restless, suggested she should read a book. She chose a volume of works by the Italian poet and playwright, Pietro Metastasio, which she read as Reynolds completed the portrait. In the painting, however, Reynolds substituted the book for an ancient coin of Smyrna.

Mrs Baldwin continued to attract the attention of artists in London during the early 1780s, including Richard Cosway and Robert Edge Pine, whose portrait of her apparently offended her husband as Pine made it 'too voluptuous'. Mrs Baldwin was, however, quite happy to use her charms in order to further her husband's career, and it was, she affirmed, through her influence upon the Prince of Wales that Mr Baldwin was given the post of British Consul-General in Egypt. Their subsequent life was by all accounts unhappy. Mr Baldwin became increasingly preoccupied with the current vogue for animal magnetism. After his death, Mrs Baldwin, having driven away all but her immediate family with her ungovernable temper, spent her final years in Clapham, south London, 'in a self-inflicted penurious seclusion' (*Gentleman's Magazine* 1839, p.658).

MP

Provenance
Reynolds's studio sale, Greenwood's 16 April 1796 (31) as 'A Grecian lady', bought in; Richard Westall RA by 1813; afterwards sold privately to the 3rd Marquess of Lansdowne; sold by the Trustees of the Bowood Collection, Sotheby's 1 July 2004 (8), bought by the Peter Moores Foundation for the Compton Verney House Trust.

Literature
Gentleman's Magazine 1839, new series, no.12, part 2, p.657; Jameson 1844, p.329; Waagen 1854, vol.3, p.160; Leslie and Taylor 1865, vol.2, pp.350–1, 362–3; Ambrose 1897, no.125; Graves and Cronin 1899–1901, vol.1, pp.44–5; Waterhouse 1941, p.73; Miller 1982, p.15; Ribeiro 1984, p.232; Mannings and Postle 2000, vol.1, pp.70–1, vol.2, pl.107, fig.1374.

Engraved
S.W. Reynolds 1821.

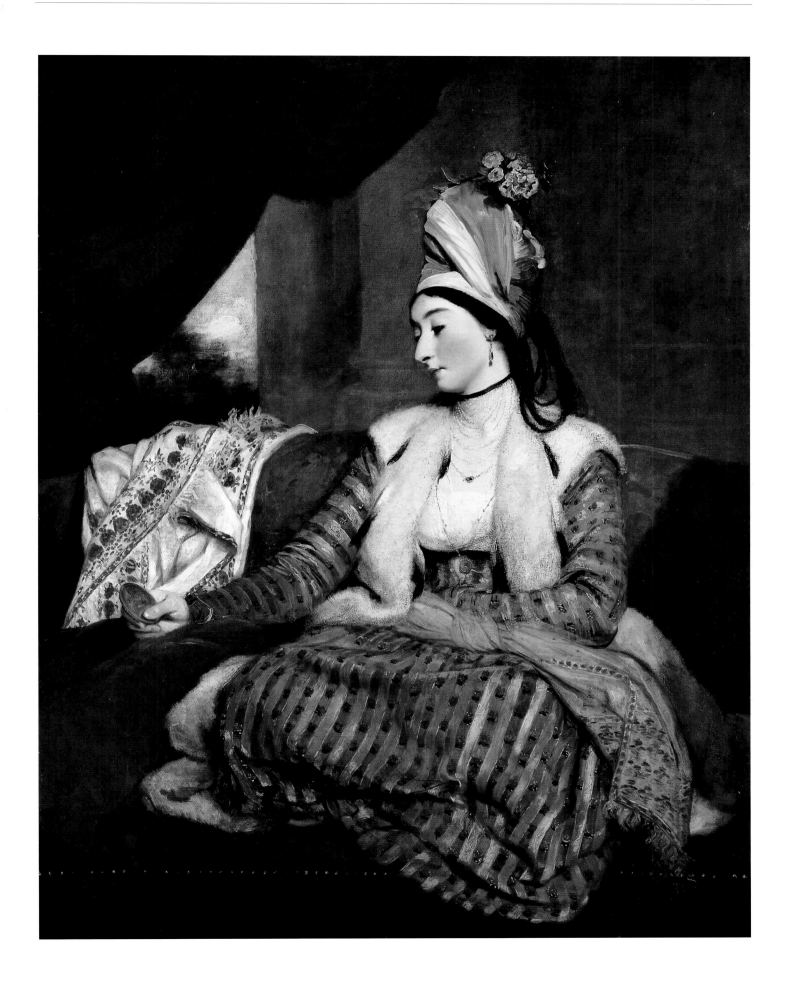

69. *Mrs Siddons as the Tragic Muse* ?1784 or 1789

Oil on canvas, 239.7 x 147.6

The Trustees of Dulwich Picture Gallery, London

This is a replica, possibly made under Reynolds's supervision, of his celebrated portrait of Mrs Siddons (1755–1831). It was copied from the prime version, exhibited by Reynolds at the Royal Academy in 1784 (now in the Huntington Art Gallery, San Marino). Reynolds's composition at once confirmed Mrs Siddons's status as the greatest tragic actor of her day, and, to Reynolds's supporters, vindicated his decision to present portraiture as a form of 'confined' history painting. In Reynolds's portrait Mrs Siddons appeared not merely in a theatrical role, but as the embodiment of Melpomene, the Muse of Tragedy. For decades Reynolds had represented female subjects in the guise of assorted mythological deities. He had first painted the Muse of Tragedy in the early 1760s, in his allegorical portrait of David Garrick (cat.60), although in that instance the figure, which had not taken the form of a portrait, was parodied. Shortly afterwards he had painted Mrs Abington as Thalia, the Comic Muse (1764–8; Waddesdon Manor, The National Trust). Mrs Siddons, who was a commanding presence both on and off the stage, was to be taken more seriously.

Sarah Siddons established her credentials as the country's leading tragedienne in 1782, following her success at the Drury Lane theatre, then managed by Reynolds's friend, Richard Brinsley Sheridan (cat.42). Although it has been supposed that Sheridan commissioned Reynolds's first version of the portrait, it seems more likely, given the subsequent history of the picture (and Sheridan's finances), that the artist painted it of his own volition. Reynolds devoted far more time and effort to the portrait than usual, X-rays confirming that he made a number of changes to the final composition along the way, including the removal of a winged cherub at the base of the throne (see Asleson 1999, pp.115–17). In later years Mrs Siddons, who had posed for the portrait in 1783, took the credit for the figure's attitude. However, the pose of her enthroned figure recalls the figure of the prophet Isaiah from the ceiling of the Sistine Chapel, as well as Domenichino's *Saint John the Evangelist* (before 1621; Glyndebourne, Sussex). Reynolds also inserted his own face into the picture, using himself as the model for the figure of 'Terror' (on the right of the picture), which, along with 'Pity', constituted Tragedy's attendants (see Mannings 1992, p.33).

Given the adulation enjoyed by Mrs Siddons, and the effort Reynolds had put into making her portrait, he was in no hurry to sell the work, despite newspaper accounts to the contrary. Certainly, the price-tag that Reynolds put on the original picture was guaranteed to deter all but the wealthiest purchaser. As a newspaper joked in 1785: 'It is said that the price of 1,000 guineas which Sir Joshua Reynolds has fixed upon his portrait of the Tragic Muse, will hardly pay him for the white lead he has used in that composition, even at four-pence per pound' (*Morning Herald*, 14 March 1785). Reynolds, who retained the picture for display in his gallery, eventually sold it in 1790 for 700 guineas to the French picture dealer, Noel Joseph Desenfans, on behalf of the émigré statesman, Charles Alexandre de Calonne.

The present replica appears to be signed and dated 1789, although the date can also be read as 1784 (John Ingamells, draft entry for a catalogue of paintings belonging to Dulwich Picture Gallery). By 1804 this replica belonged to Desenfans, and the possibility remains that he, rather than Reynolds, commissioned it, before parting with the original to Calonne. He later bequeathed it to his friend and fellow dealer, Sir Francis Bourgeois. Mrs Siddons was not enamoured of the painting, which she described as 'but a poor imitation of the original' (Asleson 1999, p.130). A second replica, which also appears to be the work of assistants or professional copyists (?1789; Private Collection), was reputedly exchanged by Reynolds for a large painting of a boar hunt by Frans Snyders, which belonged to a client whose daughter was then sitting to Reynolds for her portrait (see the *World*, 15 April 1789).

MP

Provenance
Noel Desenfans by 1804; bequeathed to Sir Francis Bourgeois 1807; Bourgeois Bequest to Dulwich College 1811.

Literature
Hazlitt 1824, p.123; Patmore 1824, pp.100–1; Graves and Cronin 1899–1901, vol.3, pp.896–8, vol.4, p.1411; Murray 1980, p.104; Penny 1986, pp.324–5; Postle 1995, pp.305–6; Asleson 1999, pp.128–36; Asleson and Bennett 2001, p.372 and n.34; Mannings and Postle 2000, vol.1, p.415, vol.2, fig.1567.

Engraved
J. Bromley 1832.

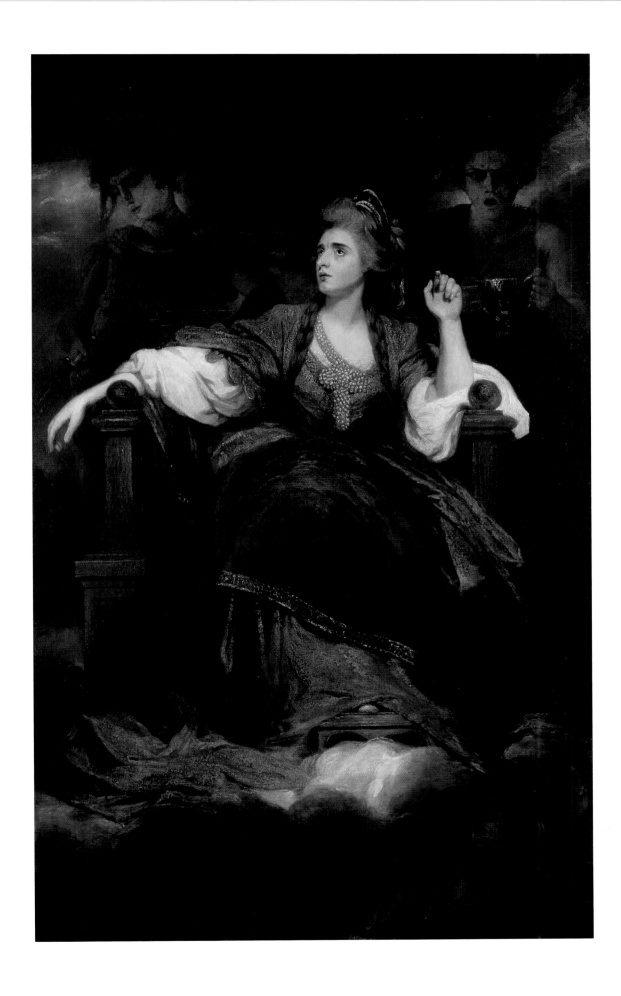

70. *Mrs Billington* 1789

Oil on canvas, 239.7 x 148

Beaverbrook Art Gallery, New Brunswick

Reynolds exhibited this painting at the Royal Academy in 1790 as 'Portrait of a Celebrated Singer'. By this time Elizabeth 'Betsy' Billington (1765 or 1768–1818) was, indeed, the most celebrated diva of the age. She was also notorious, rumours being rife about her scandalous private life. Elizabeth Weichsel, as she was born, had been a child prodigy in London, tutored on the harpsichord by Johann Christian Bach. In 1783, when still a teenager, she married the musician, James Billington. The pair moved to Dublin, where she reported to her mother: 'I am counted a very pretty actress, and every body that has heard me play on the piano forte, say [*sic*] that I am the greatest player in the world' (Highfill, Burnim, Langhans 1973–, vol.2, pp.122–4). By now she was also conducting an affair with her manager, and her husband was accused of profiting financially from the liaison. Her singing career, however, went from strength to strength and in 1786 Reynolds's friend, Lord Rutland, was instrumental in bringing her to the London stage.

Mrs Billington, who by this time commanded huge fees for her operatic performances, commissioned the portrait in 1789. The decision to portray her in the guise of Saint Cecilia, the patron saint of music, may well have been hers. In any event, the subject was not new to Reynolds: in 1775 he had painted an allegorical figure of Saint Cecilia for Sir Watkin Williams-Wynn's Music Room at Berkeley Square (1775; Los Angeles County Museum of Art), and the same year a portrait of Mrs Elizabeth Sheridan in the character of Saint Cecilia (see cat.78) for her husband, Richard Brinsley Sheridan (cat.42). In composing Mrs Billington's portrait, Reynolds was perhaps influenced by Raphael's famous painting *Saint Cecilia with Saints* (*c*.1514–15; Pinacoteca Nazionale, Bologna), although the cherubs above her head derive from a drawing Reynolds had made in Italy of part of the vault of the Sala di Psyche in the Palazzo del Te, Mantua.

When the painting was exhibited it drew criticism: 'Were the Bishop of London to speak', observed one writer, 'we apprehend that he would pronounce it to be an improper mixture of the sacred and profane' (quoted in Postle 1995, pp.263–4), clearly an allusion to Mrs Billington's lurid private life. The most famous critic of Reynolds's portrait was the composer Joseph Haydn, who was taken to see it at Reynolds's house by Mrs Billington herself. '"It is like",

said the composer, "but there is a strange mistake". "What is that?", asked Sir Joshua. "You have made her listening to the angels; you should have made the angels listening to her"' (Whitley 1928, vol.2, p.129).

MP

Provenance
Painted for the sitter; Michael Bryan, his sale by Coxe, Burrell & Foster 17 May 1798 (43), bought by Henry Hope; Mrs Elwyn, who sold it 1807 to 8th Baron Kinnaird; his sale Phillip's 26 February 1813 (78); Thomas Wright, his sale Christie's 7 June 1845 (59), bought by Heathcote (?bought in); Henry Graves and Company, who sold it to the Lenox Gallery, New York, later the New York Public Library; sold Parke Bernet, New York, 17 October 1956 (44), bought by Lord Beaverbrook.

Literature
Buchanan 1824, vol.1, p.292; Leslie and Taylor 1865, vol.2, p.529; Graves and Cronin 1899–1901, vol.1, pp.82–4; Whitley 1928, vol.2, pp.128–30; Waterhouse 1941, p.82; Ashton and Mackintosh 1982, p.69, no.122; Penny 1986, pp.332–3; Watson 1988 pp.75–6; Postle 1995, pp.15, 263–4, 286, 292; Mannings and Postle 2000, vol.1, p.88, vol.2, fig.1557.

Engraved
James Ward 10 January 1803; P. Pastorini 26 April 1803.

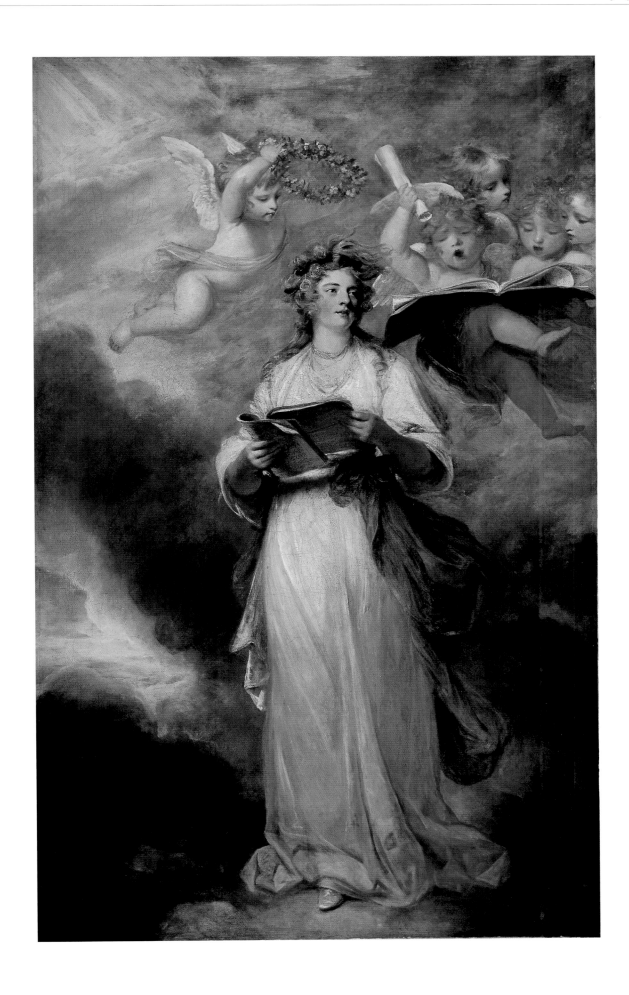

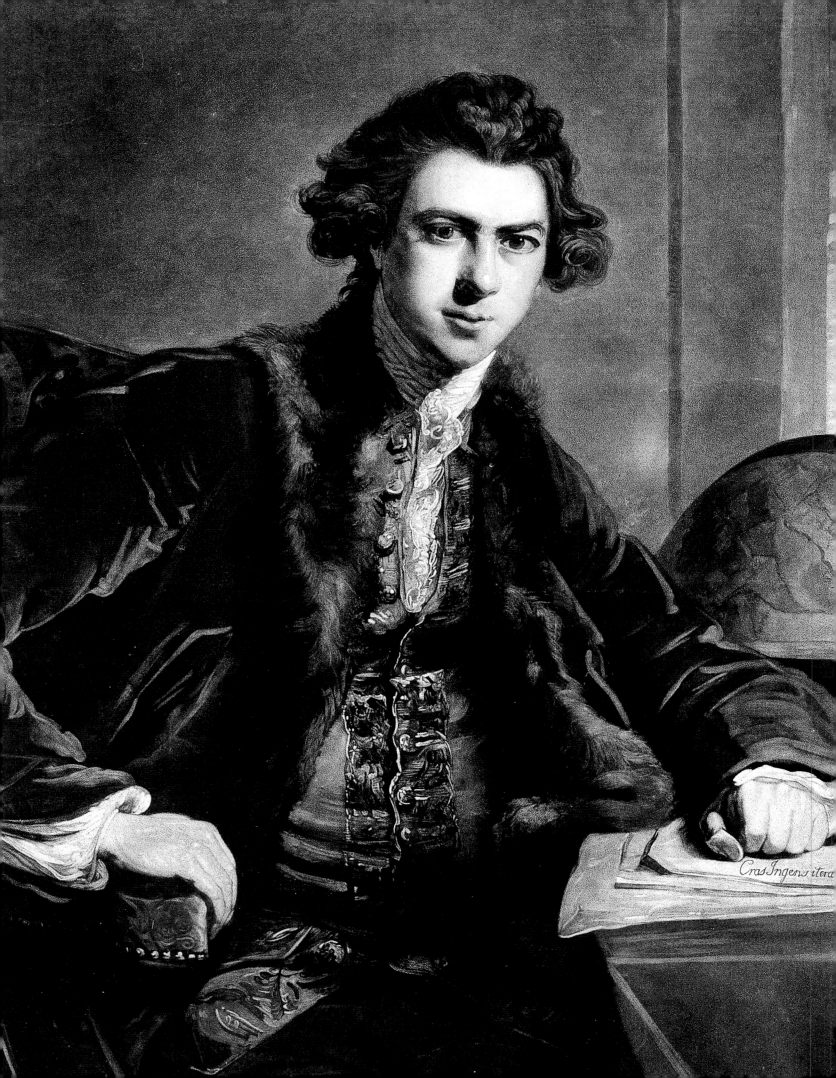

Cras Ingens itera

Reynolds and the Reproductive Print

Engraving played a crucial role in the dissemination of Reynolds's art and the creation of his international reputation. No other British artist, with the exception of William Hogarth, relied so heavily upon the print to promote their art, and as Richard Godfrey has observed: 'No class of reproductive print has so close an association with a particular painter as that of the mezzotint with Reynolds' (Godfrey 1978, p.48). The prints after Reynolds selected for the present exhibition are all mezzotints of the highest quality, made from some of Reynolds's most important portrait subjects by the greatest practitioners of the art. In later years, other print techniques, such as line engraving and stipple, were used to reproduce Reynolds's paintings. Only mezzotint, however, which relied upon a fine range of tonal gradations, could do full justice to Reynolds's dramatic use of light and shade and his powerful sense of composition.

The mezzotint process, which relied in part upon a mechanical technique in order to cover a copper plate with thousands of tiny indentations, was invented in the Netherlands in the early seventeenth century. Knowledge of the technique spread to England during the 1660s, and although it initially flourished, it was already in decline by the 1730s. Its spectacular revival in the early 1750s was largely owing to the example of Reynolds, who permitted the Irish printmaker, James McArdell, and other mezzotint printmakers of the so-called 'Dublin Group', to reproduce his portraits in this manner. The success of these images encouraged the best printmakers to compete to reproduce Reynolds's paintings, inevitably selecting images of the artist's most celebrated or attractive subjects. As Tim Clayton discusses in this catalogue (pp.49–59), Reynolds's portrait clients also commissioned prints to distribute to friends, in addition to a host of print publishers marketing them both at home and abroad. During his lifetime, hundreds of mezzotint engravings were made from Reynolds's paintings. He did not seek to profit financially from the enterprise – he did not have to – for, while others undertook the labour and bore the costs and financial risks, Reynolds reaped the reward of free publicity. For his portrait subjects, too, the willingness of others to invest in their image served to confirm their celebrity status.

MP

William Dickinson (1746–1823) after Joshua Reynolds
Joseph Banks 1774 (detail of cat.76)
The British Museum, London

71. Edward Fisher (1722–82) after Joshua Reynolds

Lady Elizabeth Keppel 1761

Mezzotint, 58 x 36

The British Museum, London (1902-10-11-2173)

Lady Elizabeth Keppel (1739–68) was the sister of Reynolds's close friend Augustus Keppel (cats.9 and 17). She is shown here, attended by a black servant, garlanding a term of Hymen, the god of marriage. The picture commemorates her role as bridesmaid at the wedding of George III and Queen Charlotte in 1761: the Latin inscription is taken from the celebrated classical marriage poem by Catullus, which invokes the blessing of Hymen upon the happy couple. The royal wedding took place early in September and Lady Elizabeth began sitting to Reynolds for her portrait three weeks later. The picture is one of a number of grandiose portraits by Reynolds of aristocratic English ladies making sacrifices or libations to pagan deities. As such it anticipates *Lady Sarah Bunbury Sacrificing to the Graces*, painted the following year (Art Institute, Chicago), *The Montgomery Sisters* (1773; Tate) and *Lady Talbot* (cat.26). Reynolds exhibited the portrait at the Society of Artists in 1762, as 'a whole length of a lady, one of her Majesty's bridesmaids'. As he worked upon the painting, the Scots artist Allan Ramsay was formally appointed Principal Painter to the King. In exhibiting his own portrait of the royal bridesmaid, Reynolds surely wished to show that the Court had missed an opportunity in failing to appoint him to the post.

Edward Fisher, who made the present print, was one of a coterie of Irish engravers working in London known as the Dublin Group. Reynolds enjoyed a closer relationship with Fisher than most of his engravers, and entrusted him with some of his most prestigious commissions, including *Augustus Keppel* (cat.9), *Kitty Fisher as Cleopatra Dissolving the Pearl* (cat.50) and *Garrick between Tragedy and Comedy* (cat.60). The dissemination in engraved form of these works gained Reynolds a wider audience in Britain, Europe and even America. Unusually, the inscription on the present print gives not only the engraver's name and address, but the price, fifteen shillings – which was more than a humble maidservant might earn in a month.

MP

Literature
Chaloner Smith 1883, vol.2, pp.498–9, no.36; Hamilton 1884, pp.113–14; Penny 1986, pp.208–9, no.44; Mannings and Postle 2000, vol.1, p.291.

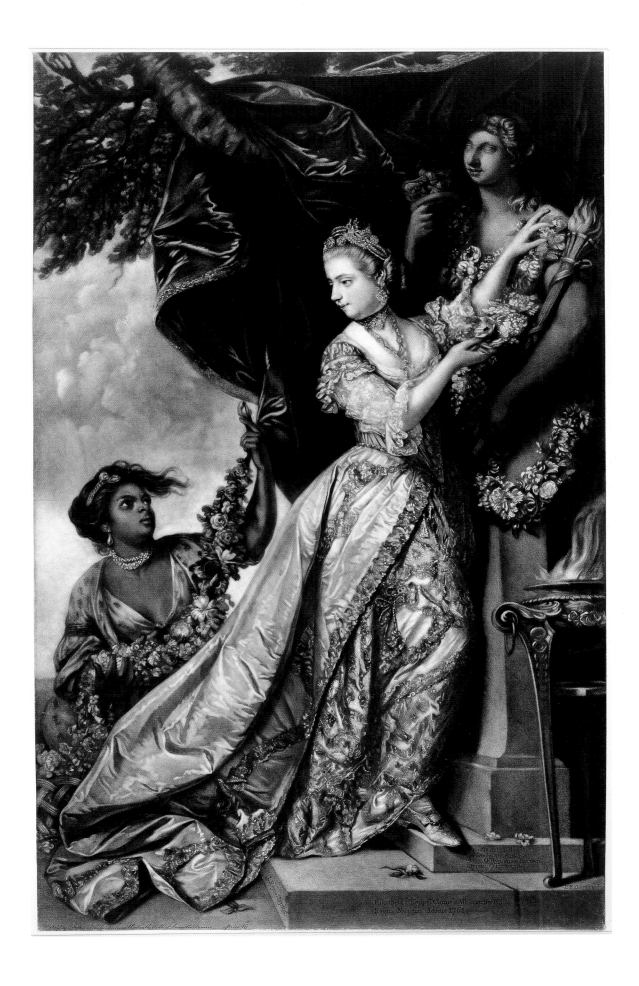

72. Edward Fisher (1722–82) after Joshua Reynolds

Garrick between Tragedy and Comedy 1762

Mezzotint, 40 x 50.2

The British Museum, London (1868-8-22-2099)

This important engraving, which is discussed in Tim
Clayton's essay (pp.51–3), was the first of a number of
prints to be made after Reynolds's portrait (cat.60) of the
celebrated actor, David Garrick (1717–79). Garrick was, by
the early 1760s, already a master of self-publicity, having
been the subject of many paintings and engravings since the
1740s. This, however, was the first portrait of Garrick by
Reynolds. Here, Reynolds sought to go beyond the standard
portrait depiction of Garrick 'in character' in order to
encapsulate the unique qualities that had caused him to effect
a revolution on the British stage, namely his naturalistic
acting style and the extraordinary versatility that allowed
him to take on comic and tragic roles with equal facility.

The impression shown here is a proof, printed before the
addition of lettering in order to ascertain the quality of the
engraving. In the final impression of the print the inscription
indicated that it was published by Fisher in collaboration
with the engraver, John Boydell, and the printsellers,
Elizabeth Bakewell and Henry Parker, who had premises
in Cornhill, in the City of London. Fisher's address is given
as 'the Golden Head', which was situated on the south side
of Leicester Square and only a stone's throw away from
Reynolds's house on the west of the square. As Sheila
O'Connell has observed, the print continued to be sold by
Boydell into the nineteenth century (O'Connell 2003, p.138),
underlining Garrick's enduring fame and, of course, the
excellence of Reynolds's image.

MP

Literature
Chaloner Smith 1883, vol.2, p.493, no.20; Hamilton 1884, p.29;
Lennox-Boyd, Shaw, Halliwell 1994, pp.107–8, no.46;
Mannings and Postle 2000, vol.1, pp.209–10; O'Connell 2003,
pp.137–8, no.3.8, repr.

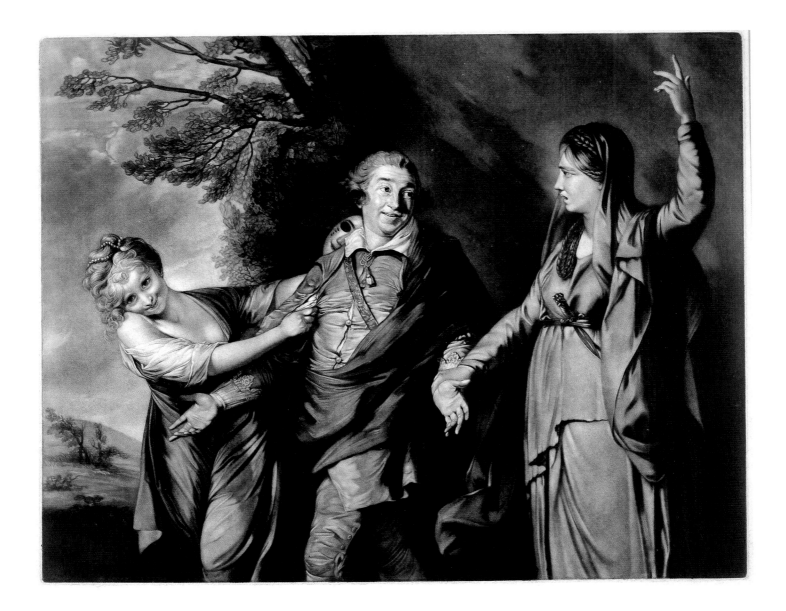

73. James Watson (1740–90) after Joshua Reynolds

*Lord Granby c.*1766–7

Mezzotint, 61 x 45.4

The British Museum, London (1902-10-11-6430)

The Marquess of Granby (1721–70) was one of the most successful commanders of the British Army during the height of the Seven Years War (1756–63). During this time he distinguished himself on the battlefield in the country's European campaign. Since the late 1750s Reynolds had been shaping Granby's public image through a series of striking martial portraits, which culminated in the great equestrian portrait (cat.15) begun in 1763 on Granby's heroic return to England. Here he is represented as Colonel-in-Chief of the Royal Horse Guards (known as the 'Blues'), attended by his black page and powerful charger. Granby's image was greatly in demand, and Reynolds, with studio assistance, painted three further versions of this composition; the last was completed in 1786, some fifteen years after Granby's death (see Mannings and Postle 2000, vol.1, pp.321–3). Granby's status as a totem of Britain's victory in the recent war inevitably generated interest in the production of an engraving of Reynolds's portrait. It was entrusted to the Irish printmaker, James Watson, one of the most skilled mezzotint engravers then working in London.

The importance of Watson's print, and indeed Granby's status as a national hero, is reflected by the lavish inscription appended to the final version of the published print: 'The Right Honble John Manners, Marquis of Granby, One of his Majesties most Honourable Privy Council, Colonel of his Majesties Royal Regiment of Horse Guards, Commander in Chief of his Majesties Forces, and Master General of the Ordnance &c &c.' Granby's fame, and the honours heaped upon him, generated extraordinary patriotic fervour, recalled today in the number of public houses that still bear his name. Unfortunately, Granby's various public offices also had the adverse effect of embroiling him in controversy. This ultimately caused him to resign all his political appointments and retire to the seaside town of Scarborough, where he died in the autumn of 1770.

MP

Literature
Chaloner Smith 1883, vol.4, pp.1510–11, no.64; Hamilton 1884, p.32; Mannings and Postle 2000, vol.1, p.322.

74. Edward Fisher (1722–82) after Joshua Reynolds

Hope Nursing Love 1771

Mezzotint, 50.3 x 35.5

The British Museum, London (1840-8-8-88)

Miss Morris (d.1769), who sat to Reynolds for the painting from which this print is made, endured a short and tragic career on the British stage. Reynolds's painting (1769; Bowood House, Wiltshire), and the print made from it, are the only record of her brief period of fame. Morris (her first name is unknown) was apparently the daughter of a governor in the West Indies, and when he died his widow and children returned to England in impoverished circumstances. Despite the objections of her family, who considered it beneath her station as a 'lady', Miss Morris was determined to become an actress. She was taken up by the playwright and producer George Colman, who may have been responsible for introducing her to Reynolds. In the autumn of 1768 Morris's family brought a court action against Colman. It was unsuccessful, and shortly afterwards, in November, she made her debut in *Romeo and Juliet*. After only a handful of performances she collapsed from nervous exhaustion (see Postle 1995, pp.38, 318–19). Early in 1769 Morris sat to Reynolds, presumably in the hope that the resulting painting would boost her career and her self-esteem. Yet one can imagine the painting having the opposite impact on perceptions of her within her family: for if they were already concerned about her taking to the stage, they may have been even more perplexed by her appearance in a painting, sensuously suckling an *amorino*.

Reynolds exhibited the painting at the Royal Academy in 1769 with the title *Hope Nursing Love*, a signal that this was to be received as a subject or 'fancy' picture rather than a portrait. The understanding, however, was that the audience would recognise the young woman in question. Sadly, however, she never recovered from her illness, and on 3 May 1769, barely a week after the exhibition opened, the *Public Advertiser* announced: 'Monday night died at Kensington Gravel Pits, where she went for the Recovery of her Health, Miss Morris, the young Lady who appeared this Season with so much Applause at Covent Garden Theatre.' By the time Fisher's print was first published in 1770, any association between Miss Morris and her mythological counterpart would have been almost entirely diminished, and the engraving's commercial appeal was reliant, instead, upon the work's allegorical subject.

Literature
Chaloner Smith 1883, vol.2, p.509, no.63; Hamilton 1884, p.121; Godfrey 1978, p.49, pl.47; Mannings and Postle 2000, vol.1, p.344.

MP

HOPE NURSING LOVE.

75. Thomas Watson (1750–81) after Joshua Reynolds
Miss Kennedy 1771
Mezzotint, 50 x 35.5
The British Museum, London (1840-3-14-177)

Polly Kennedy (d.?1781) was among the most celebrated
courtesans in London during the 1760s and 1770s. Even so, the
claim that she once commanded £2,000 for a single night of
pleasure is somewhat implausible (see Davis 1986, p.24, note).
During his London sojourn, the Italian adventurer, Casanova,
spent an hour with her. 'She became drunk', he recalled,
'and indulged in all sorts of wantonness'. Nevertheless, the
memory of his mistress, the courtesan 'La Charpillon', left him
'no appetite for possessing the charming Irish-woman' (Trask
1967–71, vol.9, p.308). Reynolds's portrait was painted some
years later, during a traumatic episode in Polly Kennedy's life,
when her two brothers were on trial for murder, and her own
position was undergoing intense public scrutiny.

Early in 1770 the Kennedy brothers killed a night
watchman in a drunken brawl, for which they were
sentenced to death. At the time Polly Kennedy enjoyed the
favours of various eminent public figures, including Lord
Spencer, Lord Palmerston and George Selwyn (cat.34).
With their intercession, the brothers' sentences were
eventually commuted to transportation, although their
supporters ultimately had to resort to bribery in order to
persuade the victim's widow to drop the case (see Leslie
and Taylor 1865, vol.1, pp.394–7). The trial, which became
a *cause célèbre*, was a victory for Polly Kennedy, although
not everyone rejoiced. The renowned commentator, Junius,
expressed indignation that the mercy 'of a chaste and pious
prince extended cheerfully to a wilful murderer, because that
murderer is the brother of a common prostitute' (Jesse
1843–4, vol.2, pp.386–7).

At the time Polly Kennedy was the mistress of Sir Charles
Bunbury, who commissioned her portrait from Reynolds.
Significantly, he reassured Bunbury that on completing the
face 'it has more grace and dignity than anything I have ever
done' (Ingamells and Edgcumbe 2000, p.34). Indeed, although
she wears a flamboyant Turkish-style dress, her expression is
serious, even mournful. Unusual among Reynolds's portraits
of courtesans, the picture was presumably intended to
highlight Miss Kennedy's current tribulations, and to evoke
sympathy for her situation. We can also be sure that the
renewed publicity that she had attracted by the end of the trial
encouraged the engraver, Thomas Watson, to believe that his
print would prove to be a good commercial proposition.

Literature
Chaloner Smith 1883, vol.4, pp.1558–9, no.22; Hamilton 1884,
p.113; Mannings and Postle 2000, vol.1, p.286.

MP

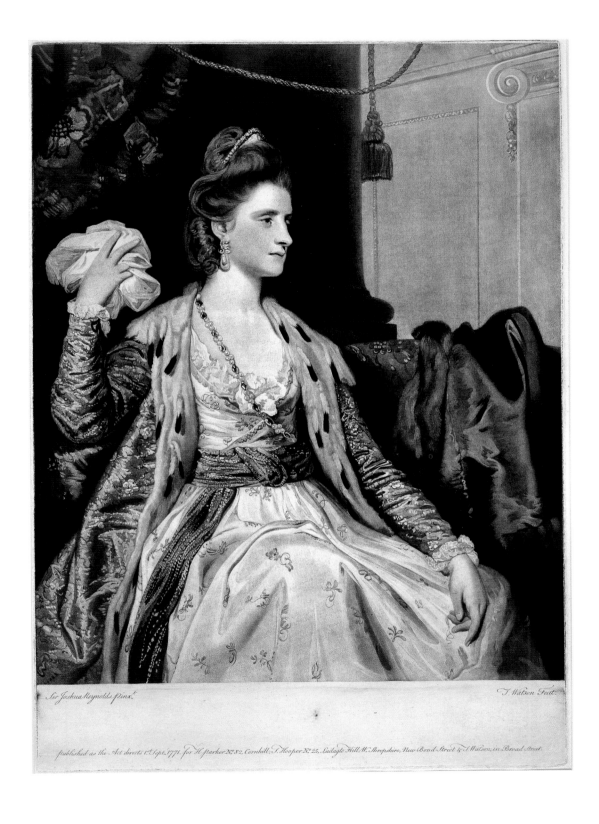

Sir Joshua Reynolds pinx.t T. Watson fect.

Published as the Act directs 1.st Sept. 1771. for H. Parker N.o 82. Cornhill, J. Hooper N.o 25. Ludgate Hill, M. Shropshire, New Bond Street & I. Watson, in Broad Street.

76. William Dickinson (1746–1823) after Joshua Reynolds

Joseph Banks 1774

Mezzotint, 50.1 x 35

The British Museum, London (1831-5-20-55)

 When Reynolds exhibited Banks's portrait at the Royal
Academy in 1773, his subject was already recognised as
the country's most intrepid botanist. From 1768 to 1771
Joseph Banks (1743–1820) had taken part in Captain
Cook's celebrated round-the-world expedition on board
the *Endeavour*, a feat reflected in the painting by the
prominence of the globe at his elbow and the Latin
inscription from the poet, Horace, on the letter, which reads
'*Cras Ingens iteramibus aequor*' (Tomorrow we will sail
the vast deep again). Yet, by the time Banks was sitting to
Reynolds for this portrait his travelling days were over, and
he was devoting his time and energy towards establishing his
career and public profile as a leader in the British scientific
community. In 1778 Banks was elected President of the
Royal Society, and in 1781 he received a knighthood. During
this time he also became a central figure in the capital's
social world. Inevitably, he gravitated towards Reynolds's
circle, gaining coveted membership of the Club. He was also
a close friend of Samuel Johnson, who even went so far as
to compose a Latin inscription for the collar of Banks's pet
goat (Balderston 1942, vol.1, p.213).
 William Dickinson, who made the engraving shown here,
was one of the leading exponents of mezzotint engraving.
He also worked increasingly as a print publisher, in
collaboration with Thomas Watson, who also engraved a
number of Reynolds's paintings. The engraving of Banks's
portrait was, for example, both engraved and published by
Dickinson, thus maximising the financial return upon the
printmaker's investment in promoting Banks's burgeoning
celebrity status.

 MP

Literature
Chaloner Smith 1883, vol.4, p.173, no.4; Hamilton 1884, p.4;
Mannings and Postle 2000, vol.1, p.72.

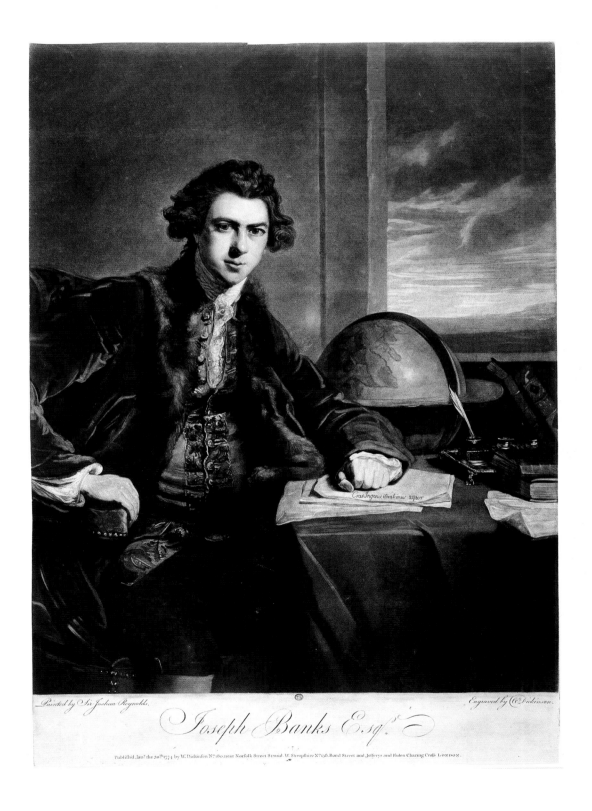

Painted by Sir Joshua Reynolds. Engraved by W. Dickinson.

Joseph Banks Esq.

Publish'd Jan.^y the 30th 1774 by W. Dickinson N.º 180, near Norfolk Street Strand, W. Shropshire N.º 158, Bond Street and Jefferys and Faden Charing Cross LONDON.

77. John Raphael Smith (1751–1812) after Joshua Reynolds

Mrs Montagu 1776

Mezzotint, 50 x 35.5

The British Museum, London (1902-10-11-5013)

The writer and critic, Elizabeth Montagu (1720–1800), was the most celebrated of London's so-called 'bluestockings', a loose-knit community of like-minded women who, at a time when a serious aspiration towards learning was still regarded as unladylike, held informal meetings to discuss the arts and literature. As well as Mrs Montagu, the capital's notable bluestockings included Mrs Hester Thrale (cat.49), Mrs Vesey, Fanny Burney and Hannah More. While they were regarded with thinly disguised contempt in some quarters (the term bluestocking was pejorative), their company was valued by more enlightened individuals, including those in Reynolds's intellectual circle, such as Samuel Johnson, Edmund Burke and Oliver Goldsmith (cats.47, 45 and 43). Johnson had a particularly high opinion of Mrs Montagu, who was, he stated, 'a very extraordinary woman; she has a constant stream of conversation, and it is always impregnated; it always has meaning' (Boswell 1934–50, vol.4, p.275). Nor were Mrs Montagu's gifts restricted to her intellectual abilities: she used her considerable wealth to good effect, helping to alleviate the penury of fellow women writers, amongst other charitable causes.

Reynolds painted his portrait of Mrs Montagu in 1775 for her cousin, Richard Robinson, Archbishop of Armagh, who was himself a close friend of the artist. After she had sat twice to Reynolds, Mrs Montagu said of her portrait that 'all people think it very like tho there is a good deal of flattery in the likeness' (Mannings and Postle 2000, vol.1, p.337). Reynolds was evidently pleased too, and exhibited it the following year at the Royal Academy. At the same time, John Raphael Smith published his engraving of the picture, which he exhibited at the Society of Artists. The whereabouts of the original painting is not known.

MP

Literature
Chaloner Smith 1883, vol.3, pp.1285–6, no.112; Hamilton 1884, p.120; Frankau 1902, p.246; Hind 1911, pl.34; Clifford, Griffiths, Royalton-Kisch 1978, p.51, no.141; D'Oench 1999, p.197, no.71; Mannings and Postle 2000, vol.1, p.337.

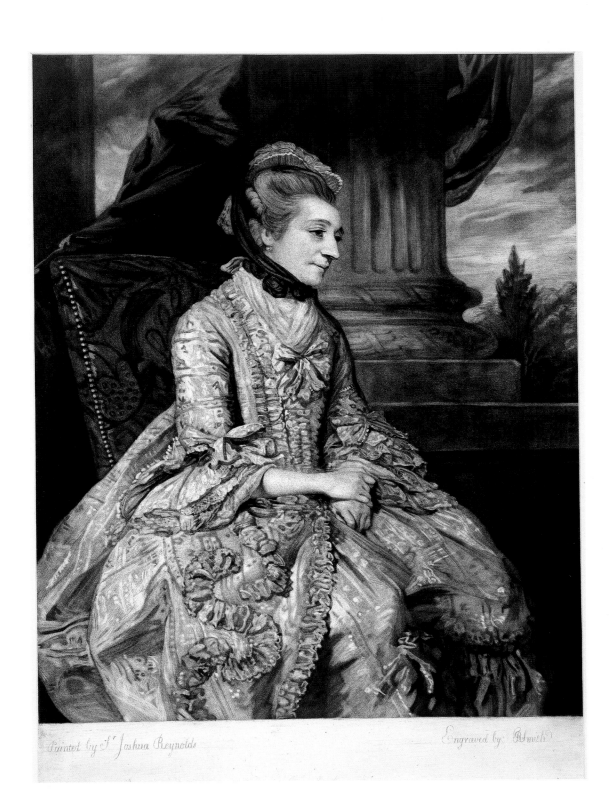

Painted by Sʳ Joshua Reynolds Engraved by Smith

78. William Dickinson (1746–1823) after Joshua Reynolds

Mrs Sheridan as Saint Cecilia 1776

Mezzotint, 49.8 x 35.1

The British Museum, London (1868-8-22-2127)

Elizabeth Sheridan (*née* Linley; 1754–92), a beautiful and talented singer, came from a family of musicians based in Bath, where she had regularly performed concerts since childhood. By the time she was a teenager Elizabeth Linley was 'already a celebrity' (Kelly 1998, p.29). In 1772, aged seventeen, she fled to France with the burgeoning playwright Richard Brinsley Sheridan, in order to avoid the advances of an unwelcome suitor. She married Sheridan the following year. At this point, she agreed to her husband's mandate that she should no longer sing in public. Nonetheless, Reynolds assumed that she would perform privately in his house. Having ordered in a new piano especially for the occasion, he was displeased when Sheridan forbade it: 'What reason could they think I had for inviting them to dinner, unless it was to hear her sing? – for she cannot talk' (quoted in Kelly 1998, p.56).

In 1775, presumably having recovered from this snub, Reynolds painted Mrs Sheridan as Saint Cecilia, the patron saint of music (see also cat.70). She was also probably the model for a subject picture of Saint Cecilia, which he painted the same year, as well as performing the role of the Virgin in his *Nativity* (see cat.6 and Mannings and Postle 2000, vol.1, pp.559 and 545–7). *Mrs Sheridan as Saint Cecilia* (Waddesdon Manor, The National Trust) was evidently painted of Reynolds's own volition, although he later acknowledged her husband's 'exclusive right to the Picture'. Eventually, in 1790, he sold the portrait to Sheridan, telling him that it 'is with great regret that I part with the best picture I ever painted' (Ingamells and Edgcumbe 2000, p.199). Sadly in 1815, Sheridan, encumbered with debts, was forced to relinquish it. 'I shall part from this picture', he said, 'as from Drops of my Heart's blood' (Ingamells and Edgcumbe 2000, p.199, n.2).

MP

Literature
Chaloner Smith 1883, vol.1, pp.196–7, no.74; Hamilton 1884, p.131; Penny 1986, pp.265–6, no.94, repr.; Mannings and Postle 2000, vol.1, pp.412–13.

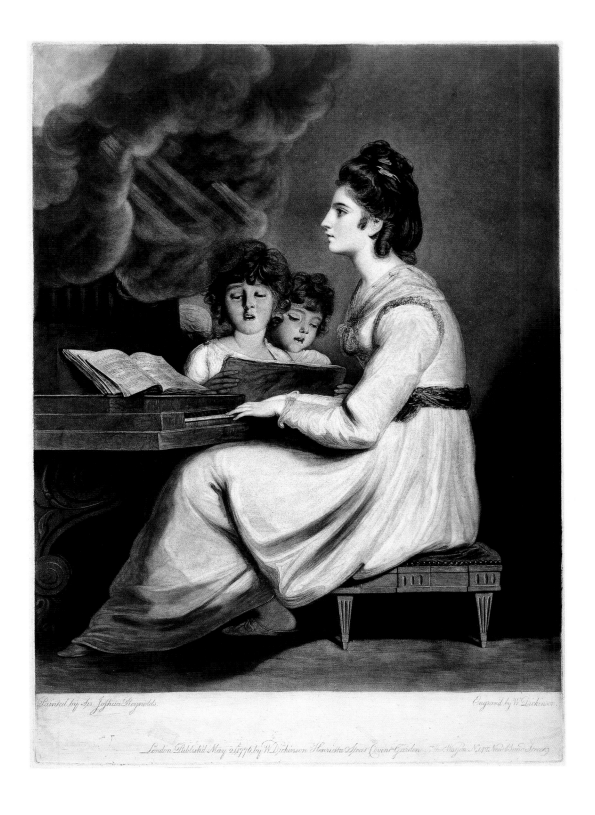

Painted by Sir Joshua Reynolds. Engrav'd by W.ᵐ Dickinson.

London Publish'd May 2ᵗʰ 1776, by W. Dickinson Henrietta Street Covent Garden, The Majors N.o 142 New Bond Street.

79. Valentine Green (1739–1813) after Joshua Reynolds

The Duchess of Devonshire 1780

Mezzotint, 58 x 36

The British Museum, London (1978 u 1899)

Reynolds's original portrait of the Duchess of Devonshire (1757–1806), upon which this print is based, was shown at the Royal Academy in 1776 (fig.15). By this time Reynolds was in the habit of exhibiting one or two full-length portraits of beautiful, aristocratic women in sylvan landscapes each year. Georgiana Cavendish, who had married the 5th Duke of Devonshire two years earlier, was admired as 'The Beautiful Duchess'. Her beauty was regarded as radiating through her vibrant personality as much as being a product of her looks. In the mid-1770s her extravagant clothes and extraordinary headdresses brought her to the public's attention, and attracted admiration and ridicule in equal measure. Over the next ten years the Duchess was also to establish herself as a leading light in London's political life, notably through her association with the Prince of Wales, and the Whig politician, Charles James Fox (see cat.41).

Valentine Green, who made the print displayed here, was among the country's foremost printmakers. In 1773 he was appointed Mezzotint Engraver to the King. Although he worked with a number of the country's most prominent artists, notably Benjamin West, Green's reputation rested principally on the series of engravings he made from Reynolds's full-length female portraits. Influenced by the example of John Faber's prints after Sir Godfrey Kneller's 'Beauties at Hampton Court', made earlier in the century, Green brought together several of Reynolds's paintings, which he published with Reynolds's consent in a portfolio entitled 'Beauties of the Present Age'. As well as the image of the Duchess of Devonshire, it also included that of Lady Talbot (cat.26). These prints were greatly sought after in their own right. Even so, the right to reproduce, and the choice of engraver, remained the artist's prerogative. A few years later, when Green demanded as of right that he should engrave Reynolds's *Mrs Siddons as the Tragic Muse* (see cat.69), the artist rebuked him soundly and ensured that he was denied the commission (see Ingamells and Edgcumbe 2000, pp.118–20).

MP

Literature
Chaloner Smith 1883, vol.2, p.349, no.36; Hamilton 1884, p.96;
Whitman 1902, pp.87–8, no.102; Mannings and Postle 2000,
vol.1, p.124.

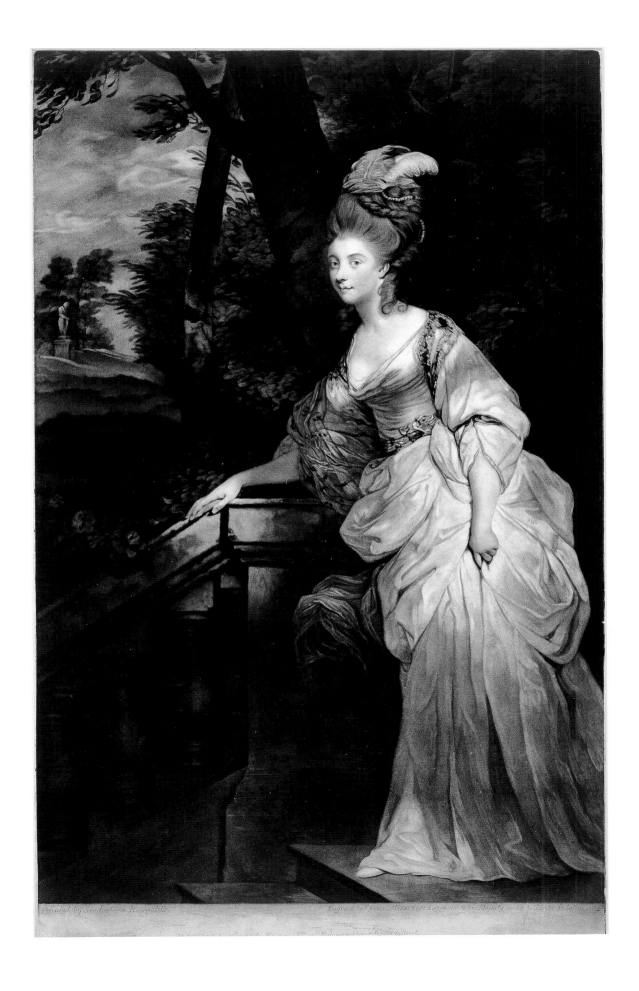

80. Johann (John) Jacobé (1733–97) after Joshua Reynolds

Omai 1780

Mezzotint, 62.6 x 38.2

The British Museum, London (1902-10-11-2807)

Omai (*c*.1753–?1779) returned to the South Seas with
Captain Cook in the summer of 1776. During his time in
London he had enjoyed celebrity status, although inevitably,
as the novelty wore off and he became more assimilated into
society, Omai also became something of a burden to his
patrons. Lacking any purpose, other than to amuse and
entertain his British hosts, Omai was glad to return home.
Yet after his departure, Omai, although lost from view, came
to epitomise the cult of the 'noble savage' celebrated in
poetry, literature and plays. Omai thus became a central
figure in an ongoing discourse regarding 'civilisation'
and 'nature', and over the controversial role of Pacific
exploration in exposing previously unknown cultures.
Inevitably, Reynolds's painting (cat.67), and the print made
from it, provided a visual focal point for such debates.

Johann (John) Jacobé was a Viennese engraver who came
to England in the late 1770s to learn the art of mezzotint,
probably under William Dickinson (see cats.76 and 78).
London's most ambitious and successful print publisher,
John Boydell, published the present impression of the print
in 1780. It was first published, however, by Jacobé himself
at 'Mrs Hedges, Henrietta Street, Covent Garden' in the
summer of 1777, the year after Reynolds had exhibited
Omai at the Royal Academy (see Hamilton 1884). Boydell,
conscious of the public's continuing fascination with Omai,
had evidently purchased the copper plate from Jacobé, who
apparently returned to his native Vienna at this time.

MP

Literature
Chaloner Smith 1883, vol.2, p.722, no.7; Hamilton 1884, p.53.

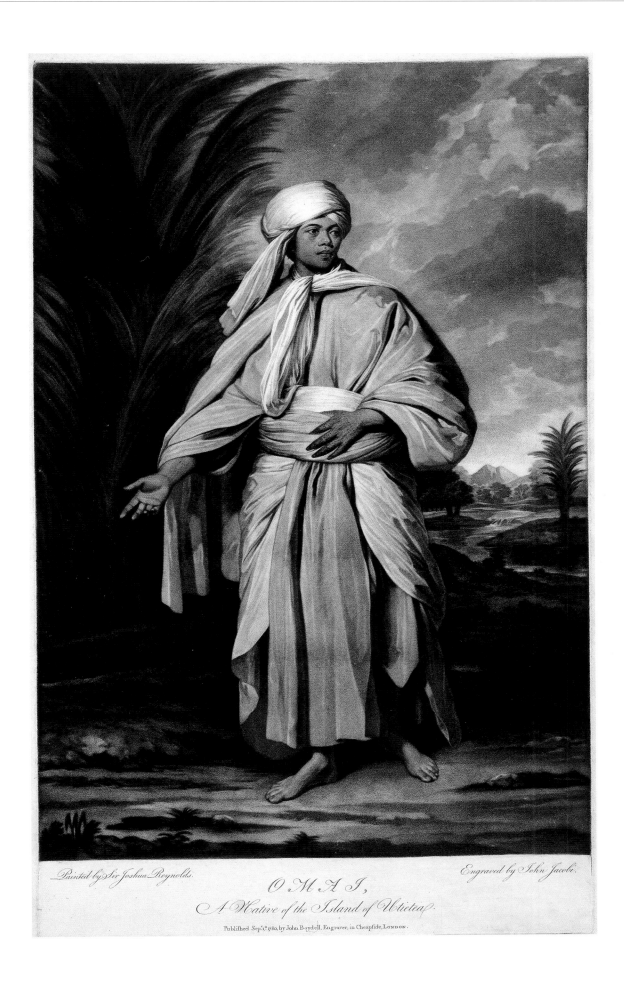

Painted by Sir Joshua Reynolds. Engraved by John Jacobi.

O M A I,

A Native of the Island of Utietea.

Published Sep.r 1.t 1780, by John Boydell, Engraver, in Cheapside, LONDON.

81. Valentine Green (1739–1813) after Joshua Reynolds

Joshua Reynolds 1780

Mezzotint, 47.8 x 37.2

The British Museum, London (1902-10-11-2356)

This magnificent print was the companion to Valentine Green's engraving after Reynolds's portrait of William Chambers (see cat.82). In his self-portrait Reynolds stands in the presence of a bust of Michelangelo. As Christopher Lloyd has observed, both the painting and the print took on an additional significance ten years later, when Reynolds gave his final Discourse at the Academy: he closed the lecture by saying 'I should desire that the last words which I should pronounce in this Academy, and from this place, might be the name of MICHEL ANGELO [*sic*]' (quoted in Lloyd 1994, p.86).

Reynolds painted some twenty-seven self-portraits in total. Surprisingly perhaps, only five of these were engraved during the artist's lifetime. For the most part, the engravings were strategically planned to coincide with his public achievements. The first print was made in 1770, shortly after Reynolds had been elected President of the Royal Academy. The second was an engraving after the portrait Reynolds presented to the Uffizi, Florence (cat.4), which was engraved in 1777. The third is the print shown here. A fourth was engraved in 1784 from an untraced portrait, and appears to be a variant of the Uffizi picture. Lastly, in 1789, a print of his self-portrait in spectacles (cat.7) was made by the female engraver Caroline Watson. It was a print that effectively marked the completion of his long and distinguished career. It was published, presciently, only months before the artist's diminishing eyesight compelled him to give up painting.

MP

Literature
Chaloner Smith 1883, vol.2, p.581, no.110; Hamilton 1884, pp.57–8; Whitman 1902, pp.90–1, no.105; Russell 1926, no.110; Penny 1986, pp.117–18, repr.; Lloyd 1994, p.86, fig.58; Mannings and Postle 2000, vol.1, p.51.

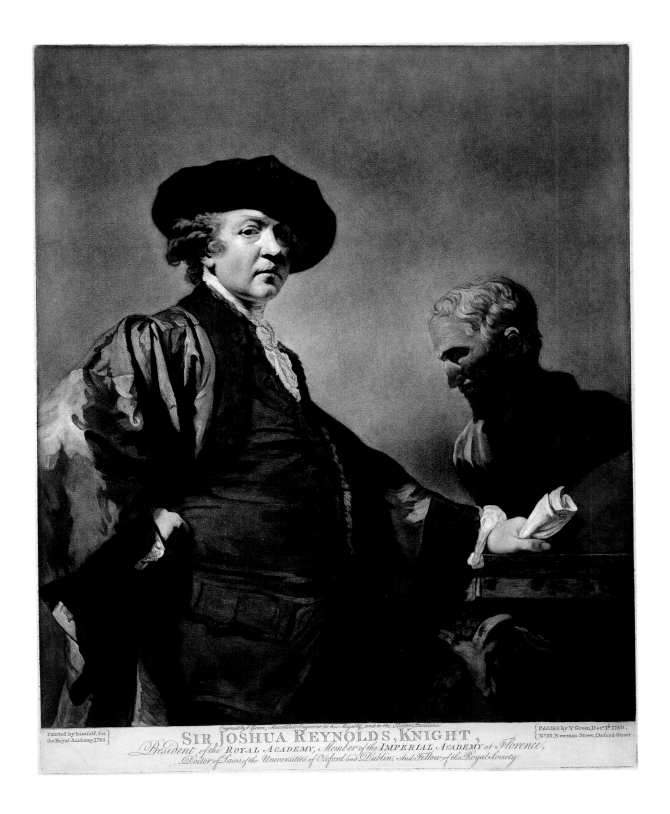

Engrav'd by V. Green, Mezzotinto Engraver to his Majesty, and to the Elector Palatine.

Painted by himself, for
the Royal Academy 1780.

Publish'd by V. Green, Dec.r 1.st 1780.
N.o 29, Newman Street, Oxford-Street.

SIR JOSHUA REYNOLDS, KNIGHT,
President of the ROYAL ACADEMY, *Member of the* IMPERIAL ACADEMY *at Florence,*
Doctor of Laws of the Universities of Oxford and Dublin, And Fellow of the Royal Society.

82. Valentine Green (1739–1813) after Joshua Reynolds

William Chambers 1780

Mezzotint, 48 x 37.8

The British Museum, London (1902-10-11-2277)

This portrait of the architect William Chambers (1723–96), painted when he was Treasurer of the Royal Academy, is the companion to Reynolds's self-portrait as President. Both paintings were published as mezzotint engravings by Valentine Green towards the end of 1780. This was the year in which the Royal Academy moved into new premises at Somerset House on the Strand. Designed by Chambers, it is shown here in the background of his portrait. Reynolds, who was an exact contemporary of Chambers, had known him for most of his adult life. Chambers had been employed by Reynolds to make improvements to his London home, as well as designing his villa in Richmond. Nevertheless, the two men were often at loggerheads, vying for supremacy within the Academy. Chambers also coveted Reynolds's presidency, which he felt ought rightfully to have been his, in acknowledgement of his key role in creating the institution.

Unlike Reynolds, Chambers had excellent connections at Court. He held influence with George III, having been appointed as his personal architectural tutor in 1757, and as Architect to the King on his accession to the throne. As Treasurer of the Royal Academy, Chambers was George III's ally within the organisation, the 'person in whom he places full confidence, in an office where his interest is concerned' (Hudson 1958, p.94). Chambers also counted among his enemies some of Reynolds's closest confidants, notably the poet and gardener, William Mason, who in 1773 had published an attack on Chambers's *Dissertation on Oriental Gardening,* entitled *An Heroic Epistle to Sir William Chambers.* That it was intended to satirise Chambers's theoretical writings only served to highlight the serious purpose of Reynolds's Discourses, which was unfortunate given both men's respective attempts to provide an intellectual basis for British art and architecture. It is not therefore surprising that Reynolds and Chambers subsequently grew ever more distant. Shortly after Reynolds's death in 1792, Chambers attempted to prevent the President's body from lying in state in the Royal Academy at Somerset House. For once, however, the King ruled in Reynolds's favour.

Literature
Chaloner Smith 1883, vol.2, pp.542–3, no.21; Hamilton 1884, p.16; Whitman 1902, pp.89–90, no.104; Lloyd 1994, p.83, no.56; Mannings and Postle 2000, vol.1, p.129.

MP

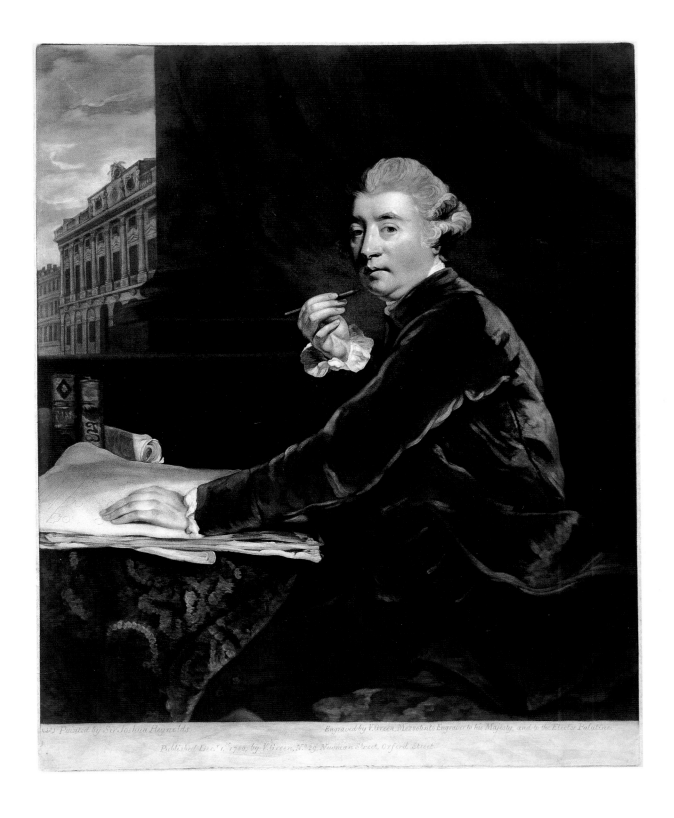

Painted by Sir Joshua Reynolds Engraved by V. Green, Mezzotint. Engraver to his Majesty, and to the Elector Palatine.

Published Dec.r 1, 1780, by V. Green, N.o 29 Newman Street, Oxford Street.

83. John Raphael Smith (1751–1812) after Joshua Reynolds

Banastre Tarleton 1782

Mezzotint, 63 x 39

The British Museum, London (1902-10-11-5056)

The life of Banastre Tarleton (1754–1833), 'Bloody Ban', is the stuff of legend: Horace Walpole remarked that 'Tarleton boasts of having butchered more men and lain with more women than anybody else in the army' (Lloyd 1994, p.73). To the British he was a brilliant soldier who fought valiantly in the Wars of Independence; to the American patriots he was a merciless martinet. Tarleton made his name as a soldier during the late 1770s, commanding the 'British Legion', a cavalry and light-infantry dragoon distinguished by their green jackets and devil-may-care mentality. He became known for his daring exploits in Carolina and Virginia, where he mounted hit-and-run attacks on the enemy with lightning speed. On his return to London early in 1782 he received a hero's welcome, and within two weeks he was in Reynolds's studio having his portrait painted (National Gallery, London).

Reynolds depicted Tarleton in the heat of battle, his pose derived from the celebrated classical statue, *Cincinnatus*, a cast of which belonged to the Royal Academy. The choice was apt, since in the eighteenth century the statue was thought to represent Lucius Quinctius Cincinnatus, a Roman patriot who had put down his ploughshare to engage in battle with the Sabines (Haskell and Penny 1981, p.184). Although Tarleton retired from active service in the 1780s, he made much of his former exploits, notably in his controversial memoir, *A History of the Campaigns of 1780 and 1781 in the southern provinces of North America*, published in 1787. By this time he was also conducting a stormy affair with the celebrated actress and writer, Mary Robinson, who paid tribute to him in her poem, 'Ode to Valour'. A close friend of the Prince of Wales, Tarleton allied himself socially and politically to the Foxite Whigs, finding himself on the losing side in peace, as in war.

MP

Literature
Chaloner Smith 1883, vol.3, pp.1305–6, no.161; Hamilton 1884, p.67; Frankau 1902, p.345; Clifford, Griffiths, Royalton-Kisch 1978, p.52, no.146; Alexander and Godfrey 1980, p.38, no.71; Penny 1986, p.300, no.129, repr.; Lloyd 1994, p.73, no.38; D'Oench 1999, pp.214–15, no.202, figs.44–5; Mannings and Postle 2000, vol.1, pp.439–40.

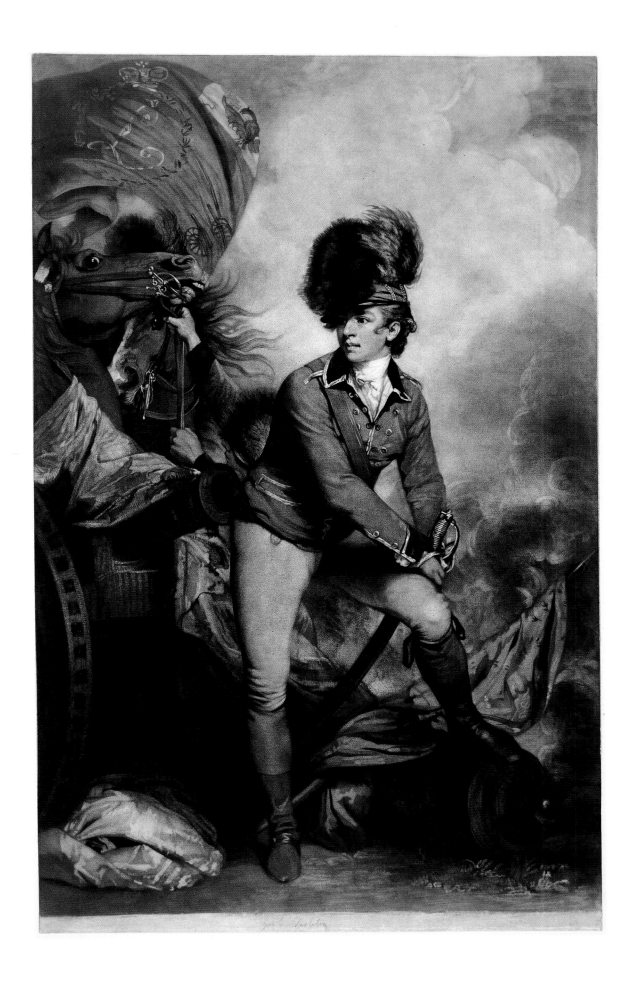

84. John Raphael Smith (1751–1812) after Joshua Reynolds

Louis Philippe Joseph, Duke of Orléans 1786

Mezzotint, 64.5 x 45

The British Museum, London (1902-10-11-5029)

In 1785 George, Prince of Wales, commissioned Reynolds
to paint a portrait of his intimate friend, the Duke of Orléans
(1747–93). As in the Prince's portrait (fig.5), Orléans
appears in the guise of a military hero on the field of battle.
In fact, he lived a life of self-indulgent luxury. The richest
man in France, and a thorough Anglophile, he was also
renowned for his liberal views and his debauched behaviour.
Although his conduct was vilified in conservative circles,
Orléans's deportment was admired by Reynolds, who
remarked that 'many men appeared graceful when in
motion, but that the Duke of Orléans was the only Man who
appeared so when *standing still*' (Farington 1978–84, vol.3,
p.1101). In 1786 Orléans was among the guests invited to
the Royal Academy's annual dinner, where he was seated
directly beneath his portrait by Reynolds.

After the exhibition the Prince of Wales placed the portrait
on display at his new home, Carlton House, which he had
designed under the Duke's guidance. There it remained until
1792 when it was removed from view, following the news
that Orléans had voted for the execution of the French King,
Louis XVI. As was reported at the time: 'The full length
picture of the Duke of Orleans which the Prince honoured
with a conspicuous place in his grand Saloon, has lately
been removed from thence to a back room; a very certain
sign that his Highness's ideas of Mob government, and in
short that his whole political conduct, is not approved at
Carlton House' (anonymous newspaper cutting, Whitley
Papers, The British Museum). The following year, Orléans,
now known as 'citizen Philippe Égalité', was executed
on the orders of the leaders of the French Republic,
despite attempts to ingratiate himself with the new
regime. In 1824 his portrait by Reynolds was wrecked
in a fire at Carlton House.

MP

Literature
Chaloner Smith 1883, vol.3, p.1292, no.125; Hamilton 1884,
p.54; Frankau 1902, p.261; Clifford, Griffiths, Royalton-Kisch
1978, pp.52–3, no.148; Galavics 1978, pp.323–33; Penny 1986,
p.309, no.137, repr.; D'Oench 1999, p.224, no.273, fig.109;
Mannings and Postle 2000, vol.1, p.311.

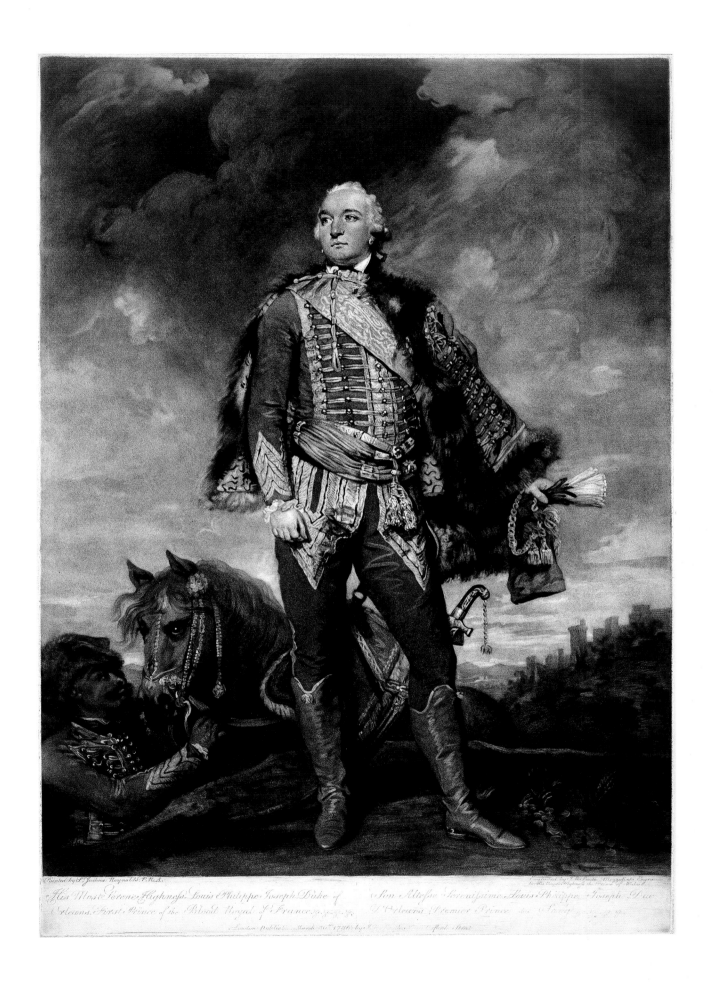

Painted by S.r Joshua Reynolds P.R.A.

His Most Serene Highness Louis Philippe Joseph Duke of
Orleans First Prince of the Blood Royal of France &c &c &c.

Son Altesse Serenissime Louis Philippe Joseph Duc
D'Orleans Premier Prince du Sang &c &c &c.

London Published March 20.th 1786 by J. R. Smith Oxford Street

85. James Ward (1769–1859) after Joshua Reynolds

Mrs Billington 1800

Mezzotint, 65.2 x 41.3

The British Museum, London (1981 u 631)

In 1789 Reynolds painted the actress and singer
Mrs Elizabeth Billington (1765 or 1768–1818; cat.70),
although James Ward's mezzotint was not published for
another eleven years. Often prints were made from
Reynolds's paintings immediately upon completion in order
to capitalise on the public interest in the sitter. And while
Reynolds exhibited the painting at the Royal Academy, the
engraver would show the corresponding print at the Society
of Artists, the premier exhibition venue for printmakers.
Sometimes, however, there was a time lag between the
production of the painting and the print: in the present
instance it can, perhaps, be explained by the trajectory
of Mrs Billington's subsequent career.

During the early 1790s, interest in Mrs Billington's private
life had intensified following the publication of a scurrilous
memoir. Whether by design or coincidence, she left England
for mainland Europe in 1794, and spent several years
singing in Italy. There she proved popular, and following
the death of James Billington, she also acquired a new
husband. Unfortunately, he turned out to be violent, and
Mrs Billington fled to England in 1801 to escape him.
He pursued her, but was arrested and deported (Highfill,
Burnim, Langhans 1973–, vol.2, p.126). As a result, the
gossip surrounding her circumstances and her celebrity
status were greater than ever. By the 1802 to 1803
season she was commanding stratospheric fees for her
performances, singing at both Covent Garden and Drury
Lane, as well as being *prima donna* at London's Italian
Opera. Although she had commissioned her portrait from
Reynolds, she parted with it, perhaps on her departure for
Italy. When Ward engraved it in 1800, it belonged to the
dealer, Michael Bryan, who presumably viewed the
engraving as a means of promoting the picture in his
possession, as well as capitalising on the public's enduring
fascination with the art and the antics of Mrs Billington.

MP

Literature
Chaloner Smith 1883, vol.4, p.1441, no.5; Hamilton 1884, p.83;
Mannings and Postle 2000, vol.1, p.88.

86. Richard Earlom (1743–1822) after Johan Zoffany (1733–1810)

The Academicians of the Royal Academy 1773

Mezzotint, 50.8 x 71.8

The British Museum, London (1848-7-8-203)

Zoffany's group portrait of the assembled Academicians
of the Royal Academy was exhibited in 1772, and replicated
the following year in Richard Earlom's masterly mezzotint
engraving. Although Horace Walpole maintained that
Zoffany had no overall design for the painting, 'but clapped
in the artists as they came to him', the composition
is carefully crafted to underline the hierarchy of the
newly formed institution as well as to promote its aims
(see Bignamini and Postle 1991, p.42). The picture is set
in the Life Room of the Academy, at the time situated in a
disused royal apartment in Somerset House on the Strand.
Reynolds stands to the left of centre, holding his silver ear
trumpet and conversing with the Academy's Treasurer,
William Chambers, who is immediately to his right. To the
left of Reynolds stands William Hunter, Professor of
Anatomy at the Royal Academy, seen stroking his chin
while he contemplates the models. Zoffany sits at the
extreme left of the picture, brush and palette in hand.

The Royal Academy, founded in 1768 under the
patronage of George III, was, according to its Instrument
of Foundation, to consist of no more than forty members;
Zoffany's painting contains thirty-five artists. The
Academy's two female members, Angelica Kauffman and
Mary Moser, are represented only by head-and-shoulders
portraits hanging on the wall to the right; their physical
presence in the room would have been prevented by the two
nude male models. There are some other notable absences,
particularly Reynolds's great rival in portraiture, Thomas
Gainsborough, who was in Bath at the time. Zoffany did,
however, manage to paint a study of his face for the present
portrait (*c.*1772; Tate). His omission was presumably
dictated by the fact that Gainsborough was already
threatening to boycott the institution.

MP

Literature
Chaloner Smith 1883, vol.1, pp.243–4, no.1.

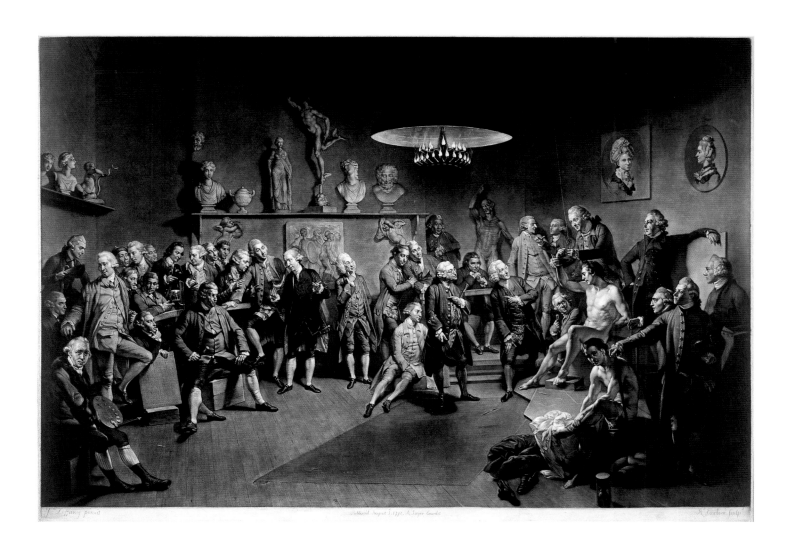

87. Pietro Antonio Martini (1739–97) after Johann Heinrich Ramberg (1763–1840)

The Exhibition of the Royal Academy 1787 1787

Coloured engraving, 37.9 x 52.8

The British Museum, London (1871-12-9-591)

In Martini's print, George, Prince of Wales, and Reynolds hold centre stage in the Great Room at Somerset House, the venue for the annual Royal Academy exhibition from 1780 to 1836. They stand shoulder to shoulder, directly below Reynolds's controversial full-length portrait of the Prince (cat.31). For nearly twenty years the Royal Academy exhibition had been the focal point of Reynolds's public art, with the exhibition portrait being a key constituent of celebrity (see Mark Hallett's catalogue essay pp.35–47). In 1787 Reynolds showed thirteen pictures, three of which are also in the present exhibition: *A Child's Portrait in Different Views: 'Angels' Heads'* (cat.64), *James Boswell* (cat.38), and the aforementioned portrait of the Prince. In this print *Angels' Heads* can be glimpsed to the left on the bottom row of pictures, near the door, while *Boswell* is also on the bottom row, on the back wall at the extreme right. The Greek inscription on the print is that which appears above the entrance to the Great Room, and translates literally as 'Let no one without the Muses enter'.

During the 1780s Reynolds had steadily become closer to the Prince, notably through his allegiance to Charles James Fox (cat.41) and the Rockingham Whigs. Although the King remained the patron of the Royal Academy, Reynolds assiduously courted the Prince and his cronies, inviting them as guests of honour to the annual Academy dinner. The Prince, in turn, dispensed his patronage to Reynolds, commissioning portraits of friends, including the Duke of Orléans (see cat.84), and the naval heroes, Keppel and Rodney (see Mannings and Postle 2000, vol.1, nos.1049 and 1545). In 1788 Martini made another engraving of that year's exhibition. This time, George III and Queen Charlotte stood in the centre. Reynolds, whom the King disliked intensely, was positioned a safe distance away to the right.

MP

Literature
Shanes 1981, p.12, fig.8; Hutchison 1986, p.49, fig.18; Solkin 2001, pp.17, 24–5, figs.36, 165, 208.

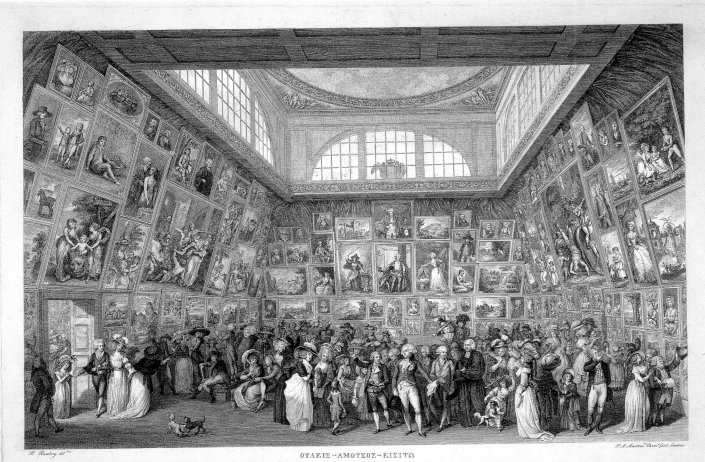

ΟΤΔΕΙΣ ∞ΑΜΟΤΣΟΣ ∞ΕΙΣΙΤΩ

THE EXHIBITION OF THE ROYAL ACADEMY, 1787.

Publish'd as the Act directs July 1.1787. by A.C. De Poggi, N.º 7 S.ᵗ Georges Row, Hyde Park.

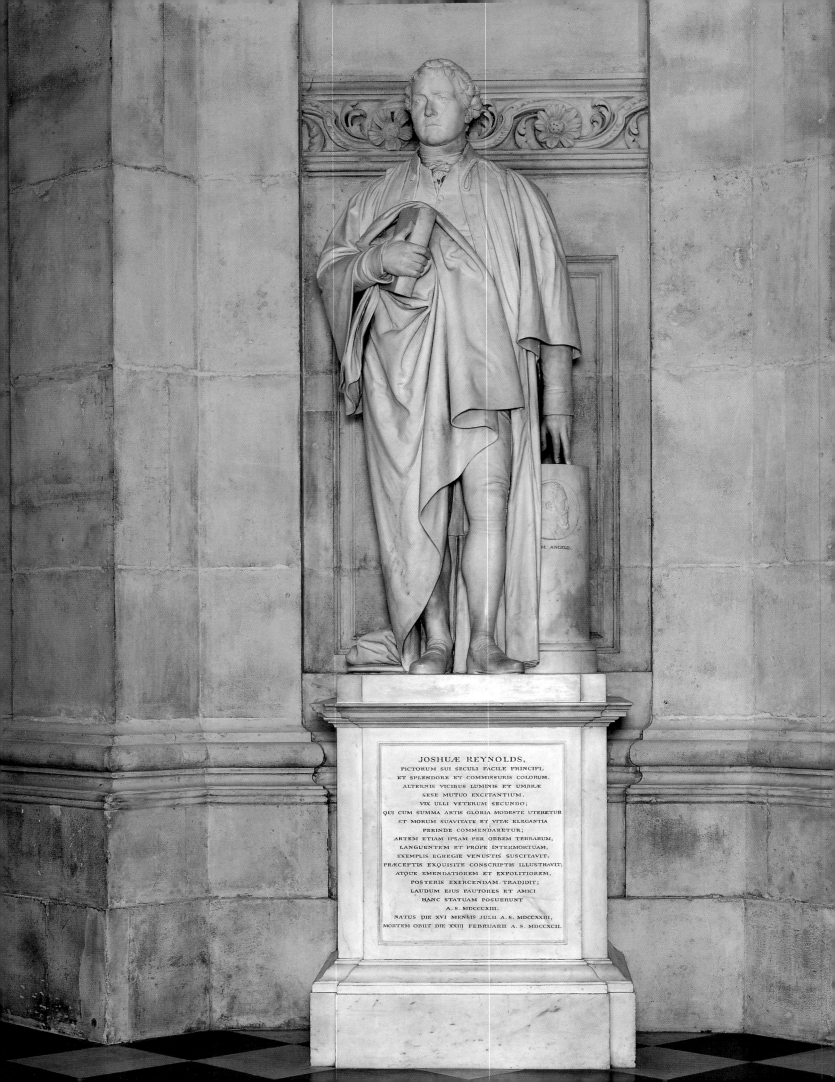

JOSHUÆ REYNOLDS,
PICTORUM SUI SECULI FACILE PRINCIPI,
ET SPLENDORE ET COMMISSURIS COLORUM.
ALTERNIS VICIBUS LUMINIS ET UMBRÆ
SESE MUTUO EXCITANTIUM.
VIX ULLI VETERUM SECUNDO;
QUI CUM SUMMA ARTIS GLORIA MODESTE UTERETUR
ET MORUM SUAVITATE ET VITÆ ELEGANTIA
PERINDE COMMENDARETUR;
ARTEM ETIAM IPSAM PER ORBEM TERRARUM,
LANGUENTEM ET PROPE INTERMORTUAM,
EXEMPLIS EGREGIE VENUSTIS SUSCITAVIT.
PRÆCEPTIS EXQUISITE CONSCRIPTIS ILLUSTRAVIT;
ATQUE EMENDATIOREM ET EXPOLITIOREM,
POSTERIS EXERCENDAM TRADIDIT;
LAUDUM EIUS FAUTORES ET AMICI
HANC STATUAM POSUERUNT
A. S. MDCCCXIII.
NATUS DIE XVI MENSIS JULII A. S. MDCCXXIII,
MORTEM OBIIT DIE XXIII FEBRUARII A. S. MDCCXCII.

Reynolds and the Sculpted Image

'Working in stone is a very serious business'
(Joshua Reynolds, tenth Discourse on Art, 1780)

The medium of sculpture commanded Reynolds's
respect. As Reynolds articulated in his Discourses on Art,
sculpture was above all the way in which the artistic
achievements of the classical world, such as the *Apollo
Belvedere* and the *Venus de' Medici*, had been transmitted
to posterity. In portraiture, likewise, sculpture's role was
to perpetuate solemnly the memory of the famous and
to celebrate their achievements. In 1780, the year that
he delivered a lecture on sculpture to the Royal Academy,
Reynolds completed a self-portrait (cat.5) in which he
stood next to a sculpted bust of Michelangelo. By this
time, the contemporary Italian sculptor Giuseppe Ceracchi
had modelled a bust of Reynolds, which also belonged to
the Royal Academy (cat.88).

While Reynolds painted portraits of his friends during
their lifetime, he was equally concerned that they should
be remembered after their death through sculpted images.
He was instrumental in raising a subscription for a
monument to Oliver Goldsmith in Westminster Abbey,
and campaigned vigorously to install a statue of Samuel
Johnson in St Paul's Cathedral. After his own death,
Reynolds's acolytes, acknowledging the importance that
he had attached to commemorative sculpture, ensured that
his statue was erected in St Paul's (fig.36), alongside
that of Samuel Johnson. It is not surprising therefore
that more sculpted images of Reynolds exist than of any
other British artist. Works by Reynolds's contemporaries
include John Flaxman's medallion for Josiah Wedgwood,
as well as busts by Thomas Banks and John Bacon
(both untraced).

During the nineteenth century, as Reynolds's reputation
as the founder of the British School began to be
unquestioningly accepted, sculptures were commissioned
of the artist's image by enthusiastic Victorians, eager to
vindicate the nation's cultural heritage. Works included
John Henry Foley's large marble statue, now belonging to
Tate (cat.90), Edward Stephens's monument on the façade
of the Royal Academy at Burlington House, and Henry
Weekes's bust, which still lodges forlornly in a corner
of Leicester Square, irredeemably damaged by inept
conservation. In the early twentieth century, the Royal
Academy requested a new statue of Reynolds by one
of its members, Alfred Drury. Commissioned in 1917,
the final model was finally approved twelve years later.
Eventually in 1931, the statue, cast in bronze, was
erected in the courtyard of Burlington House, where
it stands today.

MP

Fig.36
John Flaxman
Sir Joshua Reynolds PRA by 1813
Marble, height 235
St Paul's Cathedral, London

88. Giuseppe Ceracchi (1751–1801)

Bust of Joshua Reynolds ?c.1778–9

Marble, height 69.2

Inscribed: 'Cirachi Sculpsit. Roma'

Royal Academy of Arts, London

In his bust of Reynolds, probably made in the late 1770s, Ceracchi presents the artist in the guise of a heroic classical figure. Nicholas Penny has noted that the bust is modelled upon antique busts of Caracalla – 'except that martial ferocity has been converted into the inquisitive alertness characteristic of the slightly deaf' (Penny 1986, p.342). The bust is a tribute to Reynolds's status as a 'philosopher'; an intellectual who thinks about, as well as practises, art. It was apparently among Ceracchi's most popular pieces, and plaster replicas were 'sold by the figure-casters' (Smith 1828, vol.2, p.119, quoted in Penny 1986, p.342). Ceracchi's original terracotta model apparently belonged to the Royal Academy, although its present whereabouts is unknown. The version exhibited here was perhaps the original marble bust, which may have belonged to Reynolds.

The classical format adopted by Ceracchi, notably the neat tight curls of hair, and the toga, conform to Reynolds's own views on sculpture, as expressed in his tenth Discourse, which he delivered at the Royal Academy in 1780. Here he rejected the naturalism of sculptors of the previous generation, such as Louis-François Roubiliac, Michael Rysbrack and Peter Scheemakers, with their penchant for contemporary costume and lifelike detail. Instead, he preferred the modern exponents of classicism, including Joseph Wilton, Joseph Nollekens, and the Italians, Agostino Carlini and Giuseppe Ceracchi, all of whom were then engaged in carving designs on the facade of the new headquarters of the Royal Academy at Somerset House.

Giuseppe Ceracchi came to England from Rome in 1773, to work for Carlini, as well as for the Scots architect, Robert Adam. He specialised in making busts of celebrated public figures, including Reynolds's friends, Augustus Keppel and the Marquess of Granby (1777 and 1778; both Duke of Rutland, Belvoir Castle). Following his departure for America in 1791 he sculpted busts of Thomas Jefferson, Benjamin Franklin and George Washington. In Paris, where he settled in the mid-1790s, he made a bust of Napoleon Bonaparte. However, he was later implicated in a plot to murder Napoleon and executed. According to a contemporary account, Ceracchi travelled to the scaffold in a 'triumphal chariot' of his own design (cited in Gunnis 1951, p.89).

Provenance
Possibly 'A fine original bust of Sir Joshua Reynolds in statuary, and wooden terminal pedestal to ditto', sold by the estate of Reynolds's niece, Lady Thomond, Christie's 19 May 1821 (76), bought by G. Watson Taylor; presented to the Royal Academy in 1851 by Henry Labouchère, afterwards Lord Taunton.

Literature
Smith 1828, vol.2, pp.119–21; Gunnis 1951, pp.89–90; Penny 1986, p.342, no.172.

MP

89 John Flaxman (1755–1826)

Model of Statue of Joshua Reynolds for St Paul's Cathedral 1807

Plaster, height 121.9

Sir John Soane's Museum, London

On 29 February 1792, a week after Reynolds's death, the *Public Advertiser* published the suggestion that a monument should be erected to the artist's memory in St Paul's Cathedral, where he was shortly to be buried. According to his niece, the idea had originated with Reynolds himself, who, during his final illness, had insisted that it should be placed in St Paul's, where he himself had successfully campaigned to install a statue of Samuel Johnson (Farington 1978–84, vol.6, pp.2066–7). Johnson's statue stood in one corner of the crossing under the dome. In the other corners were monuments to the penal reformer, John Howard, and to the judge, Sir William Jones. All three statues were by the sculptor, John Bacon. Reynolds's monument eventually occupied the fourth spot, although the business was to be dogged by controversy and disagreement.

Funds for the monument were raised through subscription and from profits donated by Reynolds's friend, Edmond Malone, from the sale of his book on the artist's life and works, first published in 1798. Reynolds's niece, Lady Thomond, approached Joseph Nollekens to create the sculpture, but when he declined she chose his fellow Royal Academician, John Flaxman. Lady Thomond specified that the statue should be full-length and that 'the gown of a Doctor of Civil Law might be introduced' (Farington 1978–84, vol.6, p.2068). Flaxman made a small model, which he completed by early 1805. Lady Thomond, having inspected it, recommended various alterations, notably 'that one hand should be on a pedestal on which should be a bust or profile of Michael Angelo, & in the other His own *discourses*' (Farington 1978–84, vol.7, p.2506). These changes were accordingly carried out, including the relief sculpture of the head of Michelangelo on the pedestal. A larger half-size model, shown here, was made by Flaxman in the spring of 1807, and exhibited that year at the Royal Academy.

After a great deal of acrimony, sufficient funds to complete the monument were raised through donations from Reynolds's friends, acolytes, and members of the Literary Club. The Royal Academy, which had also been approached, was forbidden by the King to contribute, instructing the Academicians to record in their minutes 'That His Majesty wd. not suffer the money of the Academy to be squandered for purposes of vain parade and Ostentation' (Farington

1978–84, vol.7, p.2581). In 1813 Flaxman's marble statue was finally installed in St Paul's. The same year, the British Institution mounted a large retrospective exhibition of Reynolds's art. The guest of honour at the opening banquet was the Prince Regent. As Joseph Farington recorded in his diary on 8 May 1813, the Prince came from the exhibition at a quarter to seven in the evening and 'took his seat as President in a gilt Chair, having Flaxman's Model of Sir Joshua Reynolds placed behind him' (Farington 1978–84, vol.12, p.4344). John Soane, who was later to acquire the model, was also present at the dinner. Soane was a great admirer of Reynolds, from whom he had received his Gold Medal for Architecture at the Royal Academy in 1778. In addition to the statue of Reynolds, Soane also owned a version of his celebrated subject painting, *A Nymph and Cupid*, which still hangs where he originally placed it, in the Dining Room of his house at 13 Lincoln's Inn Fields.

MP

Provenance
Purchased by Sir John Soane, 1843–5 from Miss Maria Denman.

Literature
Irwin 1979, pp.167, 183, 185–6, fig.253; Dorey 2003, p.290.

90. John Henry Foley (1818–74)

Joshua Reynolds by 1874

Marble, 203.2 x 78.7 x 66

Tate. Bequeathed by Henry Vaughan 1900

This large marble statue of Reynolds was bequeathed to the Tate Gallery, then part of the National Gallery, by Henry Vaughan (1809–99), a major Victorian art collector and among the most generous benefactors to Britain's museums. The son of a Southwark hat manufacturer, Vaughan inherited a large fortune in his later teenage years, which he spent on travel and acquiring works of art. Vaughan had wide-ranging tastes, which included Old Master drawings and nineteenth-century watercolours, etchings and oil paintings. He had a particular interest in the British School, and owned works by Reynolds, Gainsborough, Flaxman, Constable and Turner. Vaughan's collection was housed at 28 Cumberland Terrace, Regent's Park, London, although he also purchased works specifically for public institutions, including Constable's *Hay Wain* of 1821, which he donated anonymously to the National Gallery in 1866. Vaughan also signalled his devotion to the major artists of the British School through the commissioning of historic statues by contemporary sculptors. They included the present statue of Reynolds by Foley, John Flaxman by Henry Weekes, and Thomas Gainsborough by Thomas Brock, the last commissioned in 1906 for the Tate Gallery under the terms of Vaughan's will. Although the statues of Flaxman and Reynolds must have been originally displayed in Vaughan's own collection, his bequest of these works to the Tate Gallery, together with the posthumous commission of the statue of Gainsborough, confirms that they were intended to be seen in a public space.

Although we do not know precisely when he created the present work, John Henry Foley was an appropriate choice for this commission, since by the mid-nineteenth century he was among Britain's leading makers of public statuary. Born in Dublin, he had trained as a sculptor at the Royal Academy Schools, London, in the mid-1830s. During the following decade he was engaged on a series of historic statues for the Palace of Westminster, while in the 1860s he was chosen to make the statue of Prince Albert for the Prince Consort National Memorial, now known as the Albert Memorial, in Hyde Park. In his native Dublin he was responsible for the monument to Daniel O'Connell (1864–82), and the bronze statues of Oliver Goldsmith (1864) and Edmund Burke (1868) in front of Trinity College. Burke's face was apparently modelled from Reynolds's portrait (cat.45), while the face of Reynolds on the present statue bears a resemblance to the self-portrait Reynolds had painted for Henry Thrale (cat.46), both in terms of the subject's age and his expression.

MP

Provenance
Bequeathed to the Tate Gallery by Henry Vaughan 1900.

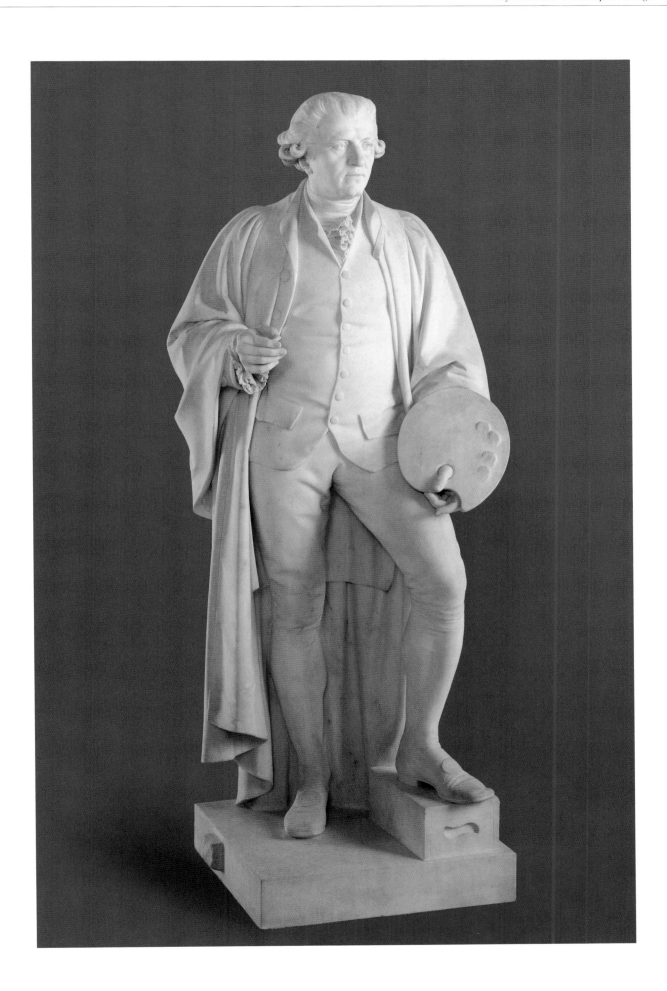

The Life and Art of Joshua Reynolds

Martin Postle

Joshua Reynolds was born on 16 July 1723 in Plympton, Devon, where his father, a clergyman, was employed as schoolmaster. Reynolds's family had strong connections with the Church, and with the local aristocracy. Although Reynolds's family had no artistic background, he was encouraged to draw and to paint from an early age: his earliest known oil painting is a head-and-shoulders portrait of the clergyman Thomas Smart (*c*.1735; Private Collection), made at the age of twelve. Under his father's tutelage Reynolds read widely, including works by classical authors, such as Plutarch, Seneca and Ovid, as well as those of Shakespeare, Milton and Pope. He also studied books on art, including the writings of Leonardo da Vinci, Charles Alphonse Du Fresnoy and André Félibien. However, the text that played the greatest role in shaping Reynolds's artistic ambitions was *An Essay on the Theory of Painting*, published in 1715 by the British painter, Jonathan Richardson.

Initially, it was expected that Reynolds would train under his father as an apothecary. However, in the spring of 1740 it was agreed that he should be apprenticed to the Devonian artist Thomas Hudson, whose portrait practice was based in London. Here Reynolds refined his painting technique. He also made drawings from casts of antique statuary. He drew from the living model, probably at the St Martin's Lane Academy, although, as he later admitted to his friend Edmond Malone, he was not as adept at figure drawing as he ought to have been. Indeed, the majority of his mature drawings take the form of rough compositional sketches for his portraits in pen and ink or oils. Reynolds did, however, at this time make copies of pen-and-ink drawings by the seventeenth-century

Baroque painter, Guercino. Hudson clearly admired Reynolds's drawings, for he kept a number of them in his own collection.

In the summer of 1743, Reynolds abruptly terminated his apprenticeship with Hudson, apparently over a minor disagreement. However, their quarrel was soon patched up and the pair remained on good terms, Hudson inviting him to join a club he had formed, which specialised in the appreciation and collection of Old Master drawings. For the next few years Reynolds, who was now practising independently as a portraitist, divided his time between London and Devon, where he made a living painting modest portraits of the local gentry and naval officers based at Plymouth Dock. He also painted a number of more ambitious portraits, including *The Eliot Family* (*c*.1746; Trustees of the St Germans Estate, Port Eliot, Cornwall), modelled upon Sir Anthony Van Dyck's great dynastic group portrait, *The Pembroke Family* (1634–6), which still hangs at Wilton House, and a three-quarter-length portrait of Captain John Hamilton (cat.8), in the manner of Titian. Reynolds's emulation of the Old Masters emerged strongly, too, in a portrait of his younger sister, Frances (*c*.1746; City Art Gallery, Plymouth), and his various self-portraits, which combined the rich tonal qualities of Rembrandt with the brio of the masters of the Italian Baroque.

By 1747 Reynolds had a modest 'painting room' in London on the west side of St Martin's Lane. The following year, a periodical included Reynolds's name in a list of fifty-seven 'Painters of our own nation now living, many of whom have distinguished themselves by their performances, and who are justly deemed eminent masters'. At the same time, the Corporation of Plympton

The Marlborough Family 1777–8 (detail of fig.39)
The Duke of Marlborough, Blenheim Palace

commissioned two portraits from Reynolds, including one of Commodore George Edgcumbe (*c*.1748; National Maritime Museum, Greenwich). It was through Edgcumbe that Reynolds met the Honourable Augustus Keppel, who in the late spring of 1749 offered Reynolds a passage to Italy on board his ship.

Reynolds travelled to Italy by way of Portugal, Spain and Minorca, where, because of a fall from a horse that left him with severe facial injuries, he was forced to recuperate. He did, however, earn money while there by painting portraits of soldiers in the British garrison. In January 1750 Reynolds left Minorca for Italy, arriving in Rome by Easter. According to current artistic practice, he began to copy works by the Old Masters, notably Guido Reni's *Saint Michael the Archangel* (*c*.1635) in the church of Santa Maria della Concezione, and Raphael's *School of Athens* (1509–11), of which he also made a parody, depicting contemporary Grand Tourists, painters and picture-dealers (fig.37). Reynolds also made sketches and detailed notes on pictures in notebooks (Department of Prints and Drawings, British Museum; Sir John Soane's Museum, London; Fogg Art Museum, Cambridge, Massachusetts; Metropolitan Museum, New York; Beinecke Library, Yale University; Private Collection, England). Collectively, they demonstrate his admiration for Italian artists of the late-sixteenth and seventeenth centuries, including Lodovico Carracci, Federico Barocci, Andrea Sacchi and Carlo Maratti.

After leaving Rome in the spring of 1752, Reynolds travelled to Naples and Florence, by way of Assisi, Perugia and Arezzo. In Florence he studied works in the Pitti Palace, including Raphael's *Madonna della Sedia* (*c*.1518) and Titian's *Mary Magdalen* (1535). From Florence, Reynolds travelled to Bologna and then north to Venice via Modena, Parma, Mantua and Ferrara. In Venice, he toured the city with the Italian painter Francesco Zuccarelli, analysing the techniques of the great Venetian colourists – Titian, Jacopo Tintoretto and Paolo Veronese. Reynolds began his journey home in the summer of 1752, accompanied by his young Italian pupil, Giuseppe Marchi, whom he had met in Rome. Following a brief sojourn in Paris, Reynolds arrived back in London in October 1752.

Immediately upon his return to England, Reynolds set about demonstrating the impact upon his art of his sojourn in Italy, notably in his exotic portrait of Marchi (cat.58) and his heroic portrait of Augustus Keppel (cat.9), in which the pose was inspired by classical statuary and the colour by the art of Tintoretto. At this time he also experimented with painting materials. Although Reynolds attained brilliant colour in his paintings, the instability of certain pigments (notably red lake, carmine and orpiment), together with the combination of waxes, oils and drying media he used, sometimes caused his works to fade prematurely and the paint surface to crack alarmingly. Even so, by the mid-1750s Reynolds's business was booming. Generally, his portrait practice was at its busiest from September until the following June, during which time he habitually worked a seven-day week. His professional engagements can be plotted precisely through his diaries or 'sitter books', most of which are now in the collection of the Royal Academy of Arts, London. As his workload increased Reynolds also began to employ the services of professional 'drapery painters' and pupils, who painted the costumes and other accessories in his portraits. And as he became more successful Reynolds raised his prices accordingly. In 1753 he was charging 48 guineas for a full-length portrait (equivalent to about £3,000 now), by the end of the decade he was able to command 100 guineas and by the mid-1760s the price had risen to 150 guineas. He was a prolific painter, capable of producing well over a hundred portraits a year. Among the most important works to have emerged at this time were his military portraits, notably *Robert Orme* (cat.11) and *John, 1st Earl Ligonier* (cat.14); portraits of intellectuals and aesthetes, including Samuel Johnson (fig.27) and Horace Walpole (cat.32); as well as aristocrats, such as the Duke of Cumberland (1758; The Devonshire Collection, Chatsworth, Derbyshire) and George III, Prince of Wales (fig.4). In addition to the paintings themselves, Reynolds's work was disseminated through engravings made from them by notable printmakers such as James McArdell, James Watson, John Raphael Smith and Valentine Green, as well as those made by his own pupils, Marchi and William Doughty. These engravings, which are beautiful works of art in their own right, did much to promote Reynolds's reputation, and were sold in England and on the Continent.

In 1760 Reynolds moved his house, painting room and picture gallery to Leicester Square, where he lived for the

fig.37
The Parody on the School of Athens 1751
Oil on canvas, 96.5 x 133.5
National Gallery of Ireland, Dublin

rest of his life. The same year he also took part in the first annual exhibition of the Society of Artists, held in London. Here, he exhibited five pictures including a full-length portrait of the celebrated society beauty, Elizabeth Hamilton, Duchess of Hamilton and Argyll (1758–9; fig.28). During this decade Reynolds exhibited regularly at this annual exhibition, including such major works as *Laurence Sterne* (cat.33); *Garrick between Tragedy and Comedy* (cat.60); *Nelly O'Brien* (see cat.52); *Lady Sarah Bunbury* (1762; Art Institute of Chicago); and *Mrs Hale as 'Euphrosyne'* (fig.38), which was based upon an engraving of Raphael's *Saint Margaret* of 1518.

During the early 1760s Reynolds, as well as exhibiting with the Society of Artists, was involved in directing its institutional affairs, which by the middle of the decade were subject to internecine rivalries between the ruling committee and the membership. This eventually resulted in the secession of the society's leading artists, who in

1768 reorganised themselves as the Royal Academy of Arts, under the patronage of King George III. In December 1768, after some hesitation, Reynolds agreed to accept the Presidency and on 21 April the following year, despite personal enmity between him and the King, he was knighted at St James's Palace. For the remainder of his life, the Royal Academy formed the main focal point of Reynolds's professional life as a painter, administrator, writer on art and figurehead of the burgeoning British School.

On his appointment as President, Reynolds took it upon himself to deliver an annual (later biennial) lecture on art theory to the Academy. Each lecture, or 'Discourse', was published shortly after its delivery. A complete edition of the Discourses appeared in 1797, after Reynolds's death, by which time they were also available in French, German and Italian editions. In his first Discourse of 1769 Reynolds discussed the fundamental role of the living model in academic training, conscious of his own deficiency in this area. In subsequent Discourses his topics ranged widely, drawing upon a range of aesthetic treatises from Horace and Longinus to Leonardo da Vinci and Giovanni Paolo Lomazzo, as well as the French seventeenth-century theorists Charles Le Brun, Henri Testelin, Félibien and Roger de Piles, and more recent writers such as Francesco Algarotti, Johann Winckelmann, Edmund Burke and Adam Smith. In the earlier Discourses Reynolds concentrated upon the essential principles of High Art; the 'Great Style' as he called it. Later, he elaborated on aesthetic concepts, such as the nature of genius, originality, imitation and taste. Taken together, the Discourses present Reynolds's views on art theory and practice as it evolved over a twenty-year period, modified both by his own experience and the critical debate in which he engaged with his peers. While Reynolds did not always practise what he preached, through the Discourses he provided an intelligent framework for understanding the traditions of European painting. And, despite his personal attraction towards the colour of Rubens and the

tonal mastery of Rembrandt, he upheld the supremacy of the artists of the Italian Renaissance, notably Michelangelo, whose name was the last word he spoke in his final Discourse of 1790.

During the 1770s Reynolds exhibited over one hundred pictures at the Royal Academy, including portraits of friends, actors and actresses, scientists, clergymen, aristocrats and children. He also painted a number of history paintings, notably *Ugolino and his Children in the Dungeon* of 1773 (Knole, The National Trust; see fig.26), which he based on an episode from Dante's *Divine Comedy*. Reynolds regarded this picture, which proved influential on the development of French Neoclassicism, as a manifesto for his theories on High Art, combining motifs from Annibale Carracci's *Pietà* (1518; National Gallery, London) and Michelangelo's Sistine Chapel ceiling, as well as ideas found in the writings of Richardson and Le Brun. At this time Reynolds also produced a number of child portraits in character, such as *Master Crewe as Henry VIII* (cat.62), as well as imaginative portrayals of beggar children, which he described as 'fancy pictures'. These include his celebrated *Strawberry Girl* (?exh. RA 1773; Wallace Collection, London), the *Infant Samuel* (c.1776; Tate), and the pendant pictures, *Cupid as a Link Boy* (c.1773; Albright-Knox Art Gallery, Buffalo, New York) and *Mercury as a Cut Purse* (c.1773; The Faringdon Collection Trust, Buscot Park), which combined classical allegory with Hogarthian earthiness.

Reynolds's most flamboyant portraits of the 1770s were undoubtedly his full-length 'Grand Manner' portraits of female aristocrats such as the Duchess of Cumberland (exh. RA 1773; The National Trust, Waddeston Manor), the Montgomery Sisters (exh. RA 1774; Tate), Jane Fleming (cat.24) and Lady Bampfylde (cat.25). In these paintings, as in works by his main rivals, Thomas Gainsborough and George Romney, Reynolds clothed his subjects in elaborate draperies designed to elevate their portraits to the level of High Art. Only occasionally did he resort to quasi-historical costume in male portraits, notably in the double portrait of Colonel Acland and Lord Sydney (cat.61) and the Polynesian, Omai (cats.66 and 67), whose flowing white robes Reynolds visualised as a form of classical toga. By now Reynolds's extensive network of patrons was centred upon Britain's leading Whig dynasties, the Crewe, Bedford and Spencer

fig.38
Mrs Hale as 'Euphrosyne' 1762–4
Oil on canvas, 236 x 146
Harewood House, Leeds

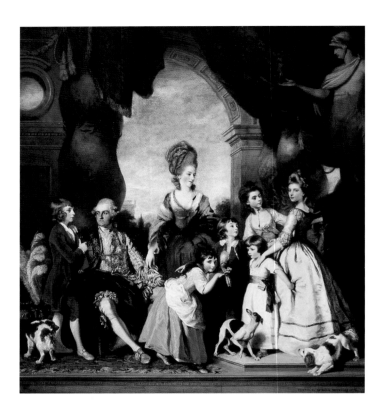

fig.39
The Marlborough Family 1777–8
Oil on canvas, 318 x 289
The Duke of Marlborough, Blenheim Palace

families. His most ambitious work to emerge from this lucrative source of patronage was his large group portrait of the family of the 4th Duke of Marlborough (fig.39), which Reynolds exhibited at the Royal Academy in 1778, and which still hangs at Blenheim Palace, Oxfordshire.

In 1780 the Royal Academy held its first exhibition at Somerset House, which had recently been completed to a design by Sir William Chambers. Here Reynolds showed seven works, including a striking full-length portrait of Lady Worsley in military riding attire (cat.55), a portrait of Edward Gibbon (cat.39) and an allegorical figure, *Justice* (exh. RA 1780; Lord Normanton, Somerley), which was one of his designs for a painted window in New College, Oxford. The central design, *The Nativity* (which was destroyed in a fire in 1816), had been exhibited at the Academy the previous year, the window being finally installed in 1785, when it received a mixed critical reception (see cat.6).

During the 1780s Reynolds became increasingly inspired by the art of Flanders and the Low Countries, especially following his visit there during the late summer of 1781. Reynolds, who had over the years built up an impressive Old Master collection, already owned works by Van Dyck, Rubens and Rembrandt, genre paintings by Pieter Breughel and David Teniers, as well as landscapes by Albert Cuyp, Meindert Hobbema and Jacob van Ruisdael. He expressed qualified admiration for the artists of the Dutch school, his greatest admiration being reserved for the Flemish artist, Rubens, notably his *Conversion of Saint Bavo* (1623) in St Bavo's Cathedral, Ghent, and his *Virgin and Child with Saints* (c.1628) in St Augustine's Church, Antwerp. Reynolds's first-hand account of his sojourns in Flanders and the Low Countries was published after his death by his friend Edmond Malone.

On 1 October 1784 Reynolds was sworn in as Principal Painter in Ordinary to the King, following the death of Allan Ramsay. Although Reynolds was dismissive of the token salary that went with the post, he threatened to resign the Presidency of the Royal Academy if the King did not agree to his appointment. As the decade wore on, Reynolds faced increasing opposition within the Academy, as well as the secession of leading artists, including Thomas Gainsborough. In order to boost the Academy's public profile, and his own fortunes, he exhibited works in increasing numbers – a total of

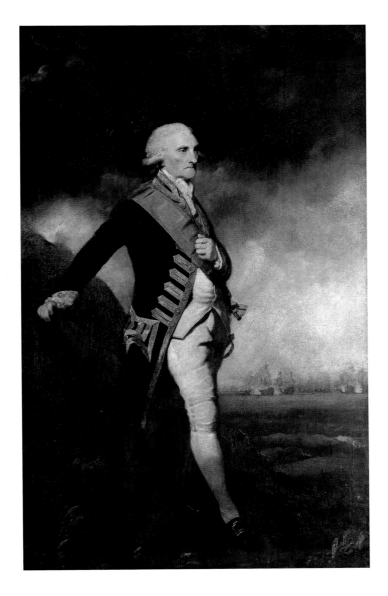

fig.40
George Brydges, 1st Baron Rodney 1788
Oil on canvas, 239.7 x 147.6
The Royal Collection

ninety-six between 1784 and his retirement in 1790. These included some of his greatest works: a full-length military portrait of George, Prince of Wales reining in a charger (fig.5), *Mrs Siddons as the Tragic Muse* (see cat.69), *Georgiana, Duchess of Devonshire and her Daughter, Lady Georgiana Cavendish* (cat.29), *Lord Heathfield* (cat.18) and *George Brydges, 1st Baron Rodney* (fig.40). As *The Times* reported in January 1785, Reynolds was a model of professional diligence: 'shaved and powdered by nine in the morning, and at his canvass [*sic*]; we mention this as an example to artists, and as a leading trait in the character of this great painter.'

Portraiture had always been Reynolds's principal artistic activity. During his lifetime, however, his reputation also rested upon his subject pictures, sensuous works such as *A Nymph and Cupid* (Tate) of 1784 and his *Venus* (1785; Private Collection), of which he made several versions, including one purportedly for the French King, Louis XVI. In 1785 the Russian Empress, Catherine the Great, commissioned Reynolds to paint a history painting of his choice. The picture, the *Infant Hercules Strangling the Serpents* (The Hermitage, St Petersburg), was eventually exhibited by Reynolds at the Royal Academy in 1788. Like a number of other leading British artists, he also became involved in producing works for John Boydell's Shakespeare Gallery, including *The Death of Cardinal Beaufort* and *Macbeth and the Witches* (both Petworth House, The National Trust), the last of which remained unfinished at his death.

In the summer of 1789, failing eyesight forced Reynolds to discontinue his portrait practice, although he remained active in the affairs of the Royal Academy where he delivered his final Discourse in December 1790. The following spring Reynolds exhibited his extensive art collection in London, including his prized version of Leonardo's *Mona Lisa* (although this is now regarded as a studio work). On 5 November 1791 he wrote his will, bequeathing the bulk of his estate to his niece, Mary Palmer. By now he was in great pain, due to chronic liver failure. He died on the evening of Thursday 23 February 1792. Just over a week later, on 3 March 1792, Reynolds's body was conveyed to St Paul's Cathedral, where he received a state burial. In 1813, the British Institution mounted the first retrospective exhibition of his art in London. The same year Reynolds's pupil, James Northcote, published the first edition of his biography.

Bibliography

ALEXANDER AND GODFREY 1980 David Alexander and Richard Godfrey, *Painters and Engraving: The Reproductive Print from Hogarth to Wilkie*, New Haven 1980.

AMBROSE 1897 G.E. Ambrose, *Catalogue of the Collection of Pictures belonging to the Marquess of Lansdowne, K.G., at Lansdowne House, London and Bowood, Wilts.*, London 1897.

ARCHIBALD 1961 E. Archibald, *Preliminary Descriptive Catalogue of Portraits in Oil, National Maritime Museum, Greenwich*, London 1961.

ASHTON AND MACKINTOSH 1982 Geoffrey Ashton and Iain Mackintosh, *Royal Opera House Retrospective, 1732–1982*, exh. cat., Royal Academy of Arts, London 1982.

ASLESON 1999 Robyn Asleson (ed.), *A Passion for Performance. Sarah Siddons and her Portraits*, Los Angeles 1999.

ASLESON AND BENNETT 2001 Robyn Asleson and Shelley M. Bennett, *British Paintings at the Huntington*, New Haven and London 2001.

ASPINALL 1938 Arthur Aspinall (ed.), *The Letters of King George IV 1812–1830*, 3 vols., Cambridge 1938.

ASTON 1988 Nigel Aston, 'Lord Carysfort and Sir Joshua Reynolds: the Patron as Friend', *Gazette des Beaux-Arts*, no.112, November 1988, pp.205–10.

BAKER 1920 C.H. Collins Baker, *Catalogue of the Petworth Collection of Pictures in the Possession of Lord Leconfield*, London 1920.

BAKER 1985 Malcolm Baker, 'That "most rare Master Monsieur Le Gros" and his "Marsyas"', *Burlington Magazine*, vol.127, no.991, October 1985, pp.702–6.

BALDERSTON 1942 Katharine C. Balderston, *Thraliana. The Diary of Mrs. Hester Lynch Thrale (Later Mrs. Piozzi)*, 2 vols., Oxford 1942.

BALKAN 1972 Katherine Shelley Balkan, 'Sir Joshua's Theory and Practice of Portraiture: a Re-evaluation' (PhD thesis presented to the University of California 1972), University Microfilms International 1979.

BATE 1968 Walter Jackson Bate, John M. Bullitt and L.F. Powell (eds.), *The Idler and the Adventurer: The Yale Editions of the Works of Samuel Johnson*, 2 vols., New Haven and London 1968.

BEATTIE 1946 R.S. Walker, 'James Beattie. London Diary 1773', *Aberdeen University Studies*, no.122, Aberdeen 1946.

BEECHEY 1835 Henry William Beechey, *The Literary Works of Sir Joshua Reynolds with a Memoir by Henry William Beechey*, 2 vols., London 1835.

BIGNAMINI AND POSTLE 1991 Ilaria Bignamini and Martin Postle, *The Artist's Model. Its Role in British Art from Lely to Etty*, exh. cat., Nottingham University Art Gallery and The Iveagh Bequest, Kenwood 1991.

BLEACKLEY 1905 Horace Bleackley, 'Tête-à-tête portraits in *The Town and Country Magazine*', *Notes and Queries*, vol.4, 10th series, 23 September 1905, pp.241–2.

BLEACKLEY 1909 Horace Bleackley, *Ladies, Frail and Fair. Sketches of the Demi-monde during the Eighteenth Century*, London 1909.

BLEACKLEY 1923 Horace Bleackley, *Casanova in England*, London 1923.

BOADEN 1831 James Boaden (ed.), *The Private Correspondence of David Garrick with the most Celebrated Persons of his Time*, 2 vols., London 1831.

BONEHILL 2001 John Bonehill, 'Reynolds's Portrait of Lieutenant-Colonel Banastre Tarleton and the Fashion for War', *British Journal for Eighteenth-Century Studies*, vol.24, no.2, Autumn 2001, pp.123–44.

BORENIUS 1936 Tancred Borenius, *A Catalogue of the Pictures and Drawings at Harewood House, etc. in the Collection of the Earl of Harewood*, Oxford 1936.

BORENIUS AND HODGSON 1924 Tancred Borenius and the Revd J.V. Hodgson, *A Catalogue of the Pictures at Elton Hall in Huntingdonshire in the Possession of Colonel Douglas James Proby*, preface by Granville Proby, London 1924.

BOSCH 1994 R. Bosch, '"Character" in Reynolds's Portrait of Sterne', *The Shandean*, vol.6, 1994, pp.9–23.

BOSWELL 1928–34 Geoffrey Scott and Frederick A. Pottle (eds.), *Private Papers of James Boswell from Malahide Castle*, 18 vols., New York 1928–34.

BOSWELL 1934–50 George Birkbeck Hill (ed.), *Boswell's Life of Johnson*, revised by L.F. Powell, 6 vols., Oxford 1934–50.

BOSWELL 1950 Frederick A. Pottle (ed.), *Boswell's London Journal 1762–1763: The Yale Editions of the Private Papers of James Boswell*, London 1950.

BOSWELL 1976 Charles N. Fifer (ed.), *The Correspondence of James Boswell with Certain Members of the Club: The Yale Editions of the Private Papers of James Boswell*, London 1976.

BOYLE 1885 Mary L. Boyle, *Biographical Catalogue of the Portraits at Panshanger, the Seat of Earl Cowper*, London 1885.

BRADY 1984 Frank Brady, *James Boswell. The Later Years, 1769–1795*, London 1984.

BRAUDY 1986 Leo Braudy, *The Frenzy of Renown. Fame and its History*, Oxford and London 1986.

BREWARD 1995 Christopher Breward, 'A Fruity Problem: Contextualizing the "Reynolds" Paper', *Wallpaper History Review*, 1995, pp.9–14.

BREWER 1995 John Brewer, 'Cultural Production, Consumption, and the Place of the Artist in Eighteenth-Century England', in Brian Allen (ed.), *Towards a Modern Art World: Studies in British Art I*, New Haven and London 1995, pp.7–25.

BREWER 1997 John Brewer, *The Pleasures of the Imagination: English Culture in the Eighteenth Century*, London 1997.

BRINTON 1903 Selwyn Brinton, *Bartolozzi and His Pupils in England*, London 1903.

BRYANT 2003 Julius Bryant, *Kenwood. Paintings in the Iveagh Bequest*, New Haven and London 2003.

BUCHANAN 1824 W. Buchanan, *Memoirs of Painting; with a chronological history of the importation of pictures by the great masters into England since the French Revolution*, 2 vols., London 1824.

BURKE 1976 Joseph Burke, *English Art 1714–1800*, Oxford 1976.

BURNEY 1832 Fanny Burney, *Memoirs of Doctor Burney, arranged from his own Manuscripts, from Family Papers, and from Personal Recollections. By his daughter, Madame d'Arblay*, 3 vols., London 1832.

BURNEY 1842–6 C.F. Barrett (ed.), *The Diary and Letters of Madame d'Arblay*, 7 vols., London 1842–6.

BURNEY 1913, Annie Raine Ellis (ed.), *The Early Diary of Frances Burney 1768–1778*, 2 vols., London 1913.

BURNEY 1972–82 Joyce Hemlow (ed.), *The Journals and Letters of Fanny Burney (Madame D'Arblay)*, 12 vols., London 1972–82.

BURNEY 1988 Lars E. Troide (ed.), *The Early Journals and Letters of Fanny Burney, 1768–73*, vol.1, Oxford 1988.

BURNEY 1990 Lars E. Troide (ed.), *The Early Journals and Letters of Fanny Burney, 1774–7*, vol.2, Oxford 1990.

BURNEY 1994 Lars E. Troide and Stewart J. Cooke (eds.), *The Early Journals and Letters of Fanny Burney: The Streatham Years, Part 1: 1778–1779*, vol.3, Oxford 1994.

BUSCH 1984 Werner Busch, 'Hogarths und Reynolds' portrats des Schauspielers Garrick', *Zeitschrift für Kunstgeschichte*, vol.46, 1984, pp.82–99.

CHALONER SMITH 1883 John Chaloner Smith, *British Mezzotinto Portraits: being a descriptive catalogue of these engravings from the Introduction of the Art to the early part of the present Century*, 4 vols., London 1883.

CLAYTON 1993 Timothy Clayton, 'Reviews of English Prints in German Journals 1750–1800', *Print Quarterly*, vol.10, 1993, pp.123–37.

CLAYTON 1997 Timothy Clayton, *The English Print*, London and New Haven 1997.

CLIFFORD, GRIFFITHS, ROYALTON-KISCH 1978 Timothy Clifford, Antony Griffiths and Martin Royalton-Kisch, *Gainsborough and Reynolds in the British Museum*, exh. cat., The British Museum, London 1978.

COCKBURN 1856 Henry Cockburn, *Memorials of his Time*, Edinburgh 1856.

COLLEY 1992 Linda Colley, *Britons. Forging the Nation 1707–1837*, New Haven 1992.

CONNELL 1957 Brian Connell, *Portrait of a Whig Peer. Compiled from the Papers of the Second Viscount Palmerston 1739–1802*, London 1957.

CORMACK 1968–70 Malcolm Cormack, 'The Ledgers of Sir Joshua Reynolds', *The Walpole Society*, vol.42, 1968–70, pp.105–69.

CORMACK 1985 Malcolm Cormack, *A Concise Catalogue of Paintings in the Yale Center for British Art*, New Haven 1985.

COTTON 1856 William Cotton, *Sir Joshua Reynolds and his Works. Gleanings from his Diary, unpublished manuscripts, and from other sources*, ed. John Burnet, London 1856.

COTTON 1859 William Cotton (ed.), *Sir Joshua Reynolds's Notes and Observations on Pictures, chiefly of the Venetian School, Being Extracts from his Italian Sketch Books,* London 1859.

CROSS 1929 Wilbur Lucius Cross, *The Life and Times of Laurence Sterne*, 3rd ed., New Haven 1929.

CROSSLAND 1996 John Crossland, 'The Keppel Affair', *History Today*, vol.46, no.1, January 1996, pp.42–8.

DAVIDSON 1998 James Davidson, *Courtesans and Fishcakes. The Consuming Passions of Classical Athens*, 2nd ed., London 1998.

DAVIES 1946 Martin Davies, *National Gallery Catalogues: The British School*, London 1946.

DAVIES 1959 Martin Davies, *National Gallery Catalogues: The British School*, revised ed., London 1959.

DAVIS 1986 I.M. Davis, *The Harlot and the Statesman. The Story of Elizabeth Armistead and Charles James Fox*, Abbotsbrook 1986.

DIAS 2003 Rosemarie Dias, 'John Boydell's Shakespeare Gallery and the Promotion of a National Aesthetic', unpublished PhD thesis, University of York 2003.

D'OENCH 1999 Ellen G. D'Oench, *'Copper into Gold'. Prints by John Raphael Smith 1751–1812*, New Haven and London 1999.

DOREY 2003 Helen Dorey, 'Flaxman and Soane', in *Flaxman: Master of the Pursuit of Line*, exh. cat., Sir John Soane's Museum, London 2003, pp.25–36.

EDWARDS 1808 Edward Edwards, *Anecdotes of Painters who have resided or been born in England*, London 1808.

EGERTON 1998 Judy Egerton, *National Gallery Catalogues: The British School*, London 1998.

EINBERG 1987 Elizabeth Einberg, *Manners and Morals. Hogarth and British Painting 1700–1760*, exh. cat., Tate Gallery, London 1987.

ENTICK 1766 John Entick, *The General History of the Late War*, 3rd ed., London 1766.

FARINGTON 1819 Joseph Farington, *Memoirs of the Life of Sir Joshua Reynolds*, London 1819.

FARINGTON 1978–84 Kenneth Garlick, Angus Macintyre and Kathryn Cave (eds.), *Joseph Farington. Diaries*, 16 vols., New Haven and London 1978–84.

FARRER 1908 Revd Edmund Farrer, *Portraits in Suffolk Houses (West)*, London 1908.

FIFE 1807 James Duff, 2nd Earl of Fife, *Catalogue of the Portraits and Pictures in the Different Houses Belonging to James, Earl of Fife*, London 1807.

FLETCHER 1901 Ernest Fletcher (ed.), *Conversations of James Northcote RA with James Ward on Art and Artists*, London 1901.

FOREMAN 1988 Amanda Foreman, *Georgiana, Duchess of Devonshire*, New York 1988.

FRANKAU 1902 Julia Frankau, *John Raphael Smith: His Life and Works*, London 1902.

FRICK 1968 *Frick Collection: An Illustrated Catalogue, Vol.1: Painting*, New York 1968.

GALAVICS 1978 Géza Galavics, 'Ein Reynolds-Blatt als politische Symbol in Ungam am Ende des 18. Jahrhunderts', *Acta historiae artium*, no.24, 1978, pp.323–33.

GARLICK 1974–6 Kenneth Garlick, 'A Catalogue of pictures at Althorp', *The Walpole Society*, vol.45, 1974–6.

GERSON 1942 H. Gerson, *Ausbreitung und Nachwirkung der holländischen Malerei des 17. Jahrhunderts*, Haarlem 1942.

GIBBON 1900 Edward Gibbon, *The Memoirs of the Life of Edward Gibbon with various observations and excursions by himself*, ed. George Birkbeck Hill, London 1900.

GIBSON-WOOD 2000 Carol Gibson-Wood, *Jonathan Richardson: art theorist of the English Enlightenment*, New Haven and London 2000.

GODFREY 1978 Richard Godfrey, *Printmaking in Britain. A General History from its Beginnings to the Present Day*, Oxford 1978.

GODFREY 2001 Richard Godfrey, *James Gillray. The Art of Caricature*, exh. cat., Tate Britain, London 2001.

GRAVES AND CRONIN 1899–1901 Algernon Graves and William Vine Cronin, *A History of the Works of Sir Joshua Reynolds*, 4 vols., London 1899–1901.

GUEST 1992 Harriet Guest, 'Curiously Marked: Tattooing, Masculinity, and Nationality in Eighteenth-Century British Perceptions of the South Pacific', in John Barrell (ed.), *Painting and the Politics of Culture. New Essays on British Art 1700–1850*, Oxford and New York 1992, pp.101–34.

GUNNIS 1951 Rupert Gunnis, *Dictionary of British Sculptors 1660–1851*, London 1951.

GWYNN 1898 Stephen Gwynn, *Memorials of an Eighteenth-Century Painter (James Northcote)*, London 1898.

HACKNEY, JONES, TOWNSEND 1999 Stephen Hackney, Rica Jones and Joyce Townsend, *Paint and Purpose: a Study of Technique in British Art*, London 1999.

HALLETT 2004 Mark Hallett, 'Reading the Walls: Pictorial Dialogue at the British Royal Academy', *British Journal for Eighteenth-Century Studies*, vol.27, no.4, Summer 2004, pp.581–604.

HALLETT 2004a Mark Hallett, 'From Out of the Shadows: Sir Joshua Reynolds' Captain Orme', *Visual Culture in Britain*, vol.5, no.2, 2004, pp.41–62.

HAMILTON 1831 G. Hamilton, *The English School*, 4 vols., London 1831.

HAMILTON 1884 Edward Hamilton, *A Catalogue Raisonné of the Engraved Works of Sir Joshua Reynolds, PRA from 1755 to 1822*, revised ed., London 1884.

HARCOURT-SMITH 1932 Cecil Harcourt-Smith, *The Society of Dilettanti: Its Regalia and Pictures*, London 1932.

HARGRAVES 2003 Matthew Hargraves, '"Candidates for Fame": The Society of Artists of Great Britain, *c*.1760–1791', unpublished PhD thesis, Courtauld Institute of Art, University of London 2003.

HASKELL AND PENNY 1981 Francis Haskell and Nicholas Penny, *Taste and the Antique: the Lure of Classical Sculpture 1500–1900*, New Haven and London 1981.

HAYES 2001 John Hayes (ed.), *The Letters of Thomas Gainsborough*, New Haven and London 2001.

HAZLITT 1824 William Hazlitt, *Sketches of the Principal Picture Galleries of England*, London 1824.

HAZLITT 1830 William Hazlitt, *Conversations of James Northcote, Esq., R.A.*, London 1830.

HEWINS 1898 W.A.S. Hewins (ed.), *The Whitefoord Papers, being the Correspondence and other Manuscripts of Colonel Charles Whitefoord and Caleb Whitefoord from 1739 to 1810*, Oxford 1898.

HIGHFILL, BURNIM, LANGHANS 1973– Philip H. Highfill Jr, Kalman A. Burnim and Edward A. Langhans, *A Biographical Dictionary of Actors, Managers and other Stage Personnel in London 1660–1800*, 14 vols., Carbondale, Illinois 1973 (ongoing).

HILL 1897 George Birkbeck Hill (ed.), *Johnsonian Miscellanies*, 2 vols., London 1897.

HILLES 1929 Frederick Whiley Hilles, *Letters of Sir Joshua Reynolds*, Cambridge 1929.

HILLES 1936 Frederick Whiley Hilles, *The Literary Career of Sir Joshua Reynolds*, Cambridge 1936.

HILLES 1952 Frederick Whiley Hilles, *Portraits by Sir Joshua Reynolds*, Melbourne, London, Toronto 1952.

HILLES 1967 Frederick Whiley Hilles, 'Horace Walpole and the Knight of the Brush', in W.H. Smith (ed.), *Horace Walpole: Writer, Politician and Connoisseur*, New Haven and London 1967, pp.141–66.

HILLES AND DAGHLIAN 1937 Frederick W. Hilles and Philip B. Daghlian, *Anecdotes of Painting in England; 1760–1795. With some account of the principal artists; and incidental notes on other arts; collected by Horace Walpole; and now digested and published from his original MSS*, vol.5, New Haven 1937.

HIND 1911 Arthur M. Hind, *John Raphael Smith and the Great Mezzotinters of the time of Reynolds*, New York 1911.

HOOCK 2003 Holger Hoock, *The King's Artists: The Royal Academy of Arts and the Politics of British Culture 1760–1840*, Oxford 2003.

HUDSON 1958 Derek Hudson, *Sir Joshua Reynolds: A Personal Study*, London 1958.

HUTCHISON 1986 Sydney C. Hutchison, *The History of the Royal Academy 1768–1986*, revised ed., London 1986.

HYDE 1979 Mary Hyde, 'The Library Portraits at Streatham Park', *The New Rambler*, London 1979, pp.10–24.

INGAMELLS 2004 John Ingamells, *National Portrait Gallery. Mid-Georgian Portraits 1760–1790*, London 2004.

INGAMELLS AND EDGCUMBE 2000 John Ingamells and John Edgcumbe, *The Letters of Sir Joshua Reynolds*, New Haven and London 2000.

INGRAMS 1984 Richard Ingrams (ed.), *Dr Johnson by Mrs Thrale. The 'Anecdotes' of Mrs Piozzi in Their Original Form*, London 1984.

IRWIN 1979 David Irwin, *John Flaxman 1755–1826. Sculptor, Illustrator, Designer*, London 1979.

JAMESON 1844 Anna Jameson, *Companion to the Most Celebrated Private Galleries of Art in London*, London 1844.

JESSE 1843–4 John Heneage Jesse, *George Selwyn and his Contemporaries; With Memoirs and Notes*, 4 vols., London 1843–4.

JOPPIEN 1979 Rüdiger Joppien, 'Philippe Jacques de Loutherbourg's Pantomime *Omai, or a Trip round the World* and the Artists of Captain Cook's Voyages', *British Museum Yearbook*, London 1979, pp.81–136.

KAYE 1861 Sir John William Kaye (ed.), *Autobiography of Miss Cornelia Knight, Lady Companion to the Princess Charlotte of Wales. With Extracts from her Journals and Anecdote Books*, 2 vols., London 1861.

KEENE, BURNS, SAINT 2004 Derek Keene, Arthur Burns and Andrew Saint, *St Pauls, the Cathedral Church of London 604–2004*, New Haven and London 2004.

KELLY 1998 Linda Kelly, *Richard Brinsley Sheridan. A Life*, London 1998.

KENNEY 1991 E.J. Kenney, 'Letter to the Editor', *Apollo*, vol.133, no.347, January 1991, p.66.

KERSLAKE 1977 John Kerslake, *National Portrait Gallery. Early Georgian Portraits*, 2 vols., London 1977.

KÖLLER 1992 Alexander Köller, 'Das Westfenster von New College Chapel', Diplomarbeit zur Erlangung des Magistergrades an der Geisteswissenschaftlichen Fakultät der Universität Salzburg 1992.

LENNOX-BOYD, SHAW, HALLIWELL 1994 Christopher Lennox-Boyd, Guy Shaw, Sarah Halliwell, *Theatre: The Age of Garrick. English mezzotints from the collection of the Hon. Christopher Lennox-Boyd*, exh. cat., Courtauld Institute of Art, London 1994.

LESLIE 1860 Charles Robert Leslie, *Autobiographical Recollections*, ed. Tom Taylor, 2 vols., London 1860.

LESLIE AND TAYLOR 1865 Charles Robert Leslie and Tom Taylor, *Life and Times of Sir Joshua Reynolds*, 2 vols., London 1865.

LEWIS AND ADAMS 1968–70 W.S. Lewis and C. Kingsley Adams, 'The portraits of Horace Walpole', *The Walpole Society*, vol.42, 1968–70, pp.1–34.

LICHTENBERG 1938 Georg Christoph Lichtenberg, *Lichtenberg's Visits to England*, Oxford 1938.

LIPKING 1970 Lawrence Lipking, *The Ordering of the Arts in Eighteenth-Century England*, Princeton 1970.

LIPPINCOTT 1983 Louise Lippincott, *Selling Art in Georgian London: The Rise of Arthur Pond*, New Haven and London 1983.

LITTLE AND KAHRL 1963 David M. Little and George M. Kahrl (eds.), *The Letters of David Garrick*, 3 vols., Oxford 1963.

LLOYD 1994 Christopher Lloyd, *Gainsborough and Reynolds. Contrasts in Royal Patronage*, exh. cat., The Queen's Gallery, Buckingham Palace, London 1994.

LONSDALE 1986 Roger Lonsdale, *Dr Charles Burney*, 2nd ed., Oxford 1986.

LONSDALE 1988 Roger Lonsdale (ed.), *The Poems of John Bampfylde*, Oxford 1988.

LUKE 1950 H. Luke, 'Omai: England's First Polynesian Visitor', *The Geographical Magazine*, April 1950, pp.497–500.

MALONE 1819 Edmond Malone (ed.), *The Literary Works of Sir Joshua Reynolds, KT. Late President of the Royal Academy*, 3 vols., 5th ed. (revised), London 1819.

MANNERS 1813 John Henry Manners, Duke of Rutland, *Travels in Great Britain*, London 1813.

MANNERS 1899 William Evelyn Manners, *Some Account of the Military, Political and Social Life of the Right Hon. John Manners, Marquis of Granby*, London and New York 1899.

MANNINGS 1975 David Mannings, 'The Sources and Development of Reynolds's pre-Italian style', *Burlington Magazine*, vol.117, no.864, April 1975, pp.212–22.

MANNINGS 1984 David Mannings, 'Reynolds, Garrick and the choice of Hercules', *Eighteenth Century Studies*, vol.17, 1984, pp.259–83.

MANNINGS 1992 David Mannings, *Sir Joshua Reynolds PRA 1723–1792. The Self-Portraits*, exh. cat., Plymouth City Museums and Art Gallery 1992.

MANNINGS 2000 David Mannings, 'The Archers', in *Christie's Sale Catalogue 14 June 2000*, London 2000, pp.26–9.

MANNINGS AND POSTLE 2000 David Mannings, *Sir Joshua Reynolds. A Complete Catalogue of his Paintings*, with subject paintings catalogued by Martin Postle, New Haven and London 2000.

McCORMICK 1977 E.H. McCormick, *Omai. Pacific Envoy*, Auckland and Oxford 1977.

McLOUGHLIN AND BOULTON 1997 T.O. McLoughlin and James T. Boulton (eds.), *The Writings and Speeches of Edmund Burke*, vol.1, Oxford 1997.

MILLAR 1969 Oliver Millar, *The Later Georgian Pictures in the Collection of Her Majesty the Queen*, 2 vols., London 1969.

MILLER 1982 James Miller, *The Catalogue of Paintings at Bowood House*, Bowood 1982.

MOORE 1967 Robert E. Moore, 'Reynolds and the art of characterisation', in H.P. Anderson and J.S. Shea (eds.), *Studies in Criticism and Aesthetics 1600–1800*, Minneapolis 1967, pp.332–57.

MURRAY 1965 Peter Murray, *The Iveagh Bequest: Catalogue of Paintings, Kenwood*, London 1965.

MURRAY 1980 Peter Murray, *Dulwich Picture Gallery: A Catalogue*, London 1980.

MUSSER 1984 J.F. Musser, 'Sir Joshua Reynolds's *Mrs Abington as "Miss Prue"*', *The South Atlantic Quarterly*, Spring 1984, pp.176–92.

NEALE 1819–23 J.P. Neale, *Views of the Seats of Noblemen and Gentlemen, in England, Wales, Scotland, and Ireland*, 6 vols., London 1819–23.

NORTHCOTE 1813 James Northcote, *Memoirs of Sir Joshua Reynolds Knt.*, London 1813.

NORTHCOTE 1815 James Northcote, *Supplement to the Memoirs of the Life, Writings, Discourses, and Professional Works of Sir Joshua Reynolds, Knt.*, London 1815.

NORTHCOTE 1818 James Northcote, *The Life of Sir Joshua Reynolds*, 2 vols., 2nd ed., London 1818.

O'CONNELL 2003 Sheila O'Connell, *London 1753*, exh. cat., The British Museum, London 2003.

PATMORE 1824 Peter George Patmore, *Beauties of the Dulwich Picture Gallery*, London 1824.

PAULSON 1975 Ronald Paulson, *Emblem and Expression*, London 1975.

PENNY 1986 Nicholas Penny (ed.), *Reynolds*, exh. cat., Royal Academy of Arts, London 1986.

PERRY 2003 Gill Perry, 'Ambiguity and Desire: Metaphors of Sexuality in Late Eighteenth-Century Representations of the Actress', in Robyn Asleson (ed.), *Notorious Muse. The Actress in British Art and Culture, 1776–1812: Studies in British Art II*, New Haven and London 2003, pp.57–80.

PIOZZI 1861 Hester Lynch Piozzi (formerly Thrale), *Autobiography, Letters and Literary Remains*, ed. A. Hayward, 2 vols., 2nd ed., London 1861.

PIPER 1954 David Piper, 'The National Portrait Gallery: some recent acquisitions', *Connoisseur*, vol.133, April 1954, pp.177–82.

POINTON 2000 Marcia Pointon, *William Hogarth's Sigismunda: In Focus*, with a technical essay by Rica Jones, exh. cat., Tate Britain, London 2000.

POINTON 2004 Marcia Pointon, 'The Lives of Kitty Fisher', *British Journal for Eighteenth-Century Studies*, vol.27, no.1, Spring 2004, pp.77–98.

POSTLE 1990 Martin Postle, 'Reynolds, Shaftesbury, Van Dyck and Dobson: Sources for *Garrick between Tragedy and Comedy*', *Apollo*, vol.132, no.345, November 1990, pp.306–11.

POSTLE 1995 Martin Postle, *Sir Joshua Reynolds: the Subject Pictures*, Cambridge 1995.

POSTLE 1995a Martin Postle, 'An early unpublished letter by Sir Joshua Reynolds', *Apollo*, vol.141, no.400, June 1995, pp.11–18.

POSTLE 2001 Martin Postle, 'Sir Joshua Reynolds, Edmund Burke, and the *Grand Whiggery*', in Elise Goodman (ed.), *Art and Culture in the Eighteenth Century. New Dimensions and Multiple Perspectives*, Newark and London 2001, pp.106–24.

POSTLE 2003 Martin Postle, '"Painted women": Reynolds and the Cult of the Courtesan', in Robyn Asleson (ed.), *Notorious Muse. The Actress in British Art and Culture, 1776–1812: Studies in British Art II*, New Haven and London 2003, pp.22–55.

POSTLE 2003a Martin Postle, 'Sir Joshua Reynolds', in Natasha McEnroe and Robin Simon (eds.), *The Tyranny of Treatment. Samuel Johnson, his Friends and Georgian Medicine*, exh. cat., Dr Johnson's House, London 2003, pp.30–8.

POTTERTON 1976 Homan Potterton, 'Reynolds's Portrait of Captain Robert Orme in the National Gallery', *Burlington Magazine*, vol.118, no.874, February 1976, p.106.

PRATT 1988 Stephanie Pratt, 'Reynolds's "King of the Cherokees" and Other Mistaken Identities in the Portraiture of Native American Delegations, 1710–1762,' *Oxford Art Journal*, vol.21, no.2, 1998, pp.133–50.

PROCHNO 1990 Renate Prochno, *Joshua Reynolds*, Weinheim 1990.

PULLING 1886 F.S. Pulling, *Sir Joshua Reynolds*, London 1886.

PYE 1845 John Pye, *Patronage of British Art*, London 1845.

RAIMBACH 1843 Michael Thomson Scott Raimbach (ed.), *Memoirs and Recollections of Abraham Raimbach*, London 1843.

REYNOLDS 1975 Joshua Reynolds, *Discourses on Art*, ed. Robert R. Wark, New Haven and London 1975.

RIBEIRO 1984 Aileen Ribeiro, *The Dress Worn at Masquerades in England, 1730 to 1790, and its Relation to Fancy Dress in Portraiture*, New York and London 1984.

RICHARDSON 1715 Jonathan Richardson the Elder, *An Essay on the Theory of Painting*, London 1715.

ROBINSON 1992 Duncan Robinson, 'Giuseppe Baretti as "A Man of Great Humanity"', in Guilland Sutherland (ed.), *British Art 1740–1820:*

Essays in Honor of Robert R. Wark, San Marino, California 1992, pp.81–94.

RUSSELL 1926 Charles E. Russell, *English Mezzotint Portraits and their States, from the invention of mezzotinting until the early part of the 19th century. With Catalogue of corrections of and additions to Chaloner Smith's 'British Mezzotinto Portraits'*, 2 vols., London 1926.

SHANES 1981 Eric Shanes, *The Genius of the Royal Academy*, London 1981.

ST JOHN GORE 1967 F. St John Gore, *The Saltram Collection, Plympton, Devon*, London 1967.

SHAWE-TAYLOR 1987 Desmond Shawe-Taylor, *Genial Company. The Theme of Genius in Eighteenth-Century British Portraiture*, exh. cat., Nottingham University Art Gallery and Scottish National Portrait Gallery 1987.

SHAWE-TAYLOR 1990 Desmond Shawe-Taylor, *The Georgians: Eighteenth-Century Portraiture and Society*, London 1990.

SIMON 1991 Robin Simon, 'Panels and Pugs', *Apollo*, vol.133, no.352, June 1991, pp.371–3.

SLOMAN 2002 Susan Sloman, *Gainsborough in Bath*, New Haven and London 2002.

SMAILES 1990 Helen Smailes, *Concise Catalogue of the Scottish National Portrait Gallery*, Edinburgh 1990.

SMART 1992 Alastair Smart, *Allan Ramsay. Painter, Essayist and Man of the Enlightenment*, New Haven and London 1992.

SMITH 1828 John Thomas Smith, *Nollekens and His Times*, 2 vols., London 1828.

SMITH 1845 John Thomas Smith, *A Book for a Rainy Day*, London 1845.

SOLKIN 1986 David H. Solkin, 'Great Pictures or Great Men? Reynolds, Male Portraiture, and the Power of Art', *Oxford Art Journal*, vol.9, no.2, 1986, pp.42–9.

SOLKIN 1993 David H. Solkin, *Painting for Money: The Visual Arts and the Public Sphere in Eighteenth-Century England,* New Haven and London 1993.

SOLKIN 2001 David H. Solkin (ed.), *Art on the Line. The Royal Academy Exhibitions at Somerset House 1780–1836*, exh. cat., Courtauld Institute of Art, London 2001.

SOUTHEY 1850 Robert Southey, *The Poetical Works of Robert Southey*, London 1850.

SPENCER 1913–25 Alfred Spencer (ed.), *Memoirs of William Hickey*, 4 vols., London 1913–25.

STEEGMAN 1933 John Steegman, *Sir Joshua Reynolds*, London 1933.

STEEGMAN 1942 John Steegman, 'Portraits of Reynolds', *Burlington Magazine*, vol.80, no.467, February 1942, pp.33–5.

STEPHENS 1867 Frederic George Stephens, *English Children as Painted by Sir Joshua Reynolds*, London 1867.

STEPHENS AND GEORGE 1870–1954 Frederic George Stephens and Mary Dorothy George, *British Museum Catalogue of Political and Personal Satires,* 11 vols., London 1870–1954.

THOMPSON AND BRIGSTOCKE 1970 Colin Thompson and Hugh Brigstocke, *National Gallery of Scotland: Shorter Catalogue*, Edinburgh 1970.

TINKER 1937 Chauncey Brewster Tinker, 'New Portrait of Omai: oil sketch by Sir J. Reynolds', *Yale Associates Bulletin*, no.7, 1937, pp.45–7.

TINKER 1938 Chauncey Brewster Tinker, *Painter and Poet. Studies in the Literary Relations of English Painting. The Charles Eliot Norton Lectures for 1937–1938*, Cambridge, Massachusetts 1938.

TRASK 1967–71 Willard R. Trask, *Giacomo Casanova. Chevalier de Seingalt, History of my Life. First translated into English in accordance with the original French manuscript*, 12 vols. (bound as 6), London 1967–71.

TSCHERNY 1986 Nadia Tscherny, 'Reynolds's Streatham Portraits and the art of intimate biography', *Burlington Magazine*, vol.128, no.994, January 1986, pp.4–10.

TURNER 2001 Caroline Turner, 'Images of Mai', in *Cook and Omai. The Cult of the South Seas*, exh. cat., National Library of Australia, Canberra 2001, pp.23–9.

WAAGEN 1838 Gustav Friedrich Waagen, *Works of Art and Artists in England*, 3 vols., London 1838.

WAAGEN 1854 Gustav Friedrich Waagen, *Treasures of Art in Great Britain*, 3 vols., London 1854.

WALPOLE 1937–83 Horace Walpole, *Correspondence*, ed. W.S. Lewis et al., 47 vols., New Haven and London 1937–83.

WATERHOUSE 1941 Ellis K. Waterhouse, *Reynolds*, London 1941.

WATERHOUSE 1951 Ellis K. Waterhouse, 'Exhibition of Old Masters at Newcastle, York and Perth', *Burlington Magazine*, vol.93, no.581, August 1951, p.262.

WATERHOUSE 1953 Ellis K. Waterhouse, 'Some Notes on the Exhibition of "Works of Art from Midland Houses" at Birmingham', *Burlington Magazine*, vol.95, no.606, September 1953, pp.305–9.

WATERHOUSE 1965 Ellis K. Waterhouse, *Three Decades of British Art (Jayne Lectures 1964)*, Philadelphia 1965.

WATERHOUSE 1966–8 Ellis K. Waterhouse, 'Reynolds's Sitter Book for 1755', *The Walpole Society*, vol.41, 1966–8, pp.112–64.

WATERHOUSE 1973 Ellis K. Waterhouse, *Reynolds*, London 1973.

WATSON 1988 Jennifer C. Watson, *Reynolds in Canada*, exh. cat., Kitchener-Waterloo Gallery and Beaverbrook Art Gallery, Ontario 1988.

WENDORF 1990 Richard Wendorf, *The Elements of Life: Biography and Portrait-Painting in Stuart and Georgian England*, Oxford 1990.

WENDORF 1996 Richard Wendorf, *Sir Joshua Reynolds: The Painter in Society*, National Portrait Gallery, London 1996.

WENDORF AND RYSKAMP 1980 Richard Wendorf and Charles Ryskamp, 'A Blue-Stocking Friendship: the Letters of Elizabeth Montagu and Frances Reynolds in the Princeton Collection', *The Princeton University Library Chronicle*, vol.41, no.3, Spring 1980, pp.173–207.

WHITE, ALEXANDER, D'OENCH 1983 Christopher White, David Alexander and Ellen D'Oench, *Rembrandt in Eighteenth-Century England*, exh. cat., Yale Center for British Art, New Haven 1983.

WHITLEY 1928 William T. Whitley, *Artists and their Friends in England 1700–1799*, 2 vols., London and Boston 1928.

WHITLEY 1930 William T. Whitley, *Art in England 1821–1837*, Cambridge 1930.

WHITMAN 1902 Alfred Whitman, *Valentine Green*, London 1902.

WHITMAN 1903 Alfred Whitman, *Samuel William Reynolds*, London 1903.

WIND 1986 Edgar Wind, *Hume and the Heroic Portrait. Studies in Eighteenth-Century Imagery*, ed. Jaynie Anderson, Oxford 1986.

WOLSTENHOLME AND PIPER 1964 Gordon Wolstenholme (ed.), *The Royal College of Physicians, London*, with portraits described by David Piper, London 1964.

WRAXALL 1904 Nathaniel William Wraxall, *Historical Memoirs of My Own Time*, London 1904.

YATES 1951 Frances A. Yates, 'Transformations of Dante's Ugolino', *Journal of the Warburg and Courtauld Institutes*, vol.14, 1951, pp.92–117.

YUNG 1981 Kai Kin Yung, *National Portrait Gallery: Complete Illustrated Catalogue 1856–1979*, London 1981.

YUNG 1984, Kai Kin Yung et al., *Samuel Johnson 1709–84. A Bicentenary Exhibition*, exh. cat., National Portrait Gallery, London 1984.

List of Works

28
Lavinia, Countess Spencer 1781–2
Oil on canvas 75 x 62.2
Earl Spencer, Althorp
(London only)

29
Georgiana, Duchess of Devonshire and her Daughter, Lady Georgiana Cavendish 1784
Oil on canvas 112.4 x 140.3
Trustees of the Chatsworth Settlement, Chatsworth

30
George IV as Prince of Wales 1785
Oil on wood 75.6 x 61.6
Tate. Purchased 1871

31
Prince George with Black Servant 1786–7
Oil on canvas 239 x 148
His Grace the Duke of Norfolk, Arundel Castle
(London only)

THE TEMPLE OF FAME

32
Horace Walpole 1756
Oil on canvas 127 x 101.6
National Portrait Gallery, London

33
Laurence Sterne 1760
Oil on canvas 127.3 x 100.4
National Portrait Gallery, London

34
George Selwyn 1766
Oil on canvas 99 x 76
Private Collection

35
David Garrick as 'Kitely' 1767
Oil on canvas 79.8 x 64.1
Lent by Her Majesty Queen Elizabeth II

36
Mr Huddesford and Mr Bampfylde c.1778
Oil on canvas 125.1 x 99.7
Tate. Presented by Mrs Plenge in accordance with the wishes of her mother, Mrs Martha Beaumont 1866

37
The Hon. Miss Monckton c.1777–8
Oil on canvas 240 x 147.3
Tate. Bequeathed by Sir Edward Stern 1933

38
James Boswell 1785
Oil on canvas 76.2 x 63.5
National Portrait Gallery, London

39
Edward Gibbon 1779
Oil on canvas 73.6 x 62.2
Private Collection

40
Adam Ferguson 1781–2
Oil on canvas 76.5 x 63.8
Scottish National Portrait Gallery, Edinburgh

41
Charles James Fox 1782–3
Oil on canvas 125 x 99
The Earl of Leicester and Trustees of the Holkham Estate

42
Richard Brinsley Sheridan 1788–9
Oil on canvas 127 x 101
House of Commons, London

THE STREATHAM WORTHIES

43
Oliver Goldsmith 1772
Oil on canvas 76.2 x 64.1
National Gallery of Ireland, Dublin

44
Giuseppe Baretti 1773
Oil on canvas 73.7 x 62.2
Private Collection

45
Edmund Burke 1774
Oil on canvas 76.2 x 63.5
Scottish National Portrait Gallery, Edinburgh

46
Self-Portrait c.1775
Oil on canvas 74.9 x 62.2
Tate. Bequeathed by Miss Emily Drummond 1930

47
Samuel Johnson c.1772–8
Oil on canvas 75.6 x 62.2
Tate. Purchased 1871

48
Charles Burney 1781
Oil on canvas 74 x 61
National Portrait Gallery, London

49
Mrs Hester Lynch Thrale with her Daughter Hester Maria 1777–8
Oil on canvas 140.4 x 148.6
Beaverbrook Art Gallery, New Brunswick

PAINTED WOMEN

50
Kitty Fisher as Cleopatra Dissolving the Pearl 1759
Oil on canvas 76 x 63
The Iveagh Bequest, Kenwood

51
Kitty Fisher c.1763–4
Oil on canvas 99 x 77.5
Trustees of the Bowood Collection

52
Nelly O'Brien c.1762–4
Oil on canvas 125 x 100
Hunterian Museum and Art Gallery, University of Glasgow

53
Mrs Hartley as a Nymph with a Young Bacchus 1771
Oil on canvas 88.9 x 68.6
Tate. Presented by Sir William Agnew Bt 1903

54
Mrs Abington as 'Miss Prue' 1771
Oil on canvas 76.8 x 63.7
Yale Center for British Art, Paul Mellon Collection

55
Lady Worsley c.1776
Oil on canvas 236 x 144
The Earl and Countess of Harewood and Trustees of the Harewood House Trust
(London only)

56
Mrs Abington as 'Roxalana' 1782–3
Oil on canvas 74 x 65
Private Collection
(London only)

57
Mrs Musters as 'Hebe' 1782
Oil on canvas 238.8 x 144.8
The Iveagh Bequest, Kenwood
(London only)

THE THEATRE OF LIFE

58
Giuseppe Marchi 1753
Oil on canvas 74 x 63
Royal Academy of Arts, London

59
*Francesco Bartolozzi ?*c.1771–3
Oil on canvas 76 x 63
Saltram, The Morley Collection
(The National Trust)

60
Garrick between Tragedy and Comedy 1760–1
Oil on canvas 148 x 183
Rothschild Family Trust
(London only)

61
Colonel Acland and Lord Sydney, 'The Archers'
1769
Oil on canvas 236 x 180
Private Collection

62
Master Crewe as Henry VIII c.1775
Oil on canvas 139 x 111
Private Collection

63
Miss Crewe c.1775
Oil on canvas 137 x 112
Private Collection

64
A Child's Portrait in Different Views:
'Angels' Heads' 1786–7
Oil on canvas 74.9 x 62.9
Tate. Presented by Lady William Gordon 1841
(Ferrara only)

65
Scyacust Ukah 1762
Oil on canvas 122 x 90
Gilcrease Museum, Tulsa, Oklahoma. Gift of the
Thomas Gilcrease Foundation, 1963

66
Sketch for 'Omai' c.1775–6
Oil on canvas 60.4 x 52.7
Yale University Art Gallery, Gift of the
Associates in Fine Arts

67
Omai c.1776
Oil on canvas 236 x 145.5
Private Collection

68
Mrs Baldwin 1782
Oil on canvas 141 x 110
Compton Verney House Trust (Peter Moores
Foundation)

69
Mrs Siddons as the Tragic Muse ?1784 or 1789
Oil on canvas 239.7 x 147.6
The Trustees of Dulwich Picture Gallery, London

70
Mrs Billington 1789
Oil on canvas 239.7 x 148
Beaverbrook Art Gallery, New Brunswick

REYNOLDS AND THE REPRODUCTIVE PRINT

71
Edward Fisher (1722–82) after Reynolds
Lady Elizabeth Keppel 1761
Mezzotint 58 x 36
The British Museum, London

72
Edward Fisher (1722–82) after Reynolds
Garrick between Tragedy and Comedy 1762
Mezzotint 40 x 50.2
The British Museum, London

73
James Watson (1740–90) after Reynolds
Lord Granby c.1766–7
Mezzotint 61 x 45.4
The British Museum, London

74
Edward Fisher (1722–82) after Reynolds
Hope Nursing Love 1771
Mezzotint 50.3 x 35.5
The British Museum, London

75
Thomas Watson (1750–81) after Reynolds
Miss Kennedy 1771
Mezzotint 50 x 35.5
The British Museum, London

76
William Dickinson (1746–1823) after Reynolds
Joseph Banks 1774
Mezzotint 50.1 x 35
The British Museum, London

77
John Raphael Smith (1751–1812) after Reynolds
Mrs Montagu 1776
Mezzotint 50 x 35.5
The British Museum, London
(London only)

78
William Dickinson (1746–1823) after Reynolds
Mrs Sheridan as Saint Cecilia 1776
Mezzotint 49.8 x 35.1
The British Museum, London

79
Valentine Green (1739–1813) after Reynolds
The Duchess of Devonshire 1780
Mezzotint 58 x 36
The British Museum, London

80
Johann Jacobé (1733–97) after Reynolds
Omai 1780
Mezzotint 62.6 x 38.2
The British Museum, London
(London only)

81
Valentine Green (1739–1813) after Reynolds
Joshua Reynolds 1780
Mezzotint 47.8 x 37.2
The British Museum, London

82
Valentine Green (1739–1813) after Reynolds
William Chambers 1780
Mezzotint 48 x 37.8
The British Museum, London

83
John Raphael Smith (1751–1812) after Reynolds
Banastre Tarleton 1782
Mezzotint 63 x 39
The British Museum, London

84
John Raphael Smith (1751–1812) after Reynolds
Louis Philippe Joseph, Duke of Orléans 1786
Mezzotint 64.5 x 45
The British Museum, London

85
James Ward (1769–1859) after Reynolds
Mrs Billington 1800
Mezzotint 65.2 x 41.3
The British Museum, London
(London only)

86
Richard Earlom (1743–1822) after Johan Zoffany
The Academicians of the Royal Academy 1773
Mezzotint 50.8 x 71.8
The British Museum, London

87
Pietro Antonio Martini (1739–97) after Johann
Heinrich Ramberg
The Exhibition of the Royal Academy 1787 1787
Coloured engraving 37.9 x 52.8
The British Museum, London

REYNOLDS AND THE SCULPTED IMAGE

88
Giuseppe Ceracchi (1751–1801)
Joshua Reynolds ?c.1778–9
Marble, height 69.2
Royal Academy of Arts, London

89
John Flaxman (1755–1826)
Model of Statue of Joshua Reynolds 1807
Plaster, height 121.9
Sir John Soane's Museum, London

90
John Henry Foley (1818–74)
Joshua Reynolds by 1874
Marble 203.2 x 78.7 x 66
Tate. Bequeathed by Henry Vaughan 1900
(London only)

Lenders and Credits

Public Collections

St Edmundsbury Borough Council, Manor House
Museum, Bury St Edmunds 13
Compton Verney House Trust, Compton Verney 68
National Gallery of Ireland, Dublin 43
National Gallery of Scotland, Edinburgh 27
Scottish National Portrait Gallery, Edinburgh 21,
40, 45
Uffizi Gallery, Florence 4
Beaverbrook Art Gallery, New Brunswick 49, 70
Hunterian Museum and Art Gallery, Glasgow 52
The British Museum, London 71, 72, 73, 74, 75, 76,
77, 78, 79, 80, 81, 82, 83, 84, 85, 86, 87
Dulwich Picture Gallery, London 69
The Iveagh Bequest, Kenwood, London 50, 57
National Army Museum, London 14
National Gallery, London 11, 18
National Maritime Museum, London 9
National Portrait Gallery, London 1, 32, 33, 38, 48
House of Commons, Palace of Westminster, London 42
Royal Academy of Arts, London 5, 58, 88
Sir John Soane's Museum, London 89
Tate, London 17, 25, 26, 31, 36, 37, 46, 47, 53, 64
Manchester Art Gallery 10
Yale Center for British Art, New Haven 2, 54
Yale University Art Gallery, New Haven 66
The Frick Collection, New York 16
The National Trust, Saltram 59
The John and Mable Ringling Museum of Art,
Sarasota, Florida 15
Gilcrease Museum, Tulsa 65

Private Collections

Abercorn Heirlooms Settlement 8
The Marquis of Lansdowne and the Trustees of the
Bowood Collection 51
The Duke of Buccleuch and Queensberry KT 19
The Chatsworth Settlement, Chatsworth 29
Lord Egremont 12
Her Majesty Queen Elizabeth II 7, 35
The Earl and Countess of Harewood and the
Trustees of the Harewood House Trust 24, 55
The Earl of Leicester and Trustees of the Holkham
Estate 41
The Duke of Marlborough 20
The Duke of Norfolk 31
Rothschild Family Trust 60
Earl Spencer 28
Lady Juliet Tadgell 3, 6, 22
Private Collections 23, 34, 39, 44, 56, 61, 62, 63, 67

Photographic Credits

Catalogue

Abercorn Heirlooms Settlement. Photography
Christopher Hill 8

With kind permission from the Earl Spencer at
Althorp 28

Reproduced by kind permission of His Grace the
Duke of Norfolk, Arundel Castle 31

His Grace the Duke of Marlborough, Blenheim
Palace. Photography Jeremy Whitaker MCSD 20

Reproduced by permission of the Trustees of the Rt.
Hon. Olive, Countess Fitzwilliam's Chattels
Settlement, and Lady Juliet Tadgell 6, 22

Trustees of the Bowood Estate 51

The Collection of the Duke of Buccleuch &
Queensberry KT 19

Manor House Museum, Bury St Edmunds. Photo:
Graham Portlock 13

© The Devonshire Collection, Chatsworth.
Reproduced by kind permission of the Chatsworth
Settlement Trustees 29

National Gallery of Ireland, Dublin 43

Antonia Reeve Photography 34, 39

© The National Gallery of Scotland, Edinburgh 27

© The National Gallery of Scotland, The Scottish
National Portrait Gallery 21, 40, 45

© Photo Scala, Florence, Galleria degli Uffizi,
Florence, 1990 4

Bequest of John Ringling, Collection of The John
and Mable Ringling Museum of Art, The State Art
Museum of Florida 15

Reproduced by kind permission of the Earl &
Countess of Harewood & Trustees of the Harewood
House Trust 55

© Hunterian Art Gallery, University of Glasgow 52

The British Museum, London 71–87

By permission of the Trustees of Dulwich Picture
Gallery, London 69

© English Heritage Photo Library 50; (Photo Library
Photographer Jonathan Bailey) 57

Courtesy of the Director, National Army Museum 14

National Gallery, London 11, 18

© National Maritime Museum, London 9

© National Portrait Gallery, London 1, 32–3, 38, 48

Royal Academy of Arts, London 5, 58, 88

The Royal Collection © 2005, Her Majesty Queen
Elizabeth II 7, 35

By courtesy of the Trustees of Sir John Soane's
Museum 89

Sotheby's Photographic 68

Photograph by courtesy of Sotheby's Picture Library,
London 67

Tate Photography 12, 17, 25–6, 30, 36–7, 46–7, 53, 64;
(Marcus Leith & Andrew Dunkley) 3; (Joanna
Fernandes & Mark Heathcote) 90

© The Palace of Westminster 42

Photography courtesy the J. Paul Getty Museum,
Los Angeles 2

© Manchester Art Gallery 10

The Beaverbrook Art Gallery, New Brunswick 49, 70

Copyright The Frick Collection, New York 16

Collection of the Earl of Leicester, Holkham Hall,
Norfolk/www.bridgeman.co.uk 41

Saltram House, The Morley Collection (The
National Trust) NTPL/Rob Matheson 59

Gilcrease Museum, Tulsa, Oklahoma 65

Elton Hall Collection 23

Prudence Cuming Associates 56

Waddesdon, The Rothschild Collection (The National
Trust), photographer Richard Valencia 60

Yale Centre for British Art, Paul Mellon Collection 54

Yale University Art Gallery, Gift of the Associates in
Fine Arts, Sept. 1936 66

Figures

Mead Art Museum, Amherst College, Museum
Purchase 13

By kind permission of His Grace the Duke of Bedford
and the Trustees of the Bedford Estates 10

Staatliche Museen zu Berlin – Gemäldegalerie/
© bpk, Berlin 2004; photo Jörg P. Anders 6

His Grace the Duke of Marlborough, Blenheim
Palace. Photography Jeremy Whitaker MCSD 39

Musée Condé, Chantilly, France, Giraudon/
Bridgeman Art Library/www.bridgeman.co.uk 11

National Gallery of Ireland, Dublin 37

© The National Gallery of Scotland, Edinburgh 31

Reproduced by kind permission of the Earl &
Countess of Harewood & Trustees of the Harewood
House Trust 38

National Museums Liverpool (Lady Lever Art
Gallery) 28

The British Library, London 7, 32

The British Museum, London 16, 19–26, 33

National Gallery, London 34–5

© National Portrait Gallery, London 1, 18, 27

National Trust Photographic Library (Andrew
Butler) 3; (Derrick E. Witty) 29; (John Hammond) 14

The Royal Collection © 2004, Her Majesty Queen
Elizabeth II 4, 40

Tate Photography 30; (Marcus Leith and Andrew
Dunkley) 36

By kind permission of the Trustees of the Wallace
Collection, London 8

Fort Ligonier, Pennsylvania 12

Plymouth City Museums and Art Gallery: Cottonian
Collection 2

Courtesy of the Huntington Library, Art Collections,
and Botanical Gardens, San Marino, California 15

Waddesdon Manor, The Rothschild Collection (The
National Trust), Photographer: Mike Fear 9

Index